CLARISSA ON THE CONTINENT
Translation and Seduction

CLARISSA ON THE CONTINENT

Translation and Seduction

Thomas O. Beebee

The Pennsylvania State University Press
University Park and London

For Frederick L. and Louise Oliver Beebee

Library of Congress Cataloging-in-Publication Data

Beebee, Thomas O.
 Clarissa on the Continent : translation and seduction / Thomas O. Beebee
 p. cm.
 Includes bibliographical references.
 ISBN 0-271-00693-5
 1. Richardson, Samuel, 1689–1761. Clarissa. 2. Richardson,
Samuel, 1689–1761—Translations. 3. Richardson, Samuel, 1689–1761—
Appreciation—Europe. 4. Translating and interpreting—
History—18th century. 5. Translating and interpreting—
History—19th century. 6. Seduction in literature. I. Title.
PR3664.C43B44 1990
823′.6—dc20 89–23223

It is the policy of The Pennsylvania State University Press to use acid-free
paper for the first printing of all clothbound books. Publications on un-
coated stock satisfy the minimum requirements of American National Stan-
dard for Information Sciences—Permanence of Paper for Printed Library
Materials, ANSI Z39.48-1984.

Contents

Preface

Translators often feel compelled to justify their choice of text for translation. The translators who are the main object of my study, the abbé Antoine François de Prévost and Johann David Michaelis, both took great pains to explain what they saw in and what they translated out of Samuel Richardson's novel *Clarissa*. I too wish to explain my choice of Richardson's novel, the longest in the English language, as my source text of interest.

Beginning with St. Jerome, the West has been practicing translation theory for almost two millennia. In a sense, translation theory was, along with rhetoric, the West's first literary theory. There has arisen a copious and engaging theoretical discussion of how translation should be done, and of what the need for and the process of translation mean within the context of human communication.

Though there is much on the how and why of translation, there is little on the methods to be used in evaluating the two or more parallel texts produced by translation. In other words, there seems to be no theory of *how to read* translations. Though much contemporary literary theory directs our attention toward the reading process, up to now few of its concepts have been applied to the laborious and delicate task of evaluating literary translation. Moreover, if one excludes the Bible, then the study of translations of narrative fiction has perhaps been even less developed than that of poetry and drama. Perhaps because of its inherent difficulty, poetry has always been the preferred topic of translation study, followed by drama. Just as prose fiction has lagged behind poetry and drama in the development of a theory for its construction and reading, so too the translation of prose fiction has always seemed straightforward and hardly in need of explanation. The theoretical concepts I introduce in this book are taken from the (fairly) recent development of a "po-

etics of prose," are of particular importance for the novel, and show that the analysis of fiction is rarely a matter of adding one sentence to another.

Once the decision to study a novel was made, Samuel Richardson's *Clarissa* immediately presented itself as one of the most international of literary texts. Its prompt simultaneous translation into German and French provided an interesting chance for comparison not just of translation with original, but of two translations, in different languages, with each other. Prévost and Michaelis did their translations of Richardson at approximately the same time, but for different purposes and within different environments. A comparison of the texts they produced helps identify the "switching points" within the original, as well as clarify the possibilities which two distinctly different literary systems gave their translators. But *Clarissa*'s advantages do not end there; the book's continued popularity and repeated translations in the nineteenth and twentieth centuries provided the opportunity for diachronic comparisons as well. Surely few works of prose fiction have had the distinction of such a wide range of influence, or of so many translations done over such a long period of time.

What were the elements of Richardson's revolution in fiction? In terms of style, the ingenuous everydayness of Richardson's letter-writers, and their construction of a new diction for the description of psychological minutiae, the replacement of the novel's simple past with the present and present perfect—"writing to the moment," as Richardson called it—greatly influenced subsequent authors, from Fanny Burney to Goethe. In terms of ideology, Richardson's ambiguous feminism and projection of middle-class values were linked in *Clarissa* with a tragic vision of the realization of these values in English society. (In this respect *Clarissa* rejects the romantic optimism of the earlier *Pamela*, and avoids the stiff idealism of the later *Sir Charles Grandison*, both of which had similar success in Europe.) In terms of its theme, *Clarissa* interested the eighteenth century both because it addressed the moral dilemmas brought about by Enlightenment (such as the preoccupation with sex), and because it communicated those dilemmas through extraordinarily complex and ambiguous analyses of language and human character (where the latter term appears, as always in fiction, as a particular and unique *style*). But I would argue that *Clarissa* has had such a lasting impact because it is a novel which contains a number of viewpoints on many subjects, any one of which the reader may identify with in vigorously rejecting the others. Paradoxically, this perspectivism has assured *Clarissa* not only of long life but also of continual misreading.

In what follows I have tried to present *Clarissa*'s unique qualities in detail, in order to explain both the special circumstances under which it was translated and the unusual features which the translators encountered. Curiously, the moral and political importance of Richardson's novel made its translation all the more difficult. Not only language per se but also entire social attitudes toward property, prudery, religion, and gender difference needed to be translated into French and German. Thus I have also, where necessary, and beginning with the lives of the translators themselves, attempted to reconstruct those lost social and literary contexts.

My starting point for this study of Samuel Richardson's *Clarissa*, then, was the perspectivism implied in applying various theories of literary meaning to an otherwise chaotic mass of linguistic and stylistic data. Intertextuality, binary logic, and dialogy became for me filters for the capturing and ordering of data. These concepts still remain in my memory as the various pen colors of red, blue, and green with which I circled likely quotations for comparison with each other.

As my comparisons disclosed differences, and as I struggled to group those differences into patterns, I was sent to the widest variety of ancillary texts in order to explain my findings. The English, French, and German languages of the mid-eighteenth century were all essentially in their modern forms. But the familiarity of eighteenth-century language is precisely one of its pitfalls, since one can easily miss meanings of a word which were then prominent but have become obsolete, or place too much emphasis on meanings of words which would have never entered Richardson's mind or those of his translators. And of course acceptable literary style, which imparts so much meaning to a text, was also considerably different then from what it is now.

Of first necessity, then, was a set of eighteenth-century dictionaries: Samuel Johnson's *Dictionary of the English Language* (1755) for English; Adelung's *Grammatisch-kritisches Wörterbuch der hochdeutschen Mundart* (1774–86) for German; and Antoine Furetière's *Dictionnaire universel, contenant généralement tous les mots françois* (1690) for French. These dictionaries are indispensable not so much because they give the meaning of a particular word at an earlier point in European history, as because they provide an entire social context within which a particular word could be used at that time. Some of the remarkably revealing entries from these dictionaries have found their way into my study verbatim. A larger number have been reformulated into my commentary; they lie beneath the surface of my text, just as a whole social world of conflicting and intercrossing meanings and

assumptions supports the linguistic surface of Richardson's. Supplementing these dictionaries are the great historical ones: The *Oxford English Dictionary*, *Grimms Wörterbuch*, and *Le Robert*. These dictionaries show us above all how much the usage of a word has changed, and allow us to judge the use of a word in a particular fashion as novel or archaic. But dictionaries have their shortcomings, the most apparent of which appears as a kind of vicious circle: On at least two occasions (the words were "vocative" and "droll") the only entry in the *O.E.D.* was the very passage from *Clarissa* which was puzzling me. On such occasions one begins to understand Deconstruction's claim that "there is no outside the text." Other sorts of texts are needed.

Still further help has been gleaned from the many books which provided *Clarissa*'s eighteenth-century ambience. I have chosen Prévost's *Manon Lescaut* to give some idea of the stylistic and thematic preoccupations which the French author may have brought to his task of creating a French *Clarissa*. Johann David Michaelis's essay on the German language has been perused for possible insights into that author's ideas of style and linguistic resources. These are only the most important examples from the large number of eighteenth-century texts which I used to gain some kind of perspective on what sort of system *Clarissa* was created from, and what sorts of systems she was translated into. As with the dictionary entries, I use some of these texts verbatim, while others I have simply devoured in order to gain a feeling for the expectations of eighteenth-century readers.

A final and no less valuable resource has been the considerable secondary literature on these three authors, and on the literature and culture of the European eighteenth century in general. In all, the widest variety of texts—dictionaries modern and ancient, reviews, letters, eighteenth-century essays, fiction, plays, and poetry—has been used to reconstruct, to the extent which we moderns can, the complex web of literature and language from which the translators carved their renditions and through which their readers read them. Needless to say, this kind of work is always approximate, as neither dictionary nor novel can keep pace with the rapid change of living language.

A lemma of Murphy's law can be formulated: $E_t = E_m{}^m$. That is, the total number of errors (E_t) increases exponentially according to the number of media used or studied. In my case $m = 3$ (English, French, and German), which has meant the utmost straining of my competence. Luckily, I have had many friends to help me cope with my many errors. The medium of French language and literature was mastered with the aid of Maureen O'Meara and Ross Chambers.

In German I enjoyed the invaluable help of Hansjoerg Schelle and Ingo Seidler. Richardson's English was made more present to me by Ralph Williams and by Lincoln Faller. To Dr. Faller I also owe a special thanks for the original concept of this book and its organization; to him, to Stuart McDougal, and to Philip Winsor also go my thanks for advice and encouragement that helped me carry the project through to the end. Of course my own English, bent out of shape from so much foreign contact, and my argumentation, by turns over-subtle and over-hasty, were in need of considerable help, which was generously provided by Mary Barnard-Quiñones, Caroline Eckhardt, Rita Goldberg, and Burton Raffel.

Besides trying to write good English, I have also tried to make my book accessible to readers by providing an English-language version for all foreign quotations in it. Where the quotes are themselves translations of passages from *Clarissa* under discussion, a retranslation seemed unnecessary. Where they are additions to Richardson, or drawn from secondary material, I have provided a translation. Where I have used a published translation (as with Prévost's *Manon*, for example) the translator's name is given as a reference. Where no published translation exists, I have provided my own. This was no easy task when translating Prévost, for instance. I resisted the temptation to try to archaize my English rendering, but some of my word choices may seem unusual to the modern reader. They are the product, however, of laborious checking against the historical dictionaries mentioned above.

Again for readers' convenience, the vast majority of references are given in the body of the text with author's last name, title, and page number. Complete entries for all works cited can be found at the end of the book in the bibliography, Part I of which is devoted solely to Richardson's *Clarissa*, its editions and translations. Part II gives all other sources. Both parts of the bibliography are intended to be practical rather than exhaustive or definitive.

1

Introduction:
Richardson, Prévost, Michaelis

La vertueuse Clarisse est éclipsée par le criminel Lovelace! Le public, se laissant séduire par ce dernier, relègue momentanément Clarisse au second plan. Clarisse Harlowe *a échappé à toute le XVIII^e siècle.*

(The virtuous Clarissa is eclipsed by the criminal Lovelace! Allowing itself to be seduced by the latter, the public consigns Clarissa to the background for the time being. Clarissa *escaped the entire eighteenth century.)*
　　　　　—*Bernard Facteau* (Les romans de Richardson, *69*)

In this epigraph, which discusses the French reception of *Clarissa*, as within the novel itself, Lovelace seduces and Clarissa escapes. Bernard Facteau's catalogue of the French dramatizations of the English novels of Samuel Richardson contemplates the parallels between the action in *Clarissa. Or, the History of a Young Lady* (1748) and the act of reading it and adapting it for the stage. The present study will discuss another sort of adaptation of *Clarissa*—that which calls itself a translation. Out of the parlous path from words to their interpretations, from *Clarissa* to its public, or from English original to its translations, the villain Robert Lovelace has always led readers astray.

　Facteau's allegorical exclamation is made possible by the polysemy of the French verb "séduire." Applied to Lovelace as a *character* in Richardson's novel, the word takes on the explicitly sexual meaning first documented in 1538. Applied to Lovelace as a model for reading, "séduire" takes on a rather different and more ambiguous meaning. Lovelace's seduction of *Clarissa*'s readers lies on the plane of art, of persuasive illusion. Indeed, the *Robert*'s definition of this latter kind of seduction could serve without alteration as a definition of Richardson's realist didactic fiction: "Convaincre quelqu'un, en

persuadant ou en touchant, avec l'intention plus ou moins consciente de créer l'illusion, en employant tous les moyens de plaire" ("To convince someone by persuading or moving, with the more or less conscious intention of creating an illusion through the power of pleasure").[1] Thus Lovelace the seducer incorporates the power of fiction. But this creation of illusion and pleasure is also the task of literary translation: unlike other forms of translation, it must please its reader, and in order to do so it generally must create the illusion that one is reading an original.

But this is only one side of translation or of fiction. Not only Lovelace's seductive linguistic practice, but also the heroine Clarissa's belief in language as truth spills over from the novel into the very act of reading, understanding, and, I will argue, translating it. After more than two centuries, *Clarissa* still splits its readers into two camps: those who sympathize with Lovelace in his attempt to conquer a "rather prim low-church English maiden" (Goldberg, *Sex and Enlightenment*, 2); and those who sympathize with Clarissa as she is sequestered, drugged, and raped. Some are bored by Clarissa's preaching, others infuriated by Lovelace's lies. In choosing one character or the other, the novel's readers have always bought into a huge amount of social and philosophical territory.[2] Readers who de-

1. "Séduire" thus shows a much wider range of expression than does its English counterpart, "to seduce." The modern English speaker is apt to experience as metaphorical and secondary any usage of the word beyond that of sexual encounter. Historically speaking, however, it is the sexual meaning which is secondary. The primary meaning of "to seduce" was originally "to persuade (a vassal, servant, soldier, etc.) to desert his allegience or service." The sexual meaning was "often apprehended as a specific application of sense 1 [just given]; in English law the plaintiff in an action for seducing a virgin is the parent or master who is supposed to have been deprived of her services" (*O.E.D.*). This equation of the seduced woman with the seduced vassal or servant immediately connects with *Clarissa*'s theme. Clarissa's abduction and rape have legal, economic, religious, and social repercussions. Sex itself is merely a sign for those more important concerns.

2. Critical attention has been paid to *Clarissa*'s plot, particularly to the book's borrowings from the drama (Konigsberg, Sherburn), its characterizations (Golden, Braudy), and its literary, social, and historical context. The epistolary form of the book was considered valuable primarily for its ability to bring characters to life in a way that third-person narrative could not.

More recently, three major studies have focused our attention on *Clarissa* as a book about writing, language, and communication: W. B. Warner's *Reading "Clarissa:" The Struggles of Interpretation* suggests that the novel is an agon between Clarissa's (and Richardson's) efforts to construct a humanistic discourse and Lovelace's efforts to deconstruct it. Terry Castle in *Clarissa's Ciphers* has taken a similar tack in viewing *Clarissa* not as a story, but as a theoretical excursus on signs and reading. Her subject is "the matter of exegesis, how it operates within *Clarissa*, both as a mode of human contact and as a mode of violence, the ways in which it may be said to condition the

fended Lovelace accepted the male, the aristocrat—or "chevalier" as he is called by his valet—the rake, the seducer, and the concept of language as power and as pleasure. Readers who preferred Clarissa valued the female, the bourgeois, the moralist, the virgin, and the concept of language as truth. Facteau's series of oppositions between Clarissa and Lovelace, between the light of truth and its eclipse, between foreground and background, between virtue and criminality, between reading and misreading, between the didactic and the aesthetic, continues this polarizing tendency.

This necessity of choosing between one character and the other perhaps explains why this particular novel has been able to generate French and German versions which demonstrate in a particularly clear fashion opposing practices in literary translation. Starting with Richardson himself, critics have lambasted the immorally "free" translation of *Clarissa* by the famous novelist Antoine François Prévost, who reshaped the novel to suit his own aesthetic purposes. Yet Prévost's version was primarily responsible for Richardson's popularity in France—and in Russia, where French translations were commonly used. The German translation by Professor Johann David Michaelis, undertaken virtually on behalf of Göttingen University with an aim to preserving the didactic elements of the original, has been less severely criticized—because it has been forgotten.

Translation and seduction lie at the heart of *Clarissa*. Its title figure is seducta, rapta (in its original meaning), translata, rapta (in its derivative meaning). The Latin participles with their feminine endings define essential movements: Lovelace progressively leads Clarissa astray (the etymological meaning of "seduce") until she is brought to regard him as a potential husband; he physically carries her away (as in the original meaning of Latin "rapere," "to seize") when she leaves the safety of her garden for a clandestine meeting; he moves her (one meaning of the verb "translate") from her country home to the wicked city of London; finally, he drugs and rapes her. The first half of the novel thus shows two gradual processes, Clarissa's seduction (which occupies three of the eight volumes), and her translation into London and iniquity. These slow movements are interrupted by two violent actions, two rapes which complete those processses yet also negate them. The second half of the novel then shows an active Clarissa, who escapes from Lovelace, discovers the

heroine's fate" (16). Terry Eagleton's *Rape of Clarissa* is a curious combination of Marxist and Lacanian analysis. In the former mode he attempts to sketch the preconditions for the production of Richardson's novel—as opposed to the classic analyses of the social content of the novel itself (e.g., by Christopher Hill and Ian Watt).

extent of his scheming against her, arranges for the publication of the collection of letters that will become *Clarissa*, writes her will, forgives everyone, and dies so that she may return to her family as a corpse.

If the single word "rapere" shows two different applications here, the different words "seducere" and "transferre" merge in the action of the novel and describe the same physical action: "to lead off" and "to carry over." The French verb "séduire" merges mental and physical meanings; so also does the verb "translate" (or "traduire" or "übersetzen"). The fact that the word for the restatement of meaning across language barriers is always a verb describing physical movement has led George Steiner to postulate that "if culture depends on the transmission of meaning across time . . . it depends also on the transfer of meaning in space" (*After Babel*, 31).

And so the present study, like Richardson's novel, will trace the path of *Clarissa*'s translation—not to London this time, but to Germany and France, *into* German and French. And our purpose will be, as Samuel Richardson's was, to examine the dialectical relationship between debasement and transfiguration. Just as Clarissa is sanctified through the trials which test her moral and mortal limits, so also *Clarissa*'s larger meaning emerges through the perversity of its translations. The very metaphors used to express the activity of translation—and the word itself is metaphorical—invoke the parlous balance between the mental and the physical, between truth and falsehood, between fidelity and infidelity. For example, the well-known Italian phrase, "traduttore traditore" ("translator, traitor") reminds us that the translation of literature can involve betrayal just as the story of Clarissa does. Yet, just as Clarissa finds her true principles in the agony of her betrayal, so can translation also show a deeper truth behind the original. Walter Benjamin has speculated that the activity of translation, by joining imperfect "copies" to an imperfect original, constitutes a search for what was meant to be expressed, what would have been expressed if the author had possessed a "reine Sprache." The purpose of translation is not communication as such, but rather the search for this "pure language": "Translation's ultimate purpose is to express the innermost relation between languages" ("Die Aufgabe des Übersetzers," 80). So it is, then, that the question of translation becomes part of the much larger search for meaning and truth in general, a quest that also lies at the heart of *Clarissa*.

For the eight thick volumes of *Clarissa*, like the row of leather-bound tomes in a lawyer's office, are testimony to Samuel Rich-

ardson's belief in the firm relationship between language and truth. There is no doubt that Richardson sided with his heroine, whose efforts to publicize her side of a sordid story of seduction and rape form the basis for this mammoth novel. The novel is in one sense a journalistic attempt to "get it right," to (re)produce through the publication of their letters every last tactic and strategem of the battle between Clarissa and her rapist, in order to convince the reading public of her sainthood and of his damnation. And when at last a considerable portion of that reading public sided with the villain of the piece, Richardson did not throw up his hands or abandon the inherently ambiguous epistolary form of fiction. He wrote to Lady Bradshaigh (26 October 1748): "It has been a matter of Surprize to me, and indeed of some Concern, that [Lovelace] has met with so much Favour from the good and the virtuous—and in some measure convinced me of the Necessity of such a Catastrophe as I have made" (Carroll, *Selected Letters*, 92). That is, both Clarissa and Lovelace must die, rather than be married off as so many of the novel's readers desired—and as English law provided for in cases of rape. This refusal to reconcile the virgin and her seducer, a refusal which stemmed from Richardson's deeper desire to preserve his two greatest characters as spokespersons of antithetical world views, allowed him to write the first tragic novel in the English language. In bringing out a second (1749), a third (1751), and a fourth (1759) edition, Richardson deleted and added passages, chiseling away at his verbal material in order to deepen the abyss between Lovelace and Clarissa even further.

That both a Lovelace and a Clarissa could emerge from the single head of Samuel Richardson should surprise, and yet it is a typical example of the contradictory or "dialogic" impulses at work in many great writers. Richardson was both a child of the Enlightenment and a religious conservative, both a printer who contributed to the increasing commodification of the literary text and a storyteller (principally through letters) very much dependent upon a palpable sense of community. Enlightenment thought presupposes language as a logical, universal tool for communicating ideas. Contradictory as it may sound, Lovelace's view of language shows more affinity with Richardson's religion (he wanted to become a clergyman, but failed to obtain adequate schooling).[3] In the Bible language is performa-

3. For the influence of Puritan literature on the form, style, and theme of *Clarissa*, see Cynthia Griffin Wolff's *Samuel Richardson and the Eighteenth-Century Puritan Character*.

tive; from the first words of Genesis to the Gospel of Saint John, language is action and deed, food and flesh, rather than the deed's phonetic shadow.

For Richardson writing and reading were conditioned by community. The motive behind his practice of sending parts of the manuscript of *Clarissa* to friends was less to seek their advice than to symbolically place his work within a community of readers. Terry Eagleton has identified the paradox of Richardson's trying to achieve a sense of intimacy and familial solidarity through commodity production:

> It was no mere avuncular masochist who sent copies of *Pamela* to Aaron Hill's daughters with interleaved pages for their corrections. . . . Richardson's life is his literary work, not his literary works. In creating this partially collective mode of literary production, he turns his texts into pretexts—into occasions for sharply nuanced debate, forums for continuous mutual education, media for social rituals and relations. He produced, not simply a set of novels, but a whole society in miniature; by sustaining a constant circulation of discourse, a potentially infinite generation of texts about texts, he converted the process of his art into an act of ideological solidarity. (*The Rape of Clarissa*, 11–12)

Thus the author Richardson inhabited a category between that of storyteller and that of "auteur," and he managed to combine authorial presence with anonymity. This ambiguity suggests a reason for the powerful connection between narration and seduction in *Clarissa*. Ross Chambers has analyzed this connection for nineteenth-century literature in *Story and Situation: Narrative Seduction and the Power of Fiction*. Chambers describes how, as texts become commodified and reified in industrial societies and hence lose the directness which comes from the original oral contact between the storyteller or story-reader and the audience, they are forced to lose their virginity (relative harmony between story and discourse) and to seduce their readers by discursive means. Richardson's case is an interesting compromise between these two models of storyteller and author. Indeed, the letter form is itself a compromise between physical presence and anonymity. It is no surprise therefore that *Clarissa*, written by a man who was both auteur and storyteller, is founded upon the deadly battle between texts seductive and virginal.

Given such contradictions, an accurate reading of *Clarissa* can not merely describe the triumph or victimization either of Clarissa or of

Lovelace, but must seek to articulate the distance and balance between them. As Paul Coates has put it, "the novel is born as the opposites are personified allegorically as 'Clarissa' (The Didactic) and 'Lovelace' (The Aesthetic), and then allowed to commence a complex, dizzying interplay . . . a consequence of the vertiginous logic of dialectical thinking, which permits opposites to change places" (*"Clarissa*, Dialectic, and Unreadability," 23). Thus an accurate reading must identify the points at which these two opposing figures meet: Clarissa, in her meticulous adherence to the truth value of words, is able to use interpretation as a deceptive device, as in the famous letter to Lovelace that begins my next chapter. And though readers of *Clarissa*, like its heroine, mistrust Lovelace at every step, still all attempts at analyzing his character—including those that see him as a pathological liar—must be based upon *his* self-analyses, and hence must create truth out of his untruths. *Clarissa*'s deepest truth is forged in the dialectic between Lovelacean and Clarissean reading strategies, a dialectic which both invites and defeats final interpretation.

It is impossible in reading *Clarissa* not to interpret the book or to take sides, and it is equally impossible to fully succeed at interpreting it. By using various avenues of interpretation, this study reproduces the tug-of-war between these two moments of *Clarissa*'s dialectic: on the one hand, the Lovelacean centrifugal strategies which continually defer the reader's experience of the History of this young lady (chapter 2, "Translation, Transposition, Intertextuality"), or which dissolve that experience into a multitude of competing voices (chapter 4, "Translating Dialogism"); and on the other hand, those Clarissean centripetal devices which structure and channel our reading experience in specific directions (chapter 3, "Texts in Opposition"). The ideas of intertextuality, of structuralism, and of dialogism introduced in the following chapters are temporary grids laid over the text in order to highlight those two larger grids—Clarissa and Lovelace—which provide the novel's most basic "allegories of reading." In addition, my use of these concepts should also be seen as an exploration of their potential usefulness for translation studies in general. A double illumination is desired: newer theories of reading can provide fresh viewpoints on literary translation; similarly, theories of reading and interpretation must consider and explain the act of translation if they are to pretend to any universal validity.

The German and French translations which form the core of this study represent two very different readings of Richardson; in fact, they tend precisely toward the two exemplary categories, the Clarissean didactic and the Lovelacean aesthetic, which Richardson cre-

ated for his novel and into which most readings of his text have fallen. I wish to read each translation on its own terms. Previous readings of Richardson translations have emphasized translators' "mistakes" or the cultural factors which caused them, ignoring the question of what sort of novel had actually been produced by the act of translation.[4] An example of such a reading is the first sentence of Lawrence Marsden Price's study, in which he asserts: "The novels of Samuel Richardson were translated into German promptly and frequently but not always well" ("On the Reception of Richardson," 7). The sentence is a truism, since the critic's job will always be to weigh various translations and find some better than others. But the sentence also begs the question of what "well" means, thus ignoring the paradoxes of literary translation which make it so difficult and so interesting. In order to gain some idea of what Richardson's translators might have meant by translating Richardson "well," we begin by examining their prefaces.

Though I will not be able to investigate the translation of *Clarissa* into Dutch by the Mennonite clergyman Johannes Stinstra, it is nevertheless interesting to examine his preface and to compare it to the French and German ones. Stinstra was the only translator to personally correspond with Richardson. His translation, which appeared between 1752 and 1755 (that is, at a later date than the French and German versions), was, if we are to judge by its preface and by Stinstra's letters to Richardson, the translation most concerned with preserving the didactic features of the original. The prominent minister Stinstra used his preface to defend himself against the charge of having become involved with a novelistic production. Not only does Stinstra agree with the original purpose of Richardson's text, he finds in that original purpose a much-needed justification for himself, a man of the cloth, to translate a work of fiction:

> I . . . admit that it would not at all be fitting to the dignity of a Minister of the Gospel to bring such books into the world, which are suited only to make readers laugh; and to help multiply them (although laughing is not useless for some people) without their having a more important use to further. . . .

4. Prévost's translations (he also translated *Grandison* and was at one time credited with *Pamela*) have been examined in Frank H. Wilcox's *Prévost's Translations of Richardson's Novels*, in Henri Roddier's "L'Abbé Prévost et le problème de la traduction," in François Jost's "Prévost traducteur de Richardson," and most recently in Vivienne Mylne's "Prévost et la traduction du dialogue dans *Clarisse*." There is no full-length study of Michaelis's translation, but there is some discussion of it in Lawrence M. Price's article "On the Reception of Richardson in Germany."

But the excellent work which I now offer and recommend to Dutch readers is an entirely different sort, not only the most beautiful and entertaining novel but also the most useful influence on the minds of those who love virtue in some degree or whose hearts are not unmoved by all incitements towards good. (Slattery, *The Richardson-Stinstra Correspondence*, 111–12)

On the one hand, Stinstra seems to balance the aesthetic with the didactic. *Clarissa* is both a "beautiful and entertaining novel" and also a "useful influence." But this part of the preface aims at demonstrating that in fact only the latter category has motivated Stinstra. Indeed, Stinstra even judges laughter according to its utilitarian value, which apparently is substantially less than that of the tears *Clarissa*'s readers were meant to shed. Stinstra's description of the book's usefulness implies a total obliviousness to the seductive dangers of Lovelace. Stinstra can see only the title figure of Richardson's novel, and can learn from her precepts alone, while ignoring those of her adversary.

Stinstra's letters to Richardson show that he completely identified the text with its author's intentions. He took advantage of his correspondence with Richardson to ask for the meaning of such obscure phrases as "Waltham disguises" so that he could provide footnotes for his Dutch readers (Slattery, *Richardson-Stinstra*, 20). Richardson seemed to be as interested as Stinstra in the fidelity of *Clarissa*'s translation. Assured both of Stinstra's faithfulness and of his distance, Richardson provided him with the fullest autobiography to survive; and he found in Stinstra a willing audience for his complaints about another, better-known translation. By 1753, Richardson had received both the German and the French translations of *Clarissa*. He remarks on them in a letter to Stinstra dated 2 June 1753:

I have the German Translation you mention; sent me as a Present: I believe, by Direction of Dr. Hollar [sic], who, I am told, is Vice-Chancellor of the University of Göttingen. I have also the French Edition, printed in 12 thin Volumes. It is translated by Abbe Prevost, who has wrote [sic] several Pieces of the Novel Kind. This Gentleman has left out, a great deal of the Book. Belton's Despondency and Death, Miss Howe's Lamentation over the Corpse of her beloved Friend: The bringing Home to Harlowe-Place the Corpse, and the Family Grief upon it. The wicked Sinclair's Despondency and Death,

and many Letters between Lovelace and Belford, all which I
thought might be useful either for Warning or Instruction.
He has given his Reasons for his Omissions, as he went along;
one of which is, The Genius of his Countrymen; a strange one
to me! He treats the Story as a true one, and says, the English
Editor has in many Places, sacrificed it to Moral Instruction,
&c. (Slattery, *Richardson-Stinstra*, 21–22)

This passage is all we have concerning Richardson's opinion of Pré-
vost's and Michaelis's work, and so it is worth dwelling on at some
length. Richardson has surprisingly little to say about the German
translation, carried out at the University of Göttingen, one of the
capitals of the German Enlightenment.[5] Monolingual himself, Rich-
ardson had failed to find a friend who could read German and give
him his opinion (as he had been able to find for Prévost's French
and for the Latin of Stinstra's earliest letters). But he takes the op-
portunity to lambaste Prévost for what he did *not* translate, including
the death scenes of Belton and Sinclair. (Chapter 3 will examine the
reasons for Richardson's emphasis on the death scenes, as well the
reasons for Prévost's excision of them.) Richardson ascribes their de-
letion to French "Genius," a word which the French might render
"goût." "Goût" will often be used by Prévost as a fundamental guide
to good translation. French Genius is "strange" to Richardson; tak-
ing "strange" in its original sense of "foreign," one can see Rich-
ardson's complaint as a tautology. "Genius" denotes the particular,
the national, the idiosyncratic, precisely what is always "strange" to
the other culture. Richardson's attitude is thus a mirror image of
Prévost's, who refused to translate precisely those passages of *Cla-
rissa* which reflected English literary "Genius" in its greatest idio-
syncrasy.

Richardson also implies that Prévost's other literary activities have
much to do with his neglect of the didactic aspect of *Clarissa*. Prévost,
after all, "has wrote several Pieces of the Novel Kind." In fact the
abbé Antoine François de Prévost, or Prévost d'Exiles as he was
sometimes known, was the author of many novels, one of which has
always stood out: the amazingly popular and decidedly amoral tale
of passion called *Histoire du Chevalier des Grieux et de Manon Lescaut*

5. Göttingen University's relations to the French Enlightenment were expressed
principally through reviews of French books and ideas in the *Göttingschen Gelehrten
Anzeigen*. See Peter-Eckhard Knabe's *Die Rezeption der französichen Aufklärung in den
"Göttingschen Gelehrten Anzeigen" 1739–1779*.

(1731).[6] Richardson distanced his own attempts at didactic moral
writing from the mere production of novels. He always avoided the
designation "novel" in the titles of his works. At one point in a letter
he admits to the term "novel" for his works, but only as part of the
claim that he has created a new genre: "And if my Work must be
supposed of the Novel kind, I was willing to try if a Religious Novel
would do good" (Carroll, *Selected Letters*, 92). In the letter to Stinstra,
he complains that Prévost's translation has degraded his work into a
common novel by excising its moral instruction, and by seducing his
readers through a mendacious insistence upon the story's facticity.

An examination of Prévost's short preface to his translation sup-
ports Richardson's indictments, and demonstrates a subtle and un-
holy alliance between the novelistic genre, reading pleasure, and
strong mistranslation.[7] Prévost writes:

> Je commence par un aveu qui doit faire quelque honneur à
> ma bonne foi, quand il pourroit en faire moins à mon discer-
> nement. De tous les ouvrages d'imagination, sans que
> l'amour-propre me fasse excepter les miens, je n'en ai lu au-
> cun avec plus de plaisir que celui que j'offre au public; & je
> n'ai pas eu d'autre motif pour le traduire. (I,7)[8]
>
> (I begin with a confession which should give some credit to
> my good faith, though less to my good judgement. Of all

6. First published in Amsterdam in 1731, *Manon Lescaut* was without doubt Prévost's
best-selling work during his lifetime. Further editions include those of 1733 (3), 1734
(2), 1735, 1737, 1738, 1739, 1742, 1744, 1745 (3), 1749, and 1751 (2). Cf. Alan Hol-
land, *Manon Lescaut 1731–1759*.

7. I coin the term "strong mistranslation" to designate a translation or that part of
translation activity which yields not a reproduction of the original, but a response to
it, just as, Harold Bloom tells us, "a poem is a response to a poem, as a poet is a
response to a poet, or a person to his parent" (*Map*, 18). Bloom's notion that the
creative process is an agon between the writer and his influences, and that influence
"always proceeds by a misreading of the prior poet, an act of creative correction that
is actually and necessarily a misinterpretation" (*Anxiety*, 30), is the source of my coin-
age.

8. I have used the translation found in volumes nineteen to twenty-four of Prévost's
collected works published in 1784 in Amsterdam. The differences between this edi-
tion of his translation and the one published in 1751 are: The twelve tomes of the
first edition have become six (this due to format and not excision); the 1784 edition is
prefaced by Diderot's "Éloge de Richardson"; it is also supplemented with a transla-
tion by J.-B. Suard of some passages which Prévost had left out, particularly the burial
of Clarissa. The additions are clearly differentiated from the rest of the text. Prévost's
translation was made entirely from the first edition of *Clarissa*. Further citations are by
volume and page number.

works of the imagination, provided that self-love does not
make me except my own, I have read none with more plea-
sure than that which I offer my readers; and I have had no
other motive for translating it.)

This first sentence reveals Prévost's ambivalent attitude towards the
original, an attitude which in effect reverses Richardson's view: If
Richardson emphasized the need to read somber death scenes even
if they detract from the pleasure of the text, Prévost has let his read-
ing pleasure overcome his more sober evaluative powers. He also
eschews false modesty and openly mentions his own creative works,
stating that they are his first love, thus immediately raising the ques-
tion of what he will do when this foreign work contradicts his own
creative aesthetic.[9] Yet there is also a playful, Lovelacean men-
daciousness in Prévost's claim to have translated *Clarissa* solely for
pleasure; in fact, this and most of his other translations were done
for money, of which Prévost was continually in need. Prévost's re-
marks are as far removed as possible from Stinstra's solemn mus-
ings. Gone are the use value and the didactic, leaving only *jouissance*
behind. It seems odd that a work which could impress a clergyman
with its seriousness has yielded Prévost only pleasure.

The enthusiasm of the first paragraph continues, though Prévost
now introduces a certain ambivalence towards Richardson. *Clarissa*
has seduced her translator:

> Si cette déclaration m'oblige de justifier un peu mon goût,
> j'ajouterai, avec la même franchise, que je ne connois, dans
> aucun livre du même genre, plus de ces aimables qualités qui
> font le charme d'une lecture à qui l'esprit & le coeur sont
> également attachés. (I,7)

> (If this declaration obliges me to justify my taste somewhat, I
> will add with the same candor that I know of no other novel
> which has more of those pleasing qualities which together
> make the seductive quality of a reading experience in which
> mind and heart have an equal interest.)

9. The preface would seem to contradict Wilcox's cliam that Prévost had only "con-
tempt for his art" (398–99). Wilcox's evidence is drawn from Prévost's letter to a
superior of the Catholic Church where, seeking a position, he conveniently denigrates
his "pieces of the novel kind." It seems clear that Prévost was trying to gain favor with
Dom LeSieur by abjuring a trivial genre to which the Church stood in open hostility.

Prévost's version of the combination of "dulce" and "utile" is the union of heart and mind, both of which are capable of experiencing pleasure and of being seduced. Unlike Stinstra, Prévost sees no conflict between pleasure and moral usefulness. The word "morality" is absent from his list of objectives. Curiously, by neglecting to pay homage to the moral usefulness of the work, Prévost was on the one hand confirming the nondidactic aspects of his own novels, but on the other hand contradicting his own practice of preface-writing. In modifying the wording of "dulce et utile," habitual in the defense of novels, Prévost denied himself the strategy he had used to introduce *Manon Lescaut*:

> Outre le plaisir d'une lecture agréable, on y trouvera peu d'événements qui ne puissent servir à l'instruction des moeurs, et c'est rendre, à mon avis, un service considérable au public, que de l'instruire en l'amusant. ("Avis," 16)

> (Besides the pleasure of an agreeable reading experience, one will find few incidents which could not serve for moral instruction, and in my opinion to instruct the public while entertaining it is to render it a great service.)

If Prévost, like most novelists of the period, felt compelled to defend his own novels against the charge that they yielded only pleasure, his preface to the *Lettres angloises* seems all the more strange. It would seem that translation in this case provided a kind of sanctuary for Prévost, a moment in which he could drop the mask of moral usefulness.

Whether productions "of the Novel Kind" were purely for pleasure or for instruction, in France they were a risky business. All books had to undergo a thorough scrutiny by government censors before they were given even tacit approval for publication. Prévost's novel *Mémoires et aventures d'un homme de qualité qui s'est retiré du monde* (1728–31) had already exposed him to the vagaries of French censorship. A reference to one of the Medicis was resented by that family. A *lettre de cachet* was released against Prévost and the passage excised from subsequent editions of the novel.

Thus the conflict between novels and morals was not new to Prévost, whose flight from the Benedictine monastic life to eventual exile in England has been seen by many as indicative of the collision course between bourgeois literature and the religious doctrine which

still held France in its grip. For example, a contemporary reviewer of Prévost's novel *Cleveland* (1731–39) said of the author:

> L'auteur de cet ouvrage . . . était ci-devant bénédictin, mais, ne pouvant pas aisément pratiquer des romans dans son ordre, il a eu la bonté de se retirer en Angleterre d'où on l'a chassé parce qu'il en faisait trop. (cited in Billy, *Un singulier Bénédictin*, 101)

> (The author of this work . . . was previously a Benedictine monk, but since he could not comfortably practice novel-writing within his order, he was good enough to move to England, from which country he was kicked out because he did too much novel-writing).

The last sentence, with its play on the double meaning of "roman," possibly alludes to the rumor that Prévost was forced to leave England because of a romantic involvement with a nobleman's daughter whom he was supposed to tutor. (Another version has him writing bad checks.) So great is the legend of Prévost's devotion to pleasure that his real-life mistress Lenki Eckhardt was "thought for a time to have been a model for Manon" (Smernoff, *L'Abbé Prévost*, 11), although in fact Prévost met Lenki for the first time in 1731, just after his most famous novel had appeared in print. For whatever reason, Prévost left England for Holland, where he supported himself and his mistress by writing and translating large quantities of material.

There were no real class differences between Richardson and his two translators. The Prévost family of Hesdin were prominent in public administration and in the clergy; that is, they had graced the First and Third estates but never the Second. Yet at some point in the midst of his chaotic and creative life, Prévost ennobled himself. He became "Prévost d'Exiles." No official act or documentation was needed; Prévost merely started signing his letters "Prévost d'Exiles," and the name stuck. The particle "de" generally precedes a name denoting a tract of land or estate. But in Prévost's case, "on ne connaît pas non plus en Artois de bien rural, château, ou propriété quelconque appelée 'Exiles,' à aucune èpoque" (Harrisse, *L'abbé Prévost*, 172; "There is no known record from any time period of an Artois estate, castle, or property carrying the name 'Exiles'"). "Exiles" is then clearly a symbolic title, chosen for its connection to life rather than to property. It is a literary title in every sense of the word. As Jean Sgard has noted:

Tout se passe comme si, dans la présentation de Prévost, son nom de moine avait été un pseudonyme, tandis que le nom noble est donné comme vrai. . . .

Le nom d'auteur de Prévost est assurément "d'Exiles." . . . Mais il y avait de la duplicité dans ce nom: il cumule tout d'abord une sorte de noblesse usurpée et un attrait romanesque, ce qui rend la dénomination instable. . . . Il veut être à la fois Prévost et d'Exiles, et ses aventures d'homme privé ternissent cette noblesse étrange mais incontestable que lui avaient conférée ses romans. ("Antoine Prévost d'Exiles," 5, 13)

(Prévost always took care to give the appearance that his monk's name had been a pseudonym, and that his title of nobility was true.

Prévost's nom de plume is surely "d'Exiles." . . . But there was some duplicity in this name: it brings at once a kind of usurped nobility and a romantic allure, which together render the designation unstable. He wishes to be simultaneously Prévost and d'Exiles, and his adventures as private man tarnish this strange but undeniable nobility which his novels have conferred on him.)

Prévost's nobility was fictional in two senses: it was an imposture, but was also, as Sgard points out, conferred on him by the success of his novels. Prévost's heroes, unlike Richardson's, are always of noble origin. We may then posit that if Prévost's nobility was a fiction, it also depended upon fiction, that is, upon his mastery of texts.[10] And so he felt obliged to continue that mastery into every area of creativity, including that of translation. The notorious faithlessness of Prévost's translation derives in part from the choice to struggle with Richardson for mastery of *Clarissa*.

Richardson wrote in the time he had left over from his work as a printer. The working conditions of his two translators were different. A description of the abbey Saint-Germain-des-Prés, the monastery which Prévost fled at the price of coming under a *lettre de cachet*, provides a useful comparison between him and Michaelis. For the

10. Prévost's contemporary Voltaire describes a similar fictional process in the creation of aristocracy: "En France est Marquis qui veut et quiconque arrive à Paris du fond d'une Province avec de l'argent à dépenser & un nom en Ac ou en Ille, peut dire 'un homme comme moi, un homme de ma qualité'" (*Lettres philosophiques*, I, 122; "In France anyone is a Marquis who wants to be, and whoever arrives in Paris with money to spend and a name ending in *-ac* or *-ille* can say: 'a man like me, a man of my standing,'" Tancock, 52).

abbey had many of the same scholarly functions assumed by a university of the period:

> The abbey, with its great tower, walls, and trenches still resembled a citadel but was celebrated for its intense intellectual life. Its Benedictines, preparing new Greek and Latin editions of the works of the Church fathers, were engaged in scholarly research everywhere through a network of correspondence which frequently necessitated traveling. They enjoyed a universal reputation. The chief work of the abbey at the time of Prévost's arrival was the editing of the *Gallia Christiana*, enormous works composed by a team of researchers. . . . Prévost's frustration at being assigned work that required little creative imagination is suggested by the many scathing portraits of members of this order that appear in the third volume of the *Mémoires d'un homme de qualité*. (Richard Smernoff, *L'Abbé Prévost*, 7)

Every element of the monastic life which Prévost found too narrow corresponds to the academic life of Richardson's German translator. One encounters a certain complementarity in the monastic and academic orders of this period: monks engaged in scholarship; academics rapidly transformed religion and morals.

Unlike Prévost, the Orientalist Johann David Michaelis wrote no novels, though he had attempted some poetry which caught the attention of Göttingen University rector Albrecht von Haller. Haller's enthusiastic review of *Clarissa* appeared in the *Göttingschen Gelehrten Anzeigen*, and as we have seen, he also sent Richardson a copy of Michaelis's translation. Haller, rector since 1736, was both an important poet and an internationally renowned scientist whose observations on the irritability of muscles would contribute considerably to La Mettrie's more radical concept of "l'homme machine." Haller himself was disturbed by the typically eighteenth-century problem of reconciling scientific discovery with religious conviction. *Clarissa* probably appealed to Haller as a kind of secular religious tract, a monumental fictional proof of the need for the continuance of religious faith in the face of Enlightenment and the vagaries of daily life.

Göttingen in this period was perhaps the most progressive university in Germany. It was the first German university to put into practice the modern conception of the university library as a research center open to the public (including to its own faculty, who up to this point had been forced to maintain private libraries for research pur-

poses). Founded on the English model and ruled by the English king, Göttingen maintained strong ties with English culture. Certainly these ties contributed to its enthusiastic reception of *Clarissa*. It would seem that the entire university, not just the literati, was gripped with *Clarissa* fever. In their enthusiasm, medicine and literature met each other on an equal footing, as "Haller bespricht sich auf der Anatomie mit seinen Studenten über die mutmaßliche Fortsetzung dieses Romans" (von Selle, *Die Georg-August Universität*, 183; "Haller discusses the possible continuation of this novel with his students during anatomy class").

The beauty of this anecdote lies not so much in medicine yielding the floor to literature, as in the belief that science and moral instruction can and must speak to each other within the Enlightened classroom. This new enthusiasm for secular literature at Göttingen was a particularly intense reflection of a general trend in German society of this period. The publication of *Clarissa* represented an important contribution to this trend. According to Bernhard Fabian, *Clarissa* was one of the first English novels to be brought out by a first-rate publisher in Germany ("English Books," 131, note 71). Indeed, for Vandenhoeck of Göttingen to publish a work of fiction was in itself extraordinary. The year 1749 saw fifteen of Vandenhoeck's works published in Latin, as opposed to four in German and one in French. The only other work of belles lettres published that year was Haller's *Versuch Schweizerischer Gedichte*. Another historian of German reading habits has singled out the 1740s as a period of rising interest in secular works:

> The first prerequisite to the growth of a wider reading public had been achieved by about the year 1740. Pietism and Rationalism had together broken the hold which the Church had previously enjoyed over society and culture. Feeling had, at least amongst certain sections of the community, at last gained recognition; the Bible and dogma had been replaced by reason and ethics as life's criteria. (Ward, *Book Production*, 16)

Michaelis was to play several different rôles in the continuation of this trend. Michaelis, who had been appointed to the Göttingen faculty in 1745, was still an "außerordentlicher Professor" (approximately equivalent to an American associate professor) of Oriental languages and of Protestant theology when Haller asked him to translate *Clarissa*. Michaelis was to achieve an international reputation not for this translation, which appeared anonymously, but for

his translations of and commentaries on the Bible. His most popular work, in fact, often translated into English, was an *Einleitung in die göttlichen Schriften* (*Introduction to the New Testament*). In contrast to Prévost, Michaelis led an uneventful academic life. His autobiography, *Lebensbeschreibung von ihm selbst verfasst* (*Life Description by Himself*) tells mainly of his student days, of his trip to England, and of the occupation of Göttingen during the Seven Years' War (1756–63). Michaelis speaks infrequently in his autobiography of his own work, and nowhere does he mention having translated *Clarissa*.

Michaelis's trip to England, from Easter 1741 to September 1742, was one of the most important events of his life. During his stay he attended a lecture by Robert Lowth at Oxford, and made the personal acquaintance of Benjamin Kennicott. These prominent Enlightenment scholars of ancient Hebrew poetry influenced Michaelis's own views on the translation of ancient texts—and, we may infer, of modern ones as well. It is worth quoting at length an account of Michaelis's relationship to Lowth, for it shows not only the standing of Michaelis within the Enlightenment, but also the strong ties between England and Germany, and the peculiar combination of aesthetic delight and scholarly interest that we have seen in Haller, and which the discipline of Orientalism seemed to hold at that time:

> At the Hanoverian University of Göttingen flourished one of the greatest figures of the European Enlightenment, the Oriental scholar Johann David Michaelis. . . . Michaelis, the first great annotator of Lowth . . . saw Lowth, not as a churchman *or* even as a professor, but as a poet speaking about poetry. Tying the poet Lowth firmly to the movement of sensibility of the eighteenth century, Michaelis observed secondly that Lowth made the reader understand beauty not through reason but through feeling. This contemporary corroboration that relates Lowth's Orientalism to the eighteenth-century poetry of feeling is crucial; for as Michaelis wrote, we "admire him and follow him like some oriental Orpheus." (Hepworth, *Robert Lowth*, 39)

Kennicott and Lowth founded the philological school of interpretation of the Bible and other ancient texts. The work of these Biblical scholars emphasized the need to understand Hebrew poetry and the New Testament in the context of the cultures in which they had been written, rather than on the basis of European religious dogma. In their work, as in Michaelis's, present will and religious needs bent

before the methods of historicism and hermeneutics; the source cul-
ture (Hebrew) was allowed to stand in its own truth and to influence
the target culture (European Christianity). James O'Flaherty defines
Michaelis's achievement succinctly: "Michaelis found Hebrew a su-
pernatural language and rendered it a natural language" ("J. D.
Michaelis," 179). Faithfulness to source text and source culture
rather than to dogma was Michaelis's guiding principle. It is reason-
able to assume that Michaelis's involvement with this movement, and
his familiarity with the problems of Biblical translation, a concern of
every Orientalist, carried over into his translation of *Clarissa*.

Michaelis possibly became acquainted with Richardson's first
novel, *Pamela* (1741), during his stay in England, for he mentions it
in his poem "Allerunterthänigste Bittschrift an Seine Königliche Ma-
jestät in Preussen, um Anlegung einer Universität für das schöne
Geschlecht" ("Petition to His Royal Majesty in Prussia to found a
University for the Fair Sex"), printed anonymously in 1747. On
page twenty-one of that text, Frederick the Great's queen, Elizabeth
Christina of Brunswick, is called "die zweite **Pamela**." Michaelis's de-
sire to break the monopoly of the male sex on learning was almost
unique in Germany at that time, and brought him into correspon-
dence with "gifted progressive women even far away from Göt-
tingen, e.g., in Altenburg in Thuringia, or in the southwest of Ger-
many" (Hakemeyer, *Three Early Internationalists*, 10).

Another factor influencing Michaelis's translation was his lack of
confidence in the German language of his time. He later noted its
abominable state in his essay *Über den Einfluß der Sprache eines Volcks
in seine Meinungen und seiner Meinungen in die Sprache* (1759). This
important essay won the Prize of the Prussian Royal Academy, and
was translated into English as *A Dissertation on the Influence of Opinions
on Language, and of Language on Opinions* (1769), and into French as
De l'influence des opinions sur le langage et du langage sur les opinions
(1762). The only modern reprint of the essay uses the French trans-
lation since, consistent with his distrust of the German language,
Michaelis made all of his revisions in the French rather than the
German version (one should recall that the francophile Frederick
the Great was a contemporary). In this essay Michaelis describes the
political chaos among the many small German states, as well as the
economic hardship which has deprived the common people of
schooling and robbed Germans of the ability to share a single lan-
guage capable of describing things scientifically. In an interesting
maneuver that recalls the strong ties between science and poetry in
this era, Michaelis then blames the insipidity of Germany's poetic
production on its lack of a scientific language.

For example, Michaelis notes that plant names, varying from region to region, are virtually unknown by the common people:

> "De génération en génération le paisan oublie quelques uns de ces noms; ce sont autant de pertes, qui à mesure qu'elles s'accumulent, appauvrissent le langage. Ignorés des savans, ces mots ne sauroient se conserver dans leurs ouvrages. Plusieurs végétaux sont proscrits de la poesie, & ne peuvent y entrer ni sous leurs noms populaires, ni sous les termes d'art qui les expriment: ceux-là sont trop bas; ceux-ci rendent des sons étrangers, & souvent ils troubleroient la mesure du vers. (51)

> (From generation to generation the peasant forgets some of these names; these are losses which, as they accumulate, impoverish the language. Unknown to scholars, these words cannot be preserved in their works. Several plants are made unavailable to poetry, and cannot enter it either under their common names, nor under the poetic phrases which express them: the former are too vulgar; the latter are strange-sounding and often disturb the verse measure).

Michaelis shows complete dissatisfaction with the expressive possibilities of the German language. Prévost shows no such dissatisfaction with the French language, even in his anglophile journal *Le Pour et Contre*. One can imagine Michaelis using translation as a means for enriching the expressive possibilities of his language. Chapter 4 will treat the comparative linguistic integrity of England, France, and Germany in this period.

The foregoing discussion has identified a number of factors which might cause Michaelis's translation to be "weak": he was an academic, primarily a scholar rather than a creative writer; Bible translation, at least in theory, must be considered the epitome of academic translation, the object always being to confer rather than create meaning; Orientalism in this period tended towards understanding source cultures on their own terms; Michaelis was a feminist and hence presumably more sympathetic to the faithful reader Clarissa; finally, he saw German as a poor literary language and so probably looked to English literature as a potential source of help.

A look at the "Vorrede des Übersetzers" or preface to his translation provides further evidence that Michaelis was a "weak" translator eager to efface himself. It begins as though written by the publisher Vandenhoeck of Göttingen, who has obtained the English original

and has been advised by a group of friends to have a translation made. Haller's role in supporting the translation is emphasized, with so much encomium of his poetic talents that *Clarissa* is momentarily forgotten:

> Der eine unter denen, dessen Rath er [the publisher] folgete, zog die **Clarissa** der mit so vielem Beyfall aufgenommenen **Pamela** vor: und weil dieser Mann von dem grössten und besten Theile Deutschlands für den grössten Kunstrichter unserer Zeit in den schönen Wissenschaften angesehen wird; und diejenigen Stücke, die er bisher (obgleich sparsam) zum Vergnügen und Besserung der Deutschen herausgegeben hat, von Dichtern so wohl, als von andern Lesern, beynahe für **canonisch** angesehen sind; und über das in den Schriften und Urtheilen dieses Mannes die strengsten Grundsätze der Tugend und der Religion herrschen: so konnte der Verleger nicht anders als vergnügt seyn, daß ihm dieses Buch zuerst in die Hände gefallen wäre. (I, n.p.)[11]

> (One of them, whose advice he [the publisher] was following, preferred **Clarissa** to **Pamela**, which had been received so favorably: The publisher could only rejoice that this book first fell into this man's hands, because he is held by the largest and best part of Germany to be the greatest literary critic of our times; and because those pieces (although not many) which he has published for the pleasure and improvement of the Germans are considered **canonical** by both poets and readers, and in addition, the strictest principles of virtue and religion guide the writings and judgements of this man.)

Reading further, we learn that Haller has found a somewhat reluctant translator, who "seine Ehre nie darinn gesucht hat, oder zu suchen gedenkt, dass er ein guter Uebersetzer heisse, sondern entschlossen ist, sich durch andere Mittel ein günstiges Urtheil der Welt zu erwerben" (I, n.p.; "has never sought or thought to seek fame for being a good translator, but rather is determined to achieve a good name in the world through other means"). This enigmatic statement shows all the paradox of weak translation: like the lighting

11. I have used the first edition of Michaelis's translation published by Vandenhoeck in Göttingen from 1749 to 1751, with an eighth "Ergänzungsband" ("supplementary volume") appearing in 1753 to bring to the German reader the major changes in Richardson's second (1749) and third (1751) editions. Further references to Michaelis's translation will be by volume and page number.

specialist or stage crew in the theater, a weak translator is precisely he who takes the utmost care to disappear into the text he is producing. The perfect weak translation is one in which the translator remains invisible. Thus the statement that the translator does not seek glory demonstrates that he will do a "good" job. At this point Michaelis takes over the narration and presents a poem praising Richardson which, he admits, was originally written to honor another writer (most probably Haller), but which will now do service for the English novelist as well. This sort of literary recycling again emphasizes the commensurability of the two literary systems. Richardson and Haller, two giants of the Enlightenment, are virtually interchangeable. Michaelis proves to be comparable to Stinstra in the vigor with which he preserves Richardson's didactic mission. The poem describes Richardson as a teacher of morals:

Er mahlete das ernstliche Gebot
Der warnenden Vernunft in lockenden Geberden.
Selbst denn, wenn es dem Frevler droht,
Hiess er die Worte reizend werden:
Bis es des Lasters Freund mit Schaudern li[e]st,
Und fast auf Schrecken lüstern ist.
Er suchte neue Redensarten,
Die Richtigkeit mit Anmuth paarten,
Und ein zur Lust gedichtet Bild,
Das scherzt, und in den Scherz den Ernst der Lehren hüllt.

(I, n.p.)

(He painted the earnest commandment
Of warning reason in attractive gestures
Just when the blasphemer is in danger,
He let the words charm:
Until the friend of vice reads them with a shudder
And almost lusts for terrible warning.
He sought new expressions,
Which pair uprightness with beauty,
And a scene, written for pleasure,
That jokes, and in that joke hides the earnestness of his teaching.)

Here the emphasis is on the potential Lovelaces of the world who might read *Clarissa* and be shocked into better behavior. A male rather than female audience is foreseen for the book; by the end of the eighteenth century *Clarissa* will become a ladies' book (See chapter 5, 182–84). The last lines of the poem then turn to the obligatory

pairing of "dulce" with "utile." Richardson combines "Richtigkeit" ("uprightness") with grace ("Anmuth"), and the pleasing shell of the novel is said to contain a hard core of earnest moral preaching. Michaelis gives notice here that the preservation of the core rather than the shell will be his goal. The opposition between "Scherz" and "Ernst" reminds us that "Scherz" refers to joking as dissimulation, as illusion, and this odd pairing of joking with teaching, of the Aesthetic with the Didactic, returns us to the dialectic with which we began our chapter. To what do the shell and the core actually correspond? To plot and subject matter? Or to language and its referent? Is Michaelis describing the novel's ability to deliver truth through its fictions? The shell leads one to the core, while at the same time also hiding and disguising it ("hüllen"). Joking and fiction, the "insincere" elements of *Clarissa*, problematize its didactic mission, as Richardson was well aware. Michaelis, in spite of his clear moral intentions as a translator, has invoked pleasure and morality, illusion and truth, as dialectically interwoven terms rather than stable opposites.

A book's title stimulates the average reader's first impressions. The divergence between the titles of the two translations, between *Lettres angloises, ou histoire de Miss Clarisse Harlowe*, and *Die Geschichte der Clarissa, eines vornehmen Frauenzimmers*, encapsulates the differences noted in their prefaces. Interestingly, neither title provides an exact rendering of the English. At stake is the place which each translator has marked out for his translation within the target literary system. The French term "lettres angloises" emphasizes the alien and innovative qualities of the English. The novel is an "other" with which the French reading public may amuse itself. The word "lettres" also links *Clarissa* to other popular works with that word in the title, including Guilleragues's *Lettres portugaises* (1669), Edme Boursault's *Lettres de Babet* (1673), Montesquieu's *Lettres persanes* (1721), and J. B. de Boyer Argens's *Lettres juives* (1736). In other words, Prévost begins by allowing his readers to situate this work vis-à-vis familiar French fictions of passion. Above all, the title *Lettres angloises*, in eliminating the heroine's name, makes the book as much Lovelace's as Clarissa's. The letter and writing are the primary foci of attention, rather than a personal history—and Lovelace's writing is undeniably more entertaining than Clarissa's.

Michaelis, on the other hand, puts the word "Geschichte" ("history" or "story") first, emphasizing the personal drama about to unfold. His translation of "young Lady" with "vornehmes Frauenzimmer" places additional emphasis upon Clarissa's social standing. "Vornehm" describes people of noble birth. Most extraordinary is its redundancy with "Frauenzimmer," which also indicates someone

highborn. Thus Michaelis has translated "Lady" as though Richardson meant to say "Lady Clarissa." Clarissa has no such title; in using the term "Lady" Richardson meant to capture her wealth and pride, rather than to give the (false) impression that she is noble. However, "vornehm" can also mean "distinguished," thus capturing Richardson's intentions with "Lady." It was possible for a German to begin reading the *Geschichte der Clarissa* with the impression that the heroine was noble.

These, then, are the battle lines drawn over the traces of the chiliastic world into which *Clarissa* plunges every reader. On one side stand Lovelace, pleasure, a free play of signifiers, and the strong translator Prévost. On the other side stand Clarissa, morality, truth, and the weak translator Michaelis. The grand strategies of this confrontation have become clear; it remains for us in the following pages to uncover its tactics.

2

Translation, Transposition, Intertextuality

O, my dear, how Art produces Art!
> —Aunt Hervey to Clarissa (503)[1]

In *Clarissa* art generates art, text is read against countertext, words change their meanings as they are transposed from one epistle to another. All these phenomena fall under the rubric of intertextuality; so does the act of translation. Aunt Hervey's letter, written soon after Clarissa's abduction by Lovelace, acquaints its reader with what her family is saying about her. Clarissa's own story of her abduction is confronted with its reading by others: "You did not *design* to go, you say. Why did you meet him then, chariot-and-six, horseman, all prepared by him? O, my dear, how Art produces Art!—Will it be believed?" (503). Aunt Hervey is remarking that one lie produces another, that the response to mendacity is seldom verity, but rather "Art." Yet precisely art's proliferation makes it difficult to specify just whom Aunt Hervey wishes to accuse with her maxim. Whose art has begotten whose art? Is she speaking of Lovelace's art, his ceaseless plotting, which has produced Clarissa's deceptive behavior? Or of James's and Arabella's deceptions, which have provoked Clarissa's and Lovelace's response? Or perhaps of the need for *any* character to lie in order to extricate herself or himself from

1. Page references are to the handy one-volume *Clarissa; Or, the History of a Young Lady* (London: Viking, 1985), edited by Angus Ross from the first edition of Richardson's novel. Both Prévost and Michaelis worked from the first edition. However, because Ross modernizes spelling and punctuation, I have drawn my quotes from the actual first edition in seven volumes (London, 1748). For discussions of passages in other editions and abridgements I cite the year in which the edition was published, and volume number where necessary. Editions of *Clarissa* are arranged chronologically in Section I.1 of the bibliography.

the difficulties caused by a previous lie? Melinda Rabb has pointed out that Lovelace's scheming has a curious capacity to reproduce itself: "Lovelace's schemes—long, intricate, brilliant—eventually sabotage him. His plots go out of control; one plot necessitates yet another plot. To be caught up in the relentlessly linear movement of a plot proves self-defeating" ("Underplotting, Overplotting," 61).

In fact, Aunt Hervey's letter is itself an artifice, for it ends in a long subjunctive description of what would have happened if Clarissa had not run away: "I'll tell you all that was intended, if you had [stayed] . . . Your father and mother . . . would have humbled themselves to *you*: and if you *could* have denied them . . . they would have yielded" (504). Of course Hervey's fairy tale, Hervey's art, provides a happy ending for Clarissa, as her present situation will not.

Aunt Hervey is writing both an apt description of her own letter and a model for the architecture of *Clarissa*. Her letter reminds us that *Clarissa* is not a story, but a collection of stories, many of which contradict each other. Indeed, they are not even stories, but rather collections of speech-acts, of language meant as much to perform as to inform, of persuasions, commands, curses, catechisms, seductions. Those speech-acts which can be judged according to their truth value run the full gamut from legal document to truth to half-truth to lie to forgery. "Art" takes its place towards the end of this list; the word is invariably used in the novel in the pejorative sense we see above. And all these heterogeneous uses of language are somehow contained within a single form, the letter, which is the building block of the novel's structure. The letters of *Clarissa* are always to be read contextually, as responses that in turn provoke response.

Like a letter to a letter, a translation is a response to a text which precedes it. Literary translation is art producing art. Both *Clarissa* and translation produce themselves in part through the Lovelacean mechanism of intertextuality. Thus one useful view of intertextuality would see it as a mechanism of textual production: intertextuality would describe the capacity of texts for generating other texts. A text exhibits intertextuality inasmuch as it is composed of other, preexisting texts.[2] Certainly the language of a translation is determined by that of another, more original text. Yet how often do we hear that the best translation is one which reads "like the original"—as though the original read like an original. Thus the paradox of translation is

2. I have decided upon this simple definition after reading more complicated ones in the following discussions: Jonathan Culler, "Presupposition and Intertextuality"; John Frow, "Intertextuality" in his *Marxism and Literary History*, 125–69; Laurent Jenny, "The Strategy of Form"; Michael Riffaterre, "La trace de l'intertexte," "Syllepsis," and *Text Production*; and Hans-Georg Ruprecht, "Intertextualité."

that the creation of the new text is always synonymous with the hiding of its intertext. The translator is faced with a choice: to make the translation read as though it were an original, or purposely "roughen" the text, to produce, as Fredric Jameson puts it in his own definition of intertextuality, a "stereoptic vision of an individual text" (*Political Unconscious*, 137) in order to emphasize the dialectic between original and imitation. We shall see that the force of intertextuality lies precisely in Freud's "fort/da," a game of showing and hiding played admirably by Lovelace and Clarissa. The various possibilities of intertextuality—citation, allusion, allegory, adaptation, censorship—can be classified according to the presence or absence of various parts of the cited text. By defining translation as a type of intertextuality, we allow translations the ability to function as any one of these forms.

I will discuss three aspects of intertextuality: *Text production* describes the ability of texts to either generate other texts or arise in response to them; *transposition* deals with the kinds of meaning that accrue when one text is rewritten within another; *stereoptics* refers to the simultaneous reading of two or more texts. This division is not absolute. Points raised about one form of intertextuality will recur in discussions of the other, and all will be incorporated into our evaluation of that fourth form of intertextuality which is translation.

Text Production

The term "text production," for which I am indebted to Michael Riffaterre, helps explain how the longest novel in the English language could be built on the simplest plot. How can *Clarissa*'s many pages be written about so little? To what is the bulk of the work dedicated, if to neither narrative nor description? The answer lies partly in the epistolary nature of the work. Letters are above all responses to other letters, and the work grows in accordance with this epistolary dialectic. An example of text production and its effect upon translation can be found by tracing the path of a single letter, which is a "roter Faden" ("red thread") running through the latter part of *Clarissa*.

Like translation itself, this letter walks a thin line between showing and hiding. It demonstrates the curious dialectic of truth in the novel: Clarissa's deceptions spring from the traps of literal interpretation, while Lovelace's "true self" is a willfully constructed fic-

tion. This short text, written to Lovelace as he seeks Clarissa in her hiding place at the Smiths, typifies the intertextuality of the novel not only because it is able to generate an inordinate number of other texts, but also because it comes to the reader within another letter (Lovelace's). The presentation of Clarissa's letter in the midst of Lovelace's own text becomes important to its many false interpretations, as we shall see. In reading the letter, one should keep in mind that Clarissa has been cursed and disowned by her father after her abduction by Lovelace, and her most urgent desire, often repeated to Lovelace, has been to be allowed to return home:

> Sir,
> I have good news to tell you. I am setting out with all diligence for my father's house. I am bid to hope that he will receive his poor penitent with a goodness peculiar to himself; for I am overjoyed with the assurance of a thorough reconciliation, through the interposition of a dear blessed friend, whom I always loved and honoured. I am so taken up with my preparation for this joyful and long-wished-for journey, that I cannot spare one moment for any other business, having several matters of the last importance to settle first. So, pray, Sir, don't disturb or interrupt me—I beseech you don't. You may, in time, possibly see me at my father's; at least, if it be not your own fault. I will write a letter, which shall be sent you when I am got thither and received: Till when, I am, &c.
> CLARISSA HARLOWE (1233)

The literal and allegorical meanings of this letter correspond to its apparent and its actual purposes, respectively. Taken literally, as it is by Lovelace, the letter is a request for him to wait until Clarissa returns to her parents' house, after which he may rejoin her, perhaps even marry her as he wishes to do. No such return is really foreseen by Clarissa, and having exerted so much energy to escape her rapist she would never actually consider seeing him again. For Clarissa the true meaning of the letter is allegorical. She is speaking of her death and of the subsequent journey of her soul to heaven. Her allegorical reading allows her almost to excuse the falseness of the literal level, a level she knows Lovelace will read as being true. The force of the letter lies in the discrepancy between the two levels of interpretation. In believing the false, literal level of the letter, Lovelace is fooled into sitting quietly at home, waiting for further notice from Clarissa, rather than actively pursuing her as he has done up to now. Clarissa has bought the time she needs to prepare herself for death.

The double meaning of this letter depends in part upon deceptive orthography. "Father," synonymous with "God," is not capitalized, nor is "friend," synonymous with "Jesus Christ." (In the third edition, Richardson, as if in an effort to make Clarissa slightly more truthful, did capitalize "Father" and "Reconciliation," but not "friend.") In other places a perfect polysemy allows two meanings, profane and sacred, to inhabit words such as "penitent," "reconciliation," "blessed," "journey," "pray," and even "I am." Such pairing of the sacred and the profane is continued in Belford's reaction when he finally learns from Clarissa's mouth what the letter "really" means: "I . . . stood astonished for a minute at her invention, her piety, her charity, and at thine and my own stupidity, to be thus taken in" (1274). Two of Belford's thoughts ("piety" and "charity") relate to the religious sphere, and two to the mundane world of duplicity ("invention" and "taken in"). His simultaneous appreciation of Clarissa's piety and her trickery is striking.

The reader of *Clarissa* is not immediately presented with the "correct" interpretation of this letter. The letter is interpreted in turn by Lovelace, Belford, and Morden, and each of these interpretations is, as it were, tried out on the reader. These interpretations confront, cross, and delay each other. Some interpretations precede Clarissa's own, presumably authoritative interpretation of her text, while others follow it. The letter itself is given to us not as an independent text, but as an insert within Lovelace's letter to Belford, that is, as a quotation within the context of its interpretation.

Clarissa's letter has in fact been the occasion for Lovelace's joyful missive to Belford, where he tells the latter of yet a third text, his own response to Clarissa. Note the quotation marks in the following passage:

> I dispatched instantly a letter to the dear creature, assuring her, with the most thankful joy, "That I would directly set out for Berks, and wait the issue of the happy reconciliation, and the charming hopes she had filled me with. I poured out upon her a thousand blessings. I declared, that it should be the study of my whole life to merit such transcendent goodness: And that there was nothing which her father or friends should require at my hands, that I would not for *her* sake comply with, in order to promote and complete so desirable a reconciliation." I hurried it away, without taking a copy of it. (1233–34)

Lovelace's use of quotation marks is somewhat misleading. If Lovelace makes no copy of his letter, how can we be sure that the word-

ing he uses here is accurate? And indeed, in an interview with Colonel Morden some time later, he gives a slightly different version:

> An answer, Colonel! No doubt of it. And an answer full of transport. I told her, "I would directly set out for Lord M's, in obedience to her will. I told her, that I would consent to anything she should command, in order to promote this happy reconciliation. I told her, that it should be my hourly study, to the end of my life, to deserve a goodness so transcendent." (1289)

These two versions of an original letter which is never presented to the reader differ in both style and detail: There are no blessings in the second version, and Lovelace proposes to obey only Clarissa's commands, not those of her parents and friends. That change is important, since Lovelace is engaged in a verbal duel with Clarissa's cousin Morden, and any hint that he had promised to obey the commands of Clarissa's friends would place Lovelace under Morden's control. The shortness and plain style of the second recapitulation are thus due not only to the six days which separate it from the first, but also to the context of verbal dueling from which it is quoted, as well as to Lovelace's careful avoidance of any utterance which might give an advantage to his opponent. But in the discrepancy between these two versions of Lovelace's answer to Clarissa, a peculiarity of the whole novel is brought to mind. In the second version Lovelace has edited his letter twice: once as he presents it to Morden in conversation, and once more as he writes down that conversation for Belford. Readers, on the other hand, never see the original letter. Showing and hiding are thus enacted simultaneously, and Lovelace reaps the advantage of both.

This situation merely serves to remind us, however, that we never see *any* originals in the course of reading the novel. Whether the characters edit or do not edit their own letters, the final choice as to inclusion and exclusion, censorship and exegesis, falls to the "editor," a fictional personality supposedly responsible for the redaction of the text. The reader is in the same position as Clarissa when she is captive in Sinclair's bordello in London: She can never be sure whether the letter she receives is a "real" letter, or an "edited" version. Like Clarissa, who never suspects Lovelace's forgeries and suppressions, the reader generally approaches the novel ingenuously. Extreme skepticism would prevent us from reading *Clarissa* at all. If the letters are at one remove from the actual events of the novel, then their printed versions are at two or even three removes. Of

course the final twist to this argument comes when we remind ourselves that there are no "actual events" in this novel, only fictitious ones created by the letters themselves, and that fair copies of the letters in question never existed. Whereas most fiction is to be read as the witnessing of an action or of actions, *Clarissa* is to be read as the alleged editing of supposed transcriptions of imaginary conversations about fictional actions or about other imaginary conversations. Texts, rather than things or actions, are the objects of narrative; such is the condition known as "intertextuality." The text shows itself to be in a constant state of flux, to be a continual parade of quotations and reportings which change form and meaning according to the context in which they appear. Thus *Clarissa* presents itself as its own intertext, and in doing so it predicts, as it were, its own continual transformation through later edition and translation.

In Clarissa's letter, for example, the translators are faced with an obvious choice between reproducing the literal or the allegorical meaning. Here is the French:

> Monsieur,
> J'ai d'heureuses nouvelles à vous communiquer. Je me dispose à partir pour la maison de mon père. On me fait espérer qu'il recevra une fille pénitente, avec toute la bonté paternelle. Imaginez-vous quelle est ma joie de pouvoir obtenir une parfaite réconciliation, par l'entremise d'un cher ami pour lequel j'ai toujours eu du respect & de la tendresse. Je suis si occupée de mes préparatifs pour un voyage si doux & si désiré, qu'ayant quelques affaires importantes à regler avant mon départ, je ne puis donner un moment à d'autres soins. Ainsi, monsieur, ne me causez pas de trouble ou d'interruption. Je vous le demande en grâce. Lorsqu'il en sera tems, peut-être me verrez-vous chez mon père; ou du moins ce serait votre faute. Je vous promets une plus longue lettre, lorsque j'y serai arrivée, & qu'on m'aura fait la grâce de m'y recevoir. Je suis, jusqu'à cet heureux jour, votre très-humble, &c. Cl. Harlowe (VI, 213)

In addition to the orthography, such unambiguous phrases as "bonté paternelle" for "a goodness peculiar to himself," and "cher ami" for "blessed friend," make an allegorical interpretation of this letter much more difficult than in the English. Similarly, the alliteration of "doux & désiré" sounds nicer but reads less ambiguously than "joyful and long-wished-for" in describing Clarissa's journey (to heaven). In general, one notes Prévost's preference for the direct

and simple. The word "diligence" is ignored, the tortuous "I am bid to hope" becomes "On me fait espérer."[3] Communication and not rhetoric are what count for Prévost. The letter's mood of urgency, however, has been captured.

Prévost even eliminates ambiguity in Clarissa's sign off. He adds "très-humble" in order to clarify that Clarissa is merely signing off her letter and not predicting a change of identity, as in the English "Till when, I am, etc. CLARISSA HARLOWE." Here Prévost again sacrifices ambiguity for readability and conformity to a conventional system of letter-writing, for, as we shall see shortly, the ambiguity in Clarissa's English signature provokes a particular interpretation from Lovelace. On the other hand, the added "votre" makes her Lovelace's, a rhetorical act of surrender that was deliberately avoided in the original.

What Prévost has left out, Michaelis takes pains to include. The English "long-wished-for" is easily reproduced in German as "längst gewünschten"; "With all diligence" becomes "mit allem Fleisse"; "I am bid to hope" corresponds to the ponderous and impersonal "mir ist Hoffnung gemacht." In short, the rhetorical aspects of Clarissa's letter are reproduced and even heightened in the German, where nominalization and the use of infinitives is even more common than in English. But note that Michaelis puts virtually no verbs in the plain indicative. Modals and infinitive constructions predominate:

> Mein Herr.
> Ich habe Ihnen eine gute Zeitung zu melden. Ich bin mit allem Fleisse beschäfftiget, mich zu der Reise nach meines Vaters Hause anzuschicken. Mir ist Hoffnung gemacht, daß er, nach einer ihm besonders eignen Güte, sein armes und bußfertiges Kind aufnehmen wolle. Denn ich habe zu einer ausnehmenden Freude für mich die Versicherung bekommen, daß durch die Vermittelung eines werthen und preiswürdigen Freundes, den ich allezeit geliebet und geehret habe, eine gänzliche Aussöhnung zu erhalten sey. Ich habe mit meiner Zubereitung zu dieser freudigen und längest gewünschten Reise so viel zu thun, daß ich keinen Augenblick zu einem andern Geschäffte davon abbrechen kann: weil ich noch vorher verschiedne Dinge von der äußersten Wichtigkeit

3. The English letter displays the stylistic devices (nominalization, actions in the infinitive, and concepts rather than persons as agents) which Carey McIntosh in *Common and Courtly Language* has identified as characteristic of Clarissa's language. Style is important: "Since Clarissa herself is put on display as a model of gentility, her language exemplifies certain (middle-class) ideals of (upper-class) elegance" (123).

zu bestellen habe. Daher bitte ich Sie, mein Herr, be-
unruhigen oder stören Sie mich nicht. Ich bitte, thun Sie es
nicht . . . Sie können mich mit der Zeit vielleicht in meines
Vaters Hause sehen: wenigstens, wofern Sie es nicht durch
Ihre eigne Schuld hindern. Ich will einen Brief schreiben, der
Ihnen zugeschickt werden soll, wenn ich dahin gekommen
und daselbst aufgenommen bin. Bis auf die Zeit bin ich Cla-
rissa Harlowe (VII, 35)

Yet for all this preservation and even heightening of rhetoric, the
polysemy of the original is almost totally lost. We can watch Mi-
chaelis struggle with the ambiguity of "blessed," as he partitions that
ambiguity by giving two adjectives for the single English one. Nei-
ther "werth" ("worthy") nor "preiswürdig" ("valuable") really cap-
tures the religious meaning of "blessed," particularly its reference
here to Christ. In direct contrast to Prévost, Michaelis not only pre-
serves Clarissa's unusual signature, but even heightens its strange-
ness by deleting the formulaic "&c," common in German letters of
this period. "Mein Herr" for the English "Sir" adds a double ambi-
guity. Unlike the English term, which forms a pair with "Madam,"
"Mein Herr" cannot correspond to "Meine Frau" ("gnädige Frau"
would be closer). While "Mein Herr" is a conventional form of ad-
dress, in the context of this letter, where every word takes on at least
two meanings, the possessive pronoun nevertheless denotes a certain
subservience to Lovelace which Clarissa would rather die than ac-
cept: He is precisely not her master. Her master is God, which is the
second ambiguity, for "Herr" can also be a synonym for "Gott."

The loss of ambiguity extends to the process of capitalization. The
French version of Clarissa's letter uses capitals for neither "père" nor
"ami." In French, capitalization is possible when referring to a divin-
ity, but is not normal for the common nouns which we find here.
The rules of German capitalization, on the other hand, force the
translator to use capitals for both nouns. The subtle deception which
Clarissa's differed capitalization engenders is thus lost in both trans-
lations.

Many of the differences between these three texts are necessary
results of the differences between the three languages. The pon-
derous style of the German, for example, and its length—Michaelis's
version takes 184 words to Prévost's 157 and Richardson's 153—are
typical of German prose of the period. Yet one can also discern a
difference in the attitudes of the two translators beyond the require-
ments of their languages. Prévost seems less concerned with the let-
ter's doubleness than Michaelis. He is more interested in rendering

it a letter, with all the concomitant formulae, whereas Michaelis is more concerned to render it a message.

We have seen how Clarissa's letter provoked a letter to her from Lovelace, two rather different transcriptions of that letter, and the letter to Belford in which the first of these transcriptions is contained. Reading further within the letter to Belford, we see that Clarissa's letter has also caused Lovelace to reinterpret his dream of Clarissa's apotheosis and of his own damnation. In a letter to Belford, Lovelace translates some words of Clarissa's letter into his own idiom: "And then her subscription: *Till when, I am,* CLARISSA HARLOWE: As much as to say, *After that,* I shall be, if not *your own fault,* CLARISSA LOVELACE!" (1235). Lovelace acts just as the translators have, resolving the ambiguity of Clarissa's unusual signature by interpreting it as belonging to a standard genre, this time that of statement as in Michaelis. (Prévost had opted for the genre of the standard signature.) What Clarissa really means is that after her death she will cease to be anything for Lovelace. Her signature is thus in fact a statement, but has a very different referent than what Lovelace imagines it to be.

The dream, as reported earlier by Lovelace (1218), had been negative; Lovelace had awoken in a "cursed fright." In the dream, Clarissa's cousin Morden breaks in on an interview between Clarissa and Lovelace in which the former demands marriage as a reparation for the rape. Lovelace's face is covered in black, the "ceiling opens," and Clarissa is drawn by angels into heaven as Lovelace tumbles down into a black hole. The dream forms an important "navel" of this long novel, a passage which compresses its themes, relationships, and events into a single image drawn from the vocabulary of baroque religious painting (cf. Margaret Doody's analysis in *A Natural Passion,* 234–40). It is indicative of the extraordinary power of intertextuality that the dream's juxtaposition with another important allegory, Clarissa's letter, would cause Lovelace to completely reverse his previous interpretation of the dream. Lovelace's two conflicting interpretations are placed just four letters apart in the novel. And the second interpretation is written just one day after the first. Lovelace's new, positive interpretation of the dream is both reassuring and false. As if to show how Clarissa's letter has influenced his thinking, Lovelace even transposes a word from Clarissa's text into his own interpretation of the dream: "I shall now be convinced that there is something in dreams. The ceiling opening is the reconciliation in view. . . . But then what is my tumbling over and over, thro' the floor, into a frightful hole (*descending* as she *ascends*)? Ho! only This; it alludes to my disrelish to matrimony" (1234).

Reading further, we realize that no such reconciliation takes place. In fact, Clarissa alludes in her letter to a journey to heaven, which is perhaps the true meaning of the apotheosis shown in the dream. Lovelace's movement in the opposite direction, his fall into the black hole, must be his damnation. But we can correctly interpret the more anguished parts of the dream, and Colonel Morden's presence, only at the end of the novel, when we learn of Lovelace's death.

Belford, who recognizes the impossibility of reconciling Clarissa either with her family or with Lovelace, responds to Lovelace's report of Clarissa's letter with extreme skepticism: "Surely Lovelace this surprizing Letter cannot be a forgery of thy own, in order to carry on some view, and to impose upon me. Yet by the style of it, it cannot; tho' thou art a perfect Proteus too. I will not, however, add another word" (1243–44). In the short space of this passage, Belford's thoughts go through four stages: two of doubting the letter's genuineness ("to carry on some view, and to impose upon me," and "thou art a perfect Proteus"); one of belief in the letter's genuineness ("it cannot [be a forgery]"); and one of recognizing his inability to interpret, and hence his inability to write further ("not . . . another word"). Belford reverses himself twice within two sentences. He is obviously confused and unable to reach a conclusion—in direct contrast to Lovelace, who is able not only to interpret the letter itself, but also to use that interpretation to construct even more grandiose ones. Belford tentatively interprets Clarissa's letter in the same manner as does Lovelace, but for that reason he must doubt its authenticity. He suggests a different purpose for the letter, and a different author and addressee. He suspects that it might have been written by Lovelace and intended for Belford, in order "to impose upon him." To read Belford's letter is to follow the twistings and turnings of his conflicting thoughts on the genuineness of Clarissa's letter. The difficulties of interpretation which he experiences are similar to those of the reader of *Clarissa*. Each change of addressee and recipient lends an entirely new significance to the text.

So must it also be in the act of translation, however much the "meaning" of the text is preserved. The reader of a translation can be naively credulous like Lovelace, or confused and suspicious like Belford. In either case, the truth or forgery of the translation generally lies beyond his grasp. Prévost omits parts of Belford's letter to Lovelace, but preserves the latter's suspicions: "Sûrement, Lovelace, la lettre que tu me communiques ne saurait être une imposture de ta façon, pour couvrir quelque nouvelle vue, & pour me tromper. Non; le style me fait rejeter cette idée: quoique, d'un autre côté, je te croie

capable de tout. Je veux suspendre mon jugement" (VI, 222). As
with Clarissa's letter, ambiguity has been subtly reduced here.
Though Belford's doubts have been preserved, they are somewhat
assuaged in the French translation, where Belford seems more con-
vinced of the letter's authenticity. Belford more explicitly rejects
("non" is more final than "yet") his idea that the letter could be a
forgery. And "I will not . . . add another word," which lets the
reader feel Belford's urge to continue his questioning of the letter's
authenticity, has been transformed into an explicit decision by Bel-
ford to suspend his judgment. Confusion has been turned into cau-
tion. The strong word "Protean" applied to Lovelace has been
erased. Overall, Belford's comments here are not as suggestive of
the real possibility of forgery as they are in the English. It seems that
Prévost was less willing than Richardson to let his readers think that
the letter could be a forgery, less willing to provoke the anxiety of
indeterminacy.

Once he has questioned Clarissa's landlady about the letter, Bel-
ford is forced not only to correct his previous suspicions, but also to
undo Lovelace's interpretation. At the same time, Belford widens
the context for the interpretation of Clarissa's letter. The letter was
supposedly itself a response to a letter from Clarissa's sister Arabella,
inviting her to return home. Arabella's letter did arrive, but con-
tained no hope of reconciliation. Belford notes that the letter from
Arabella, which Lovelace thinks has caused Clarissa's joy, could not
have done so, and hence that Clarissa's letter will have to undergo
yet another interpretation:

> By what I have mentioned, You will conclude with me, that
> the letter brought her by Mrs. Lovick (the superscription of
> which you saw to be written in her sister's hand) could not be
> the letter on the contents of which she grounded *that* she
> wrote to you, on her return home. And yet neither Mrs.
> Lovick, nor Mrs. Smith, nor the servant of the latter, know of
> any other brought her. But as the women assured me, that
> she actually *did* write to you, I was eased of a suspicion which
> I had begun to entertain, that you (for some purpose I could
> not guess at) had forged the letter from her of which you sent
> me a copy. (1247)

This letter shows that Belford's suspicions of forgery had not abated.
Though they are now quelled, new confusion arises as he searches
desperately for *another* letter which could have provoked Clarissa's.
The meaning of Clarissa's letter must be predicated upon its status

as a response to another letter, which Lovelace had thought to be one from her sister Arabella. Clarissa's personal response to Arabella's nasty letter is one of sadness, and thus it is plain to Belford that stimulus and response are out of joint. The supposed motivating text behind Clarissa's own is not what it was thought to be, and thus Clarissa's letter must be reinterpreted. Again, while the actual text remains the same, its significance changes with the changing context.

Twenty letters and nearly a hundred pages later, we read the presumably privileged analysis of her letter by Clarissa herself, prefaced by Belford's wry comment: "A *religious* meaning is couched under it, and that's the reason that neither you nor I could find it out. Read but for my *father's house, Heaven*, said she, and for the interposition of my dear blessed friend, suppose the *Mediation* of my *Saviour* which I humbly rely upon; and all the rest of the letter will be accounted for" (1274). Finally we learn that the letter was not responding to another letter, but rather derived its language from Scripture. Particularly the phrase "Father's house" recalls Luke 2:49, where Christ's words pun in a similar way. ("Father" is capitalized in the King James Version.) Belford transcribes Clarissa's speech, and adds the capitals as they should be ("Heaven" and "Saviour"), revealing Clarissa's deception. On rereading the novel, Richardson found his heroine's deception so upsetting that he made her apologize for it in the third edition, in a sentence tacked on at the end of the passage just quoted: "I hope (repeated she) that it is a pardonable artifice. But I am afraid it is not strictly right" (*Clarissa* 1930, VII:273). Art has indeed begotten art. Clarissa is only "afraid" that her artifice is not right, and after all, what does "right" mean here? John Preston observes that "it would be ruinous to [Richardson's] whole design to present [the letter] merely as a subterfuge. When she later maintains that she was deceiving Lovelace, we are prepared to believe that we understand her action better than she does herself. Her own explanation is no more authoritative and final than any other that forms part of the story" (76). We have already examined Belford's reaction to Clarissa's deception, which simultaneously admires its "piety" and "charity" while saying that she has taken him and Lovelace in. In representing God as her father, Clarissa is only reproducing a well-known religious analogy of this period, and one which is borne out by the events of the novel. As Gisela Engel observes:

> Der Vater Clarissas weist Züge auf, wie sie dem kalvanistisch-puritanischen Gott eigen sind. Wie dieser ist er streng. . . . Der kalvanistische Gott . . . straft diejenigen, die seine

> Wünsche und Gesetze nicht befolgen, mit Verdammnis, und
> auch Clarissas Vater straft den Ungehorsam der Tochter mit
> einem schrecklichen Fluch. . . . Clarissa ist überzeugt davon,
> daß ein Kind vollständig unter der Macht und Herrschaft des
> Vaters stehen sollte. (*Individuum*, 146–47)

> (Clarissa's father shows traits peculiar to the Calvinist-Puritan
> God. Like the latter, he is strict. . . . The Calvinist God . . .
> punishes those who do not follow his wishes and laws with
> damnation, and Clarissa's father also punishes the disobe-
> dience of his daughter with an awful curse. . . . Clarissa is
> convinced that a child should remain wholly under the power
> and control of the father.)

Clarissa accepts her father as God, so why not write of a reconcilia-
tion to God as if she were writing of a reconciliation to her father?
Furthermore, Clarissa does finally make a journey to her earthly
home—as a corpse—and finds all the reconciliation and "peculiar
goodness" which she describes in her letter.

Preston's claim that Clarissa's own interpretation is no more final
than any other is born out by the rest of the novel; the process of
interpretation of her letter does not stop after Clarissa explains what
she really meant. However, Clarissa's explanation does give the
reader leverage for interpreting those further interpretations. Here-
after the various interpretations of her letter will have an ironic ring
to them.

The first such ironized interpretation comes from Lovelace's pen.
Belford's letter giving Clarissa's explanation is dated August 29th.
Lovelace's account of his interview with Clarissa's cousin and protec-
tor Colonel Morden, for which the "Father's house" letter builds a
centerpiece, is also dated the 29th. In Lovelace's letter (which con-
tains the second version of his response to Clarissa), he complains
that Clarissa's letter was merely a ruse, but Morden refuses to believe
any such thing: "That can't be the thing, depend upon it, Sir. There
must be more in it than That. But I own, I know not what to make
of it. Only that she does me a great deal of honour, if it be me that
she calls her *blessed friend, whom she always loved and honoured*" (1289).
Morden's self-congratulation on being Clarissa's "blessed friend" (he
is pulled in by the false orthography, since if "friend" refers to
Christ it should be capitalized) can only be read ironically. The
ironic effect has been activated merely by Richardson's physical
placement of the two August 29th letters. If we were to read this
account of Morden's words *before* reading Belford's disclosure of

Clarissa's true intentions, then Morden's reading would sound as plausible as those of Lovelace and Belford. The reader would experience mild suspense in waiting to see whether Morden was correct. However, since the reader already knows that the "blessed friend" is really Christ, Morden's interpretation just seems egotistical and silly. Furthermore, the gap between his interpretation and Clarissa's meaning emphasizes his inability to be the blessed friend that he thinks he is.

In the only extended study devoted to the minor figure of Morden, Robert Schmitz notes the irony of the term "blessed friend" used in conjunction with Morden, and even reproduces the word "savior" in his negative evaluation of Morden's actions: "Morden is [Clarissa's] potential savior, but Clarissa and the reader are left in suspense while he makes the slowest progress ever recorded for a trip from Florence to England" ("Death and Colonel Morden," 346–47). Schmitz declines to list Morden's many other failures. When he finally does arrive, Clarissa desires him to arrange a reconciliation between her and her family. He is unable to do so. Brought to the point of death by Morden's delays, Clarissa does not want him to visit her in her last hours. He comes anyway. One of her dying requests is for him not to seek vengeance on Lovelace. Lovelace falls by his hand. Morden is indeed no "blessed friend." Schmitz posits that Morden functions as a Grim Reaper figure, necessarily present at the two most important deaths in the novel. Interestingly, the transposition of Morden's name into French captures both its ironic and its symbolic aspects more obviously than in English: pronouncing his name very nearly gives the adjective "mordant," meaning "sarcastic," while his name also shares its first three letters with the noun "(la) mort." In German, Morden's name suddenly foreshadows his murder of Lovelace by containing the noun "Mord" ("murder"), and by being contained in the verb "ermorden" ("to murder").

In spite of its irony, the identification of Morden as a "blessed friend" possesses the power to open again what should be a closed subject, namely the true meaning of Clarissa's letter. And Lovelace seizes upon this opportunity. "The devil take thee for calling this absurdity an *innocent* artifice!" (1302) he writes to Belford. Lovelace devises still another interpretation of Clarissa's letter, making it into a sign of his own innocence, or at least a sign that Clarissa is as guilty as he is: "I insist upon it, that if a woman of her character, at such a critical time, is to be justified in such a deception, a man in full health and vigour of body and mind, as I am, may be excused for all his strategems and attempts against her. And, thank my stars, I can now sit me down with a quiet conscience on that score" (1302). Judg-

ing by the number of readers who have sided with Lovelace rather than with Clarissa, we cannot automatically discount his interpretation.

The continuing interpretations prove that once it has been sent, a letter always arrives at its destinations, i.e., that Clarissa's letter is subject to exegesis by all. In this novel letters, like death, are not a private matter, but a public concern. Invasion of privacy is certainly not the issue in this fictional struggle;[4] what is at issue is the question of who in the end controls the meaning of all the letters Clarissa, or any other character, has written. Yet even this formulation of the question appears inadequate, for we have documented not a control of meaning, but rather a continual production of meanings. The letter's significance is produced by its intertext, that is, by the many possible texts which Clarissa's letter produces, which produced it, or which it can interpret, the countless possible contexts into which it will fit. Intertextuality thus emerges as a Lovelacean strategem for "plotting" and for the continual deferment of textual responsibility.

I have pointed out how at several crucial passages Prévost has controlled the explosion of interpretations. He further avoids the dangers of interpretive supplanting by cutting the whole discussion of Clarissa's letter by Morden and Lovelace, and by giving Clarissa's interpretation of her letter not within another letter, but rather in one of his own interpolations:

> M. Lovelace, détrempé par toutes circonstances, se plaint amèrement à M. Belford, que, pour se garantir de sa visite, Miss Clarisse ait été capable d'employer la ruse dans une lettre dont il ne comprend point encore le sens. M. Belford, qui en a reçu l'explication d'elle-même, fait ouvrir les yeux à son ami. C'est dieu qu'elle a nommé son père. La maison paternelle, où elle est heureusement appelée, c'est le ciel. Tout le reste est une allusion à sa mort, qu'elle croit peu éloignée. (VI, 352)

> (Mr. Lovelace, disappointed by the way things are going, complains bitterly to Mr. Belford that, in order to prevent his visiting her, Miss Clarissa has proved capable of deception in a

4. Christina Marsden Gillis's title for her study of *Clarissa*, *The Paradox of Privacy* captures the idea that the thematization of privacy in this novel is more significant than its violation. The door, metonymy of both closure and admittance, is the symbol of this paradox. Gillis writes: "Clarissa is broken as a private individual only to gain a new identity as a public saint, just as the integrity of a single letter must be "broken" in order to become an element in a public form" (36). This process of "Veröffentlichung der Innerlichkeit" ("publication of inner life") during the eighteenth century has been treated by Jürgen Habermas in his *Strukturwandel der Öffentlichkeit*.

letter whose meaning he still has not grasped. Mr. Belford, who has received an explication of the letter from her, enlightens his friend. It is God whom Clarissa has called her father. The father's house, where she has been called, is heaven. All the rest is an allusion to her death, which she believes to be near.)

Most important here is the shift from direct to indirect discourse. It is impossible to tell whether the last three sentences are a quotation or Prévost's own comments. One suspects the latter, since the last sentence is found nowhere in the English. Why does Prévost emphasize Clarissa's death, and not her salvation (and Lovelace's!), which is what her letter is all about? By adding that final sentence, the translator has interpreted the allegory "correctly," but in words which would never have issued from Clarissa's mouth, since they lack the subtlety and hesitation which marks the English. Indeed, in the English Clarissa makes no truth statements, but merely invites interpretation with her command to "read." How different is the threefold repetition of French "est." In compensation, there is no report on "blessed friend" as "savior." Later in the text Morden's words will be omitted, and hence this explication of the letter need not refer to the special role of the word "friend." By juxtaposing Lovelace's final interpretation with Clarissa's own explication, Prévost constructs a bounded interpretive realm for the letter, which now falls not so much under the authority of Clarissa as of the third-person discourse into which hers has been absorbed. Lovelace's final interpretation of the letter as indicative of Clarissa's deceit still remains, but Prévost's narration here anticipates it and explicitly negates it, just as it excises the irony of the subsequent Morden interpretation. The introduction of narration brings relief, for the reader no longer feels pushed and pulled by the various turns of interpretation. The whole interpretive cycle occupies in the French translation only eight letters and seventy pages of text, whereas in the English and German it flickers on and off for over two hundred pages.

We have examined a particularly important and complex example of the process of textual production in *Clarissa*, but there are numerous others to which the same analysis could be applied, and through which the same concept of intertextuality could be presented. This play of interpretations is what gives the novel a deceptive sense of repetition (undoubtedly the desire to avoid repetition also motivated Prévost's cuts). But the effect of this repetition is exactly the opposite of what a nineteenth-century editor of Richardson, E. S. Dallas, took it to be. Dallas felt that telling the same

story twice led to a firmer delineation of its truth. Yet it is interesting that his remark, made in the preface to his abridged edition of *Clarissa*, is meant to prepare the reader for his decision to eliminate those repetitions:

> Tell a story twice, and it begins to take. Out of the mouths of two witnesses the world is convinced. Richardson knew this well, and liked to give importance to an event by telling it over and over again with variations. Who could doubt the reality of an event which was attested by several witnesses, and which all were anxious to relate with a minute accuracy wonderful to behold? (*Clarissa* 1868, I:xviii)

It is unclear how we might reconcile these two claims: on the one hand that repetition is necessary for making the story convincing, and on the other hand that each witness tells the story with "variations." Since in this novel the story exists only in its variations, one can hardly be convinced by its truth—rather only by its truths, by the truth of paradox, of dialectic, of intertext, of translation. The uncertainty which Dallas represses—and which returns in his contradicting himself—is as important a motivating force behind simultaneous excision and narration (excision *as* narration, narration *as* excision) as the urge to condense. And so Dallas, in his edition of the novel, finds it appropriate to pare Richardson's repetitions, since he feels that the reader will not "believe" in this story no matter how many times it is told.

As Clarissa's letter produces a seemingly endless series of copies, quotations, and interpretations, so *Clarissa* produces a seemingly endless series of editions, abridgements, and translations. What causes a single text to produce such wild variations? Why do two witnesses tell different versions of the same event? As we have seen in Lovelace's two versions of his letter, and in Prévost's translation compared with the original, it is the situation within which text production occurs that is crucial to the final molding of its language. This pressure between text and intertext is created by transposition.

Transposition

"La transposition est nécessaire à . . . l'intertextualité, qui command[e] la signification du texte" (Kristeva, *Révolution*, 340; "Trans-

position is essential for intertextuality, which controls the signifying process of the text"). Julia Kristeva, considered the person most responsible for introducing the concept of intertextuality into Western theoretical discourse, makes that concept dependent upon the related one of transposition:

> Le terme d'*inter-textualité* désigne cette transposition d'un (ou de plusieurs) système(s) de signes en un autre; mais puisque ce terme a été souvent entendu dans le sens banal de "critique des sources" d'un texte, nous lui préférons celui de *transposition*. (*Révolution*, 59)

> (The term *intertextuality* designates that transposition of one [or of several] sign systems into another; but since this term has often been understood in its banal sense of "source hunting" for a text, we prefer the term *transposition*.)

In his glossary to the English translation of a collection of Kristeva's articles, Leon S. Roudiez paraphrases Kristeva's concept in such a way that we might use it as a definition of translation: "[Intertextuality] is defined . . . as the transposition of one or more *systems* of signs into another, accompanied by a new articulation of the enunciative and denotative position" (Roudiez, *Desire in Language*, 15). Like "transposition," "translation" etymologically denotes physical movement—Kristeva herself at one point defines translation as the "permutation of texts" (Roudiez, 36). But such a view is opposed by most linguistic theories of translation, which prefer the static term "equivalence" to "transposition" or to other nouns implying motion. Thus Roman Jakobson, in his famous article "On Linguistic Aspects of Translation," states that "the translator recodes and transmits a message received from another source. Thus translation involves two equivalent messages in two different codes" (233).[5] The first sentence of Jakobson's definition affirms the intertextual nature of translation, the second sentence denies it. Rather than one system transposed into another, Jakobson simply has the same message appearing in two different systems.

The paradox of translation tells us that neither viewpoint is correct: if Kristeva here, as always, posits a linguistic kinesiology whose very physicality seems questionable, the linguists in turn seem un-

5. The central thesis of J. C. Catford's *Linguistic Theory of Translation* also involves the notion of equivalence. He defines the act of translation as "the replacement of textual material in one language by equivalent textual material in another language" (20).

willing to account for the possibilities of a translation preserving certain irreducible elements, indigestible physical particles which then change and enrich the target system. No doubt the linguists would respond, as J. C. Catford does, by claiming that not all parts of a translation have really been "translated." We would thus have two forms of translation, one a cultural/literary activity which invariably includes some transposition, the other a purely linguistic process. The first-named activity would include the second, but not vice versa.[6] "Transposition" and "equivalence" articulate two poles of a dialectic in which every literary translation is caught, somewhere between the "smooth" text, which reads like an original (equivalence), and the "rough" text, which plainly transposes the signs of the original into the target system.

It is precisely at those points of transposition in the original text that the limiting cases of translation and transposition appear. How often does one read a translated novel and find quotations from poetry given in the original? Readability has been sacrificed for a display of the intertextual complexity of the original. Yet of course such an act of transposition, apparently faithful, gives a completely different picture of the text than the original, where the verses appeared not as something exotic and foreign but as the link between the main text and the related literary and linguistic systems which give it meaning. On the other hand, the equivalence approach would attempt to find a poem in the target language which produces similar effects on its context.

Proper names are usually, though not always, transposed. We have just encountered an effect of transposition in the name "Morden" (see above, 39). We noted that the proper name "Morden," transposed letter for letter into French and German, will suddenly reverberate with meanings lost on most English readers. By transposing rather than equating, the translator has now introduced a whole new field of tension between the source system and the target system. "Lovelace," on the other hand, loses its English meaning of spiritual emptiness (not to mention its allusion to several stage characters) upon transposition. This loss of meaning bothered a later German translator so much that he decided to use equivalence in-

6. This idea of transposition in translation is rather different from that advanced by D. S. Carne-Ross. Carne-Ross uses the term "transposition" for a certain type of translation where the expectations of readers in source and target systems are entirely comparable: "Transposition . . . occurs when the language of the matter to be translated stands close enough to the language of the translator—in age, idiom, cultural habits and so on—for him to be able to follow the letter with a fair hope of keeping faith with the spirit" ("Translation and Transposition," 3).

stead, and so "Lovelace" became "Graf von Winterfeldt." The winter field is obviously meant to convey Lovelace's lovelessness. Slightly less obvious is Belford's equivalent, the "Baron von Steinbrecher," and most mysterious of all is the substitution of "Albertine" for "Clarissa."

If proper names are usually transposed, in this novel quotations always position themselves between transposition and equivalence. The act of quotation shows not a character's control of sign systems, but rather his or her imprisonment within them. Richardson presents us with two characters whose personalities are comical because they are completely intertextual. One is Elias Brand, sent by the Harlowes to spy on Clarissa, a pedant who inflates his fulsome prose with Latin quotations. Besides Latin authors, Brand also quotes moderns like Daniel Defoe; Brand quotes everything, in fact, except the Bible, which remains conspicuously absent from the discourse of this most unchristian clergyman. If Brand is the caricature of a learned pedant, the second comical character, Lovelace's uncle Lord M., plays the complementary role of "motto-monger." His discourse is composed of prefabricated bits of proverbial folk wisdom. The saturation of each character's letters with unoriginal discourse causes the reader to view them as warnings against the extremities of quotation.

In opposition to Brand and Lord M., both Clarissa and Lovelace are strong readers of their sources. Rather than allow the quotation to define their personality, they use quotations to control other characters' personalities and behavior. The different attitudes of the two characters to their alterations can be seen as analogous to the different attitudes of the translators towards their own acts of quotation with alteration. Yet the precise circumstances of each transposition also affect its appearance in translation. The differing reactions to varied circumstances hint at the fact that translation is always a local phenomenon, never fully capable of delineation into theory or general rules. If literature always presents an allegory of its own reading, as Paul de Man has argued, then it also always presents the rules for its own translation. Let us note how this works in two very different passages by Michaelis.

Typical of Lovelace's practice of transposition is the care he takes to advertise his editorial changes. For example, he underlines his own changes to Shakespeare's *Troilus and Cressida* (the changes are printed in roman in the first edition):

> *Henceforth*, O watchful Fair-one, *guard thee well:*
> *For I'll not kill thee There! nor There! nor There!*

> *But, by the* zone that circles Venus' Waist,
> *I'll kill thee Ev'ery-where, yea, o'er and o'er.*
>
> (627)

The addition of "watchful Fair one" has turned this passage into a warning to Clarissa and a prediction of her rape. Indeed, it is important that Belford not read these lines, but rather hear them recited in a dramatic context. Lovelace identifies the play from which they come, even provides blocking for the scene: "Supposing the charmer before me; and I meditating her sweet person from head to foot." Lovelace's transposition of this text into his own situation thus necessarily differentiates it from Shakespeare's original, in which the speaker, Hector, taunts Achilles before they fight:

> I'd not believe thee. Henceforth guard thee well,
> For I'll not kill thee there, nor there, nor there;
> But, by the forge that stithied Mars his helm,
> I'll kill thee everywhere, yea, o'er and o'er.
>
> (*Tro.* IV.v.252–55)

We see that Lovelace, besides adding his own epithet for Clarissa, has also substituted an erotic oath for the martial one of Hector. Lovelace's changes in the line thus overwrite (without erasing) Shakespeare's idiom of war with one of eroticism. Such a combination of savagery and love is characteristic of Lovelace's projects throughout the novel. Indeed, it could define his act of rape. Furthermore, in rewriting these lines he takes on the rôles of creator, manipulator, and even forger of texts, rôles to which he returns at crucial places in the novel.

Yet for anyone familiar with Shakespeare's play, Lovelace's changes also provide an interesting reading of Shakespeare. They brilliantly express the basic theme of *Troilus and Cressida.* The Trojan War, after all, was a military action founded upon lust, and Shakespeare merely explores that juxtaposition ad absurdum. Lovelace rewrites Shakespeare as Shakespeare rewrote Caxton's rewriting of Homer. And all this rewriting, no matter how drastic, does not destroy the "original," but enlarges it and makes it more comprehensible.

Michaelis, during his year in England, had undoubtedly become acquainted with the works of Shakespeare, and he perhaps knew what was at stake in Lovelace's misquotation, although Shakespeare would become a German classic only near the end of the eighteenth century. The first apology for Shakespeare in German would appear

just two years after the first German translation of *Clarissa* (Gundolf, *Shakespeare*, 120). Had Shakespeare been better known, Michaelis would perhaps have hesitated to remove a line from Lovelace's quotation, since the language could be mistaken for Shakespeare's. But Lovelace's explicit marking of his changes has caused Michaelis to break out of character and respond with an equally strong revision. He renders the quotation as follows:

Von nun an hüte dich, **mein allzu wachsam Kind**,
Ich will nicht da, nicht da, nicht dort dich töten
* = = = = = =
So stirbt dir jedes Glied. . . .

*Hier stehen zwei Verse, welche der Übersetzer nicht gern in dem Deutschen mittheilen wollte. (IV, 312; Here come two lines which the translator did not wish to communicate in German.)

Lovelace's citation is four lines long, and three appear in the German. More accurately, two and one half appear in German; the final line has been truncated. The footnote's claim that two lines have been suppressed seems inaccurate, unless Michaelis is referring to the final half of the fourth line. The line which has not been translated concerns the "zone that circles Venus' waist" ("zoné" in Greek indicates a woman's undergarment). Michaelis has thus rendered the quotation incomprehensible: the second line states that no killing will be done, whereas the last line reports the dying of every limb. Indeed, the last line itself dies prematurely with a dying fall, whereas the first two lines preserve Shakespeare's blank verse. Lovelace's threat has been made more grim by the removal of any sort of erotic reference. Many of the scenes in *Clarissa* were censured in England as being "too warm," but Michaelis includes them all, even Lovelace's fantasy of raping the Howes, which was added to the third edition. It seems odd that he would omit this line out of prudery. Furthermore, the omission is less interesting than the footnote which draws our attention to it. In suppressing Lovelace's language, Michaelis overmasters him, censors him, and censures him as a violent libertine.

Michaelis's rendering of Shakespeare's lines varies from his normal practice in that it transposes rather than finds an equivalent. Shakespeare is rendered literally, and the weight of the original is palpable in its silencing. In almost all other quotes from poetry, although verse is rendered in verse form and with the same argument as in English, all other resemblance between original and translation

ceases. The German version usually adds one or two lines to the English. Rhymed couplets are the rule, even though most of the originals are in blank verse. Michaelis's translation of Lovelace's altered quotation thus raises the question of how transposition affects the transposed text.

When we examine Clarissa's use of an unaltered quotation, the opposite question is raised: what are the effects of the transposed text on the sign systems which surround it? A blank-verse passage from the tragedy *Ulysses* by Nicholas Rowe, a playwright scarcely less popular in eighteenth-century England than Shakespeare, is quoted to Lovelace by Clarissa in an attempt to hasten his reformation. The quotation is an example of Michaelis's preference for equivalence:

1 Habitual *evils change not on a* sudden;
 But many *days must pass, and* many *sorrows;*
 Conscious remorse and anguish must *be felt,*
 To curb desire, to break the stubborn will,
5 *And work a second nature in the soul,*
 Ere virtue can resume the place she lost:
 'Tis else DISSIMULATION—
 (445; line numbers added)

Except for an insignificant change in the first line, which in Rowe reads "Habitual evils seldom change so soon" (Rowe, *Ulysses*, 11), the words of this passage remain intact upon transposition from the original play. Yet in quoting *Ulysses*, Clarissa also tries to transpose her own relationship and Lovelace's character into the moral universe of Rowe's play. Whereas Lovelace changes Shakespeare's words to make them fit his own designs, Clarissa attempts to use Rowe verbatim in order to change Lovelace. On the most obvious level, she uses the lines to remind the rake of his need for continuous self-examination and repentance. Clarissa cites her source to her listener. In doing so, she hopes to impress upon him the analogy between their own relationship and that of Antinous and Penelope in the play. In this masquerade, Lovelace becomes Antinous, a proud, noble wooer of Ulysses' wife Penelope. Penelope, however, has brought Antinous under her control by denying his suit. In fact, the lines immediately preceding Clarissa's quotation demonstrate Penelope's mastery of Antinous: "She aw'd this rash Ision with her frown; / 'Taught him to bend his abject head to earth, / And own his humbler lot—" (Rowe, *Ulysses*, 10). Clarissa does not merely use these lines for their content value, but also attempts to lock herself

and Lovelace into the grid of Rowe's moral world, where not the rake but the chaste Penelope holds power.[7] Clarissa's hidden agenda, like Lovelace's open one, reveals the power struggle inherent in intertextuality.

Michaelis's response to Lovelace's open display of textual strength was a similar display of strength; his response to Clarissa's subtlety is more complex. As noted in the analysis of Clarissa's letter (see above, 33), more words are needed to express an idea in German than in English. Still, Michaelis's inflation of Rowe's lines is extraordinary:

1 Das Laster, das Gewohnheit langer Jahre
 Schon zur Natur gemacht, ist alten Schäden gleich.
 Dem frischen Vorsatz einer Stunde
 Weicht sein betagtes Uebel nicht:
5 Man fühlt vorher die aufgerissne Wunde,
 Man zücket, wenn die träge Beule bricht.
 Man spürt ein innres Weh, man muß das schelten hören,
 Vor dem das stärkste Herz erbebt:
 Gewissens-Angst muß uns uns selbst beherrschen lehren,
10 Sie tödtet unsre Lust, bis daß ein neues Herz
 In unserm Busen schlägt, und eine Seele lebt
 Die wahre Tugend liebt. Die Tugend ist ein Scherz
 Des träumenden Gehirns, sie ist nur Heucheley,
14 Wenn sie bey Scherz und Lust entstehet.
 (III, 218; line numbers added)

1 (Vice, the habit of many years
 turned into nature, resembles old wounds.
 To the fresh resolution of a moment
 its veterate evil does not yield:
5 One first feels the wound torn open,
 one shudders as the stubborn blister breaks.
 One feels an inner agony, one must hear the curses,
 which make the strongest heart tremble.
 A guilty conscience must make us masters of ourselves,

7. In considering Clarissa's use of the quotation to achieve power over Lovelace, we should note that Rowe in 1705 undoubtedly intended Penelope as both an image of and incentive to England's Queen Anne. (I am indebted to Annibel Jenkins's discussion of the play in her *Nicholas Rowe*, 78–86.) In opposition to Clarissa's use of the quote, we could also discuss Richardson's. There Ulysses would be equated with Clarissa's Cousin Morden, who will avenge her rape by killing Lovelace, just as Ulysses kills Antinous after his rape of Penelope.

10 it kills our voluptuousness, until a new heart
 beats within our breast, and a soul lives
 that loves true virtue. Virtue is but the jest
 of a dreamy brain, it is but hypocrisy,
14 if created by voluptuousness and jesting.)

Rowe's seven lines of blank verse have yielded a fourteen-line "Madrigal," i.e., a short poem whose lines may rhyme in any order (or not at all). Perhaps due to its ease of composition, such a verse form was used particularly in the writing of occasional poetry. For example, Haller composed his "Serenate," honoring the visit of King George to Göttingen in 1748 (cf. his *Gedichte*, 147–51), in madrigal form. Clarissa's explicit naming of Rowe's *Ulysses* thus becomes somewhat anomalous in translation, since the madrigal form was not part of theatrical practice in either England or Germany. This of course is merely the most visible sign of the complete loss of intertextual tension in a country where Rowe's work was unknown, and where theatrical works were not yet used as models of conduct and morals by the middle class. The theater would begin to function didactically only with the work of G. E. Lessing a generation later. In Germany, poetry was regarded as the primary vehicle for moral pronouncements, as one may see by reading Barthold Hinrich Brockes's *Irdisches Vergnügen in Gott* or Haller's *Versuch Schweizerischer Gedichte*. And so Michaelis's *Clarissa* turns to poetry for the same moral sustenance that the English *Clarissa* derives from the theater.

Moving from genre to diction, we find that equivalence has once again prevailed over transposition. The German introduces, for example, anaphora (lines 5–7), a poetic device which exists nowhere in the original. In those same lines appear repulsively graphic metaphors that compare former immorality to a healed wound and a blister threatening to break open. These metaphors lie far from the diction of the original, which is notable precisely for its lack of imagery and its dry, abstract moral vocabulary ("sorrows," "remorse," "anguish," "desire," "will," etc.). Even such common concrete nouns as "Luft" and "Herz" are antithetical to Rowe's diction. There are two reasons for the introduction of the elaborate metaphor of the wound. One is to bring the poem in line with poetic practice in Germany in this period, exemplified particularly in the work of Brockes, perhaps the most important German poet of the first half of the century. The last volume of Brockes's moral, monumental, and extremely popular work *Irdisches Vergnügen in Gott* (begun in 1721) appeared in the same year as *Clarissa*. Nearly all of the poems in this collection first describe a natural phenomenon—cherry blossoms at

night, a peaceful field, the work of bees—with great poetic skill. Each poem then ends with a didactic comparison of nature with the divine. Here Michaelis follows a similar allegorical strategy by invoking the moral realm through a vision of physical pain. Yet—and this is the second reason for Michaelis's choice of metaphor—that image of pain also has a definite and traceable origin in the original, though not in the quotation itself. In fact, Michaelis has blended frame and quotation. In the original, Clarissa's quotation is provoked by Lovelace's showing her a scar from a duel in which his severe wounds brought him near death and near reformation. Clarissa introduces her quotation with the following words: "And I would have you bear those charming lines of Mr. Rowe for ever in your mind; you, who have, by your own confession, so much to repent of; and as the scar, indeed, you shew'd me, will, in one instance, remind you to your dying day" (445). Thus we see that Michaelis has cleverly replaced the intertextual force of Clarissa's quotation with a more complete analogy to Lovelace's situation. Lovelace's scar, which in the original is but the occasion for Clarissa's seizing upon Rowe in an effort to define her own position, becomes a shared element between Lovelace and the quotation.

Indeed, the key word "dissimulation," printed in capitals in the English, exposes Lovelace once again as the plotter, consummate actor, and manipulator of texts. Michaelis divides "dissimulation" into "Scherz" (line 12), a joke, and "Heuchelei" (line 13), hypocrisy. It is interesting to read line 14 against the dedicatory poem to Richardson given in the preface of the translation. There "Lust" and "Scherz" were the shell concealing a worthy moral kernel. There Michaelis praised "ein zur Lust gedichtet Bild, / Das scherzt, und in den Scherz den Ernst der Lehren hüllt" (I, n.p.; "and a scene written for pleasure, / that jokes, and in that joke hides the earnestness of his teaching"). Here, on the other hand, "Lust und Scherz" cannot function didactically because they are incompatible with seriousness or the didactic. A careful German reader would have to wonder which poem to believe. He would have to question either the whole of Richardson's effort or Clarissa's act of quotation.

In general, the German text liberates Lovelace from the intertextual grid onto which Clarissa has pinned him. The hidden parallel to Antinous is replaced by the open and realistic one to a wounded man. The quotation now describes general shared characteristics rather than similar tactical situations; it points to essential rather than situational resemblances. And paradoxically, its own point has been dulled by its contradicting the didactic principle of "dulce et utile" upon which *Clarissa* is founded. Nevertheless, the great care

which Michaelis took to write an equivalent poem shows his overriding interest in the didactic aspect of *Clarissa*.

These quotations remind us that fidelity and dissimulation are terms in a dialectic, and that either one may change into its opposite. Their difference exists only at the surface, allowing readers a more immediate grasp of Lovelace's project, whereas Clarissa's intentions remain hidden. So too with the translations, in which Prévost's more visible interventions bring aspects of the original to the surface which Michaelis cannot reach. We have seen one translator use two different methods, transposition and equivalence, in accordance with the way in which the original text displays or hides its intertextuality. I will now explicitly compare the two translations in their treatment of a single transposition.

Clarissa's quotations from the Bible, or "meditations" as she calls them, provide a more difficult intertextual situation than does her quotation from Rowe or Lovelace's from Shakespeare. They are carried out at Mrs. Smith's, where Clarissa has finally found a refuge from the persecutions of Lovelace. Her first meditation (1125), an adaptation of the Book of Job, is simply deleted by Prévost, and therefore cannot provide the basis for our comparison. Her second meditation, "On Being Hunted After By the Enemy of My Soul," in which she mixes lines from the book of Psalms with her own words, raises the same issues as does the first, but in a slightly more subtle way. Whereas in the first meditation Clarissa meditates on herself, she prepares the second as a weapon against Lovelace, who is clearly the "enemy." To follow the hunting metaphor of the title, then, the text functions as shark repellent. Lovelace is given the meditation when he comes hunting Clarissa in her refuge, and he presents it in a letter to Belford.

The table below shows the composition of the whole meditation:

Lines 1–4	Psalm 140:1–4
Line 5	Psalm 141:5
Line 6	Psalm 141:9
Lines 7–8	Original
Lines 9–13	Psalm 102:2–7
Lines 14–16	Psalm 102:9–11
Line 17	Psalm 140:8

By examining part of the meditation, from line 7 to line 14, one can see how unobtrusively Clarissa's own lines (7–8) blend in with the quotes:

7 *The enemy hath persecuted my soul. He hath smitten my life down to the ground. He hath made me dwell in darkness, as those that have been long dead.*

8 *Therefore is my spirit overwhelmed within me. My heart within me is desolate.*

9 *Hide not thy face from me in the day when I am in trouble.*

10 *For my days are consumed like smoke: and my bones are burnt as the hearth.*

11 *My heart is smitten and withered like grass: so that I forget to eat my bread.*

12 *By reason of the voice of my groaning, my bones cleave to my skin.*

13 *I am like a pelican of the wilderness. I am like an owl of the desart.*

14 *I watch; and am as a sparrow alone upon the house-top.*

(1221)

Critical assessment of Clarissa's activity has generally been in the tradition of Lovelace, who calls her writing a mere "collection of Scripture-texts." For example, Carol H. Flynn feels that in her meditations Clarissa merely "recreates the Catholic saints' experiences and meditations in *their* own language" (*Man of Letters*, 27, emphasis added). Flynn and Lovelace both disregard Clarissa's ability to alter her quotations (it is *he*, not *she*, who is supposed to manipulate texts), the way he will later dismiss her ability to allegorize. Opposed to this view is the opinion voiced by Linda Kauffman. Kauffman claims that, besides her original lines, Clarissa's entire transposition of the Bible into her own textual system and her use of this particular meditation to rebuke and ward off her rapist represent "a remarkable transgression of the boundaries of gender, of language, of prophecy, of lamentation. By transforming all the biblical references from *he* and *him* to *she* and *her*, [Clarissa] encloses an alternative sign system in a testament of radical feminism" (*Discourses of Desire*, 155). Kauffman's view is even less plausible than Lovelace's, for Clarissa consistently rejects radical feminism throughout the novel. Furthermore, in the mystical tradition it was quite common for women, whether feminist or not, to "mingle thoughts" with Biblical quotation.[8]

The careful editing and concatenation from three Psalms is based around the presentation of an "I" downtrodden and arrayed against a hostile world. By cutting and pasting three different Psalms to-

8. I am indebted to Dr. Caroline D. Eckhardt of Penn State University for this insight.

gether, Clarissa is able to send several contradictory "messages" at once: Psalm 102 is one of the seven penitential Psalms, but 140 is a Psalm of vengeance, while 141 asks for rescue from a godless community. In liturgical practice each Psalm must be given separately and in its entirety. Its theme must be deemed appropriate to the context of the service as a whole. In presenting them together, Clarissa carefully selects those passages which use powerful imagery to present her situation in the most moving terms, and nearly eliminates their theological context. The fact that a number of lines of these meditations are Clarissa's own creations makes her editing even more meaningful. She handles the Bible as Lovelace handles Shakespeare, as a text to be creatively altered to render it an adequate vehicle for the expression of one's personality. However, Lovelace is usually eager to point out the violence he has done to a text in order to show that he is its master. Clarissa does not advertise her alterations through underlining or with indices. Conversely, the transposition of the Biblical text into Clarissa's situation causes it to be altered as well.

Michaelis's transposition of Clarissa's words into German heightens the effect of her adaptation and creativity. Let us examine lines 7–14 of the meditation as they appear in the German translation:

7 Der Feind hat meine Seele verfolget. Er hat mein Leben zu Grunde gerichtet. Er hat gemacht, daß ich im Finstern wohne, als diejenigen, welche lange todt gewesen sind.

8 Daher ist mein Geist in mir überschwemmet. Mein Herz in mir ist zerstöret.

9 Verberge dein Antlitz nicht vor mir an dem Tage, da ich in Unruhe bin.

10 Denn meine Tage sind verzehret, wie Rauch: und meine Beine sind verbrannt, wie der Feuerherd.

11 Mein Herz ist zerstossen, und verwelket, wie Grass: so daß ich mein Brodt zu essen vergesse.

12 Vor der Stimme meines Seufzers kleben meine Gebeine an meine Haut.

13 Ich bin wie ein Pelikan in der Wildnis. Ich bin wie eine Eule in der Wüsten.

14 Ich wache; und bin wie ein verlassener Sperling auf dem Giebel.

(VI, 830–31; line numbers added)

These lines represent a nearly exact transposition into German of the English text, which is itself—with the exception of Clarissa's

lines—an exact copying of the King James Version of the Bible.
Thus here, as with Lovelace's quotation from Shakespeare, Michaelis
opts for transposition. His translation is based not on the German
Bible, but on Clarissa's text. He has concerned himself with repro-
ducing these texts as the words of Clarissa, and not with establishing
them as passages from scripture. The German translation of the Bi-
ble by Martin Luther, while without benefit of the official monopoly
granted to the Authorized Version, was as standard for eighteenth-
century Protestant Germany as the King James translation was for
England. The overwhelming majority of Bibles and psalters printed
in northern Germany during the mid-eighteenth century used Lu-
ther's translation, more often than not with his name on the title
page. Michaelis quotes from Luther's *Biblia* (and from no other Ger-
man translation of it, nor from the Vulgate) in his essay on the Ger-
man language discussed in chapter 1.[9] Both personal experience and
knowledge of his audience would have led Michaelis to compare his
transposition of Clarissa's meditation with Luther's German. Let us
then also make that comparison, using the 1748 edition of the "Lu-
therbibel" printed in Halle:

Psalm 102, 3–8:
Verbirge dein antlitz nicht vor mir in der noth
Denn meine tage sind vergangen wie ein rauch, und meine gebeine
 sind verbrant wie ein brand.
Mein hertz ist geschlagen, und verdorret wie gras: daß ich auch
 vergesse mein brodt zu essen.
Mein gebein klebet an meinem fleische, vor heulen und seuftzen.
Ich bin gleich wie ein rohrdommel in der wüsten: ich bin gleich wie
 ein käutzlein in den verstörten stätten.
Ich wache, und bin wie ein einsamer vogel auff dem dache.
 (Luther, *Biblia*, 362)

One can imagine the Biblical scholar Michaelis, who had met the
leading textual critics of England and who would later publish a new
translation of both Old and New Testaments, intrigued by the
chance to present an alternative to Luther's version, whose impor-
tance for the German language and culture was monumental. The
substitutions of "verzehret" for "vergangen," "Feuerheerd" for

9. See above, 19–20. Michaelis is discussing the changing meaning of "Essence"
("Wesen"): "Luther pouvait traduire sans la moindre équivoque, *c'est de ta volonté qu'ils
tiennent leur Essence*" ("Luther was able to translate without hesitation, *it is from Thy will
that they have their essence*"). A footnote gives Luther's German: "*Durch deinen Willen
haben sie das Wesen*" (De l'influence, 16).

"Brand," "Pelikan" for "Rohrdommel," and "Giebel" for "Dach" give Clarissa's meditations a different tone from Luther's Psalter. So also do certain grammatical changes, such as "wie" for "gleich wie" and "so dass" for "dass." Changes in whole lines, such as the adaptation of "Mein gebein klebet an meinem fleische, vor heulen und seuftzen," to "Vor der Stimme meines Seufzens kleben meine Gebeine an meine Haut," prosify Luther's verse. Since the Bible is read intensively, word-for-word and line by line, such favoring of transposition over equivalence in translating a mere novel is significant.[10] At the very least, it serves to emphasize that Clarissa has *rewritten* her text rather than merely copying it. There is little doubt that German Protestants experienced some shock in reading Clarissa's meditations.

In the choice between fidelity to Clarissa and fidelity to his own biblical tradition, Michaelis has chosen the former. Michaelis thus has found in *Clarissa* an opportunity to begin his own later textual criticism in service of Enlightenment, for it is precisely the task of Enlightenment to pry the Bible loose from religious dogma, as Clarissa does with her meditations and as Michaelis does with his translation of them. For, as Hans-Georg Gadamer has put it, "the critique of the enlightenment is directed primarily against . . . the bible. By treating the latter as an historical document, biblical criticism endangers its own dogmatic claims. This is the real radicality of the modern enlightenment as against all other movements of enlightenment: it must assert itself against the bible and its dogmatic interpretation. It is, therefore, particularly concerned with the hermeneutical problem" (*Truth and Method*, 241). Michaelis's specialty became just that hermeneutic problem as it appeared in biblical translation and exegesis.

In contradistinction to Michaelis, Prévost allows Lovelace to paraphrase Clarissa's text rather than writing it out in full. And here is Lovelace's summary:

> C'étaient differens versets des pséaumes, où le roi David demande au ciel de le délivrer du méchant homme, de l'homme

10. A comparison of the relative "fidelity" of these two German versions in turn to the Hebrew discloses no winner. Whether firebrand ("Brand") or hearth ("Feuerheerd") is meant is unclear—the RSV has "furnace." The lone bird on the housetop is most likely a sparrow, though the Hebrew word "zippor" is generic and not specific— "Pelikan," on the other hand, is much more likely than "Rohrdommel." In short, the differences in word choice are minimal and come at precisely those points where interpretation becomes necessary. The choice between Luther and Clarissa was not a question of accuracy, but of effect.

violent, qui ne médite que du mal dans son coeur, qui tend des pièges à l'innocence; & d'autres où il se pleint d'être comme le pélican du desert. (VI,194)

(There were several verses from the Psalms, where King David asks heaven to deliver him from the evil man, from the violent man who only plans evil in his heart, who sets traps for innocence; and others where he laments being like the pelican in the desert.)

Prévost's refusal to transpose the text removes Clarissa's original lines, and hence her meditation can be identified as a simple transcription of the Biblical text. Lovelace's words are suddenly entirely accurate in calling Clarissa's activity mere "scripture gathering." Indeed, it is not immediately apparent from the French what Clarissa intended with her quoting. Second, Prévost transforms the first-person lyricism of the original meditation into a third-person paraphrase. Third, Prévost's linking of the Psalms to the name of David, accurate in terms of the biblical tradition but not mentioned in the English, foils Clarissa's attempts to project herself into the text. "Il" is the pronoun here, not "je" as in direct quotation, nor even "elle," as in indirect quotation. The Psalms return not so much to their sacred context as to their male author. Clarissa's originality or transgression has thus been removed, while Lovelace has been made an even greater manipulator of texts than he is in the English version. Richardson makes his villain give Clarissa full credit for her meditations, copying them out in full for Belford. Prévost's Lovelace foils even this last paradoxical attempt of Clarissa to communicate through the words of others. If Michaelis made Clarissa's text even more radical, Prévost clearly has recuperated and tamed her project.

Clarissa's meditations receive one more mention in the French, in a footnote to another letter from Lovelace. The note begins with a gesture which minimizes the importance of the quotes:

On n'a fait remarquer que M. Belford envoyait avec sa dernière lettre, une copie de quelques passages de l'écriture sainte, de la main de Clarisse, & dont elle faisait quelquefois le sujet de sa meditation. Il l'avait obtenue de Madame Lovick. (VI, 152)

(We failed to note that Mr. Belford sent with his last letter a copy of some passages from scripture written down by Clarissa, and which she often made the subject of her meditations. He had obtained them from Madame Lovick.)

Of the two paraphrases of Clarissa's meditations, one is given in Lovelace's words, the other in Prévost's. As with the translation of Clarissa's explanation of her letter (see above pp. 40–41), the voice of the translator blends with the voice he is translating.

Prévost's strategy of equivalence and paraphrase is carried out on all poetical passages in his translation. Never did Prévost feel Michaelis's compunction to hide the English original behind a sample of his own verse. He clearly recognizes the impossibility of reproducing the symbolic field surrounding each quotation. About half the time he simply eliminates the quotation (for example, Lovelace's from *Troilus and Cressida*). Prévost's criterion for eliminating quotations is founded on the extent to which each quotation is integrated into the argument of the character's letter; where the quotation is merely tacked on as a tour de force (as it often is in Lovelace's letters), it is most likely to be omitted by Prévost. When Prévost does include a quotation, the English is translated into French prose, and a footnote is usually added at the bottom of the page noting that the original is verse, e.g., "sont quatre vers." F. H. Wilcox describes Prévost's procedure in just one instance, Lovelace's first letter (142–48):

> In a letter ten pages long, there are seven quotations from poetry. Three of these are of some length—five to ten lines— the others are only lines or couplets. The shorter quotations Prévost retains, for it would have been more trouble to recast the sentences than to translate them as they stand. One of the longer quotations he retains, for it is given as expressing Lovelace's own feelings. Prévost omits the quotation from Cowley, as well as ten lines of Shakespeare, intended to express the sum of Clarissa's virtues. (*Prévost's Translations*, 355)

Throughout his translation, Prévost retains Lovelace's feelings and jettisons Clarissa's virtues. Wilcox defends Prévost's omissions as a necessary correction to Richardson's irritating transpositions, which stem from his desire to appear more educated than he really was (*Prévost's Translations*, 357).

Prévost's procedure is usually to preserve the verse's literal meaning and its diction, but to change the verse to prose. His footnoting method, like Lovelace's underlining, focuses the reader's attention on the discrepancy between the French prose and the English original. A footnote stating that several lines of Prévost's translation "sont quatre vers," if taken literally, contradicts the French text, which is presented in prose. The note emphasizes the absence of the original. At other times, Prévost assumes control of the quotation by remov-

ing the author's name from the letter in which the quotation occurs and placing it in his own footnote, as though he, and not the letter-writer, had identified the source.

We may say that Prévost's method opposes Michaelis's in two senses. Prévost treats the quotations as messages, preserving their content and dismissing their form. Michaelis, in trying to preserve the form of the quotation, is forced to write an equivalent German poem, and in one case to make a new translation of the Bible. Prévost gleefully points to the discrepancy between the original English poem and its translation into French prose. Thus Prévost, like Lovelace, enjoys exhibiting the violence which he is able to do to the text. Michaelis, while also participating in violence, impedes the irruption of that violence onto the surface of the text. Like Clarissa, he creates by making his readers think he is merely quoting. Both translators allow their voices to enter the text: Michaelis as censor, Prévost as paraphraser. Our final aspect of intertextuality compares these two translatorial voices with the voice of Richardson's "editor."

Stereoptics

Both Michaelis's footnote to his censorship of Lovelace and Prévost's footnotes to his paraphrases point to the discrepancies between translation and original. They refer to the original both as absence and as necessity for the understanding of the translator's goals. In an article devoted to the intertextuality of translation, Brian Fitch has called translation a metatext which comments on the possibilities of reading the original:

> La traduction est, à notre sens, un métatexte qui articule à l'intérieur de lui-même les conditions de réception de tout texte. Le statut de ce dernier pour son lecteur s'y trouve ainsi dévoilé et mis à nu ("L'intra-textualité," 89)

> (Translation in this sense is a metatext which articulates in its interior the conditions for the reception of any text. The status of the text for its reader is found exposed and stripped in its translation.)

Fitch's thesis implies that to read a translation is to simultaneously read original and copy, and it is this possibility which I wish to desig-

nate as "stereoptics."[11] Here is a type of reading which at first glance would seem to be available only to those who can simultaneously read both the translation and its original, that is, to those who do not need the translation in the first place. However, the translations by Prévost and Michaelis uniquely dramatize this metadiscursive aspect of translation. The average French or German reader, even without access to the original, must read parts of their work against the English original, as metatext, as commentary on rather than translation of *Clarissa*. If the translators provide in places a stereoptic view of *Clarissa*, as transmitted text and as deleted text, it is partly because Richardson himself presented *Clarissa* as an edited text. *Clarissa* asks to be read in stereo, as text and as commentary on that text. One metadiscursive aspect of the novel is the voice of the "editor." I will now examine both that editorial voice and its reappearance in French and German as the voice of the translator.

Glen M. Johnson has measured the importance of the editorial voice for the novel statistically: "When one adds to 429 footnotes the editorial interpolations within and between letters (ranging from a single line to two pages), the total number of . . . intrusions approaches that of letters in the novel. Strictly in terms of total appearances, the editor is the most frequent speaker in *Clarissa*" ("Richardson's 'Editor,'" 100). These numbers, based on the third edition of *Clarissa*, represent a substantial increase over the first edition, which contained a mere 325 footnotes and numerous interpolations. The words "intrusion" and "speaker" collide in the above quotation, indicating on the one hand an unwelcome authorial intervention (one is less likely to speak of Fielding's "intrusions" into *Tom Jones*), and on the other hand an increase of conflicting voices as the editor takes on the status of a character. In fact the editor is neither the author of *Clarissa* nor a character in the novel, but rather its first reader. The editorial voice presents *Clarissa* stereoptically, i.e., as a text already read, as its own scholarly edition.[12] As such it provides a

11. I take the term "stereoptics" from Fredric Jameson, for whom the double vision refers to simultaneous immanent and historical readings of a text (*Political Unconscious*, 136–37). But it is important to note that the term points to one of the fundamental tenets of intertextuality: the simultaneous reading of text and intertext. As such, it has been implicit in my previous discussion.

12. This viewpoint is reinforced by the fact that Richardson's practice in *Clarissa* was modeled on his previous editing of the papers of Sir Thomas Rowe, for which he provided an index and table of contents. In this case his scholarship was admired by reviewers, but the book failed to sell (cf. Eaves and Kimpel, *Samuel Richardson*, 81–83). *Clarissa*, on the other hand, was a success, but the scholarship both failed to control interpretation as Richardson would have liked, and drew the wrath of critics who felt preempted.

valuable gap through which the translator may enter the text; since *Clarissa* is already presented as an edition, it is less aberrant for its translation to become one.

I will follow Glen Johnson's lead in discussing three types of editorial interventions: footnotes, explanatory footnotes, and interpolations. The first term designates the relatively simple connecting references that appear when a remark made by a character in one letter recalls, or refers to, a passage from another letter. Thus "See Letter XX," or "See Vol I, p. 58," appears after a passage in which the correspondent has referred to language or events contained in letter XX or on page 58 of the first volume, respectively. These footnotes modify the type of intertextuality exemplified by Clarissa's letter to Lovelace. They are devices for tying texts together, for pointing out how letters in the novel allude to and quote from each other. They are traffic signs, reminding the reader of territory already covered, or pointing forward so that our perception of our present position is altered by what lies ahead. These traffic signs are of course not neutral; they lay certain traps for the reader. A negative example, a passage where needed traffic signs are *not* provided, is Clarissa's "Father's house" letter, which should have (or could have) had an editorial footnote pointing the reader ahead to the eventual explanation of the letter's meaning. But the editor, meaning to play with his reader and heighten suspense, deliberately withheld the connector here.

The German translation reproduces these footnotes without fail; the French translation omits all of them. Considering the labor and expense of reproducing footnotes, the German decision is the more surprising. As a scholar Michaelis was familiar with footnotes; Vandenhoeck's press, founded together with Göttingen University, undoubtedly also was accustomed to a procedure which to the novelist Prévost, or to his press Nourse, undoubtedly seemed misplaced in a work of belles lettres.

The second type of editorial intervention in *Clarissa* is the explanatory footnote. In this device, the characters' voices are contrasted with the somber and omniscient voice of the editor. For example, in the following footnote to Clarissa's letter, the editor pulls the reader back from full sympathy with the writer by using cautious, impassionate language to contrast with her outrage. Clarissa is complaining bitterly to Anna about her family's plans to force her into marrying Solmes

> This intended violence [the forced marriage] my aunt often
> excused by the certain information they pretended to have of

> some plots or machinations, that were ready to break out
> from Mr Lovelace:[a] the effects of which were thus cunningly
> to be frustrated.
>
> [a] It may not be amiss to observe in this place, that Mr. Love-
> lace artfully contrived to drive them on by permitting *his*
> agent and *theirs* to report machinations which he had no in-
> tention, nor power, to execute. (348)

Clarissa sarcastically dismisses what to her seem pretended reasons
for her forced marriage. The editor supplies information which jus-
tifies Clarissa's family, shows Lovelace to be the true enemy, and
makes Clarissa seem a bit rash in her judgements. Yet, perhaps more
striking than the sudden reversal of perspective which results from
this new information is the stylistic contrast between the two
writers—the effect on the reader is analogous to jumping out of a
sauna into a cold mountain lake. The clumsy, bureaucratic first
clause of the editor's note both apologizes for intruding into the
story and leaves it up to the reader whether to accept this extra in-
formation; it "may not be amiss" to do so. Yet in exercising such
caution the editor makes his point even more strongly: cool, rational
writing will prevail over hasty, passionate outbursts.

Thus, the explanatory footnotes serve both as devices to control
our reading and as warnings against our putting faith in the words
of any one character. An alien voice enters the text and alters each
character's style into something different. This alteration continues
when the translators turn Richardson's footnotes to their own pur-
poses.

Both translators mingle Richardson's footnotes with their own,
which are inserted not to correct the characters, but to explain some
of the strangeness of the foreign text. Prévost and Michaelis choose
different elements to explain. The only phenomenon that the Ger-
man and French translators both explain is the institution of the
penny-post! This first public postal service, introduced in 1680, was
in fact "admired by visitors from other countries who recognized this
service as one of the significant accomplishments of the English, and
a great advantage of London life" (Perry, *Women, Letters, and the
Novel*, 64).

Michaelis is at much greater pains than Prévost to describe unfa-
miliar terms. He explains the English "closet," (a cultural artifact in-
dispensable to the epistolary genre, and a word which will appear in
German novels of the later eighteenth century), the English system
of government, English monetary values, and the concept of board-

ing schools. In only one instance does Michaelis make an explicit comparison with German customs. At one point Lovelace explains to Belford how he should address letters to him: "I have changed my name: Changed it without an act of Parliament. 'Robert Huntingford' it is now. Continue *Esquire*. It is a respectable addition, altho' every sorry fellow assumes it, almost to the banishment of the usual travelling one of *Captain*" (417). Michaelis translates Lovelace's last sentence as "man will fast keinen mehr Landsmann nennen," and his footnote reads "im Englischen stehet: Capitain. Dieses Wort gebrauchen die Engländer gegen einen jeden, den sie nicht anders nennen können. Das Wort Esquire wird fast in allen Aufschriften der Briefe gebraucht, wo wir kaum Monsieur setzen" (III, 138). The translator claims that there is an inflation of titles in England, an uncertainty about who is a gentleman and who merely a "Captain." Michaelis has reinforced this idea of inflation by translating the military term "Captain" with the much more neutral "Landsmann" ("countryman"). However, when he gives the French word "monsieur" as a title comparable to the English "Esquire," it becomes apparent that German forms of address are as inflated as the English, so that speakers of German must go to the more highly esteemed French language to find proper terms of respect. In his short footnote Michaelis has struck upon a topic which was central to English literature of the eighteenth century: how to classify people. It is a prominent problem in *Clarissa*, as we shall see in the next chapter.

At times Prévost's translator's notes introduce an oppositional discourse similar to that of the editor, as when he introduces the bad style of Lovelace's friend Mowbray: "On doit se rappeler le caractère de Mowbray" (VI, 425). The French reader must be reminded that the bad language of the letter is not the fault of the translator, but reflects the original. Besides the penny-post, Prévost also explains the nature of the English constable ("connétable") and one other English legal peculiarity. When Clarissa screams to the passersby outside Sinclair's house, and they respond by forming a mob to demand her freedom, Prévost feels compelled to insert: "Elles sont fort rigoureuses en Angleterre, contre ceux qui attentent à la liberté d'autrui" (V, 399). This comment echoes not so much French sentiment as the generalizations made by most Englishmen about their country as a land of personal liberties unheard of in France or Germany. One can hear in this brief comment the sigh of relief of a man who came to England precisely because a *lettre de cachet* had been released against him in France. John Brewer and John Styles, in their introduction to a collection of historical studies of eighteenth-century legal practice, agree with Prévost that "it was a shibboleth of

English politics that English law was the birthright of every citizen
who, unlike many of his European counterparts, was subject not to
the whim of a capricious individual but to a set of prescriptions that
bound *all* members of the polity." They add, however, that "such a
characterization of the English 'rule of law' will not, of course, pass
muster as an accurate description of the modus operandi of the legal
process" (Brewer, *An Ungovernable People*, 14). Similarly, Prévost's
theoretical footnote stands in contradiction with the text which it
explicates, for the incident described here does not result in Cla-
rissa's release from Mrs. Sinclair's brothel. The mob is dispersed,
their intervention has no effect. The law, on the other hand, can be
used as an instrument of terror, for when Clarissa does escape from
Sinclair she is immediately placed in jail on the charge of having
bilked the very lady who has kept her prisoner and participated in
her violation. Mrs. Sinclair, as a property owner, is able to command
such imprisonment without proof. The whole operation very much
resembles that of a *lettre de cachet*. Prévost's footnote appears almost
as a feeble injection of hope into *Clarissa*'s dismal legal world. (For a
further discussion of the law in *Clarissa* see "Legal Genres" in chap-
ter 4.) Yet Prévost, besides merely repeating proverbial wisdom, was
perhaps also expressing his personal stake in English liberty, having
fled to England to escape precisely the arbitrary imprisonment
which Clarissa experiences. Prévost's footnote is less an explanation
of the social context of *Clarissa* than a critique of the French condi-
tions under which he had suffered.

Interpolations constitute the third type of editorial strategy. The
term refers to parenthetical editorial remarks within the body of the
text. Invariably, they also link two texts together (usually two parts
of the same letter), but only by showing the absence of a third text,
which is summarized in the interpolation. They provide a stereoptic
illusion of *Clarissa*'s reality by pointing to a larger body of texts from
which the particular edition is drawn. We may look at an example
from one of Lovelace's letters, where he informs Belford of his suc-
cessful abduction of Clarissa. The letter breaks off and the editor
writes: "*[Lovelace] here relates the conversation between him and the Lady,
(upon the subject of the noise and exclamations his agent made at the garden-
door) to the same effect as in Letter XX and proceeds exulting*" (440). The
conversation between Lovelace and Clarissa and the abduction form
a crux of the novel. Clarissa's family maintain that she willingly
eloped with Lovelace, while Clarissa reports that she fled at the
threat of violence implied by the "noise and exclamations." More
information and a comparison between versions is needed here for
final judgment on the actors' behavior. Yet precisely at this point the

editor denies the intertextuality of this novel in favor of getting the story told. There can be little doubt that Lovelace's report of the conversation would be different from Clarissa's. Precisely the "effect" of Lovelace's presentation of the scene would be different. We read not only the interpolation, but also the "gap" that it points to, an absence that is both mysterious and meaningful.

We can see, then, how Prévost's scandalous cuts have found their model in the original. Prévost seized upon the interpolations as a device for speeding up the novel, for denying its intertextuality, and for redefining the text in his own aesthetic terms. The two key words in Prévost's interpolations are "inutile" and "goût," words which function as filters to eliminate the repetitive qualities or the perceived English grossness of the original text, respectively. Letters are rejected by Prévost either because they add nothing to the essentials of the story, or because their language or their subject matter does not agree with French literary tastes.

Thus the tone and purpose of Prévost's interpolation describing Clarissa's meditations, or the one giving her interpretation of her letter, are entirely comparable to those of Richardson's editor. The latter interpolation summarizes Clarissa's explanation of her letter and Lovelace's reaction to it "en supprimant ici plusieurs lettres inutiles de Madame Norton, de Miss Howe, de M. Lovelace, de M. Belford & de M. Wierly" (VI, 351; "in suppressing several useless letters of Madame Norton, of Miss Howe, of Mr. Lovelace, of Mr. Belford and Mr. Wierly"). Twelve letters and forty pages of text are considered useless in this case. The verb "supprimer" here is polyvalent, meaning simultaneously "hide," "suppress," "censor," and "annul." It, along with "passer," is Prévost's most frequent choice to indicate the act of excision. The word "inutile" indicates that the translator has entered the text as an oppositional voice. We get a more specific sense of what Prévost considers "inutile" from his next interpolation: "On passe ici sur près de vingt lettres qui n'ajoutent rien à la partie historique" (VI, 402; "Let's skip about twenty letters which add nothing to the plot"). Or again, in his suppression of the interview between Morden and Lovelace: "Passons sur un détail inutile" (VI, 376; "Let's skip this useless detail"). It is interesting that the interview which Prévost cuts became the basis for most of the stage play *Clarissa, ein bürgerliches Trauerspiel* (1765) by Johann Heinrich Steffens. This play begins near the end of the novel, as Clarissa is already dying, and consists of long speeches—mostly heated ones between Lovelace and Morden—and little action. Steffens undoubtedly seized on the interview because it is already in dialogue form, one of Richardson's many debts to the theater. For Prévost, on the

other hand, the chain of events or "histoire" is what counts in the
novel. The weave of discourse bends before the primacy of action.

Thus Prévost eliminates the letter of Dr. Lewen, the principle ar-
gument of which is that Clarissa should prosecute Lovelace for the
rape. Prévost then gives Clarissa's answer to Lewen in full, for the
following reason: "On ne croit pas devoir supprimer . . . les réponses
de Miss Clarisse au docteur & à sa soeur, parce qu'elles servent à
justifier sa conduite & ses sentimens" (VI, 342; "We don't think we
should suppress the responses of Miss Clarissa to the doctor and to
her sister, because they serve to justify her conduct and feelings").
Clarissa's letter is important to understanding her conduct, which
forms part of the plot; hence, it must be kept. Lewen's is important
only for understanding Clarissa's letter and hence may be elimi-
nated. Thus the reader is in the interesting position of evaluating a
response to a letter which he has not read. Perhaps the most crucial
text which Prévost chooses to eliminate on utilitarian grounds is
Clarissa's own narration of her rape. In his view, since it adds no
new information, but merely retells an old story from a new point of
view, it is expendable. Prévost sacrifices the novel's intertextuality to
get the story told. Perhaps it is more accurate to say that one type of
intertextuality has replaced another: Prévost's interpolations replace
the complex relationships between characters' points of view with a
tension between the English original and the French translation.
Prévost's interpolations rarely fail to attract the French reader's at-
tention to the gap between original and translation, and to the par-
lous process of making an English novel into a French novel.

The clearest example of Prévost's method is given in the following
interpolation:

> On supprime plusieurs autres lettres qui ne contiennent que
> d'inutiles détails, quoique toujours mêlés d'excellentes réflex-
> ions. L'editeur anglois sacrifie souvent l'interêt historique, au
> dessein d'instruire par les plus sages leçons de religion & de
> morale. (VI, 523–24)

> (We suppress many more letters which only contain useless
> details, although they are always joined with excellent obser-
> vations. The English editor often sacrifices the plot in order
> to instruct through the wisest lessons of religion and ethics.)

"Interêt historique" is the second (cf. "partie historique" given
above) of Prévost's epithets singling out a part of the novel that
makes for "histoire," which moves the story forward. Prévost blames

the English editor (not the author) for not taking complete control of his material as he should have, for not paring the mass of original letters into the shape of a narrative. Here, as in his preface, there is a complete contradiction between Prévost's practice as a translator and the responsibility he always claimed as a novelist. He clearly wishes to rescue pleasure and drown instruction in his translation. Instruction itself, he confesses, is "inutile." Thus, despite the title *Lettres angloises* given to his translation, Prévost is unwilling to allow for the didacticism inherent in Richardson's concept of epistolary fiction, which derived from the letter-writing manual which itself often functioned as a conduct book.

But in France as well, the letter remained a vehicle of moral instruction. We might contrast Prévost's remarks here with those of the anonymous editor of a 1756 collection of Madame de Sévigné's letters. There the editor also acknowledges that it has been necessary to eliminate material, but:

> On a cru devoir . . . recueillir en un corps les *Pensées ingé-nieuses*, les *Particularités intéressantes*, les *Anecdotes curieuses*, les *Instructions utiles* & les *Plaisanteries fines* qui se trouvent comme noyées dans tous les Volumes de Madame de Sévigné. (Sévigné, v)

> (We have found it necessary to gather into one work the *clever thoughts*, the *interesting details*, the *singular anecdotes*, the *useful instruction* and the *refined humor* which are as though drowned in all Madame de Sévigné's tomes.)

Both editors intervene to save their texts, but with opposite goals. Everything which Prévost has eliminated appears here, as though this quote were the photographic negative of his interpolation. Note the phrase "instruction utile," an oxymoron in Prévost's translation.

One could go on to discuss many more omissions by Prévost, but it is important to establish what these cuts mean for the narrative as a whole. They give Prévost the chance to return the narrative to a single voice, and in fact to insert his own voice into the narrative. This struggle is demonstrated most clearly by an interpolation which wrests control of the narrative away from Belford. As noted above, Mrs. Sinclair has Clarissa falsely imprisoned for debt when she escapes from the bordello. Belford visits Clarissa in her cell, and in a letter to Lovelace he describes her circumstances in minute detail. The description, both in its detail and its psychology, is unusual for *Clarissa*, where settings are functional rather than physical, men-

tioned rather than described. Belford's description reads like a passage out of a nineteenth-century novel:

> A horrid hole of a house, in an alley they call a court; Stairs wretchedly narrow, even to the first-floor rooms: and into a den, they led me, with broken walls, which had been papered, as I saw by a multitude of tacks, and some torn bits held on by the rusty heads. . . .
>
> An old, tottering, worm-eaten table, that had more nails bestowed in mending it to make it stand, than the table cost fifty years ago, when new.
>
> On the mantle-piece was an iron shove-up candlestick, with a lighted candle in it, twinkle, twinkle, twinkle, four of them, I suppose, for a peny. (1064–65)

Most remarkable here is the almost complete absence of verbs. Nothing is supposed to happen in this tableau, since Hell is eternal. Even the spatial arrangement of the room contributes little to the structure of Belford's description. Each item described, stairs, walls, table, and candlestick, is instead fully equivalent to the other as a metonym for the evil situation Clarissa finds herself in.

Prévost does not translate Belford's close description of Clarissa's jail, choosing instead to provide an equivalent narrative which he feels will sufficiently move his readers:

> Les circonstances n'en peuvent être touchantes que pour ceux qui connaissent parfaitement les usages d'Angleterre. Mais on doit se représenter en général l'épouvante et l'affliction d'une jeune personne élevée dans l'abondance, qui tombe dans les mains des plus vils officiers de la justice, et qui se voit conduire au travers d'une foule de curieux, dans une misérable retraite, dont la peinture a quelque chose de plus révoltant que celle d'une véritable prison. (V, 501)

> (The circumstances [of Clarissa's jail] can only move those who are thoroughly acquainted with English customs. But in general one should imagine the terror and affliction of a young lady raised in wealth, who falls into the hands of the vilest officers of the law, and who sees herself being conducted through a crowd of curious onlookers into a wretched lodging whose description has something more revolting than that of a real prison.)

The first line of this interpolation negates the entire purpose of translation. For is not its purpose precisely that of bringing something new to the target culture? If translators were to give up their practice for lack of a cultural framework, then very few literary translations would ever be made. Prévost's metatext here, his commentary on the possibility of reading, has an entirely different purpose: the translator's art rests on his knowing something that his readers do not know, and here Prévost chooses to demonstrate his power over his readers. Again, the title *Lettres angloises* which Prévost gave to his effort points in the direction of the alien. But where literature is concerned, the importation of the alien into one's own system brings also the risk of altering that system.[13] Here Prévost fights back by eliminating ten pages of close description which he could never have written, substituting an emotional summary of his own masterpiece *Manon Lescaut*.

One characterization of Prévost's intervention would be the claim that he has restored *time* to Clarissa's situation. Verbs are notably absent from Belford's tableau; its effect upon the reader depends upon the static incongruity of an angel in Hell. On the other hand, verbs dominate Prévost's *précis* of Clarissa's story. Particularly poignant is the verb "tomber," which resonates with the pathos of a fall from grace. Georges Poulet calls these two opposing chronologies, the one given by Belford and its correction by Prévost, Lockean versus Prévostian time:

> Just as Lockean time consists in continually substituting one idea for another, in the same thought, so Prévostian time is constituted from the first by the perpetual substitution, in the same existence, of one adventure for another. This rhythm of pure successiveness is peculiar to the epoch, and Prévost accelerates it. . . . He multiplies episodes, precipitates the course of each, and hurries to finish one and begin another; as a consequence, hardly has the hero begun one adventure when he is seized and carried off to a dénouement, from which he escapes only to be hurled into the following episode. ("L'abbé Prévost," 149)

Belford's description is a single thought, expressed through a certain progression—in the order of his entrance into the house and his

13. The essays in *The Manipulation of Literature*, edited by Theo Hermans, specifically address the question of the effect of literary translation on target textual systems, and vice versa.

scanning of the room—of images and ideas. Prévost substitutes for this his own "rhythm of pure successiveness."

The spectacular—I use the word in its literal sense—opening passage of *Manon Lescaut*, where we see a young woman being conducted by officers of the law through a crowd, may be an example of the literary sensibility which has caused Prévost to move from space to time, from image to story. The narrator of this scene is the editor of des Grieux' adventures, the man of quality:

> Je fus surpris, en entrant dans ce bourg, d'y voir tous les habitants en alarme. Ils se précipitaient de leurs maisons, pour courir en foule à la porte d'une hôtellerie. . . . Je m'arrêtait un moment pour m'informer d'où venait le tumulte; mais je tirai peu d'éclaircissement d'une populace curieuse, qui ne faisait nulle attention à mes demandes, et qui s'avançait toujours vers l'hôtellerie, en se poussant avec beaucoup de confusion. . . . Parmi les douze filles qui étaient enchaînées six à six par le milieu du corps, il y en avait une dont l'air et la figure étaient si peu conformes à sa condition, qu'en tout autre état je l'eusse prise pour une personne du premier rang. (*Histoire*, 365)

> (I was surprised, on entering this little town, to see all the inhabitants in an uproar. They were rushing out of their houses and running in a crowd up to the door of a wretched inn. . . . I stopped a moment to find out the cause of the tumult; but I derived little enlightenment from the curious crowd, which paid no attention to my inquiries and kept jostling their way toward the inn in great confusion. . . . Among the twelve girls who were chained by sixes around the waist was one whose manner and face were so incongruous with her situation that in any other circumstances I would have taken her for a lady of the highest rank.) (Frame, 21–22)

Every key element—woman of noble appearance trapped in squalor, crowd ("foule de curieux"), officers, temporary lodgings—appears in both narrations. We note particularly how the last phrase, deceptive as it is (Manon is not of higher birth) has made its way into Prévost's interpolation in *Clarissa*. In the interpolation one can feel Prévost the author taking control, summarizing, finding the whole meaning of *Clarissa* in a scene which tells a story. That story is similar to what Prévost has already described so well in *Manon Lescaut*, but with a man as the "jeune personne" raised in wealth and now

fallen to the lowest degree and contending with the curse of a fa-
ther. Nevertheless, in this first scene it is Manon rather than Des
Grieux who appears to have fallen.

Clarissa is the story of a love repressed until death, *Manon* of a love
indulged in until death. The repression in *Clarissa* paradoxically
brings about a need for continuous discussion and the dissection of
each character's thoughts and language. The epistolary form was,
Richardson found, adequate to the task. *Manon*, on the other hand,
is the explosion of the repressed, as the hitherto virtuous des Grieux
is converted step by step to fornicator, card sharp, murderer, and, as
one might say from reading the last sentence of the work, uninten-
tional parricide: "J'ai appris . . . , la triste nouvelle de la mort de mon
père, à laquelle je tremble, avec trop de raison, que mes égarements
n'aient contribué" (*Histoire*, 440; "I learned . . . the sad news of my
father's death, to which I fear, with only too much reason, my wild-
ness may have contributed," Frame, 191). These symmetries between
the two works suggest that Prévost may have seen Richardson's novel
as a *Manon* gone wrong, as the possibility of an interesting narrative
botched by Richardson into a miasma of repetition and intertex-
tuality. *Manon* and *Clarissa* are "Zerrbilder" of each other; Prévost
saw his own deformed reflection in Richardson as though looking
into an angry pool of water. And it is precisely this image of Nar-
cissus contemplating his own image which Renato Poggioli has used
to describe the act of translation: "Like the original poet, the transla-
tor is a Narcissus who in this case chooses to contemplate his own
likeness not in the spring of nature but in the pool of art" ("The
Added Artificer," 139). And that, too, is what is meant by intertex-
tuality.

The German and French translations of *Clarissa* differ widely in
their handling of the original novel's intertextuality. Prévost's seizure
of the editorial apparatus, and his elimination of what from his point
of view were repetitive or redundant passages, along with his use of
the interpolations to project himself into the text as a third person
"narrator," deflect the dialectic unfolding of the novel into a more
linear trajectory. In addition, his handling of poetic quotation, as
well as his commentary in footnotes and interpolations, enlarge
rather than diminish the readers' notion of distance between Pré-
vost's text and the original. Prévost's translation thus resembles
Lovelace's transcription of Anna Howe's letter, in which he sprinkles
indices over the text to indicate those passages which infuriate him
(743–52). The indices force Belford and us to read the letter as al-
ready read, to layer whatever interpretations we may have over the
reading that Lovelace has already given the letter. We thus experi-

ence simultaneously the contents of the letter and Lovelace's reading
of those contents. I have adumbrated in this chapter the many ways
in which *Clarissa* presents itself reading itself. Similarly, in these
translations we are often confronted simultaneously with a trace of
the original text and with the violence done to that text by the trans-
lator.

Michaelis's violences are generally the changes of a reader,
changes which leave no trace upon the textual surface. The domes-
tication of the poetry found within the novel is a good example of
the quiet way in which Michaelis wreaks great changes. His method
thus resembles that of Clarissa in her meditations. Though the trans-
lations here fall into two camps, those of Clarissa and Lovelace, it is
important to remember that those very categories are unstable and
incorporate each other across the very gulf of their difference. That
difference, and the very possibility of producing meaning through
difference, is the subject of the next chapter.

3

Texts in Opposition

You have shew'd yourself so silly, and so wise; so young, and so old; so gentle, and so obstinate; so meek, and so violent; that never was there so mix'd a character.
> —Arabella to Clarissa (230)

Clarissa's transgression is not that she falls into the first or the second of sister Arabella's opposing categories, but that she belongs to both of them. Clarissa is a complex term, a union of opposites. She is a minor made independent by her grandfather's legacy, a daughter who claims the son's right to choose her spouse. These incompatibilities cause her isolation from and final rupture with her family, who try to recuperate her by marrying her to their creature Solmes, thus reclaiming her property and her volition at once. And Lovelace's rape places her in the most cruel combination of categories, an unmarried nonvirgin. Clarissa is killed by her incongruity with the prevailing social patterns, by her inability to conform. Richardson's banal morality is overshadowed by his riveting account of how incongruities such as Clarissa and Lovelace find life impossible in the society which produces such moral categories.[1]

If intertextuality depends upon the order and context of reading, opposition constructs a still and timeless architecture. If intertextuality leads to a Lovelacean instability, oppositions deliver an immobile Clarissean viewpoint from which to view and judge. This chapter will analyze Richardson's use of oppositional structures to

1. Christopher Hill's "Clarissa Harlowe and Her Times," to give but one example, has shown the victimization of both characters by society. It is impossible for either Clarissa or Lovelace to derive pleasure from marriage in a society which, as seen in the Solmes episode, has given to marriage all the tenderness of a corporate merger.

construct a moral work. It will discuss the various levels of opposition outlined by Terry Castle:

> On classicly structuralist grounds, a case can be made . . . that antithesis is the controlling semantic function in *Clarissa*—and the basic shape of the novel's structure of meaning. The interplay of paired terms throughout the fiction—"Black" and "White," "Art" and "Nature," "Angel" and "Woman," and so on—suggest as much, of course; but plot itself is generated out of fundamental oppositions. (*Clarissa's Ciphers*, 143)

The "classicly structuralist" ground that Castle invokes is the famous statement of the linguist Ferdinand de Saussure that "dans la langue il n'y a que des différences *sans termes positifs*" (*Cours de linguistique*, 166; "in language there are only differences *without positive terms*," Baskin, 120). Structuralism then applied this linguistic and digital logical model to virtually all systems of signification, from architecture to dance. If the new directions structuralism gave to reading have any validity, then critics of translation cannot confine themselves to the assessment of individual phrases or idioms. If structuralism is right, then in order to transfer textual meaning, translation must capture or find an equivalent not (just) for words or sentences, but also for the work's structure of oppositions. This chapter will demonstrate how Richardson constructs morality out of oppositions between characters, between scenes, and between important words of this novel. It will then see whether those constructions have survived translation into French and German.

Four Writers

The single most important oppositional structure in *Clarissa* is the relationship between the four main correspondents. The overwhelming majority of sentences in the novel come from the pens of just four of its characters: Clarissa, Anna Howe, Belford, and Lovelace. The differences in temperament and circumstance among these correspondents help to generate the novel's extraordinary volume, to define its conceptual limits, and to provide the force fields that serve to conduct the reader through its maze of rhetoric. *Clarissa* shows us not a cloistered writer, but a set of relationships between writers. It thus fulfills A. J. Greimas's own definition of the

principle of opposition: "La signification présuppose l'existence de la relation: c'est l'apparition de la relation entre les termes qui est la condition nécessaire de la signification" (*Sémantique structurale*, 19; "meaning requires relationship: the appearance of a relation between two terms is the necessary condition for signification"). Greimas has used the so-called "semiotic rectangle" to explain these relations.[2] A number of relations in *Clarissa* can also be arranged in rectangles, beginning with those between the four main writers.

The opposite natures of Clarissa and Lovelace have of course been noticed by countless readers, and indeed this study opened with the remark that the two figures can be read as allegories of contrasting theories of truth, reading, and interpretation. One critic formulates the opposition between Clarissa and Lovelace dialectically: "Wholly dedicated to the care and maintenance of their separate identities, therefore inevitably dependent on other people in whom their selves are reflected or reified by contrast, [Lovelace and Clarissa] are opposing principles: ultimate self-assertion for each of them involves denial of the other" (Brownstein, "An Exemplar," 39). Leo Braudy also notes this dialectic in his analysis of the novel: "Using Lovelace to define herself (as he uses her), Clarissa believes that she is a totally interior being, while he is totally exterior" ("Penetration and Impenetrability," 192). Lovelace and Clarissa can live neither with nor apart from each other. They are the contrasting terms of an opposition, each side dependent for its existence upon the other term which it negates, neither side having meaning without the other. Yet there is a complication, for the relation between Lovelace and Clarissa is available to us only through that phenomenon to which Janet Altman has given the name "epistolary mediation" (*Epistolarity*, 13–46). Their close physical proximity and their great moral and psychological distance allow Lovelace and Clarissa to exchange only six letters within this huge novel; and an exchange between them nearly always presages a break in their relationship, for example when they correspond following the fire scene and preceding Clarissa's escape to Hampstead, or when Lovelace sends his unanswered proposals to Clarissa while she is in jail. Anna Howe and Clarissa, on the other

2. The idea behind the rectangle is presented in A. J. Greimas's *Sémantique structurale*. See also Greimas and François Rastier, "The Interaction of Semiotic Constraints," and the entry for "carré sémiotique" in Greimas and Joseph Courtés, *Sémiotique: Dictionnaire raisonné de la théorie du langage*. The rectangle serves as a convenient way to diagram the relationships between elements of this novel, but it is certainly not the only way. An analogous adaptation of Greimas is made by Fredric Jameson in *The Political Unconscious*, especially in the chapters "Realism and Desire," 151–84; and "Romance and Reification," 206–80.

hand, who see each other only once during the course of the novel, form one of its main axes of communication. The other axis is Belford-Lovelace. These exchanges constitute two friendships which also stand in opposition, for the women's friendship is characterized as virtuous, the men's as wicked.

The opposition virtuous/wicked is articulated by Clarissa to Belford during one of their early meetings at Mrs. Smith's. Belford reports her remarks:

> On that passage where you say, *I had always been her friend and advocate*, This was her unanswerable remark: "I find, Sir, by this expression, that he had always designs against me; and that you all along knew that he had: Would to Heaven, you had had the goodness to have contrived some way, that might not have endangered your own safety, to give me notice of his baseness, since you approved not of it! But you gentlemen, I suppose, had rather see an innocent fellow-creature ruined, than be thought capable of an action, which, however generous, might be likely to loosen the bands of a wicked friendship!" (1078)

On the next page, Clarissa makes the opposition between the two friendships explicit: "Permit me to wish, Mr. Belford, that you were capable of relishing the pleasures that arise to a benevolent mind from VIRTUOUS friendship!—None *other* is worthy of the sacred name" (1078). Thus we see that in the moral realm these two axes of communication stand in opposition to each other. This opposition is important for the novel's didactic element, but still does not explain its generative structure.

The most important oppositions, those which compel the characters to write to each other, are found *within* each axis. What is the relation between Clarissa and Anna Howe, and between Lovelace and Belford? Both axes are maintained by the principle of exchange, and it must strike any reader that the exchange of letters is unequal. Belford and Howe play supporting roles to the more central ones of Lovelace and Clarissa. This observation is confirmed by the number of letters each character writes: Belford 68, Lovelace 165, Howe 54, Harlowe 134.[3] Anna Howe defines her own role in the epistolary exchange in the first letter of the novel when she en-

3. These and subsequent letter-counts are from François Jost, "Prévost traducteur," 298. The counts are slightly inaccurate because they are based only on the numbered letters in the novel and do not include inserts.

courages Clarissa to write: "Write me therefore, my dear, the whole of your story" (40), a command which is repeated again when Clarissa is captured by Lovelace:

> Pray inform me of everything that passes between you and him. My cares for you (however needless, from your own prudence) make me wish you to continue to be very minute. If anything occur, that you would tell me of, if present, fail not to put it down in writing, altho', from your natural diffidence, it should not appear to you altogether so worthy of your pen, or of my knowing. A stander-by may see more of the game than one that plays. (407)

Anna Howe in these passages expresses an opposition which may be useful: player versus spectator, or better player versus coach. Clarissa also desires Anna Howe's correspondence, but not for its narrative value. She feels the need for a coach, for someone who can read her thoughts and criticize her actions. Anna's function is primarily to read and criticize, Clarissa's to provide texts for Anna's eager exegeses. This opposition between theory and praxis has been articulated by Ramona Denton in her analysis of Howe: "[Richardson] dramatizes in Clarissa's plight the very dangers of which Anna is aware. Ironically, Anna can function safely in this world, while Richardson's heroine must be translated to the next" ("Anna Howe," 53). Thus the opposition writer versus reader could also delineate the relationship between the two friends. But the *semes* which ground all these oppositions are "active" versus "passive."[4] It is Clarissa who goes out into the world, while Anna stays at home. It is Clarissa who must make decisions, which Anna then takes the liberty of criticizing. Activity underlines all of Clarissa's positions as actor, player, and writer. Anna is the director, the coach, the critic.

The opposition between active and passive is even more apparent in the relationship between Lovelace and Belford. Lovelace sees himself as the leader of a group of rakes and the originator of all their schemes. Lovelace is of course the prime mover in the plot of the novel; even the Harlowe family are mere puppets dancing upon his wires. He is the leader in the epistolary exchange as well, although Belford is an equal partner once he becomes Clarissa's

4. Greimas defines the "sème" (*Sémantique structurale*, 22) as a unit of meaning which allows a word to stand in a relation of opposition to other words. The semes "masculine" and "young" inhabit the word "boy," opposing it to "girl" and "man," respectively.

friend. Lovelace pours his innermost secrets into his letters to Belford, revealing more of the rape and the insidious plotting behind it than is prudent. Whereas Clarissa seems to prize Anna Howe as a critic, Lovelace uses Belford as a mere receptacle for his correspondence while studiously ignoring his advice.

That advice is deliberate, consistent, and monotonous: do not harm Clarissa. The advice of Anna Howe, on the other hand, is a mass of contradictions. She advises Clarissa to marry Lovelace, while at the same time railing against the institution of marriage, against men in general, and against Lovelace in particular. Anna also lashes out against both her own mother and the Harlowes. She is, as has been pointed out, a representative of feminist sentiment, which a patriarchal society views as a disturbance in the social order.[5] Clarissa shares some of Anna Howe's sentiments, but rarely expresses them in the enraged tone of her friend. For her calamity she blames no one but herself, and she always urges Anna Howe to be deferential to parental authority and to her future husband, Mr. Hickman. Clarissa, then, in her correspondence is a model of conformity, at one point articulating a desire to eliminate her own personality by merging it into a network of social conventions and moral precepts with which it conflicts. At one point even the pronoun "I" causes her to halt and blame herself for egoism: "*I*, my *best self*, have not escaped. . . . What a tale have I to unfold! But still upon Self, this vile, this hated Self!" (974). The English "this" is ambiguous; Clarissa is railing against both "herself" and against "the Self" as a concept. Michaelis has translated the passage as a general diatribe against "das Selbst" (and not against "mich selbst"): "Was habe ich zu erzählen! Aber das kommt ja noch immer auf das **Selbst**, auf das schändliche, das verhaßte **Selbst** hinaus!" (VI, 16). Prévost, on the other hand, has made the individual, the person of Clarissa, the focal point of her remarks: "Quel horrible récit ai-je à vous faire! Mais je retombe encore sur moi: sur moi qui ne me dois plus que de la haine et du mépris?" (V, 415). Here Clarissa is not cursing the principle of self, but rather her own sad person and personal history. The difference in these translations is between philosophy and psychology, between a book wishing to contemplate ideas and one wishing to delineate character. Clarissa embodies social norms and sup-

5. Some feminist literature entitled the "Sophia Pamphlets" appeared just as Richardson was beginning *Clarissa*, and Richardson may have incorporated ideas and material from those pamphlets into the diatribes of Anna Howe (cf. Mattern, "Samuel Richardson and Feminism").

presses personal desire in German more than in French; in German she remains a "conformist."[6]

Anna Howe, in contrast, is always ready to defend (at least on paper) the prerogatives of self against the encroachments of society. She advises Clarissa to take steps which she herself would not take. She rails against marriage, against surrendering herself to the will of another, but in the end she marries her suitor, while Clarissa dies rather than marry hers. The paradoxical relationship between Anna's desires and Clarissa's practice has been described by Terry Eagleton in psychoanalytic terms: "Caustic, humorous and debunking, unswerving in sisterly solidarity yet astringently critical, Anna is part of Clarissa's own unconscious, able to articulate that which it would be improper for the heroine herself to voice" (*The Rape*, 78). The term "unconscious," inasmuch as it describes the private, interior self, is alien to Richardson's world, where even that self is suspended in a grid of public conventions. But the metaphor of Clarissa as the conscious and Anna as the unconscious is attractive precisely because it brings out the same semes with which we have been concerned: the conscious is active, it engages the outside world and makes effective decisions, while the unconscious is passive and ineffectual. It can desire, but not fulfill its desires. The conscious, however, formed by social rules, is by nature conformist. The unconscious is supremely nonconformist, knowing neither decency nor logic—hence the contradictions in Anna's advice.

Taking these two sets of oppositions, then, active/passive and conformist/nonconformist, and starting from the truism that a passive nature should be conformist, we see that both women embody contradictions, tensed between the levels of words and of action: it is Clarissa the conformist who defies social convention, both in her flight from home and in her escape from the world into death. It is Anna Howe the virago who never ventures from her home without her mother, and who ends up married to Hickman. The contradictions within the characters of the two women, and the opposite situations which these contradictions lead to, help generate and sustain the correspondence between them over *Clarissa*'s many pages. Within Greimas's rectangle, then, Clarissa represents the complex term or unity of contradictions, while Anna is the neutral (see diagram).

6. The term "conformist" had particular resonance in Richardson's time. Specifically, the Anglican Church in 1661 had passed the Uniformity Act, and all those who did not follow its exact rules and regulations were said to be "non-conformist."

Clarissa

Active *Conformist*

Non-Conformist *Passive*

Anna Howe

The same set of four semes can be used to describe the Belford/
Lovelace friendship. One can see even more clearly here the strug-
gle of a deliberate, rational writing embodying the standard moral
precepts of society against a confused, fluid, often dreamlike style
full of antisocial outbursts. If Anna is Clarissa's unconscious, Belford
is Lovelace's conscience. Belford is at once the most sententious and
the least active of the major characters. His role in the novel is best
defined by two words: confidant and executor. In the first role Bel-
ford reads and hears and reports to others, in the second he trans-
lates Clarissa's written words into action. Language never originates
with Belford, but is always reported. His passive conformity is re-
warded by marriage to Lovelace's cousin Charlotte Montague at the
end of the novel.

Belford's status as Lovelace's conscience is readily apparent, and in
fact motivates much of his narration of events such as the death of
Belton and Clarissa's imprisonment. Belford himself indicates his
desire to persuade Lovelace with his writing. As he tells Lovelace, "I
will leave this matter upon thy own conscience, to paint thee such a
Scene from my memoranda, as thou perhaps wilt be moved by more
effectually than by any other" (1224). If Lovelace had a working
conscience of his own, no such painting would be necessary. And
Belford does paint. When writing of Clarissa's false imprisonment
for debt, he gives a lengthy description of her wretched surround-
ings, pausing every few paragraphs to let the lesson sink in:

> Only, Lovelace, remember, *All this was to a Clarissa!!!* (1052)
>
> *What thinkest thou, Lovelace, of this!—This wretch's triumph was
> over a Clarissa!*
>
> *The divine Clarissa, Lovelace—reduced to rejoice for a cup of cold
> water! By whom reduced!* (1054)
>
> *Pause here a moment, Lovelace!—and reflect—I must.* (1055)
>
> *And This, thou horrid Lovelace, was the bedchamber of the divine
> Clarissa!!!* (1065)

Yet so hardened a wretch art thou, that I question whether thou wilt shed a tear at my relation. (1067)

Notions of conscience such as these are found only in Belford's writing, never in Lovelace's. Were the reader not to accept Belford's role as Lovelace's superego, the former's character would strike him as unsympathetic and hypocritical, since, as pointed out earlier, an active character would have prevented Clarissa's rape.

Lovelace's nonconformity to social values is fully matched by a capacity to wreak the havoc he dreams of. His fantasies nearly always involve some form of social chaos: violence against persons (e.g., Clarissa's rape, the duel with Clarissa's brother James, a rape scheme against Anna Howe and family, and threats against Solmes); a breaking of moral conventions (he dreams of being a patriarch of the Bible with many wives and concubines); or an upset of political order (as in his scheme for annual marriages and annual parliaments). Though Lovelace's fantasies are always greater than his capacity to fulfill them, the violence that he does engage in certainly surpasses that of any other character.

The schematization of the relationships among these four characters is based on the assumption that mere conformity is unlikely in a novel. That is, some sort of transgression of societal rules by the main character is usually necessary to motivate the action of a novel (though of course there are antinovels, such as *Tristram Shandy*, in which lack of action is the structural principle). *Clarissa*, like so many other novels, is essentially an agon between individual and society, and a record of a series of infractions against the rules of society committed by Clarissa's family, by Clarissa herself, and by Lovelace. Belford and Anna Howe confine their infractions to the realm of thought—to wishes, in the case of Anna, and to memory, in the case of Belford. Starting with the opposition conformist/active, then, the rectangle appears as in the diagram.

Clarissa

Active *Conformist*

Lovelace Belford

Non-conformist *Passive*

Anna Howe

The bottom and top positions indicate contradictions within characters, while terms in the side positions imply each other and hence reside more easily within a single personality.

The oppositions between these characters act as a kind of spring to keep the novel going over its tremendous length. Were all the characters on one plane, the exchanges between them would be dull indeed. The active characters, Clarissa and Lovelace, write approximately two and one-half times as many letters as their passive counterparts. The French translation rearranges the ratios between letter-writers: in the French Lovelace writes nearly four times as many letters as Belford, while Clarissa continues to write two and a half times as many letters as Anna Howe. Lovelace's share of the number of letters in the novel rises from around 30 percent in the English (165 of 537) to 35 percent in the French (128 of 371). Clarissa's share rises from 25 percent to 31 percent (115 of 371). Thus the two main characters, who in the original write just over half the letters, now write almost exactly two thirds. Prévost notices the opposition between Lovelace and Clarissa, the romantic interest which fuels the reader's curiosity, and not the double opposition which generates epistolary voltage. He therefore turns the novel into a war between two discourse systems: Lovelace's versus Clarissa's. In trying to trim the story to its romantic essentials, Prévost is losing the very balance between correspondents which causes them to keep writing. The rectangular structure of correspondence degenerates to a mere pair of voices: Clarissa versus Lovelace.

In the French, Belford and Anna Howe exchange their relative positions of prominence, Belford's share of the letters shrinking from 13 percent to 9 percent, and Anna Howe's rising from 10 percent to 13 percent. It is not hard to see why this switch has occurred. Anna Howe writes most of her letters in the first three volumes, before Clarissa has been abducted and when the suspense of the novel is still high. She is also a more contradictory and less straightforward character than Belford, who writes most of his letters after the rape has occurred and the story (if not the novel) is over. Anna Howe also has a romantic interest, as is mentioned in many of her letters to and from Clarissa, whereas Belford's marriage to Charlotte Montague is merely tacked onto the conclusion of the novel. In choosing Howe over Belford, Prévost was preferring the secondary marriage plot embedded in the Howe letters to the didactic elements, which all fall to Belford's pen. Those didactic elements have their own logical arrangement, which Prévost also skews, as we shall see. There is, for example, the didacticism of death.

Four Deaths

Clarissa is a rich tapestry of death. Several deaths are mentioned (those of Clarissa's parents, of her brother, of "Captain Tomlinson"), but those of Clarissa, Lovelace, Belton, and Sinclair are presented to the reader in gruesome detail. The long and detailed description of each of these deaths precludes the possibility that any of them could be a mere excrescence of plot. Here death is not a plot device; rather, plot serves as an excuse for the observation and description of death. Furthermore, in the first edition the four exemplary deaths took up nearly the whole of the seventh volume. Their close proximity to each other increased their impact upon the reader, who was virtually compelled to compare and contrast them. Margaret Doody has thoroughly documented the seventeenth- and eighteenth-century literature on death and dying from which Richardson drew his material. His descriptions of death, clearly intended as exempla to the living, are drawn from such books of piety as Taylor's *Holy Dying* and the anonymous *Second Spira*.[7] But if Richardson thought that death could teach his readers something, why would not one death suffice? How does the series of four work to create a message above and beyond what any single death could do?

The unfortunate traveler and passive reporter Belford is forced to witness three of the four important deaths in the novel. Only in this way was Richardson able to bring those three deaths into opposition with each other, in the thoughts of someone who has lately seen too much of mortality: "I see in Miss Harlowe, how all human excellence, and in poor Belton, how all inhuman libertinism, and am near seeing in this abandon'd woman [Sinclair] how all diabolical profligateness, end" (1393–94). Belford invokes here the topos of "memento mori," the concept that all human existence ends in death. Yet Richardson's purpose, hinted at in Belford's description of the dead and developed fully in the death scenes themselves, is to contradict this topos. In fact, the deaths of Belton, Clarissa, Sinclair, and Lovelace are as different as their lives.

In translating Belford, Michaelis has recognized and even highlighted the comparable aspects of the three characters by using the same substantive ending ("-keit") for each quality:

7. See Doody, "Holy and Unholy Dying: The Deathbed Theme in *Clarissa*," in her *A Natural Passion*, 151–87. I am indebted to Doody for many points of my analysis, which is intended to answer the question of why so many exempla are needed and to trace the effects of translation on the didactic content of the novel.

> Ich sehe an der Fräulein Harlowe, wie alle menschliche Vor-
> trefflichkeit; an dem armen Belton, wie alle unmenschliche
> Liederlichkeit; und nun bald an diesem verruckten Weibe,
> wie alle teuflische Ruchlosigkeit sich endige. (VII, 562)

Michaelis has captured the rhythm of comparison which he found in the original: "menschliche Vortrefflichkeit" ("human excellence") and "*un*menschliche Liederlichkeit" ("inhuman lasciviousness") stand in opposition, whereas teuflische Ruchlosigkeit ("diabolical profligacy") is opposed to both in that it transcends the human realm altogether. Michaelis's care with the structure of opposition here continues in his preservation of each individual death scene.

Prévost, on the other hand, decided that there was nothing in the series that could excuse its morbidity, and excised not only the quote from Belford, but also the deaths of Belton and Sinclair. Prévost's reasoning can be scrutinized in his translation of another quote from Belford. Witnessing Belton's death, Belford is motivated to write to Lovelace: "If Miss HARLOWE'S glorious *Example*, on the one hand, and the *terrors of This* poor man's on the other, affect me not, I must be abandoned to perdition; as I fear thou wilt be, if thou benefittest not thyself from both" (1228). The "terrors" Belford invokes are experienced not by Belton, but by the witnesses and readers of his death. Not one, but two exempla are necessary to drive the lesson home. The transformation of these individual deaths into opposing exempla, attractive and unattractive—"Beispiel" and "Schrecken" as Michaelis translates them, the first term inviting imitation and the last repugnance—gives them the power to influence the actions of others. Death is no more private in this novel than are the other two preoccupations—sex and writing—which recur over its entire length.

Prévost is apparently interested in neither the opposition nor the warning: "Si le glorieux exemple de miss Harlowe & les terreurs de ce malheureux ami n'avoient pas la force de me toucher, je me croirois aussi abandonné que je crains que tu ne le sois" (VI, 209). Here Belford makes no attempt to draw Lovelace back from the brink, nor does he exhibit belief in death's didactic power. Death impresses but does not educate (in the word's etymological sense of "to lead out [of sin]"). Indeed, in *Manon Lescaut* Prévost uses death as Richardson does not use it, as a plot device. *Manon* is as full of death as *Clarissa*, though there the dying never stink or scream. We have already seen the narrator restrainedly mention the death of his father. But what about the most significant death in *Manon*, that of the heroine? Manon follows her lover out into the wilderness and

dies of cold and hunger. Des Grieux buries her there, grieves, learns nothing, and communicates nothing afterwards. He describes only his refusal to describe:

> N'exigez point de moi que je vous décrive mes sentiments, ni que je vous rapporte ses dernières expressions. Je la perdis; je reçus d'elle des marques d'amour, au moment même qu'elle expirait. C'est tout ce que j'ai la force de vous apprendre de ce fatal et déplorable événement.
>
> Mon âme ne suivit pas la sienne. Le Ciel ne me trouva point, sans doute, assez rigoureusement puni. Il a voulu que j'aie traîné depuis une vie languissante et misérable. (439)

> (Do not ask me to describe my feelings or report her last words. I lost her; I received tokens of love from her even at the moment she was dying; that is all I have the strength to tell you of that fatal and deplorable event.
>
> My soul did not follow hers. No doubt Heaven did not consider me punished rigorously enough. It willed that I should since drag out a listless and miserable life.) (Frame, 187–88)

Des Grieux eschews a complete description of Manon's death. Her death has only a circumstantial relation to her life, not the moral relation which Richardson emphasizes in his depictions. Des Grieux and not Manon is punished with her death—here as everywhere she is but a figure of his desire. Like Hogarth's Rake, who has been ruined by a roll of the dice, des Grieux points vaguely to the heavens, that is, not to himself nor to God nor to any religious feeling, but rather to destiny. Naomi Segal has pointed out that Des Grieux never uses the simple word "Dieu" in its primary meaning; the word is used only by his squarely moral friend Tiberge: "The equivalents most frequently used by [des Grieux] are 'Ciel' (twenty-seven times), 'fortune' (twenty times . . .), and 'sort' (eleven times); in their places we find the synonymous 'destinée,' 'destin,' 'ascendant,' 'Nature,' 'fatalité,' 'génie. . . .' What all this evidence suggests is a strong awareness of extrapersonal forces, which, however, change their face . . . easily" (*The Unintended Reader*, 194–95). All the above words are transformations of the single word "passion," for destiny itself in Prévost is merely the return of desires which one has repressed and alienated, only to encounter them again as extrapersonal forces which rule the world. Destiny results from that overpowering love which encroaches upon and eventually replaces religious vocabulary in Prévost's text.

Fate in Prévost, "la fortune" as both the lover and the gambler

know it, thus precludes in its myriad and whirling vocabulary any rigid schematizing of patterns of death such as we find in Richardson. In unleashing the passion that lies dormant in *Clarissa*, it was inevitable that Prévost also oppose and smash Richardson's religious machinery. Richardson's long descriptions of death were contrary not only to Prévost's literary aesthetic, but to his very cosmology. In viewing the whole of Prévost's work, Richard Smernoff concludes that "like Pierre Bayle, Prévost the defrocked priest walked along a path of skepticism, unprepared to state that man could be held responsible for sin if God is all-perfect. Ultimately he submitted that human reason is incapable of understanding the relationship between God and man, that the human mind cannot fathom the problem of evil" (*Abbé Prévost*, 79). If man is not responsible for sin, then he also is not responsible for the manner of his death. Thus the disjunction between Manon's life of unfaithfulness and her death of fidelity.

Manon's death is mercifully short; Clarissa's takes up the last quarter of the novel. This extraordinary length is due not to descriptions of her agonies, but to the ideological components of her dying. The literature which Richardson used as a basis for his scenes had arisen in order to quell a basic contradiction in the Christian view of death: death had always been a fearful event, one to be dreaded and fought against; yet for the Christian death was not to be feared, because it was the beginning of a newer, closer relationship with God. This closer relationship could only be achieved, however, if the dying person were in a proper condition. In Richardson's world "repentance," which could be produced only by the paradoxically simultaneous fear and love of God, eliminated the fear of death. Clarissa's death, preceded by a well-planned and early repentance, is the model of a good death, as Sinclair's is the epitome of a bad one.

Clarissa's repentance is of course more noticeable to the reader precisely because she is the only major character in the novel who seems to have no need for it. We have seen how Clarissa equates her father with God (see above, 37–38). Her repentance, requested in a letter to her father, simultaneously invokes both male figures:

> With exulting confidence now does your emboldened daughter come into your awful presence by these lines. . . .
>
> Still on her knees, let your poor penitent implore your forgiveness of all her faults and follies, more especially of that fatal error which threw her out of your protection. . . .
>
> I have the strongest assurances, that the Almighty has accepted my unfeigned repentance. (1371)

Both God and father reveal their "awful presence" through absence and writing. Repentence will allow Clarissa to enjoy a blessed death, with hope for a journey to her Father's house. Such a death is without fear. Within the theological scheme presented by the novel, repentance and fear are mutually exclusive, or alternatively, repentance implies hope. Thus the isolation of death's most important seme, "repentance," along with the implied seme of "hope," allow us to construct the semiotic system which gives death its meanings in this novel (see diagram).

Repentance *Despair (Fear, Terror)*

Hope (Calm) *Defiance*

In Prévost's *Manon* the word "repentir" appears only in the context of passion. We see this relationship in a passage that follows, after des Grieux has reproached Manon violently for her unfaithfulness and then confessed that he cannot live without her. To appreciate the contrast with Richardson's practice, one should imagine des Grieux on his deathbed addressing a female God:

> En réfléchissant sur l'état de mon sort, toute-puissante Manon! vous qui faites à votre gré mes joies et mes douleurs! après vous avoir satisfait par mes humiliations et par les marques de mon repentir, ne me sera-t-il point permis de vous parler de ma tristesse et de mes peines? Apprendrai-je de vous ce qu'il faut que je devienne aujourd'hui, et si c'est sans retour que vous allez signer ma mort, en passant la nuit avec mon rival? (*Histoire*, 417)

> (All-powerful Manon, you who create my joys and my sorrows as you wish, after satisfying you by my humiliations and the signs of my repentance, shall I not be allowed to tell you of my sadness and my griefs? Am I to learn from you what is to become of me today, and whether it is past recall that you are going to sign my death sentence by spending the night with my rival?) (Frame, 140)

Except for its final clause, every bit of this speech could be reinserted into the religious discourse without which it would be unthinkable. Des Grieux's repentance is rewarded not with death, as in Richardson, but with life. Des Grieux hopes that in repenting he will regain his life, which is defined by him as the continuation of his passion undampened by jealousy. He repents so that his life may be

spared by his "all-powerful" lover Manon. The above passage is cited by Mirjam Josephson as the prime example of a process which takes place throughout Prévost's work. In a chapter entitled "Die neue Religion" ("The New Religion") of her *Die Romane des Abbé Prévost als Spiegel des 18. Jahrhunderts,* she posits that "das geliebte Wesen [wird] zu dem, was früher Gott war: zu dem absoluten Bezugspunkt des Daseins" (51; "The loved one [becomes] what God used to be: the absolute center of existence"). She documents a number of similar passages in Prévost which use religious terminology in contexts of secular passion. And indeed, the blasphemy of this movement is not lost on des Grieux, as he is fascinated by his own diction:

> "Elle me répondit des choses si touchantes sur son repentir, et elle s'engagea à la fidélité par tant de protestations et de serments, qu'elle m'attendrit à un degré inexprimable. Chère Manon! lui dis-je, avec un mélange profane d'expressions amoureuses et théologiques." (*Histoire,* 378)

> (She told me in reply such touching things about her repentance, and pledged herself to fidelity by so many vows and protestations, that she softened me to an inexpressible degree. "Dear Manon!" I said to her in a profane mixture of amorous and theological expressions.) (Frame, 52)

Such supplanting of religious by amorous discourse makes death in *Manon Lescaut* of an entirely different order than death in Richardson. As Des Grieux points out, language itself is of an entirely different order, an order in which the opposition between the religious and the secular is undermined.

We have seen that Clarissa's death exemplifies repentance, and that this spiritual condition brings her hope and calm in her last hours. She is positioned on the left-hand axis of the rectangle, one of the "axes of implication." The opposite axis is, appropriately, occupied by another woman, Madame Sinclair. Sinclair's spiritual odyssey, as implied in her name ("sine" + "clarus" = "without light"), moves in a direction diametrically opposed to Clarissa's. She is, to quote Belford, "abandoned," without the hope of receiving grace. If Clarissa dies without fear because of her repentance, Sinclair is unable to repent. "No time for my affairs! No time to repent!" (1389) she wails. Yet this idea is contradicted by the protraction of her agony, which carries on for days. Sinclair cannot repent not because she lacks time, but because she is so afraid of death. She is "readier to take despair from [her] own fears, than comfort," (1390) as Belford puts it. When he suggests that she call a minister, she screams and shouts at him, not wishing to admit that she is near death.

Though Belford sees his other friends through to their ends, he is forced to leave Sinclair because of her defiance, because of her refusal to accept her approaching demise, and because of the fetid atmosphere in the room, a symbol of the Hell to which she is consigned. Her death is reported instead by the "editor," who notes that it shocked the witnesses—mainly Sinclair's whores—into a "transitory penitence" (1394). The complete absence of sympathy and grace from Sinclair's exit reinforce its diametric opposition to the death of Clarissa.

Like Belford, Prévost is overwhelmed by the horrors of this scene; like Belford, he relieves his anxiety by blocking it from perception, in fact by cutting it entirely, citing differences in taste as the reason for his action. Years later, Pierre de la Tourneur will have a similar view of the terrible physical discomfort which the scene provokes; only his objective is to reinstate it:

> Ne craignez pas que l'on remporte de cette description aucun goût, aucun attrait pour le vice & la débauche. On sort de la chambre de la Sinclair avec le même sentiment qu'exprime Belford: on sent le plaisir & la douceur d'être vertueux, comme Belford sentit avec transport l'avantage de respirer un air frais au sortir de ce séjour de contagion physique & morale. (VIII, 37)

> (One need not fear that this description could give one the least taste, the least attraction for vice and debauchery. One leaves Sinclair's room with the same feeling expressed by Belford: one feels the pleasure and sweetness of being virtuous, just as Belford profoundly felt the advantage of breathing fresh air in leaving this scene of physical and moral contagion.)

Tourneur thus confirms that a translation based upon the pleasure of the text could never include this scene. Tourneur identifies another allegory of reading in this novel: the purpose of reading long-winded Richardson is to obtain the pleasure of stopping and catching one's breath, as Belford does when he leaves Sinclair's deathroom.

Lady Bradshaigh, clearly a Clarissean (and anglophile) reader, notes in a letter to Richardson both the lack of pleasure in these scenes and the loss when they are omitted from the French translation:

> The death of Belton is one of the finest descriptions, and one of the most useful, though shocking, pictures, that can be exhibited, in my poor opinion. . . . He [Prévost] has found out

that moral instructions, warning, etc., were principally in your thoughts; yet thinks that you should have preferred your story to everything; spoke like a Frenchman, all shew and parade. The exemplary, the useful, the solid, are too weighty for a Frenchman's brain. (Barbauld, *Correspondence*, VI, 233)

In the original, Belton's death opposes that of Lovelace. Belton's death is oversignificant, Lovelace's signifies nothing. The possibility of combining repentance with despair is provided in Belton's case by the special category of late repentance. The repentance of the former rake, companion to many of Lovelace's worst follies, is in Belford's opinion real and probably effective: "We are told, that God desires not the death, the *spiritual* death, of a sinner: And 'tis certain, that thou didst deeply repent!" (1243). But Belton, visited in the manner of such Shakespearian villains as Richard III and Brutus by ghosts of the people he has wronged, is still afraid. His own knowledge that his repentance comes not from deep religious principles, but merely from the fear of death, prohibits him from enjoying any relief from that fear. Whereas Clarissa's repentance caused her lack of fear, and Sinclair's fear prevented her repentance, Belton's fear causes his repentance. The fact that others have wronged Belton (his mistress Tomasine has betrayed him and usurped his estate, while fellow-rake Mowbray continually chides him for his fears of the hereafter), plus his penitent attitude, allow the reader to sympathize with his anguish. The reader, who can be certain of the opposing afterlives of Clarissa and Sinclair, can only speculate on the fate of Belton's soul after his death. This ambiguity will be repeated in the description of Lovelace's death. By eliminating both Sinclair and Belton, Prévost rearranges the rectangle, making Lovelace's death the diametric opposite to Clarissa's. In doing so he relieves all the deaths of their exemplary status and returns them to plot.

In contrast to the beatitude of Clarissa's death and the torture of Belton's and Sinclair's, the death of Lovelace seems strangely quiet and enigmatic. Motivated by an unconscious liking for his villain or by the artistic principle of surprise and variation, Richardson makes this death different from all the others. Everything is singular about it. Not only is it not narrated by Belford, it is in fact reported by a character making his first and only appearance in the novel, Lovelace's hired valet de la Tour. His relation of Lovelace's fatal duel with Morden is said to have been "translated from the French." This letter is the only one in the novel which labels itself a translation. Perhaps Richardson had been told the tricky meanings of the French word "tour"—signifying, among other things, "tower," "tour," and "trick" as a specialized meaning of "way of saying or

doing something"—and had chosen the reporter's name and the original language of his words so as to signal the ambiguity of the event reported. Richardson could have had de la Tour write in broken English, and there was no need to point to the fact that the letter was translated by labeling it as such in its heading, or by allowing a certain amount of unmotivated transposition in keeping the French words "voiture," "Monsieur," and "Chevalier." These constant reminders of the letter's translated state, like Prévost's own editorial comments, serve to outline the existence of a hidden text, the "original" of de la Tour's letter, a text in opposition to this present one, a text which may reveal rather than hide the "truth" of Lovelace's death. Prévost's translation is forced into the infidelity of keeping those French words, as the whole pretense of translation becomes paradoxical. Transposed into French, de la Tour's name, like that of Morden, is both more revealing and less tricky than in the original context. Michaelis, the academic, removes every trace of an oppositional text: "voiture" becomes "Wagen," "Chevalier" is now "Ritter," "Monsieur" is "Mein Herr." Both translators, by moving in completely opposite directions, remove those signs which were necessary in order to show that this final death, which will stand in opposition to all the others, itself derives from the oppositional system of a foreign language and a "strange genius."

As trickster, foreigner, and translated author, de la Tour possesses the same neutrality, presented here as ambiguity, as Lovelace's death. Indeed, it would appear that Richardson himself cannot see behind this author's prose to what "really" happened. In a letter to Edward Moore, written after the publication of *Clarissa*'s first edition, Richardson questions but does not interpret Lovelace's ultimate composure: "The *Ultimate Composure* mentioned by de la Tour, [is] rather mentioned to comfort [Lovelace's] surviving Friends than to have reason to suppose it to be so, from his subsequent description of his last agonies" (Carroll, *Selected Letters*, 122). Richardson notes the combination of opposites in de la Tour's description, but does not resolve it. He makes the whole even more tricky by reminding us that de la Tour wrote his letter with a specific audience and goal in mind.

De la Tour describes Lovelace's death in a few paragraphs—about the length Prévost reserved for Manon—and does not place it into any grand theological scheme. His narrative is cold, objective, and ultimately unrevealing:

> Contrary to all expectation, he lived over the night: But suffered much, as well from his impatience and disappointment, as from his wounds; for he seemed very unwilling to die.

He was delirious, at times, in the two last hours; and then several times cried out, Take her away! Take her away! but named nobody. And sometimes praised some Lady (that Clarissa, I suppose, whom he had called upon when he received his death's wound) calling her, Sweet Excellence! Divine Creature! Fair Sufferer!—And once he said, Look down, blessed Spirit, look down!—And there stopt;—his lips however moving.

At nine in the morning, he was seized with convulsions, and fainted away; and it was a quarter of an hour before he came out of them.

His last few words I must not omit, as they shew an ultimate composure; which may administer some consolation to his honourable friends. (1487)

The verbs "seem," "suppose," and "may" lend this passage a feeling of equivocation. We may agree that Lovelace is invoking Clarissa, but for whom is the command "Take her away" intended? Another of Lovelace's wronged women? Mrs. Sinclair? Margaret Doody seriously underestimates the ambiguity of Lovelace's death when she places it alongside the other moral "Beispiele" and "Schrecken": "Richardson has freed himself of any necessity for dwelling on the death of Lovelace. . . . Here Richardson moves farthest from the traditional deathbed scene in showing the dying sinner, not cowering in fear of hell, or lamenting his inability to repent, but calling upon the spirit of the one whom he has most loved and most injured to intercede for him" (*A Man of Passion*, 179, 181). But it is precisely the Prévostian, passionate, secular nature of this death, the absence of repentance, which must disturb the reader of the other three death scenes. Lovelace's words, like those of Des Grieux, show "pride and self-dramatization, not remorse. [His] is a dramatic, not a religious end" (Kinkead-Weekes, *Samuel Richardson*, 275). Here, as always with Lovelace, the aesthetic subverts the didactic. Indeed, the irony of Lovelace's apprehension of death is obvious. Lovelace believes that he achieves some dignity in falling to the sword of a "Man of Honour," as he calls Colonel Morden (1487), which is more important to him than the religious and moral prohibitions against dueling.[8] Moreover, Lovelace paradoxically believes that his defeat in

8. Richardson felt strongly enough on this subject to write a short epistolary tract, "Six Original Letters upon Duelling," published only after his death in the *Candid Review and Literary Repository*, 1 (March 1765), 227–32. A comparison of the views expressed there with Richardson's letters and with the circumstances of Lovelace's death suggest an intended irony.

the duel has the transcendent meaning of expiating his sin against Clarissa. Even as he falls he cries "Oh my beloved Clarissa! Now art thou—Inwardly he spoke three or four words more" (1486). This pregnant blank, if filled with words such as "avenged by your cousin," would wrench Clarissa from the Christian theological scheme of charity so carefully constructed over the length of the novel and place her into a Druidic world of bloodlust and feuds; we must remember that one of Clarissa's dying wishes was precisely for the two men *not* to try and kill each other. A provision in her will seems to entail a legal forgiveness of Lovelace (see below, 172–73). But Lovelace's sentence remains incomplete, and hence indeterminate like the rest of the scene. Richardson himself drew attention to this fact in his response to Edward Moore: "Was not this more *expressive* than if those three or four words had been given?" (Carroll, *Selected Letters*, 121). Richardson repeats this literary strategy in his letter, coyly declining to specify just what those three (or four) words might have been. Here the reader—of *Clarissa* or of the letter—is called upon to complete the text, as he is called upon to complete the entire text of Lovelace's death.

Lovelace's death combines aspects of all the other deaths, while at the same time refusing to divulge a meaning or be an exemplum as the other deaths have been. Doody is correct in pointing out that elements of all the other death scenes reappear here—Belton's spectres, Sinclair's impatience, Clarissa's look heavenward. Yet their commingling in one brief description allows us to grasp none of them as the central element. By participating in all deaths in the quadrangle, Lovelace's belongs to none of them. The reader of Prévost's translation is relieved of these interpretive difficulties, since the only comparison will be to Clarissa's death. Hence the relatively horrible description of Lovelace's agony and fever make his punishment clear. Without the additional, more horrific deaths of Belton and Sinclair, Lovelace's death has little ambiguity. Prévost has ameliorated a situation which perplexed many readers of the novel. Edward Moore had provoked Richardson's ambiguous addendum to Lovelace's death with the observation that the "triumphant Death of Clarissa . . . need[s] a more particular contrast than in the Deaths of Belton & Sinclair" (Carroll, *Selected Letters*, 119). Moore realized that without those deaths as lures for the reader, the opposition which the reader expects between Clarissa and Lovelace would at last be allowed to function. Prévost has realized this as well, and removed the lures.

Lovelace's final words remain obscure as well, his lips moving with no audible sound escaping. The last words la Tour manages to catch, "LET THIS EXPIATE!" form a signifier behind which many

signifieds could lie, and hence which harbors none at all. Subtly, expiation has replaced repentance, action has replaced attitude as the measures of death's value. "Expiation" invokes a substitution, death for rape, with no need for theological considerations like repentance. And the little word "this" becomes the most ambiguous single word in this immense novel. Jean Hagstrum remarks on "this":

> What can the profoundly contextual, as distinct from the literally grammatical, antecedent of "THIS" be? Surely not Christian repentance, for he has refused the last rites of the church. No more can it refer to his death in dueling, for that act had no seeds of salvation in it. It must refer to his love for Clarissa. (*Sex and Sensibility*, 210)

Must it? One knows neither what the expiation is, nor whether it is genuine or just another rôle which Lovelace is playing. In his letter to Moore, Richardson continues turning the screw of interpretation, this time with his subtle use of the word "apparent": "And at last with his [Lovelace's] wonted haughtiness of spirit—LET THIS EXPIATE all his apparent Invocation and address to the SUPREME" (Carroll, *Selected Letters*, 122). The author of *Clarissa* stubbornly continues to deny the possibility of seeing behind the words he has written to their "real" meaning or to the true theological implications of Lovelace's death.

The questions inherent in this ambiguous finale were calmed by Prévost, who rendered the line "Reçois cette expiation!" The demonstrative pronoun has become an adjective, its meaning bound up in the following noun. And through this grammatical change, Lovelace's act has been made performative. The addressee is clearly Clarissa, who is asked to receive Lovelace's expiation as she has asked him to recieve her forgiveness. The hidden question in "let" is brushed aside. The German "Laß dieß versöhnen" is closer to the English grammatically. With "versöhnen" Michaelis seems eager to capture the difference between expiation and repentance, for a "Versöhnung" is a reconciliation, presumably with Clarissa, and not a repentance as in the English.[9] If Lovelace were addressing God, "versöhnen" might mean repentance, but is he? He most certainly is

9. *Grimm's Wörterbuch*, for example, emphatically restricts the word to subjective and secular meanings: "Versöhnen *beschränkt sich im nhd. im allgemeinen auf die subjective sphäre, auf die innerliche umwendung bei der wiederherstellung eines gestörten guten verhältnisses einer person zu einer andern person*" ("Versöhnen *is generally limited in modern German to the subjective realm, to the psychological change brought about at the restoration of a good interpersonal relationship gone bad*").

in a later adaptation of *Clarissa* for the German stage: "Ach—Gott—heiliger—heiliger—laß—dich—versöhnen" (Steffens, *Clarissa, ein bürgerliches Trauerspiel*, 96). Dramatist Johann Heinrich Steffens felt the need to insert the name of God and thus remove an ambiguity which Michaelis was willing to leave open.

Lovelace's refusal to accept any last rites "in the Catholic way"—a refusal which finds its way neither into Prévost's translation, nor into the later one of Tourneur—is again ambiguous. Is Lovelace to be interpreted as an atheist, a characterization which he has been at pains to deny? Or is he the opposite, a strict Anglican, who feels that the acceptance of Catholic rites would send him to Hell sooner than no rites at all? Lovelace's refusal of the sacrament is either a rejection of God or a fervent, bigoted embracing of his native religion. Both attitudes have been contradicted by his own previous statements; he has tried to portray himself as both believing and tolerant. De la Tour's distanced reporting (re)produces the ambiguity of Lovelace's final act. He could have written in more detail, explaining whether Lovelace was refusing Catholicism or religion in general. Instead, he presents a final ambiguity which labels Lovelace's death as "neutral" in relation to the others. That is, we can find neither repentance nor desperation here, or we may find both and many other things. Oddly, then, Prévost's excising of the reference to Catholics helps to remove that air of neutrality.[10]

Because it escapes the categories of repentance and fear, Lovelace's death is the opposite of Belton's, which demonstrates both categories at once. The deaths of Clarissa and Sinclair, while also standing in opposition to each other, follow a more conventional representation: repentance eliminates fear and fear repentance, respectively (see diagram).

<div align="center">

Belton

Repentance *Despair (Fear, Terror)*

Clarissa Sinclair

Hope (Calm) *Defiance*

Lovelace

</div>

We have then two hierarchies of oppositions: the more basic one is formed by the mutually exclusive nature of repentance and fear,

10. The excision was also a pragmatic attempt to escape the wrath of the French censors. Throughout the novel Prévost eliminates passages such as this, which engage in Catholic-baiting. Cf. Wilcox, *Prévost's Translations*, 356–57.

which means in turn that repentance implies a lack of fear, and defiance, or the failure to repent, brings necessary terror. The second hierarchy of oppositions is formed by the four deaths of the novel, which demonstrate the logical connections inherent in the first set: Clarissa's death is a positive model, marked as it is by repentance and hope; Sinclair's death is a negative model, marked by fear and defiance. Belton provides the complex term, uniting the contrary attitudes of repentance and terror; and Lovelace is the neuter, with neither repentance nor fear (i.e., unlike in the other deaths, we cannot be sure that these factors are present). By comparing one death to another, the reader can perceive the possibilites for a happy versus an unhappy death, depending upon the combination of the elements in the first set of oppositions.

As Alan McKillop has pointed out, the charge of Sentimentalism so often levied against Richardson applies more to the translations and abridgements of his work than to the novel itself: "The evidence at hand indicates that Richardson was appropriated by the sentimentalists in France as in no other country, and that French enthusiasts often took his emotionalism without his compromise" (*Samuel Richardson*, 276). Nowhere is this more apparent than in *Clarissa*'s unappealing and unsentimental treatment of death. The death of Clarissa is not an exercise in sentiment, but a public exemplum corresponding to the tradition of moral instruction which had its start long before Sentimentalism became popular. Prévost's translation abridges Belton's death, omits Sinclair's, shortens Clarissa's, and bowdlerizes Lovelace's. Perhaps nowhere else does Prévost show such methodical consistency as he does in smashing the oppositional structure of morbidity which Richardson had expended so many pages to produce. Clarissa's death stands alone in French, demoted without the necessary counterexamples from an exemplum into a merely pathetic event.

Art versus Nature

The oppositions between words repeatedly used in different contexts over the course of the novel form a structure less stable than those based on contrasted characters or events. The struggle *between* opposing words is complicated by a more primary struggle *within* individual terms. Each important word in this text, be it "nature," "estate," or "rake," carries within it a dialectic, a battle between

semes which threatens to tear one word into many. Translation here functions like the iron filings on a piece of paper held over a magnet to show the lines of magnetic force. In confronting the oppositions *within* terms, the translators can never use "verbum pro verbo," but rather must allow their language to branch off in the various directions of meaning inherent in the original.

I will follow Terry Castle's lead in examining first the opposition between "Nature" and "Art." Each of these terms is so multivalent that only their opposition, which at times equals the difference between good and evil, allows sense to be made of them. The usage of the terms "art" and "nature" presents a complicated history. In his important study "Nature as Aesthetic Norm," for example, A. O. Lovejoy documents sixty-six different meanings for the word. Richardson's oppositional pairing represents an attempt to contrast two terms to each other which had stood in a dialectical relationship since the Baroque period, as is shown in the following quotation from Sir Thomas Browne. From Browne's viewpoint, the essential opposition is not between the natural and the artificial, but between the natural and the supernatural: "Now, nature is not at variance with art, nor art with nature, they being both the servants of His providence. Art is the perfection of nature. . . . Nature hath made one world, and art another. In brief, all things are artificial, for nature is the art of God" (*Religio Medici*, 21). The peculiar dialectic still informs the poetry of two important writers of the early eighteenth century, Johann Hinrich Brockes and Alexander Pope. Nature for both these poets is a book to be read, a didactic tool. Nature for these poets ultimately resolves into something artificial, for Brockes the work of God, for Pope the art of man. Pope's "Windsor Forest" closes with the forest's oaks being made into the hulls of English ships in the most "natural" art in the world. Richardson, on the other hand, attempts to place art and nature at odds with each other.

Only once in *Clarissa* do we find the concept of nature which would become so important for the Romantics: A force independent of human or divine control, responsible for the disposition of the world. Lovelace opposes this Romantic concept of nature not to art, but to discretion, which at other places in the novel will receive the synonym "education." Lovelace laughs at the Harlowes for their egregious management of their daughter: "But these fathers and mothers—Lord help 'em!—Were not the powers of nature stronger than those of discretion, and were not that busy *Dea Bona* to afford her genial aids, till tardy prudence qualified parents to *manage* their future offspring, how few people would have children!" (440). Love-

lace is talking of nature as the sexual urge, the "dea bona" being a fertility goddess. Lovelace suggests here that procreation is due to a lack of discretion and an inability to overcome the demands of nature, which is depicted as a force overpowering and outwitting human intentions. This concept of nature as a cunning force is apparently foreign to both Prévost and Michaelis, who misread the passage. Prévost makes the passage much more diabolical: "Si la providence n'avait pas plus de part à leur conduite que la discretion, sauveroient-ils une de leurs filles?" (III, 174). Reading Lovelace's comment in the context of his plotting against Clarissa, Prévost uses "filles" ("girls") in order to focus the comment specifically on female children, and uses "sauver" ("to rescue") to nuance "have." The sentence has thus been pulled back from the brink of digression into the center of Lovelace's plotting to rob the Harlowes of their daughter. Lovelace now speaks not of births, but of the attitude of the family towards their daughters which allows rakes like himself to operate. Prévost has also replaced "Nature" with his favorite term "providence," shifting the focus from reproduction to seduction. The accepted French meaning of "providence" in this period was equivalent to Thomas Browne's, i.e., of the wise government of the world by God. Hence the word's use here almost contradicts the idea of nature presented in the English. However, it seems that Prévost used "providence" here to secularize it, rather than to deify nature. For example, the French passage repeats the close relationship between passion and providence found in *Manon Lescaut* and other of Prévost's novels. Prévost once again sublates the opposition between supernatural and human forces into terms such as "providence" and "le hasard." Just as he has done with Richardson's theological categories, Prévost here subsumes the difference between reason and passion under the headings of fate and love.

However, Prévost does use "Nature" eagerly in conjunction with Woman. For example, when Belford begs Lovelace to spare Clarissa for "motives of justice, generosity, gratitude, and humanity, which are all concerned in the preservation of so fine a creature" (555), Prévost takes "creature" in its etymological sense. Belford now urges "la conservation d'un si bel ouvrage de la nature" (III, 512). Similarly, when Lovelace plays the lovesick boy, saying that he "can think of no creature breathing of the sex, but my Gloriana" (418), Prévost once again lets nature slip into the picture: "Je ne puis penser, *dans la nature*, qu'à mon adorable Clarisse" (III, 108–9). "Gloriana," like "Lovelace," was a code name denoting a particular attitude towards sex. Sophia's usage of the character in her polemic *Woman's Superior Excellence Over Man* clarifies what Lovelace is insinuating:

"Witness the hapless still pitied *Gloriana*, who too unpractic'd in the baseness of [Fidius's] sex sacrificed her person, peace, and honour to his unwearied artifice" (20). The opposition between Gloriana and Fidius, ingenue and roué, female and male, resumes that between nature and art. If Fidius is all artifice, Gloriana is too natural for her own good. Thus Prévost's addition of "nature" to Lovelace's statement has some justification.

Like Prévost, Michaelis substitutes his own cosmology for Lovelace's, transforming the powers of nature into human nature, or character. Note the addition of the possessive "ihre" ("their"), which makes "Natur" synonymous with English "character" rather than with "nature": "Wenn ihre Natur nicht besser wäre, als ihr Verstand, und wenn die geschäftige Göttin die Bona Dea ihnen ihre Hülfe zur Fruchtbarkeit so lange versagete, bis sie im Stande wären Kinder zu erziehen: o wie wenige Leute würden denn Kinder haben?" (III, 307). Besides his recuperation of "nature" as a personal quality rather than a superhuman force, Michaelis also clarifies the classical allusion of the English: his addition of the word "Fruchtbarkeit" ("fecundity") gives the species for Lovelace's generic "genial aids."

Lovelace and Clarissa embody the negative qualities of art and the positive qualities of nature, respectively. Except for the quotation examined above, the opposition between the two terms is restricted to the realm of human personality. "Art" is then what a person consciously designs in order to achieve his or her purpose, "nature" the unwilled essence of the person. Yet even these categories participate in dialectic. Clarissa soon discovers that Lovelace is a master of art, as she complains soon after receiving his tempestuous letter supposedly written while kneeling outside the Harlowe garden: "I see his gentleness was *art*: Fierceness, and a temper like what I have been too much used to at home, are *nature* in him" (270). But Clarissa's model of a natural fierceness hidden by an artificial gentleness is still too simple, for Lovelace has consciously couched his letter in angry tones to convince Clarissa of the sincerity of his desire. Art is natural to Lovelace, and his nature is artificial—as he himself admits, in reference to the country maid Rosebud: "What would I give . . . to have so innocent, and so good a heart, as . . . my Rosebud's . . . ! I have a confounded mischievous one—by *nature* too, I think!" (163). Behind Lovelace's mask is another mask. He is, as Belford says, Protean. Prévost preserves the opposition with the words "artifice" and "naturel": "Je vois que sa douceur n'était qu'un artifice. Le fond de son naturel est l'arrogance, & je ne lui trouve que trop de rapport avec ceux dont j'éprouve ici la dureté" (II, 219).

Michaelis, on the other hand, introduces a new term, "Verstellung," to convey the idea of artifice: "Ich sehe, daß alle seine Artigkeit nur Verstellung gewesen ist: diejenige Härte, die ich zu Hause allzuviel habe kennen lernen, ist ihm natürlich" (II, 199).

Two social groups considered to be more natural in this period were peasants and children. The seventeen-year-old female peasant Rosebud thus easily becomes a focal point for discussions of nature and art. Rosebud lives in the inn near Harlowe Place that Lovelace inhabits while waiting to seduce his victim. He deliberately avoids ruining the girl in order to appear virtuous. Lovelace himself opens the discussion of her naturalness as he tells Belford "thou wilt see in her mind, all that her superiors have been taught to conceal, in order to render themselves less natural, and more undelightful" (162). As Anna Howe prepares to interview Rosebud in order to discover whether Lovelace has seduced her, she declares that if she finds "more Art than Nature in either her or her Father, I shall give them both up [as corrupted]" (285). Art in this passage is equated almost with sin; it is a symptom of the ruining of an innocent girl. Lovelace's art is contagion, a poison that reproduces itself. Similarly, a later passage from Clarissa's pen, in describing the same Rosebud, expresses the worry that "when her Innocence is departed, she will endeavour by art to supply the natural charms that engaged him" (286). Clarissa's statement here borders on cliché. A similar phrase can be found, for example, in Eliza Haywood's 1728 novel *The Per-plex'd Duchess*: the perverse Gigantilla "knew how to embellish the Charms she had from Nature, with all the Aids of Art; in fine, she was ignorant of nothing which those who call themselves of the po-lite World take a pride to understand" (2). In using the phrase "sup-ply" ("supply the loss of" in the third edition), however, Richardson enters the very dialectic between nature and art that he wishes to avoid.

As Jacques Derrida has pointed out in analyzing the writings of Rousseau, the two opposite meanings of "supply"—"to substitute" and "to add a surplus"—are simultaneously present in each usage of the word and necessarily problematize the concept of "origin" or "nature." The following comment on Rousseau applies equally well to the passage at hand:

> The supplement adds itself, it is a surplus, a plenitude enrich-ing another plenitude, the *fullest measure* of presence. It cumu-lates and accumulates presence. It is thus that art . . . repre-sentation, convention, etc., come as supplements to nature and are rich with this entire cumulating function. . . .
> But the supplement supplements. It adds only to replace. It

intervenes or insinuates itself *in-the-place-of*; if it fills, it is as if one fills a void. . . .

Evil is exterior to nature, to what is by nature innocent and good. It supervenes upon nature. But always by way of compensation for [sous l'espèce de la suppléance] what *ought* to lack nothing at all in itself. (*Of Grammatology*, 144–45)

Thus Clarissa's evaluation of Rosebud applies to herself as well; sex is a supplement to the virginity that it destroys. Women, once their loss has been supplied, become Sinclairs; that is, they become like men. The innocent, natural love, the most unguarded and unsuspecting, is the most prey to evil and subsequently to art. And this dialectic is also that of translation, which constitutes simultaneously an addition to the original text and its replacement by another, strange one. Translation is on the one hand a good supplement, adding meaning and importance to the original text and increasing its being; on the other hand, translation is, like Haywood's Gigantilla, "la belle infidèle," a beautiful but evil and unnatural substitution of a corrupt for a virgin text. Like the two necessary and opposite meanings of "supply," condemned to inhabit the same narrow word, neither view of translation can exist without suggesting the other.

It is no surprise that the two translations of these key passages diverge at the double meaning of "supply." The first of these passages gives Michaelis an opportunity to translate with the oppositional pair "Kunst/Natur": "Wenn ich bey ihr oder ihrem Vater mehr Kunst als Natur finde, so muß ich sie verlohren geben" (II, 246). We recall that earlier Michaelis had chosen "Verstellung" to translate "art." In the second passage, however, Michaelis correctly interprets "natural charms" as being those of virginity. This equation allows Michaelis to avoid the opposition "art/nature" in favor of the opposition between the charms of virginity and those of artifice: "Wenn die Annehmlichkeit ihrer Unschuld geraubet ist, so wird sie diesen Mangel durch künstlich angenommene Annehmlichkeiten ersetzen müssen" (II, 251). The choice of "ersetzen" and the preservation of binary opposition in the repetition of "Annehmlichkeit" shows that Michaelis sees art as substituting for nature. Our second sentence represents a delicate balance between conversation and philosophy. Michaelis has chosen to translate the philosophy, dependent upon the use of antithesis. The phrase "künstlich angenommene Annehmlichkeiten" smacks of academic prose. The German language cannot follow the suppleness of English in its distinction between art and nature.

Prévost's translation also reproduces the opposition in the first

passage, but supplies a more specific one in the second: "Si je trouve dans l'un & l'autre plus d'art que de naturel, je les renverrai sur le champ" (II, 261). Prévost consistently uses "naturel" in both its adjectival and substantive functions to translate both "nature" and "natural," and even to translate other terms such as "soul" (meaning "character" or "temperament"). For him, "naturel" has an even wider range than "nature" has for Richardson. The use of the adjectival form rather than of the noun "nature" avoids any confusion with natural powers, which we have seen Prévost also willing to speak of. In the second quote, however, Prévost has chosen to emphasize Rosebud's lower-class origins and the possibility of their being supplemented: "Aprés avoir perdu son innocence, elle saura suppléer par l'art à ce qui lui manque du côté de l'éducation" (II, 264). Here Prévost has defined nature as a lack of breeding and good manners. The passage thus becomes paradoxical, since "education" in Richardson's novel is itself a near synonym not for "nature," but for "art." For example, at one point Lovelace asks whether "*Education* can have stronger force in a woman's heart than *Nature*?" (695). At the same time, Prévost keeps this opposition intact: "L'éducation peut-elle avoir plus de force que la nature dans le coeur d'une femme?" (IV, 358). Thus the word "education" becomes Prévost's supplement, equally capable of synonymy and antonymy with "nature."

Persons versus Property

Like the word "supply," the word "property" contains two contrary semes. It can connote both freedom and slavery. Oddly, "property" is repeatedly used in *Clarissa* to refer to living and nominally free persons. For example, "property" becomes a metaphor for woman and a synecdoche for male hegemony over her. The repeated use of the word "property" in these opposing senses reflects both the immense importance of property, especially of the estate, in eighteenth-century English society, and also the severe restrictions that society placed upon women's independence and personhood. A close examination of the term and its translations will reveal the links between these seemingly independent semes.

The importance of property can be inferred from a curious footnote which Prévost has seen fit to insert after a passage in which Anna Howe reminds Clarissa of the consequences of marriage. Commenting on the English laws which made the husband the ex-

clusive owner of all property in a marriage, Anna warns Clarissa that upon marrying Lovelace "your estate will then be his right" (549). The passage highlights the peculiar dialectic of property-holding in this novel: property, and particularly her estate, make Clarissa independent, but this independence is so intolerable to family and society that a marriage is contemplated which will not only remove her property, but also render her the property of Solmes. Anna's phrase "his right" implies Clarissa's lack of rights as married woman. Her "(e)state" will devolve from freedom into slavery. "Estate" is not simply a synonym for "property" here. The word had undergone relatively rapid changes from the fourteenth century onward, and the meaning which it has in this novel had only become current at the beginning of the eighteenth century. In the thirteenth century the word had had a meaning close to its Latin origins (from the verb "stare," "to stand"): it meant "state," "condition," or "status." In the sixteenth century "estate" came to mean property or possessions themselves. But only in the eighteenth century did the word take on the additional meaning, so important here, of landed wealth. This final change in the meaning of the word seems to point to the increasing importance of landed wealth for this period (cf. Habbakkuk, "Marriage Settlements in the Eighteenth Century").

"Il sera alors de votre bien" says the French, and then at the bottom of the page Prévost explains to his readers "suivant les lois d'Angleterre" (III, 494; "according to the laws of England"). The apparent superfluity of the comment is actually a clue to its importance, and to the curious opposition which Prévost has made to the English. Rather than reproducing the English absorption of property into male prerogative, the French passage documents the opposite movement, the absorption of the man into the property. The translation and footnote raise the question as to whether the first part of the novel, in which, as Christopher Hill has pointed out, Clarissa is regarded by the other members of her family as a mere conduit for property, was fully comprehensible to French and German readers. A similar plot is not found in German or French novels of the period. We may begin to answer our question with a close look at the ways in which words such as "property" and "estate" are rendered into French and German.

In the above passage Prévost has used "bien" to translate the English word "Estate." But special significance of the word "Estate" lies in the specific form of power it confers upon the owner, a kind of power different from that conferred by other forms of property such as money. The difference is clearly expounded in Clarissa's analysis of her brother James's ambitions:

My brother, as the only son, thought the two girls might be
very well provided for by ten or fifteen thousand pounds
apiece: And that all the real estates in the family, to wit, my
grandfather's, father's, and two uncles, and the remainder of
their respective personal estates, together with what he had an
expectancy of from his godmother, would make such a noble
fortune, and give him such an interest, as might intitle him to
hope for a peerage. (77)

This passage would have also merited a footnote in French and Ger-
man, for to understand it one needs a knowledge of the relationship
between economics and politics in England. The passage clearly im-
plies that an accumulation of landed wealth was the single most im-
portant factor in becoming a "peer," i.e., a member of the House of
Lords. The actual process was almost as ambiguous as is described
here (hope is all that is offered, with a play on the word "entitle"),
but certainly landed property was a prerequisite to a title. As the
owner of an estate, Clarissa is forced to see her own independence as
a hindrance to her brother James's political plans, preventing him
from being able to sit in Parliament. It is also obvious from the pas-
sage (and it is made even more clear elsewhere) that the male heir is
normally the successor to all the landed property of the family. The
money which James will use to pay off his sisters is wholly adequate
for their preservation and amusement, but it cannot serve as the
basis for higher political and social ambitions—women should have
none—as the family estates will for James. The vision presented
here is of a patriarchy based on landed wealth, for which the "real"
in "real estates"—opposed here to "personal estates"—has special
significance. A woman property-owner among these male family
members pooling their wealth is an anomaly to say the least. It has
been correctly pointed out (Spearman, *The Novel and Society*, 183)
that the bequest of Clarissa's grandfather is absurd: he passes over
not only his own son, Mr. Harlowe, but also his grandson and the
elder granddaughter, Arabella, to bestow his property on Clarissa.
Indeed, one portion of the will asks the family members to abide by
its provisions even though they contradict law and custom. The will
is a plot device to turn the rest of the family against Clarissa. The
easiest way to wrest the property from her is to marry her off, in
which case her property instantly disappears into the hands of her
husband. Once married, Clarissa is merely another victim of the pa-
triarchy, subject to the whims of her husband. But more than merely
adumbrating a situation from which Clarissa, otherwise virtuous,
would take the risk of eloping with a man, the legacy has made her,
as we have seen in the epigraph to this chapter, a man-woman, an

adult-child, a propertied property. This anomalous situation, this transgression of oppositional boundaries, is necessary for the plot in the same way as the four opposing letter-writers are necessary for the writing of this novel. Marrying Clarissa to Solmes will supposedly return her property to the Harlowes. The legal details of the Solmes deal remain somewhat unclear and preposterous, but this lack of legal clarity only reinforces the mythic patriarchal image of James, Solmes, Mr. Harlowe, and Uncle Antony freely sharing land among themselves because they are all male. Erotic, economic, and political desires are thus brought into a relationship of mutual dependence and frustration.

In the French translation, "real estate" becomes "bien réel." There is an important difference in meanings, for "bien réel" refers to whatever assets are not liquid, including furniture and art works, as well as land. Thus it cannot be opposed to "personal estates," as happens in the English. Prévost instead uses the vague and nonlegal phrase "acquisitions personelles." Here is the passage in full:

> Mon frère, en qualité de fils unique, s'étoit imaginé que deux filles pouvoient être fort bien pourvues, chacune avec douze ou quinze mille livres sterling, & que tout le bien réel de la famille, c'est-à-dire, celui de mon grand-père, de mon père, & de mes deux oncles, avec leurs acquisitions personelles, & l'esperance qu'il avait du côté de sa marraine, pouvaient lui composer une fortune assez noble, & lui donner assez de crédit, pour l'élever à la dignité de pair. (I, 121)

If the opposition between "real" and other property is lost in French, Prévost's choice of "crédit" cleverly reproduces the original ambiguity of "interest." Like "estate," "interest" is also a word which plays in a double register of finance and of social influence. The usage here brings us back to the word's root meaning of "créer dire," of believing what another says—the origin of all credit in either the social or financial sphere. "Crédit" reflects the curious blend of social maneuvering and outright purchase by which titles of nobility were granted in France in this period. The hedging and uncertainty of the last sentence in the passage are also alleviated in French. In the English, James will be entitled to *hope* that he *may* become a peer. In French as in English, James's ambition is to join not just any branch of the aristocracy, but that most elevated branch, the peerage, which was responsible for governing the nation. (However, in mid-eighteenth-century England, the peerage's political power was real, while in France it was more nominal.) To a greater extent than in English, the word "pair" places the Harlowes among

the "Grands," the great French nobility whose origins were lost in the mists of time.

If Prévost has slightly enlarged the Harlowe ambition, Michaelis has slightly narrowed it. He has done this through use of an English term, but not the one in the original! "Lord," which covers the meaning of "peer," could also include nobility of a lower rank:

> Hingegen glaubte mein Bruder . . . wir beiden Mädgens wären überflüssig reichlich bedacht, wenn ein jedes zehn oder 15 tausend Pfund mit bekäme und so würden die liegenden Gründe der Familie, die mein Grossvater, mein Vater und dessen Brüder besässen . . . mit dem Gute seiner Pathe . . . zusammen genommen, so viel ausmachen, und ihm so viel Ansehen und Freundschaft erwerben, daß er hoffen könnte, ein Lord zu werden. (I, 120)

Michaelis is also careful in his use of legal terminology. "Liegende Gründe" is a legal term for an estate (as opposed to "fahrbare Habe," which includes any property which can be transported). The equivalence to "real estate" is almost total. Remarkably, Michaelis has even intensified the English references to land by using "Guthe seiner Pathe," which in this context would almost certainly be read as equivalent to "landed property," to render the much vaguer (and more cumbersome) English "what he had an expectancy of from his godmother." The polyvalent "Interest" must be rendered here by two terms, "respect" ("Ansehen") and "friendship" ("Freundschaft"). The choice of these two German terms indicates a reading of the English process of "building a family" as mainly dependent upon personal friendships. No other European state seemed to be able, as England was, to live with the paradox of simultaneously declaring all men to be free and making freedom dependent on landholding.[11] Thus the word "estate" could not have had the same resonance for the translators which it did for Richardson.

11. The holding of land had long been considered necessary in England to give a person free status. For Cromwell, only property in freehold land or chartered trading rights made a man free. For the political scientist James Harrington, estate and government were nearly synonymous: "If a man has some estate, he may have some servants or a family, and consequently some government, or something to govern, if he has no estate, he can have no government" (Harrington, "A System of Politics," 835; cited in Damrosch, "*Clarissa*," 227). And John Locke managed to construct a contradictory philosophy which said that all men were naturally equal, but that the natural phenomenon that some held land and others did not produced a tolerable inequality. On this subject, see C. B. Macpherson's *The Political Theory of Possessive Individualism*; cf. also his "Social Bearings of Locke's Political Theory."

One again sees the flexibility and importance of the word "Estate" in a passage in which Lovelace is making his marriage proposal to Clarissa: "I offer to settle upon you, by way of jointure, your whole estate. . . . My own Estate is a clear 2000 *l. per annum*" (596). In the first usage, the emphasis is on the whole of Clarissa's assets, all that which makes her independent. Lovelace's offer of financial independence is unusual and is a deliberate contrast to the slavery envisioned by Anna Howe. When talking of himself, on the other hand, Lovelace places the emphasis on cash. Thus Prévost is forced to use two different terms to translate: "J'offre de vous assurer la jouissance particulière de votre propre terre. Le fond de mon revenu est de deux mille livres sterling" (IV, 94). Other French substitutes for "estate" include "bien" (which is also used to translate the more general "property"), "terre," "grosse succession," and "un trésor inestimable." A man "with a great and clear estate" (68) is in France merely "un homme fort riche." Neither translator succeeds in finding a single term for the complex word "estate," but Michaelis tends to go to terms such as "liegende Gründe" and "Gut," which at least hint at the connection between landownership and power so clearly expressed in the English.

There the line between the propertied and the unpropertied is as absolute and important as that between the noble and the common. It is as absolute and important as the opposition between men and women, or as the opposition, to be examined in the next chapter, between the lettered and the unlettered. Noble men have real estate, and married women do not. Clarissa's dilemma demonstrates that the only alternative to having property in this society is to be someone's property. Taking the other reality, voiced by Anna Howe, that the woman and all she possesses is the property of her father or her husband, we can construct a rectangle (see diagram).

<div align="center">

Clarissa, Sinclair

Female *Propertied*

Whores, married women James, Lovelace, etc.

Property *Male*

Joseph Leman

</div>

The vertical relationships imply that to be a female in this society means to be the property of either one's father or one's husband or one's pimp. Conversely, being propertied implies being male. The

complex term in this novel, the propertied female, is Clarissa. Inter-
estingly, she shares this position with Mrs. Sinclair, the owner of
whores. Joseph Leman, explicitly described as Lovelace's puppet,
i.e., as a thing totally obedient to Lovelace's will, is the neuter, the
unpropertied male. Sinclair's prostitutes are the clearest example of
woman as property—specifically, of the commodification of
woman's sexuality—while James is the epitome of the propertied
male. Yet the married woman is also seen as property. Clarissa lec-
tures her uncle James on the solemnity and terror of the state of
marriage by noting that it is the woman's misfortune "to be ingrafted
into a strange family . . . To give up her very name, as a mark of her
becoming his absolute and dependent property" (148). Such a for-
mulation typifies what the law actually had to say about marriage.
Clarissa, in marrying, would be engrafted onto a more powerful
branch, would pass from a position of power and legal existence to
one of complete assimilation to the male. Janelle Greenberg, in a
study of the legal gender structure of this period, concludes:

> The *femme sole* enjoyed, for the most part, the same rights and
> responsibilities as did men. She owned property and chattels,
> which she could bequeath by will. She made contracts; she
> sued and was sued. The situation changed dramatically when
> a woman married. At that time and by that action she surren-
> dered those rights and fell prey to a whole series of disabilities
> which placed her in the same legal category as wards, lunatics,
> idiots, and outlaws. ("The Legal Status," 172)

Michaelis reproduces this chilling transition word-for-word: "Das
Eigenthum eines Fremden werden: in eine fremde Familie
eingepfropft werden: den Namen sogar verändern, und dadurch
ein Zeugniß ablegen, daß sie das vollkommene Eigenthum des
Mannes sey" (I, 343). The verb "einpfropfen," borrowed from the
realm of horticulture like the English "engrafted," indicates that the
woman is as passive and voiceless as a plant. She is a twig which will
be subordinated to the thicker branch to which she is attached. The
word "Mann," in the genitive case here, can mean either "husband,"
or "man" in general. Woman is the property of man, as well as of
her husband.

The French translation tones down the frankness of the passage:
"Perdre jusqu'à son nom, pour marque d'une dépendance absolue,
entrer dans l'obligation de préferer cet étranger à son père, à sa
mère." (I, 339). Prévost has chosen to emphasize not the bondage of
women in marriage, but the shift in their social position when they

change from the locus within their own family to a sudden need to obey a stranger. Similarly, whereas the German preserves the idea of woman as property in the epithet "das unglückliche Eigenthum" to describe Clarissa's projected marriage to Solmes, the French is euphemistic: "d'être livrée à ce miserable Solmes" substitutes a play on the double meaning of "miserable" (both "unhappy" and "miserly") for Richardson's hypallage. Prévost is less euphemistic when Clarissa, hiding from Lovelace in Hampstead, expresses her fear of Lovelace: "The man, who has had the assurance to think me, and to endeavour to make me, his property, will hunt me from place to place, and search after me as an 'estray'" (754). This passage has a double reference to woman as chattel, for besides the word itself, "estray" is used in its legal denotation of "any beast not wild, found within any Lordship, and not owned by any man" (*O.E.D.*; note the specific gender of "man"). While Michaelis again uses "Eigenthum" for "property," the French has "l'homme qui a l'audace de s'attribuer des droits sur moi, va s'effacer de me suivre à la trace, et me chercher comme un meuble égaré" (IV, 516). Though still unwilling to use the word "bien" in connection with persons, Prévost has kept some suggestion that Clarissa is regarded as chattel with the word "meuble."

Prévost had trouble translating for French readers not only the word "property," but also the social and economic relationships between property, women, and their husbands in eighteenth-century England. In France married women could own property, and sometimes their signatures were required for the husband to transact business if the wife's property was involved (Lee, 22). England was the European country which went farthest in legally codifying women as property. Yet this can be looked at in two ways, both as the degradation of women to the status of property, and as the elevation of property to a nearly human status. Property in eighteenth-century England was anthropomorphized and apotheosized:

> Once property had been officially deified, it became the measure of all things. Even human life was weighed in the scales of wealth and status. . . . Again and again, the voice of money and power declared the sacredness of property in terms hitherto reserved for human life. Banks were credited with souls, and the circulation of gold likened to that of blood. (Hay, "Property," 19)

Similarly, Terry Eagleton has spoken of Clarissa's body as the single locus for all forms of exchange in this novel. Money, women, and words are all mutually convertible:

> What "circulates" in the novel, what unifies its great circuits of textual exchange, is simply Clarissa herself, whether as daughter or lover, rival or confidante, protégée or property-owner. It is on the trading, withholding, surrendering or protecting of Clarissa that the currency of all that letter-writing is founded. The "universal commodity" (Marx), magically unchanging in itself yet source of "magical" transformations in others, "pure gold" yet in ceaseless liquidity, Clarissa's body is itself the discourse of the text. (*Rape*, 56)

Clarissa's struggle is to become a free, speaking subject rather than an inert object owned by others. The translations seem mostly not to convey this synonymy between women and property. Like the other binary oppositions we have examined, the one "propertied"/ "property" bears a strong relationship to the single most important opposition in the novel, that between male and female.

The Decent Rake

We have seen that two sets of oppositions, Nature/Art and Property/ Propertied, participate simultaneously in constructing and undermining semantic and social categories. Lovelace raises the process of undermining to a general principle. Lovelace is always at pains to reverse the expectations of the other characters in the novel: where they separate concepts, he merges; where they unify, he divides. Perhaps the very roots of Lovelace's personality are formed of two opposing forces. Judith Wilt has made a good case for viewing Lovelace as an androgynous character, a woman-man analogous to Sinclair the man-woman (Wilt, 22). Lovelace's style betrays a curious doubling imagery, ranging from his hope of being father to twins, to his fantasy of seducing both Clarissa and Anna and having a child by each, to a desire for both Sorling girls. Where conventional morality sees two as excess, he seems unsatisfied with one.

Lovelace is the only character whose language and ideas tend to merge the poles of good and evil, which the other characters try to hold as far apart as possible. He is thus the only character whose use of language may be called unstable. He is one of the best examples of Richardson's ability to create characters whose intentions are not linear, who show complexity, ambiguity, and contradiction. Lovelace is interested in causing damage only when he can be fully aware of the moral infractions which his actions embody. In some letters to

Belford he boasts of being a rake; in others he debates that categorization in such a way that the reader recognizes the hollowness of the term. Lovelace's language (which is all we have of him) gives the impression that although he can tell the difference between good and evil, he takes delight in trying to eliminate that difference.

It is fitting that the one word which best describes Lovelace, "rake," should undergo the dialectical turnings which his actions provoke. Lovelace typically has no compunctions about assuming the title of "rake." He knows that the term is unstable, chiefly because it refers to a social category and has no opposite with which it may be contrasted. His defense of rakehood consists in applying various adjectives to the word in order to expose the various semes which simultaneously compose and destabilize it. Here he is quoted by Clarissa, whom he has been attempting to impress with his moral sensibility:

> I always called another cause, when any of my libertine companions, in pursuance of Lord Shaftesbury's test (which is a part of the rake's creed, and what I may call *The whetstone of infidelity*), endeavour'd to turn the sacred subject into ridicule. On this very account I have been called by good men of the clergy, who nevertheless would have it, that I was a *practical* Rake, *The decent Rake*: And indeed I had too much pride in my shame, to disown the name. (443)

Lovelace posits two sorts of rake, one of praxis and one of theory. The first type is apparently more defensible than the second. The passage confuses rather than clarifies the idea of what a rake is, since one would think that a "decent rake" would be an absolute contradiction in terms. Here Lovelace is playing upon two meanings of "decent," one referring to character in general, the other to utterance (preserved today mainly in the negative, e.g., "indecent language"). In his last sentence Lovelace uses two oxymorons ("decent Rake," "pride in my shame") in order to ameliorate his status. His hope is that, without actually committing himself to reform, he can escape categorization in order to keep Clarissa hopeful and wondering. Scrutiny of this passage fails to yield a particular category into which one could put Lovelace. Does the pride of his shame cause him to deny the name of "rake," or the name of "decent rake"? In the third edition, Richardson, apparently troubled by this important ambiguity, resolved it by adding "of Rake" after "name."

Armed with the convenient French term "libertin," Prévost is equal to the task of recreating Lovelace's dialectical tour de force:

> J'ai toujours changé de discours, lorsque mes compagnons de libertinage, en vertu du Test de milord Shaftbury, qui fait parti du symbole des libertins, & que je puis nommer la pierre de touche de l'infidélité, se sont efforcés de tourner les choses saintes en ridicule. C'est ce qui m'a fait donner le nom de libertin décent, par quelques hônnetes prêtres, qui ne m'en croyaient pas plus réglé dans la pratique; & mes désordres m'ont laissé une sorte d'orgueil, qui ne m'a pas permis de désavouer ce nom. (III, 134)

In French, only the oxymoron of "libertin décent" troubles the prose of Lovelace's declaration. The noun "libertin," which Prévost uses to cover both rakes and libertines, emerges but once in the final passage, as Prévost carefully avoids Lovelace's deliberate contradictions. For example, Lovelace's pride in his own shame has been replaced by a pride caused by his "wildness"—"désordres" was a code word for libertine behavior in this period—in his evil conduct. The passage does not dizzy the reader as the English does; it puts its contradictions at a higher level, that of trying to explain why debauchery causes pride.

Prévost's smoothing of the passage conforms nicely to his ability to use a single French term—"libertin"—to denote both rakes and libertines. The word indeed could cover action as well as ideas, as Paul Hazard informs us:

> If one of the meanings of the word "libertin" signified a person who had no religious belief, another denoted one who was living a life of gross self-indulgence; if the word connoted two such different sorts of freedom, freedom of thought and freedom to wallow in the sensual sty, the time was coming when these two types of freedom would be put in their respective places. . . . The hedonists clamoured for grosser, more unbridled sensuality; they wallowed more openly in debauchery, grew more blatantly cynical. Under the Regency there was no attempt to strike a balance between the mind and the senses, but much rather a deliberate determination to flaunt every kind of excess. (*The European Mind*, 128–29)

Hazard's idea that an essential feature of the French libertine was that he flaunt his "désordres" helps explain why the French Lovelace takes pride in his excesses. Prévost knew libertinism in a way Michaelis and Stinstra did not. One chapter of Jean Sgard's biography

of Prévost is entitled "La tentation du libertinage." (*Prévost romancier*, 348–76). Confirming Hazard's (and Lovelace's) distinction, Sgard denotes the two synonyms of libertinism as "débauché" and "athée." Thus we see that in Prévost's era the word was in a state of confusion (or collusion) between philosophy and debauchery, which allowed Prévost not only to capture the paradox of Lovelace's musing, but also to capture two birds with a single word in the remainder of his translation. (Occasionally Prévost uses "débauché" to translate "Rake," but usually "libertin" does double service for "rake" and "libertine.")

Michaelis is at pains to make things as comprehensible as possible for his readers. He translates Lovelace's oxymoron into a relative clause: "Einige fromme Geistlichen haben deswegen gesagt: ich sey ein Bösewicht, ohne gegen den Wohlstand zu sündigen: oder, ich sey nur in Wercken und nicht in Worten ein Bösewicht" (III, 216). The introduction of "Wohlstand" highlights the social, as differentiated from the purely religious or moral, aspect of rakehood. That which is open to judgement by the general public, and especially one's discourse, is governed by the rules of "Wohlstand." What one thinks or what happens away from polite circles is not concerned in "Wohlstand." Adelung's definition of "Wohlstand," and especially his sample sentences for its usage, emphasize the word's social aspect: "Der Wohlstand ist das angenommene Urtheil anderer, von dem, was einer Person und ihren Verhältnissen anständig ist" ("'Wohlstand' is the accepted judgement of others concerning what is proper to a person and his circumstances"). Adelung's examples all contrast the inner worth of an action ("Tugend") with its judgement by others ("Wohlstand"): **"Selbst die Tugend muß den Wohlstand beobachten. Es gibt tausend Dinge, welche an sich unschuldig sind, welche aber der Wohlstand verbietet"** (**"Even virtue must observe 'Wohlstand.' There are a thousand things which in themselves are innocent, but which 'Wohlstand' prohibits"**). This German word, less ambiguous than the English "decent," allows the passage to remain free of contradiction, though in a manner similar to the English and French it defeats reader expectations; for Lovelace is a rake who does not express atheistic or immoral views in public. He is a villain of deeds only, and not of words. Michaelis has brought to the fore the distinction between language and action which is under discussion in the original. Elsewhere in his translation, Michaelis uses a Lovelacean epithet to translate "libertine": in the term "Freydenker in seiner Aufführung," thought is turned into action in the movement from "denken" ("to think") to "aufführen" ("to enact"). Yet it is precisely this distinction which makes the

phrase "Rakes and Libertines" nonredundant. For a rake is a man of free action, a libertine a man of free thought.

But Michaelis's problem stems precisely from this split, from his inability to find an equivalent term for "rake" in German. "Bösewicht," used in the quote above, has the more general meaning of "villain," and it is used to translate "rake" only in this passage. Elsewhere, a large variety of terms are used, as indicated by the table below, which records the German translations for "rake" and "libertine."

German Translations of "Rake(s)" (R) and "Libertine(s)" (L)

English		German
p. 109	R & L	ein liederlicher und niederträchtiger Freygeist
p. 201	R & L	Freygeist und Schelm
p. 284	brother-R	Brüder in der Bosheit
p. 297	L	Leute von freyer Lebensart
p. 441	R	Bösewicht
p. 504	L	Bösewicht
p. 563	R & L	wilde und liederliche Mannsperson
p. 563	L	ein Mensch, dessen Lebens-Art unordentlich ist
p. 564	to be an L	ein solches freyes Leben anfangen
p. 613	R	Freygeist
p. 614	Libertinism	unsere wilden Jahre
p. 615	Libertinism	ungebundene Lebensart
p. 747	L	Freygeist in der Lebens-art
p. 748	L	Freydenker in seiner Aufführung
p. 749	L	Liederliche Leute
p. 924	L	Freygeist
p. 1015	R & L	liederliche Leute und Liebhaber der so genannten freyen Lebensart
p. 1034	L	Freunde der so genannten freyen Lebensart
p. 1077	R	liederliche Brüder
p. 1086	L	Freydenker
p. 1130	we R & L	Wir liederlichen Brüder und Liebhaber der so genannten freyen Lebensart

This table traces what happens when a single English word is torn apart by the vastly differing social forces which inhabit it. Even a cursory glance demonstrates the utter confusion of the German translation. Especially telling are those passages within the same letter, or on adjacent pages, where the word "rake" or "libertine" re-

ceives different translations. Clearly Michaelis was at a loss to find either a single German term which could cover both English words—as Prévost found in "libertin"—or a single term for each word. In fact, Michaelis often uses the same German word to translate either English term—as when "Bösewicht" and "Freygeist" show up opposite both "rake" *and* "libertine."

The instability of the German translation indicates two things. First, there was no general social trend in the Germany of this period which could be labeled libertinism, as there was in France and England. The Enlightenment in eighteenth-century Germany did not turn antireligious or anticlerical. Second, the terms "rake" and "libertine" in English are extremely pliable and hard to define. They indeed could have meanings all the way from "Freydenker" (indicating only a philosophical opposition to positive religion) and "Freygeist" (which includes the idea of "Freydenker" but adds the dimension of social norms), through "Liederlicher" (a stronger and less philosophical term than "Freygeist," more opposed to social than to religious norms and eventually taking on the meaning of debauchee), to the completely brutish "Bösewicht." Indeed, English dictionaries show almost as much variety in explaining the term "rake" as Michaelis does in translating it. Cotgrave's *Dictionarie* of 1611 vituperates: "pendard, a rake-hell, crack-rope, gallow-clapper." Cotgrave's idea that rakes are criminals who should be deprived of life would throw the translation towards the "Bösewicht" end of the scale. Dr. Johnson, a Clarissean, shows in his dictionary that he also did not appreciate rakes. His definition, like the German translation, lashes out in all directions at once: "A loose, disorderly, vicious, wild, gay, thoughtless fellow; a man addicted to pleasure." The *O.E.D.* definition of the word, couched long after the crisis of rakism had passed, is accordingly somewhat anodyne, calling a rake merely an "idle dissipated man of fashion." Even this definition, however, shows that rakehood has several dimensions. Three different social activities are invoked, for work, vice, and fashion are all things which must be determined by social consensus rather than empirical observation. Finally, in a chapter on Richardson's use of the rake figure, Carol H. Flynn tells us everything about rakes except how to define them. She is forced to resort to examples, which again reproduce the movements of the German translation: "In truth, the rakes were a mixed lot: scoundrels like Francis Charteris; aged voluptuaries like Lord Baltimore; sadists like George Selwyn . . . political activists like John Wilkes; and dilettantes like Francis Dashwood" (199).

Not even after the Sturm und Drang had come to Germany and created its own version of the rake could a single term be fixed upon

as a translation. Another Göttingen professor and anglophile, Georg Christoph Lichtenberg, was to write the book on a figure for which he could find no German term. As editor of the *Göttinger Taschenkalendar* in 1794, Lichtenberg began a series of explications of the engravings of William Hogarth. And at the beginning of his analysis of *The Rake's Progress*, Lichtenberg felt compelled to make a definition which justifies Michaelis's confusions and Lovelace's pride:

> Man übersetzt ["Rake"] gewöhnlich im Deutschen durch Liederlicher. . . . Sonst ist allerdings zwar jeder *Rake* ein Liederlicher, aber nicht jeder Liederlicher ein *Rake*. Die Liederlichkeit hat ihre Gattungen wie die Poesie und, was sonderbar ist, auch fast ähnliche. Im Leben des *Rake* ist durchaus etwas Lyrisches. . . .
>
> Der eigentliche *Rake* (männlichen Geschlechts, versteht sich) trinkt, spielt, h..t, spricht von galanten Pillen und Bougies wie unser einer von kandiertem Anis und Gerstenzucker; macht aus Nacht Tag und aus Tag Nacht. . . . Ruiniert unschuldige Geschöpfe, die ihn liebten, und schießt sich mit Leuten, deren Ehre er gekränkt hat; wirft überall Geld und Geldeswert weg, eigenes und fremdes durcheinander, und nicht selten sich selbst hinterdrein, und in all diesem sucht er eine Ehre. (985–86)

> (["Rake"] is as a rule translated in German as *Liederlicher* (Good-for-nothing). . . . But although, as a general rule, every Rake is a Good-for-nothing, every Good-for-nothing is not a Rake. Good-for-nothing-ness has its classes, like poetry, and, strangely enough, very similar ones. In the Rake's life there is something definitely lyrical.
>
> The true Rake (of the male sex, of course) drinks, gambles, whores, talks of French pills and bougies as we of candied aniseed and barley sugar; turns night into day and day into night. . . . He ruins innocent creatures who have fallen in love with him, and fights duels with people whose honour he has offended; he squanders money everywhere and whatever money can buy, his own and other people's, and not infrequently himself into the bargain, and in all this he is seeking honour.) (Herden, 189–90)

Lichtenberg has captured the fascination of rakehood by formulating the same paradox as we find in Lovelace (and particularly in

Prévost's translation of him): the honor ("Ehre") of debauchery. Lichtenberg indicates that one of Michaelis's terms, "Liederlicher," is more correct than the others, but at the same time admits that it does not quite do the job, because it does not contain the lyrical impulse, because it is not torn by the very dialectic that we have charted in Lovelace's paradoxical statement and its translation. (In turn, the English retranslation of Lichtenberg's translation of "rake" intensifies the problem by rendering "liederlicher" as "good-for-nothing," a word which cannot capture all that Lichtenberg has to say about rakes.) Through his depravity the rake seeks a sort of honor. Both Hogarth's engravings and Richardson's characterization of Lovelace hold our attention by virtue of this untranslatable paradox.

Thus the word "rake" exemplifies the Saussurean principle that a term can be properly understood not in itself, but only through its opposition to other terms. And it is precisely here that the language of Richardson's England fails, since there is no single noun that can express the opposite of "rake." If Lovelace is the worst of rakes, then clearly Richardson intends Clarissa as his opposite, but there is no noun by which we may call her. "Lady," like "gentleman," has become too debased, although in the subtitle for the novel Richardson contemplates this possibility. "Virgin" is too sensual, "Angel" too abstract—the latter, along with "Charmer," comes from Lovelace's vocabulary. As a solution, Clarissa's very name is pressed into service as a common noun to oppose the term "rake" or "libertine." Aunt Hervey, dismayed by the flight of her niece with Lovelace, asks her "will it be believed?—If it *would*, what power will he be thought to have had over you!—He!—Who?—*Lovelace!*—The vilest of Libertines!—Over whom?—A *Clarissa Harlowe!*" (503–4). Mrs. Hervey's "who" and "whom" mark a vertiginous "writing-to-the-moment" style far different from Clarissa's graceful prose. They do not really ask a question, but provide a transition between the delineation of a situation and the elevation of that situation into a generalized concept. Who is Lovelace? A libertine. Whom does he have in his power? A Clarissa. Mrs. Hervey is trying to impress upon Clarissa the tragic absurdity of her situation, an absurdity deriving once again from her bringing together opposing categories. In reading the passage we realize that there is no common noun which can be inserted into the conceptual slot opposite "libertine." We may say that Richardson's creation of Clarissa filled a conceptual gap by providing an opposition to "rake."

Michaelis, failing perhaps to see the purpose behind Mrs. Hervey's rhetorical questions, converts them to real ones. The passage no

longer shows the juxtaposition of two irreconcilable principles, as in the English. It is instead a real query by the aunt, disguised faintly by the use of the impersonal "man" in the first sentences. The aunt wonders aloud what Lovelace must have meant to Clarissa for her to take flight with him. "Wer wird Ihnen glauben? Und wenn man Ihnen glaubte, wie viel Gewalt müßte er denn über ihr Gemüth gehabt haben? Er, Lovelace, ein Bösewicht über alle Bösewichter? Was mußte er bey einer Clarissa Harlowe gegolten haben?" (III, 384). Such questions seek information, rather than function rhetorically to oppose Clarissa to "Bösewicht."

Prévost even leaves off the indefinite article before Clarissa's name. The generalization of her name for use as a concept has been reversed, and now it is her uniqueness which is being emphasized: "Est-il croyable que ce n'ait pas été votre dessein? Si vous vouliez qu'on le croie, quel pouvoir ne faut-il pas lui supposer sur vous? lui! qui? Lovelace; le plus infâme des libertins. Sur qui? Sur Clarisse Harlowe" (III, 352). The loss of the definite article and of several exclamation points has subtly stripped the question of its rhetorical force. Clarissa has been "demoted" from concept to character.

Richardson's Clarissean structural impulse is frustrated by the workings of dialectic. Translation exposes that dialectic like an X-ray and speeds up its operation. Social values are constructed in this novel through oppositions, but the principles of opposition also operate within single characters or single words, thus destabilizing meaning, though meaning must first be perceived in order for the dialectic to make sense. (This paradox defines the necessary relation between structuralism and deconstruction.) One movement, toward or away from a stable meaning, does not precede or follow or replace the other. Rather, they are indispensable opposites which depend upon each other for their respective force. So also the paradox of translation, expressed most eloquently in the Italian "traduttore, traditore." In the first, positive term ("translator") we find communication, in the second ("traitor") silence or lies. It is more than paranomasia which binds these two terms to each other. They attract and betray each other like Clarissa and Lovelace, Manon and des Grieux, original and translation. These are all texts which face each other in the dialectic of opposition and engage each other in dialogue.

4

Translating Dialogism

Mr. Hickman said, That Mr. Lovelace was very happy, as he under-
stood, in the esteem of the Ladies; and, smiling, to make them believe he
did not think amiss of it, that he push'd his good fortune as far as it
would go. Well put, Mr. Hickman! thought I; equally grave and
sage—Thou seemest not to be a stranger to their dialect, as I suppose
this is!

—Anna Howe to Clarissa (213)

Clarissa is a war of social dialects, where the battles are acts of trans-
lation. In the epigraph, Clarissa (and the reader) receive Miss
Howe's account of Mr. Hickman's account of his conversation with
Belton and Mowbray. (Howe, anxious to gain more detailed infor-
mation on Mr. Lovelace's morals, has sent her suitor to London to
converse with the rake's cronies.) Each sifting represents a move up-
ward on the scale of delicacy, from the crassness of Mowbray to the
sobriety of the male Hickman to the very different sphere of lan-
guage appropriate for ladies. The original utterance—"I say, Bob
does seduce a lot of women" or some similar crudity—undergoes a
remarkable number of siftings before it arrives at the reader. Since
Anna Howe and Clarissa share the same dialect, the final transmis-
sion of language, in Anna's letter, seems least problematic. The fil-
tering process characterizes each of the speakers and quoters in
terms of his or her familiarity with the rakes' "dialect." Mowbray and
Belton are identified with this dialect, Anna Howe rejects it entirely,
and poor Hickman, able to converse in the dialect, but only as a
"second language," finds that this ability gives him an ambiguous
status in the eyes of his fiancée. Most striking of all, however, is the
way that these various social layers reveal and determine rather than
cover or efface each other. Anna's formulation is able to expose

them all simultaneously, as the Grand Canyon provides a synchronic view of the geological history of northern Arizona. This simultaneous presentation of two or more speech genres is the main thrust of Mikhail Bakhtin's concept of dialogism.

The epigraph shows Anna Howe longing for a single, "decent" language as the lighter side of her realization that this monological world does not exist; not only must she dialogue with the languages that are there, but she must also use them in order to express herself. Similarly, Bakhtin's idea was that "we are actually dealing with somebody else's words more often than with our own. . . . Somebody else's speech makes it possible to generate our own, and thus becomes an indispensable factor in the creative power of language" (Pomorska, "Mikhail Bakhtin," 382).

Bakhtin proposed defining the novel as dialogized language. Dialogism describes not just the variety of dialects which may be present in novelistic discourse, but also the interaction between them, the fact that they speak for or against in speaking *through* one another:

> In the novel, literary language possesses an organ for perceiving the heterodox nature of its own speech. . . . Languages are dialogically implicated *in* each other and begin to exist *for* each other (similar to exchanges in a dialogue). It is precisely thanks to the novel that languages are able to illuminate each other mutually; literary language becomes a dialogue of languages that both know about and understand each other. (*The Dialogic Imagination*, 286)

Clarissa, however, does not merely present such dialogism; it theorizes it.

As Caryl Emerson has noted in "The Outer Word," dialogism also implies translation: "Each dialect reflects and embodies a set of values and a sense of shared experience. Because no two individuals ever entirely coincide in their experience or belong to precisely the same set of social groups, every act of understanding involves an act of translation and a negotiation of values" ("The Outer Word and Inner Speech," 24). Emerson's formulation is similar to George Steiner's dictum that "inside or between languages, human communication equals translation" (*After Babel*, 47); or indeed to Derek Bickerton's interesting hypothesis that the first language was necessarily a pidgin, i.e., the transposition of one idiolect into another and of "cultural language" onto "biological" or conceptual language.

Emerson's "and" is also an "as": "Every act of understanding in-volves an act of translation *as* a negotiation of values." Those values are not personal, but social in nature and embedded within language itself. Though Hickman's phrasing in the epigraph is blatant enough to arouse Anna Howe's suspicions, it is undoubtedly not the exact phrasing used in his conversation with much cruder men. In other words, this rakish dialect appears to us only in the form of a transla-tion. Rakish dialect and feminine decorum somehow exist for and illuminate each other in this quotation. This translation, like that of Michaelis, is more willing to bend the target language (Anna's dia-lect) than the original. It is this bending, this intrusion of rakish dia-lect into polite society, which Anna perceives as an invasion.

A letter from Clarissa, however, executes a more Prévostian trans-lation of rakish dialect. Clarissa shares Anna Howe's linguistic fastid-iousness, rejecting Miss Partington, one of the guests at Lovelace's collation (i.e., a whore dressed up and pawned off as a gentlewo-man), because she shows no displeasure at "some talk from the gen-tlemen, not free enough to be openly censured, yet too indecent in its implication to come from well-bred persons" (542). Lovelace and his friends "in what they went out of their way to say, must either be guilty of absurdity, meaning *nothing*; or, meaning *something*, of rude-ness" (543). The reader is of course curious to hear what this conver-sation could be, but Clarissa's translation remains at this level of paraphrase. Her reporting bears a remarkable similarity to Prévost's footnotes, characterizing language that is too indecent or absurd to be reproduced. Paradoxically, Clarissa's refusal to reproduce certain dialects is vital to her identity as translator. And as with Prévost, what is said turns out to be less important than its ability to define social categories. Clarissa has reproduced not language, but the struggle between opposing language systems. As in Prévost, not ut-terance but genre is important, and translation becomes a struggle *between* languages rather than a movement from one to the other.

Thus two ideas can be developed from the title of this chapter. One could see the word "dialogism" as a direct object of the verbal "translating." The subject of the chapter would then be how to trans-late the logomachia of *Clarissa*, how to render the multiplicity of so-cial dialects found in the novel into French or German. The other idea requires a hidden comma between the two words of the title, making them nouns in parallel. Such a repressed "as" reveals that in considering the translations of *Clarissa*, the act of translation itself emerges as a war between dialects.

Clarissa's Dialects

The English language is unmasked in *Clarissa* as a competition
between its various components or "dialects." Within the word "dia-
lect" lies both the positing of a linguistic system and the limiting of
that system to deviances from another, larger norm. The *O.E.D.*
gives only two basic meanings for the word "dialect," both of them
current in the eighteenth century. One meaning equates the word
with "phraseology or idiom." The other meaning is more familiar to
modern readers: "one of the subordinate forms of a language." De-
fining *Clarissa*'s linguistic universe requires the replacement of "sub-
ordinate" with "competing."

The inability of the translators to participate fully in Richardson-
ian dialogism is indicated by their neglect of the specificity of the
term "dialect." In rendering the epigraph to this chapter, both trans-
lators avoid the specificity of this key word: "Il me semble que leur
langage t'est familier" (II, 65); "Du scheinst kein Fremdling in ihrer
Sprache zu sein" (II, 24). Prévost's use of "langage" for "dialect" in-
troduces ambiguity, for the word can mean either language in gen-
eral, or dialect, or the linguistic style of a single individual. Further
passages show a similar flattening. Rosebud, the "natural" country
girl who lives near the inn where Lovelace stays, is marked lin-
guistically when she is recorded by Lovelace making grammatical er-
rors in the phrase "a widow neighbour's son, living (to speak in her
dialect) *at the little white house over the way*" (162). Lovelace humor-
ously reproduces Rosebud's use of "over" rather than "across" in a
kind of linguistic slumming. The activity is not innocent. Lovelace
contemplates ruining the girl, an act which he supposedly could ac-
complish with consummate ease given the girl's lower-class origins.
The identification of her "dialect" defines those origins, and thus
from Lovelace's remark flows the whole tension between him and his
prey.

The passage is rendered in French as "fils d'une veuve qui de-
meure de l'autre côté de la rue" (I, 388). In an effort to reproduce
the ungrammaticality of "over," Prévost has substituted "de" for "à."
More significantly, however, he has removed Lovelace's parentheti-
cal remark identifying Rosebud's words as belonging to a specific
dialect. Mistake replaces alternate system. Similarly, the German
uses an ungrammatical "über." Rosebud speaks of "einem jungen
Tischler, dessen Mutter eine Witwe in der Nachbarschaft ist . . . der
nach ihrer Redensart, in dem kleinen weißen Hause über dem Wege
wohnt" (I, 388). Whereas Prévost eliminates Lovelace's linguistic re-

marks, Michaelis translates "Dialect" with a term so ambiguous that the German reader must decide Lovelace's degree of linguistic awareness. Adelung defines "Redensart" simply as "phrase" or "sentence," in which case Lovelace would be making no specific comment on Rosebud's language as a dialect, but merely identifying it as a grammatical unit. It seems unlikely that Michaelis had this in mind, and Adelung points out in his entry for "Redensart" that the term is often confused with the very similar-sounding "Redeart." If Michaelis is making such a confusion, then ambiguity does not cease, for "Redeart" can mean either dialect ("Mundart"), or "idiom"; that is, it can refer either to the language of a particular social group, or to personal style. It is interesting to contemplate the terms Michaelis avoids: it is understandable that he declines to use the more scientific term "Dialekt," but rather surprising that he does not use the convenient term "Mundart," which in eighteenth-century Germany could have the widest possible meaning, from colloquial city language to dialect proper, to supra-regional educated German, or in fact to anything spoken (Wells, *German*, 314). The result is that both "*de* l'autre côté" and "*über* dem Wege" will likely be read only as idioms, rather than as forms of speech linking the speaker to a particular social group.

Clarissa uses the word "dialect" in one of her interviews with Lovelace shortly after he has abducted her. Here the term "dialect" has neither Lovelace's meaning, nor its present meaning, nor the meaning of "idiom" with which the German translator identified it. Lovelace talks of the possibility of his reforming, and Clarissa lauds him by saying "you know not how much you please me, that I can talk to you in this dialect" (444). The linguistic conflict—here assuaged—is much the same as in our epigraph. Lovelace, in speaking of reform, has cast aside gallant rhetoric and taken up Clarissean moral dialect. Again, the linguistic emphasis in Clarissa's utterance is remarkable; translation is no longer necessary between rake's dialect and sermonese. The passage demonstrates that one explanation of the failure of communication between Clarissa and Lovelace is their speaking of different dialects, and their lack of an interpreter.

Clarissa's use of the word indicates an awareness that hers is but one of many competing dialects, with no guarantee of victory. Both translations tone down her temporary victory. Prévost has even turned things around, so that it is Lovelace who gives Clarissa the opportunity of speaking. The passage appears in French as "Vous ne savez pas combien vous me faites de plaisir, lorsque vous me donnez occasion de vous parler dans ces termes" (III, 184). Similarly, Michaelis changes "you please me" to "ich freue mich über sie" ("I

am happy for you"): "Sie glauben nicht, wie ich mich über sie freue,
daß ich einmahl in dieser Sprache mit ihnen reden kann" (III, 217).
Here the French translator has developed the same strategy as the
German translator did when he used "Redensart" for "dialect." The
focus is on the *terms*, the lexicon, and not on the fact that Lovelace
and Clarissa speak two different dialects. Michaelis has translated
"dialect" so as to remain on the borderline between content and
style, since "in dieser Sprache" could mean "in this manner of speak-
ing," as well as "in this language." But "Sprache" brings a sense of
wholeness and monologism to the discourse which are not present in
the English "dialect."

So far "dialect" has designated the speech genres of different
moral and social groups. There are also the dialects of gender. Love-
lace uses the term as he imitates what he believes to be female dic-
tion: "How my heart then went *pit-a-pat!*" (792) was amended in the
third edition to "How my heart then went *pit-a-pat!* to speak in the
female dialect" (*Clarissa* 1930, V:127). Both translators have refused
to reproduce the supposedly female "pit-a-pat," opting instead for
paraphrase: "Quelle émotion de couer j'ai senti!" (V, 85); "wie
pochte und klopfte mir hiebey das Herze!" (V, 294). It is possible
that both translators left out "pit-a-pat" because neither of them was
able to find appropriate words to translate it, in particular to repro-
duce it as female dialect. Lovelace continues his analysis of female
dialect a few pages later: "These women think, that all the business
of the world must stand still for their *figaries* [a good female word,
Jack!]. . . . After all, methinks I want these *tostications* [Thou seest
how women, and womens words, fill my mind] *happily* over" (818).
Here the translations diverge only to reach identical points of incom-
prehension. The French and the German eliminate both the dialect
words and Lovelace's reference to them. Prévost eliminates all refer-
ence to women: "Après tout, Belford, j'ai besoin d'avoir l'esprit & le
coeur agités par cette variété de scènes, pour goûter mieux, quelque
jour, la douceur du repos" (V, 148). Michaelis tries to keep the refer-
ences to female words, but fails to justify those comments through a
selection of differentiated German words: "'Dergleichen Weibes-
leute bilden sich ein, daß alle Geschäfte in der Welt um ihrer einge-
bildeten Mutterbeschwerden willen,' ein Wort das sich gut für die
Weiber schickt, Bruder! 'liegen bleiben mussen. Wenn ich alles
überlege: so deucht es mich, es wäre wohl einmal für mich nöthig,
daß diese Wehen;' du siehst, wie voll mir der Kopf von Weibern und
ihren Worten ist" (V, 380–81). "Mutterbeschwerden," commonly
used for the complaints of pregnancy, and "Wehen," for labor-pains,
are both clearly oriented towards the female; but that is not Love-

lace's point. He is propounding the existence of a female dialect, with a separate lexicon of words never used by men. For example, "tostications" probably is known as a woman's word because it is identified with ignorance, deriving as it does from the mispronunciation of the word "intoxication" by the uneducated. In addition, the word came to have its own separate meaning of "agitation, distress," in short anything that makes one toss and turn. "Figaries" is probably a version of the word "figgeries," the ornaments worn on women's clothes. According to Lovelacean linguistics, women's words show women's preoccupations and women's ignorance. In this respect the German translation fails to show any regard for the existence of a separate female dialect. Indeed, Lovelace's first comment is changed to accommodate this new situation: "female word" becomes "ein Wort, das sich gut für die Weiber schickt." The word no longer belongs to women; it merely can be used by men to describe them. But in one sense, this elimination of Lovelace's "discovery" of an alleged female dialect in translation is correct; Lovelace's linguistic explorations are hardly scientific in nature. His identification of a female dialect is an act of depreciation and aggression, a caricature. The real difference between male and female dialects in this novel lies in a completely different aspect of communication, the dialectic between speech and silence, confession and disguise.

Public Discourse, Private Passion

In criticizing the friendship between Anna and Clarissa, Lovelace momentarily abandons parody in order to formulate a theory of women's language, a theory which adopts the strategy of emptying that language of any content and denying it the possibility of functioning as discourse. The following invective hinges on the supposed difference between a male language connected with power and action, and a female language of fluid, disembodied signifiers batted about among themselves:

> These vehement friendships are nothing but chaff and stubble, liable to be blown away by the very wind that raises them. Apes! mere apes of *us*! they think the word *friendship* has a pretty sound with it; and it is much talked of; a fashionable word: And so, truly, a single woman, who thinks she has a Soul, and knows, that she wants something, would be thought

> to have found a fellow-soul for it in her own Sex. But I re-
> peat, that the word is a *mere* word, the thing a mere name with
> them; a cork-bottomed shuttlecock, which they are fond of
> striking to and fro. (863)

Lovelace uses the word "ape" literally, questioning thereby whether
women's language is language at all, and denying them a soul. Lan-
guage for Lovelace, for the male, is action. For the female it is mere
language, that is, mere signifiers linked together and used according
to their sensual properties ("a pretty sound"), rather than according
to their connection with respective signifieds. Women's dialect is
then a noisy silence; but it is also poetry, the perfect sensuous dis-
course. Lovelace defines women's discourse in the same terms that
post-structuralism (in particular Jacques Lacan) will reserve for lan-
guage in general: a chain of signifiers with a fluid and mysterious
relation among themselves rather than to any signified. Lovelace's
perception here is just as false as his invention of women's words,
and yet it is also a self-fulfilling prophecy, a theory which makes
itself come true, inasmuch as language is always public, and can only
mean as it is perceived to mean.

Indeed, the difference between Lovelace and Clarissa as allegories
of two competing linguistic philosophies is one of the governing
metaphors of this book. And Richardson himself, in a letter to Stin-
stra dated 20 March 1754, posited a linguistic theory separating the
male from the female: "As to the Knowledge I seem to have had of
the wicked Hearts and Actions of such Men as Lovelace, which en-
gages your Wonder, I have been always as attentive to the Commu-
nication I may say to the profligate Boastings of the one Sex, as I
have been to the Disguises of the other" (Slattery, *Richardson-Stinstra*,
71). This unequal symmetry is paradigmatic of the relation between
male and female dialects.[1] Boasting is a garrulous deception, a hid-
ing of fact within the folds of discourse. Disguises, on the other
hand, are usually nonlinguistic; they place women in the realm of
appearance, of spectacle. Thus Richardson subtly confirms the pro-
cess, which is all too apparent in *Clarissa*, of denying women access to
discourse. This is but one more dialectic of *Clarissa*, that so many
pages of this novel, which unleashes woman's voice as no other En-

1. Unequal symmetry between the sexes is seen, for example, in the table of con-
tents of one of the most popular English books on marital life, William Gouge's *Of
Domesticall Duties* (1622), which reveals a perfect balance: for every male duty and
injunction there is a female counterpart. A closer look reveals the inequality in the
duties themselves, and their separation into public (male) and domestic (female)
spheres.

glish novel had done, should depict the suppression of its heroine's voice. The dialogism in *Clarissa* between male and female discourse takes the form of a dialectic between language and silence. Male discourse derives its power from the silencing of women, as Lovelace attempts to "silence" Clarissa and Anna in the above passage. This dialectic is exemplified by Clarissa's statement about the relation between herself and Lovelace: "I am but a cypher, to give *him* significance, and *myself* pain" (IV, 40). Terry Castle has interpreted the "cipher" as a code, making both Clarissa and her language indeterminate (*Clarissa's Ciphers*, 15–16). The word does not mean code here, but simply the number "0"; Clarissa complains not of the incomprehensibility of her language, but of its silence, its lack of force, a lack that paradoxically inflates the power of Lovelace's discourse, just as a zero to the right of a one increases its power to ten (see Beebee, "Deciphering the Word 'Cypher'). Our analysis of female dialect is then not based upon style or lexicon, but upon the different fundamental relationships between language and truth, language and body found in the different genders. Silence, for example, both voluntary and enforced, is a dialect more familiar to women than to men in *Clarissa*. The issue for translation now becomes not so much how to reproduce different dialects but how to reproduce language's varied relationships to nonlinguistic systems, e.g., to physiology or to silence.

Yet Terry Eagleton, writing from the same Lacanian perspective as a number of feminist critics have done,[2] uses Lovelace's model of the difference between female and male discourse only to assure us that *Clarissa* reverses it:

> The paradox of *Clarissa* is that Clarissa's writing is "masculine," whereas Lovelace's is "feminine." It has been claimed that men and women under patriarchy relate differently to the act of writing. Men, more deeply marked by the "transcendental signifier" of the phallus, will tend to view signs as stable and whole, ideal entities external to the body; women will tend to live a more inward, bodily relationship to script. . . . Clarissa herself exerts the fullest possible control over her meanings. . . . Lovelace's writing is mercurial, diffuse, exuberant." (Eagleton, *The Rape*, 51–52)

2. For a Lacanian analysis of *Clarissa*, see Katherine Cummings's "Clarissa's 'Life With Father.'" Though not speaking from a strictly Lacanian perspective, Judith Wilt notes like Eagleton the "female" qualities of Lovelace and his language in "'He Could Go No Farther.'"

In one sense Eagleton's claim is accurate. Certainly many critics have felt that Clarissa's is the patriarchal language "of containment, repression, relearning" (Taylor, "An Odd and Grotesque Figure," 75). Clarissa's language cannot merely be lifted out of this dramatic novel and posited as its dominant mode, but must be analyzed in the act of being denied, contradicted, and silenced by the novel's other characters.[3]

Thus our themes of language as silence, as physiology, and as disguise are explored to their fullest in Clarissa's feelings for Lovelace. The ambiguity surrounding her feelings for the rake is essential to the novel's plot, provoking Lovelace's continued attentions, and the equal and opposite reaction to them from her family. Clarissa never affirms her love; she only rejects simultaneously the possibility of her affection for Lovelace and her family's objections to him. Richardson hesitated over whether to allow Clarissa to be in love with Lovelace at the beginning of the novel or not. Such hesitation reflects the ambiguous status that the ideology of women and women's discourse took in his novel. The delicacy of Richardson's intention is shown in the following letter to Aaron Hill, dated 29 October 1746: "As to Clarissa's being in downright Love, I must acknowledge, that I rather chose to have it imputed to her . . . by her penetrating Friend, (and then a Reader will be ready enough to believe it, the *more* ready, for her not knowing it, or being blind to it herself) than to think *her self* that she is" (Carroll, *Selected Letters*, 72). This subtlety made no impression whatever on the majority of readers, who, obeying the social imperative of disbelieving a woman's denials, could see only that Clarissa was passionately in love with Lovelace. One such reader was Voltaire, who commented in a letter to the Marquise du Deffant (12 April 1760): "Cette Lecture m'allumait le sang; il est cruel, pour un homme aussi vif que je le suis, de lire neuf volumes entiers, dans lesquels on ne trouve rien du tout, et qui servent seulement à faire entrevoir que Mlle. Clarice aime un débauché nommé Mr. de l'Ovelace" (Besterman, *Lord of the Manor*, 194; "Reading this book got my dander up; it is a cruel thing for a clever man like me to have to read nine volumes in which nothing at all happens, and which only serve to show that Miss Clarissa loves a debauchee named Sir d'Ovelace"). For Voltaire the novel *Clarissa*, like its heroine, disguises rather than reveals the truth about itself. The nine volumes confirm that Voltaire was reading Prévost's translation, where steps

3. Eagleton also ignores Clarissa's ability to change styles in Lovelacean fashion, to assume, for example, the rhetoric of legal discourse (which she in turn "feminizes"), or of she-drama. See William J. Farrell's "The Style and the Action in *Clarissa*."

were taken to insure the recognition of a love story. Voltaire's peculiar spelling and addition of "de" before Lovelace's name indicates the elevation of his status in translation. (One of Wilcox's most penetrating points in his study of Prévost's translation concerns the filing and censorship carried out by the translator in order to whip Lovelace's language into proper aristocratic elegance.) This elevation of social status and of discourse in the male implies an opposite reaction, the relegation of female discourse to the margins of language. Thus the vehemence of Voltaire's affirmation of Clarissa's passion.[4]

A twentieth-century English critic subtly echoes Voltaire. Mark Kinkead-Weekes's view of Clarissa's emotional state differs little from that of Voltaire, but he correctly repeats Richardson's claim that the text itself authorizes such an interpretation in the voice of Anna Howe, who almost from the beginning of the novel pounces upon Clarissa's "conditional liking" for Lovelace:

> From this moment the eagle eye of Anna is continually on the lookout, and so should ours be. Her claim that Clarissa gives herself away in fifty instances may be exaggerated, but there are certainly enough to show the progress of a strong attraction, difficult though it may be to distinguish from the way the persecution turns her towards Lovelace, and little though she realises it herself. (*Samuel Richardson*, 167)

This quotation strangely posits a "strong attraction" which cannot be located in the mind of the attracted, nor isolated from the plot. What could have been the pressures making such an erotic force invisible?

For women of eighteenth-century England, silence about passion was the expected behavior. Katherine Rogers reports that women were customarily silent about their feelings towards men because "a mere positive preference on her part was taken as evidence of 'somewhat warm desires.' This sinister imputation so frightened women that they hesitated to admit that they loved" (*Feminism*, 11). Other women in this novel also conform to this accepted model of female discourse. When Anthony Harlowe courts her widowed mother, Anna Howe is appalled; she is more appalled, however, when she

4. Voltaire goes on to condemn *Clarissa* (or rather the *Lettres angloises*) in terms which show that for some, Prévost did not omit enough of the text to make it readable: "J'avoüe que le reste ne m'a fait aucun plaisir, et que je ne voudrais pas être condamné à relire ce roman anglais" (Besterman, *Lord of the Manor*, 195; "Let me say that the rest of it did not please me at all, and that I would not want to be condemned to re-read this English novel").

senses behind the pro forma denial of her mother (Richardson gives both proposal and rejection in full) a certain willingness to be persuaded otherwise: "It vexed me heartily to have her tell me of this proposal with self-complaisant simperings; and yet she affected to speak of it, as if she had no intention to encourage it" (589). In this formulation Anna manages to simultaneously record her mother's words (that she will not encourage the proposal) and her own reading of those words (that she will indeed encourage it). Here the reporting of discourse becomes simultaneous with its interpretation, as we witness the translation of feminine denial into masculine encouragement.

The evident self-contradiction of Mrs. Howe's behavior of encouraging-by-denying, the complexity of a communication situation in which a person can say one thing and mean its opposite, and the resulting need to translate disguise simultaneously with its detection, are all factors which complicate translation. In the German, the focus of the sentence shifts to Anna's position against the proposal. Mrs. Howe's language is not to be read oppositionally, as it is in the English. The transformation of the adjective "self-complaisant" into the nouns "Eigenliebe" and "Einbildung" eases the contradiction of "self-complaisant simperings," and it is only stated that Mrs. Howe spoke of the proposal as though Anna had nothing to worry about, not that her mother meant the opposite of what she said. Only the subjunctive remains as a clue to the real meaning of Mrs. Howe's words: "Es verdroß mich im Hertzen, als sie mir von dem Antrage Ihres Onckels mit einem solchen Schmunzel-Lächeln Nachricht gab, welches ihre Eigenliebe und Einbildung so gleich verrieth; wiewohl sie sich Mühe gab, so davon zu reden, als wenn ich nichts zu besorgen hätte" (III, 65). It is interesting that in the last clause Michaelis has given Anna's subtext rather than her words—exactly as Anna has done with her mother. Anna speaks only of her mother encouraging the proposal or not; the German speaks only of her having cause to worry (about this encouragement) or not.

Like Michaelis, Prévost makes the "mistake" of removing Mrs. Howe's contradictory ability to communicate with "self-complaisant simperings." More radically than Michaelis, Prévost will locate the oppositional, hidden discourse in body-language, in an air of satisfaction "répandu sur son visage" that contradicts her words. Two separate semiotic systems replace a single language working against itself. Furthermore, here as in the German there is no indication that Mrs. Howe may end up encouraging the proposal: "J'ai souffert beaucoup de l'air de satisfaction qui était répandu sur son visage

lorsqu'elle m'a communiqué les propositions. Cependant elle affectait de m'en parler comme une chose qui la touchait peu" (IV, 71).

This dialectic of encouragement through denial parallels that of an earlier situation in which Lovelace had proposed to Clarissa's sister Arabella. Arabella also rejected Lovelace's suit, hoping that she would have a chance of encouraging it later. Using a paradoxical formulation similar to that of Anna Howe, Clarissa talks of her sister's "consenting negatives." Here the German translator preserves the oxymoron ("bejahende Verneinungen"), while Prévost backs off, weakening the paradox through a relative clause and the use of "croire" ("d'autres négatives, que je crois pouvoir nommer un consentement"). Elsewhere Clarissa attempts to identify the real cause of Arabella's artifice as the male repression of women's language. And here too, the translators come up short. In a letter to Anna, Clarissa quotes a female poet on the subject of man-made language:

> Miss Biddulph's answer to a copy of verses from a gentleman, reproaching our sex, as acting in disguise, is not a bad one, altho' you perhaps may think it too acknowledging for the female character.
>
> *Ungen'rous sex!—To scorn us if we're* kind;
> *And yet upbraid us, if we seem* severe!
> *Do* you, *t'encourage us to tell our mind,*
> *Yourselves, put off disguise, and be sincere.*
> YOU *talk of coquetry!—Your own false hearts*
> Compel *our Sex to act dissembling parts.*
>
> (44)

The poem admits that women are not to be believed, but excuses their subterfuge as a defense against male abuses. In her introduction, Clarissa confirms the accuracy of the poem's view of women's dissembling, for she finds that the poem itself breaks the taboo of silence in acknowledging that dissembling. She writes that Anna (but hence not herself) might find such a confession "too acknowledging for the female character." In other words, to admit the existence of female disguise is already to violate the performative rules of female discourse. The dialectic between language and silence is recapitulated in the ambiguity of "female character," which points simultaneously to the core of the self (synonym "nature") and to mimesis (synonym "rôle," or "part," as in the last line of the poem; this meaning of "character" was relatively rare in Richardson's time, but occurs in the preface to *Clarissa*). Not to mention a third, ety-

mologically more basic meaning from which all others derive: character as brand or stamp, as *letter*. In this third reading, Anna would be in favor of banishing truth from female writing altogether.

As we have seen in chapter 3, translation must usually opt for one side or the other of a dialectic. And it is no surprise that Michaelis, the Clarissean, opts for a side of "female character" which points to the true and the unproblematic. In fact, "Character" receives no translation at all. In the German, Clarissa makes no judgement about the appropriateness of the poem as a sample of female discourse. She merely laments the candor ("freymüthig") with which "mistakes" are acknowledged. "Fehler" is ambiguous, meaning either "error" (as in "sin") or simply "mistake":

> Mir gefällt die Antwort der Fräulein Biddulph auf einige Verse, die von einem jungen Herrn herumgehen, der sich über die Verstellung des Frauenzimmers lustig machte: Sie werden nichts daran tadeln, als daß unsere Fehler zu frey-müthig bekannt werden.
>
> Du niederträchtiges Volk das Zärtlichkeit verlacht
> Wenn es durch falschen Schwur die Schönen zärtlich
> macht?
> So bald wir spröde sind, und unsre Gunst verheelen,
> Höhnt ihr die Blödigkeit ihr pöbelhaften Seelen.
> Entschließt euch selbst zuerst zu offner Redlichkeit,
> So wird dem Redlichen ein offnes Herz geweyht.
> Sonst spottet unsrer nicht: es liegt in euren Ränken
> Die Ursach, daß wir nicht so reden, wie wir denken.
>
> (I,17)

As the women have become more honest, so this woman's poem has exceeded the bounds of feminine decorum. Words such as "niederträchtig," "pöbelhaft," and "Blödigkeit" represent a much stronger and more direct diction, and reveal a much more masculine dialect than is found in the original. "Spröde" has a much more explicitly (anti)sexual meaning than "severe." Adelung's definition of "spröde" shows that the word, like the English "pert," is an asymmetrical adjective applicable only to females: "Es ist von dem andern Geschlecht am üblichsten, wenn es die Liebkosungen des männlichen mit Kaltsinn oder Ungefälligkeit aufnimmt" ("it is most commonly used to describe the female, when she receives the caresses of the male with coldness or displeasure"). Michaelis uses the word elsewhere to express the English "prudish." Because of its explicit

sexual content and predominant usage by males, the utterance of "spröde" by a woman in polite discourse—not to mention in the public genre of verse—was highly unusual in the Germany of this period. This lexical choice certainly gives these verses the ring of a woman assuming a rôle, mimicking masculine dialect. The poem's last line, with its contrast between speaking and thinking, conveys more explicitly than the English the split for women between public and private language, and yet that split is overcome in the German more forcefully than in the English through the elimination of Clarissa's remarks, and through the creation of a female dialect of directness. There is perhaps another reason for the relative vehemence of the German, for Michaelis identifies the gentleman's verses to which it responds as Lovelace's! A footnote at the bottom of the page says simply "*Siehe den 31. Brief," which is Lovelace's first letter in the novel. In other words, Lovelace is "der junge Herr." Lovelace's own emphatic style is then seen to have colored the Fräulein's response. Such an attribution, an act of pure invention on Michaelis's part, gives a good indication of his understanding for the relation between Clarissa and Lovelace as synecdoche for the dialogism between male and female discourse in general.

Prévost has responded to the mimetic element of the passage by allowing the poem to blend into Clarissa's own discourse. Whereas Michaelis's negative "Fehler" was used to remove the problem of language, allowing the creation of a freer female dialect in the following lines, Prévost's use of the word "libre" makes the passage imply that female dialect is proper only when unfree and imprisoned, bound to the rules of decorum. Paradoxically, the absence of any markers between Clarissa's introduction and the poem itself makes it read like a "free" translation, particularly since she, like Prévost in his translation (cf. the discussion in chapter 2, 58–59) identifies the poem as "vers" and gives us prose. The poem is accordingly rendered in abstruse, polished, and indirect language; similarly, the metaphor of reading ("vous faire lire dans notre coeur") and the preservation of "déguisement" emphasize the fictional side of the female character:

> La réponse de miss Bidulphe à quelques vers d'un homme qui reprochait à notre sexe d'aimer le déguisement, n'est pas trop mauvaise, quoique vous la puissiez trouver un peu libre de la part d'une femme. Sexe peu généreux, de prendre droit de notre facilité pour nous mépriser, & de nous accabler de reproches si nous paroissons trop sévères! Voulez vous nous en-

courager à vous faire lire dans notre coeur? Jetez le masque vous-memes, et soyez sincères. Vous parlez de coquetterie; c'est votre fausseté qui force notre sexe à la dissimulation. (I, 17–18)

So pervasive is the notion of female dissembling during courtship that Clarissa feels herself obliged to take the opposite tack in rejecting Solmes. Her dismissal of him is plain, even brutal. Her explanation of her rudeness to her mother is equally plain: "If I did not speak with earnestness upon it, I should be supposed to have only maidenly objections against a man I never can abide" (95). The phrase "maidenly objections" or "maidenly reservations" is often used to resume the whole theme of female discourse. In the word "maidenly," however, the theory of woman's discourse as dissembling meets the theory of feminine language as located in the body. "Maidenly" objections are those of the virgin afraid of penetration; but they are also those of the sheltered female lacking adequate knowledge and reasoning power. Thus "maidenly objections" are simultaneously those of the body and those of the symbolic order imperfectly mastered by (young) women.

Only the latter idea is picked up in the translations. Thus Michaelis inserts "Grillen," an anodyne term equally applicable to men and to women: "Wenn ich nicht ernstlich redete, so würde es scheinen, als hätte ich nur einige Grillen, nach Art der Mädchens, im Kopfe, da mir doch der Mann ganzlich unerträglich ist" (I, 179). There is left only a sense of the arbitrariness of female whims ("Grillen") and none of the sexual nausea Clarissa experiences when she views Solmes or when he presses on her hoop. Prévost's choice of "jeune fille" as opposed to "vierge" has a similar cooling effect: "S'il y avait moins de chaleur dans mes discours, on supposerait que je n'ai que des objections de jeune fille, contre un homme qui me sera toujours insupportable" (I, 177).

Phrases such as "maidenly objections" function as switches between the two models of female discourse. The model we have seen so far posits a fairly simple relation between truth and disguise. Women's words in matters of passion are simply meant to be read as their opposite. But there is a second, deeper problem of feminine discourse which posits a more complex translational procedure. Richardson's predecessor in realist fiction, Daniel Defoe, has given us an example filled with boundless irony. His Colonel Jack (from the novel of the same name) gives a detailed description of the same complicated courtship ritual we have seen in *Clarissa*:

As we Convers'd freely together in Publick, so she took a great many Occasions to rally the Men, and the weakness they were guilty of, in letting the Women insult them as they did; she thought if the Men had (not) been Fools, Marriage had been only Treaties of Peace between two Neighbours. . . . I told her I thought it was a Decency to the Ladies to give them the Advantage of denying a little, that they might be Courted, and that I should not like a Woman the worse for denying me. I expect it Madam, *says I*, when I wait on you to Morrow, intimating, that I intended it; you shan't be deceiv'd Sir, *says she*, for I'll deny now, before you ask me the Question. . . . We said a Thousand ill-natured things after this, but she out-did me, for she had such a Stock of bitterness upon her Tongue, as no Woman ever went beyond her, and yet all this while she was the pleasantest, and most obliging Creature in every Part of our Conversation that could possibly be, and meant not one Word of what she said, no, not a Word. (*Colonel Jack*, 188–89)

Jack mentions the incompatibility of the woman's "publick" words with her true feelings (the interlocutors later marry), but says nothing about his own discourse, which from start to finish here is ironic. The true meaning of this woman's conversation lies not in her language at all, but in her body, in her assumed disposition as a pleasant and obliging creature, a disposition which is expressed not through language but through intonation and expression. Yet there is a further irony: after marrying her, Jack promptly discovers that this woman really is as misanthropic as her words imply. As a wife she is most unpleasant and unobliging, and Jack soon leaves her.

Faced with the seemingly unfathomable deception of female dialect, both Anna Howe and Robert Lovelace feel called upon to invent nonlinguistic tests to determine the ineffable state of Clarissa's affections. Despite Clarissa's careful denials in the first part of the novel, Anna Howe is convinced that her friend has more than a "conditional liking" for Lovelace—perhaps because Anna herself is attracted. She devises a lie-detector test, i.e., a process that will translate physiological responses into language disclosing the truth. In a letter to Clarissa, Anna suddenly breaks off a discussion of Lovelace and asks the reader for her physiological responses: "But I will not make you *glow* as you read!—Upon *my word*, I won't.—Yet, my dear, don't you find at your heart somewhat unusual make it go throb, throb, throb, as you read just here?" (71). In Anna's question lan-

guage becomes sensual; the rhythmic repetition of syllables conveys the idea that Clarissa's true feelings literally lie deep within her heart, and are recuperable only through a testing of her involuntary system. As Irwin Gopnik puts it, "throb" here "becomes a verbal counter for the physiology of love" (*A Theory of Style*, 86). Yet not entirely verbal either. In other words, the question of translation— this time between verbal and nonverbal signifying systems—surfaces again. Anna is a "weak" translator from body into mind, producing a "rough" translation. She has allowed the source language, the language of the heart, to invade the symbolic order. Not one throb, but three are needed to transpose passion onto the page. Clarissa responds vehemently (and without the repetition of "throb") that there is no increase in heart rate when she reads about Lovelace. But in her response she also confirms the curious autonomy of her body, its obedience to a signaling system beyond her conscious control:

> *I* cannot own any of the *glow*, any of the *throbs* you mention.— *Upon my word*, I will repeat, I cannot. And yet these passages in my letter upon which you are so humorously severe, lay me fairly open to your agreeable raillery. I own they do. And I cannot tell what turn my mind had taken, to dictate so oddly to my pen. (72)

Again, the ironic use of "upon my word" by the two correspondents points to the very discrepancy between their real feelings and the narrow field of language permitted them in order (not) to express them. What Clarissa really feels about Lovelace remains a mystery.

Is it possible to render such a "hinge" sentence, which reveals two distinct signifying systems simultaneously, into yet *another* language? Both translators decline to reproduce the "throb, throb, throb" of Anna's question, as they also declined to reproduce Lovelace's "pit-a-pat" (see above, 124–25). Michaelis reverses the sensualization of Anna's question. His excessive subordination—first a relative clause, and then a "daß" clause—dilutes the physicality of the passage: "Finden Sie aber nicht eben bey Durchlesung dieser Zeilen eine ungewöhnliche Empfindung, die macht, daß Ihnen eine Röthe ausbricht, and daß ihr Herz stärker schläget?" (I, 103). Prévost too, while preserving the compactness and surprise of the question, eliminates its extra beats: "Cependant, ma chère, ne sentez-vous pas ici que le coeur vous bat?" (I, 104). Here the question has become so much a part of the linguistic order that it must always be answered with a "oui"—does not Clarissa's heart always beat? Perhaps Prévost was thinking of the idiom "son coeur lui bat" ("she loves him").

Lovelace's own test, in which he takes the poison ipecacuanha to induce vomiting and produce sympathy, is more succesful in uncovering Clarissa's feelings for him—or in producing them. It too depends for its effect upon surprise: Clarissa must suddenly be given the news and the evidence of his illness. It too calls forth a nonlinguistic response: Clarissa's body language, her running up and down the stairs, reveals worlds of meaning to Lovelace. In showing a concern for Lovelace which goes beyond the merely humane, Clarissa appears to have betrayed her love for him. In this case she almost concurs, writing afterwards that she has discovered more feeling for Lovelace than she had thought she had. Richardson's "editor," in writing the epitome of the letters for the third edition, was tight-lipped about what Clarissa had really discovered: "Acknowledges tenderness for Lovelace. Love for a man of errors punishable" (*Clarissa* 1930, IV:410). It is not clear whether the last sentence is meant to apply specifically to Clarissa's case, or to be one of the many moral maxims in the book. Clarissa herself still does not use the word "love." Her confession begins with what she calls kindness: "How lately did I think I hated him!—But hatred and anger, I see, are but temporary passions with me. One cannot, my dear, hate people in danger of death, or who are in distress or affliction. My heart, I find, is not proof against kindness" (678). A few paragraphs later, however, she concurs with Lovelace on the success of his lie detector, still without explicitly committing herself: "You will not wonder that I am grave on this detection—*Detection*, must I call it? What can I call it?—I have not had heart's-ease enough, to inspect that heart as I ought" (679). This passage, as the previous ones, shows Clarissa unable to investigate her own unconscious. She is curiously unable and unwilling, expressive and repressive: "I am afraid to look back upon what I have written. And yet know not how to have done writing" (679).

Clarissa, then, can never use the word "love." She always characterizes her feelings for Lovelace as relative and conditional, indicating that she could have liked him better than any other of his sex. Though she may not use the word "love," Lovelace triumphantly does, opening the door for all subsequent readers of the novel. And his first nonlinguistic test leads to another, more sinister one: the rape itself. Lovelace violates all of his principles and his promises to Belford by raping Clarissa, but sexual intercourse for him is a scientific instrument, the litmus test to ascertain whether Clarissa's body speaks another language than her mouth and her pen do.

Outside the family, Lovelace and Anna form a curious alliance in trying to make Clarissa speak. In contrast, her own family members

are concerned only with silencing her. If her silence about her feel-
ings for Lovelace is always read as a lover's discourse, the words she
uses to express her desires fail to function as discourse at all. To
merit the title of discourse, language must have an exchange value,
and Clarissa's has none. Her speech is denied by interruption; her
writing is erased by the simple refusal to read it. Clarissa's letters are
often returned unread or torn in two, and the letters that family
members address to her continually depreciate her writing and for-
bid her to write further. Indeed, it is remarkable how much lan-
guage is expended trying to keep Clarissa silent. Brother James re-
sponds to Clarissa's letters by denying the need for a response, or
rather by specifying that the only purpose of a response is to pro-
hibit further communication. James's letter abounds in paradox: "I
know, there will be no end of your impertinent scribble, if I don't
write to you. I write therefore: But, without entering into argument
with such a conceited and pert preacher and questioner, it is, to for-
bid you to plague me with your quaint nonsense" (138). The rela-
tionship between Clarissa's letters and those of her brother James is
a synecdoche for that between female and male discourse in general.
The latter is dialectically dependent upon the former. Male dialect is
constructed as mastery and *interruption* of female dialect. Thus
James's surprising formulation, "I know there will be no end of your
impertinent scribble, If I don't write to you." Such an idea reverses
the epistolary premise, examined in chapter 2, that one letter begets
another. What James has written is the contrapositive of what he
wants to say: "If I can end your writing, then I will be able to write."
That is, the power of masculine discourse is founded upon its ability
to silence the female. "All domination begins by prohibiting lan-
guage," as Roland Barthes says.[5] Nearly everything we read from
James or from Mr. Harlowe in this novel contains a prohibition of
Clarissa's language. James's tactic here is to label everything his sister
writes as "nonsense" unworthy of reading. The phrase "quaint non-
sense" anticipates Lovelace's defense against Clarissa's mad-papers as
"eloquent nonsense." Female writing is mere "scribble," i.e., marks
made on the page, traces of physical rhythms of the hand, neither
language nor action.

The German makes of Clarissa's "scribble" a "silly writing" ("al-

5. Barthes, *S/Z*, 68. But one need not cross the channel to encounter a theory of
male discourse as founded upon female silence. William Gouge's *Of Domesticall Duties*
names silence as one of woman's chief duties: "A wive's reverence is manifested by her
speech, both in her husband's presence, and also in his absence. For this end in his
presence her words must be few. . . . Too much speech implieth an usurpation of
authoritie" (281).

bernes Schreiben"), but this phrase already concedes more meaning to her writing than James would admit. Where the English has created an opposition between writing and scribbling, the German depreciates Clarissa's writing *as* writing. The latter part of the translated passage, however, is even more revealing of the cause of James's anger than the English: "Allein ich will nicht mit einem so naseweisen Mädchen, das mir prediget und Fragen zur Beantwortung vorlegt, in keinen schriftlichen Streit einlassen" (I, 310). In the English, what irritates James is being preached to and questioned. Only the adjective "pert," reserved for females like the German "spröde," implies that Clarissa has assumed areas of discourse which a female should not. In the German, we sense more directly that James refuses to allow a *girl* ("Mädchen") to preach and put questions to him. The idea of "schriftlicher Streit" is also an interesting reading of the English "argument." There exists a specific word "Streitschrift" in German, denoting a piece of writing used for public argumentation. James seems to be avoiding the kind of *public* argumentation so common to Germany and England in this period. "Streitschriften," like preaching, constituted a public activity in which women rarely took part.

The French translation also eliminates the references to what Clarissa *is*, but uses two words which perfectly mark the special category of what she *produces*:

> Je prévois qu'on ne verra pas la fin de votre impertinent griffonnage, si je ne prends pas le parti de vous écrire. Je vous écris donc; mais sans entrer en dispute avec un petit esprit plein de hardiesse et de présomption, c'est pour vous défendre de me tourmenter par votre joli galimatias. (I, 308)

Prévost shows interest only in James's attack on his sister's writing. He is not interested in marking off the areas of female competence—thus Clarissa is neither "preacher" nor "questioner" here. "Galimatias" is defined by Furetière as "discours obscure & embrouillé où on ne comprend rien" ("obscure and confused discourse where one understands nothing"). Though "Griffonnage" captures the otherness of "scribbling," it only depreciates the legibility of Clarissa's writing (the word can also refer to a botched painting), rather than its sense. Thus intentionality is once again recuperated.

Prévost never did come up with a translation for the word "scribbler." Where the word is applied to Clarissa, he left the sentence out of his translation. Michaelis too could find no equivalent for the word, just as he had found none for "scribbling." And his circum-

locution rescues Clarissa from her marginal position: "For nobody else [than James] was permitted or cared to write to such a *ready scribbler*" (220) becomes the very different "weil ich im Antworten so fertig war" (II, 44).

In the preface to his translation, Michaelis had shown an attitude towards women's writing which had much in common with that of Richardson. In turning to the question of the literary qualities of the text he is translating, he noted that *Clarissa* is a better work than *Pamela* mainly because Clarissa's style is much more elegant than Pamela's. He felt that he must defend the work against the criticism that women cannot write as well as Clarissa does, that their writing is always "scribble":

> Es haben einige gemeynt, die **Clarissa** schreibe zierlicher als ein Frauenzimmer schreiben könnte. Wenn Frauenzimmer selbst diesen Einwurf machen sollten, so rühret er gewiß entweder von ihrer Demuth, oder daher, daß sie nicht **Clarissen** sind. In dem Munde einer Mannsperson aber wird er weder höflich noch bescheiden lauten: und es wird immer die Frage seyn, welche Frauenzimmer ein solcher Tadler zum Muster nehme? Sind es vornehme Frauenzimmer von Verstande, von Belesenheit und Erziehung: so meyne ich, daß es manche solche Frauenzimmer den Mannspersonen in der Schreibart zuvor thun. Des Herrn von Bussy Briefe sind niemals so hoch geschätzt worden, als die von seiner Verwandtinn, der Frau von Sevigne. Der Uebersetzer ist hierinn so sehr verschiedener Meynung, daß er sich nicht unterstanden hat, die Ode zu übersetzen, die im zweyten Theile Bl. 80. mangelt, weil sie nach dem Zeugniß des Englischen Schriftstellers **von einem Frauenzimmer verfertigt ist, und dem ganzen Geschlechte zur Ehre gereicht.** (I, n.p.)

> (Some think that **Clarissa** writes more elegantly than a young lady ever could. If young ladies were to make this reproach, then it would come either from their modesty, or from the fact that they are not themselves **Clarissas**. Such a reproach out of the mouth of a man will sound neither polite nor modest: and the question will always be, which young ladies does this critic take as his model? If they are intelligent, well-read, and well-educated upper-class young ladies, then I believe that many such ladies surpass the men in this form of writing. Mr. von Bussy's letters have never been as highly valued as those of his relative, Madame de Sévigné. The translator is of

such a different opinion, that he has not dared to translate the ode, which is missing from page 80 of Volume Two, because it was composed **by a young lady, and dedicated to the entire sex,** as the English author tells us.)

After defending the possibility of women's writing as an art form, Michaelis introduces the paradoxical Prévostian idea of censorship as the highest form of tribute. Michaelis's version of the dialectic between honor and exile is embodied in his decision not to translate Elizabeth Carter's ode, because it is written by a woman and for women! Thus on the one hand, women's writing is as good as, or better than, men's, as the anecdote about Madame de Sévigné and her husband is meant to show. On the other hand, women's writing can appear only as an absolute difference, as the product of another race expressed in an alien language incapable of translation. Michaelis, as pointed out in the first chapter, could be called an early feminist, having presented a poetic petition to the king asking that women be allowed to attend institutions of higher education. His daughter Dorothea was the first woman to obtain a degree from a German university. We can see some resemblance between the contradictions of Michaelis's defense of Clarissa, and Richardson's own defense of the female sex.

Eighteenth-century France has generally been perceived as being different from England and Germany in regard to the equality of women's and men's discourse. We can see an example of this generalization about France from a near-contemporary of Richardson. In 1766 William Fordyce was proposing that women be allowed to speak, that their language be granted the status of discourse. As though commenting on Clarissa's predicament, Fordyce asked the readers of his *Sermons to Young Women*, "must women then keep silence in the house, as well as in the church? By no means" (I, 99). And in outlining the many benefits that female conversation could have for the male sex, Fordyce pointed out that in France women had always been allowed to converse with men. In his opinion Louis XIV was virtually saved from perdition by the graces of his conversation with Madame de Maintenon. Such salvation apparently was only available in France: "Madam Maintenon had from her youth improved herself by reading and the best company, whom her beauty and talents drew about her, in a country where the society of women is much more regarded than in this" (II, 17).

Women were often hosts of those centers of French literary (and political) life, the *salons*, while the literary life of London centered around the tavern and the coffee-house, both off-limits to women.

The rules of discourse in the *salon*, as George Steiner points out, were exactly opposed to those operating in *Clarissa*: "The *salon*, as it begins during the seventeenth century, exactly defined a neutral ground: one on which men and certain elect women . . . could claim and exercise equal rights of verbal instigation and response" ("The Distribution of Discourse," 71–72). The Brothers Goncourt go even further, giving women's language the upper hand: "There, in a woman's salon, under her shaping hand, was formed and perfected the polished France of the eighteenth century" (*The Woman of the Eighteenth Century*, 43–44). In the years preceding his translation of *Clarissa*, Prévost was a guest at the salons of Madame du Châtelet, lover of Voltaire and a prominent scientist, and also at those of Madame Doublet, from which originated the celebrated "nouvelles à la main."

But the effect of this different status of female dialect on Prévost is difficult to determine. He never, as Richardson did, elected to portray heroines in his novels. Naomi Segal's *The Unintended Reader* convincingly demonstrates the masculine point of view from which *Manon Lescaut* is narrated. From the evidence given above, Prévost seems much more likely both to have overlooked the marginalization of female discourse in *Clarissa*, and to have identified it with the plot elements rather than as synecdoche for the power relations between genders.

Prévost's translation enters into the same dialectic relationship with the original as we have seen between James's letters and Clarissa's scribbles. Prévost's language will be founded upon a repression of *Clarissa*'s. As with James, he will not allow his own language to enter into dialogue with another, but will simply label and reject. His translation resembles one of the dialogs of *Clarissa*, punctuated and interrupted. Yet the language of the original, like Clarissa's "pert" letters, occasionally breaks through and takes over the French text.

Translating Emotion

We have seen that Clarissa, like Lovelace and Anna Howe, is aware of her discourse as a dialect awash in a sea of other dialects, a situation which makes communication possible only through parlous translation. And like Lovelace, Clarissa sarcastically reproduces the dialects against which her own struggles to assert itself. Her adversaries include Lovelace, her own family, her prospective suitor

Solmes, and her sister's servant Betty. Whereas we have seen Clarissa choosing to paraphrase rather than transpose rakish dialect, she reproduces every detail of the dialects of her tormenters in her letters to Anna Howe. Clarissa's transcriptions begin with the verbal taunts of brother and sister, of which Clarissa strives to preserve the phonological nuances. Here are two examples:

> With what ap *pa*-rent indifference, drolled my brother—(58)

> [Bella] was surprised that the *witty*, the *prudent*, nay, the *dutiful* and pi-ous (so she sneeringly pronounced the word) Clarissa Harlowe, should be so strangely fond of a profligate man. (192)

Clarissa's transcriptional system is rather complicated. Three different symbols are used for marking the nuances of scorn: underline or italics (the second syllable of "apparent"); a space (between the first and second syllables); and dashes. Clarissa's use of dashes marks not the cognitive value of these utterances, but the emotions of the speakers James and Bella. For James's remark typographical innovations are supplied, such as the separation of the first syllable and the placing of the second in italics. But what is the purpose of the dash? Marking the prolongation of a vowel for which italics has already marked emotion, the dash cannot further specify feeling. It indicates either a "droll" intonation or a "sneer." Clarissa investigates an aspect of language which modern linguistics is only beginning to explain. She fulfills Roman Jakobson's demands that language description capture the full information of an utterance, including the emotional attitude of the speaker:

> If we analyze language from the standpoint of the information it carries, we cannot restrict the notion of information to the cognitive aspect of language. A man, using expressive features to indicate his angry or ironic attitude, conveys ostensible information. . . . The difference between [big] and the emphatic prolongation of the vowel [bi:g] is a conventional, coded linguistic feature. . . . Saporta's surmise that emotive difference is a nonlinguistic feature, "attributable to the delivery of the message and not to the message," arbitrarily reduces the informational capacity of messages. ("Linguistics and Poetics," 90–91)

Emotion need not be translated into language at the phonological level, as it is in the example of "big." Dimunitives, for example, often

add emotional content to the utterance. The difference between
"bem explicado" and "bem explicadinho" (both meaning "thor-
oughly explained") in Portuguese, for example, is a purely emo-
tional one, and cannot be translated semantically—though it could
possibly be translated into another language where diminutives or
other semantemes also color meaning. It is important to consider
Jakobson's remarks in the context of translation. There has as yet
been no systematic study of the possibilities for translating emotions.
Yet more than one Chinese reader with a knowledge of English has
felt that in his *Cathay* Ezra Pound, despite or because of the "errors"
in his translation, has managed to convey the all-important *emotions*
of the original poems (cf. Yip, *Ezra Pound's "Cathay"*). Can Clarissa's
typographical translations of the emotional content of utterances in
turn be translated?

As the French language uses neither stress nor vowel length to
signify emotion, Prévost's translation replaces Clarissa's typographi-
cal markers with whole words. Also, French printing conventions did
not allow for the use of "tirets" in Clarissa's manner. In English, the
dash in these two passages unites Bella and James in their dialect of
irony, whereas in the French the two passages bear little relation to
one another. The reader's attention is no longer focused upon Cla-
rissa's transcription of the text, but on what is said. In the translation
of James's remark, it is difficult to decide whether the effect of spac-
ing James's syllables has merely been dropped, or whether it has
been absorbed into the curious combination of verb ("murmurer")
and adverb ("d'un ton moqueur"): "Avec quelle apparente indif-
ference . . . a murmuré mon frère d'un ton moqueur" (I, 161). Sim-
ilarly, in Bella's speech the sarcastic "so strangely fond" becomes the
more obviously dangerous "si passionée": "Sa surprise était extreme
de voir la spirituelle, la prudente, et même la pieuse Clarisse Har-
lowe, si passionée pour un infame débauché" (II, 2). The French
"même" is a translation of the adverb "nay," putting piety on a
higher level than the other two traits.

While remaining far from the English, Prévost's translation here
strains the limitations of his language and of printing conventions.
Vivienne Mylne has pointed out that even the use of the verb "mur-
murer" represents a dialogic relationship between English text and
French literary system: "Puisque 'murmurer' ne figurait pas parmi
les verbes de discours communément admis, la version augmentée
donnée par Prévost . . . représente une nouveauté d'un point de vue
du style, en même temps qu'elle en exprime corrrectement le sens"
("Prévost," 48–49; "Since 'murmerer' was not among the commonly
admitted verbs of discourse, the modified version given by Prévost

. . . represents an innovation from the point of view of style, while also correctly rendering the meaning [of the English]"). Prévost's innovative use of the verb "murmurer" thus represents the dialogism of translation, the ability of the original to reformulate French practice. It is thus equivalent to Clarissa's own stretching of the boundaries of orthography in her attempt to capture every nuance of her tormentors' language.

The German translation opts for transposition, losing thereby even more than the French. Redundant attention is paid to Arabella's sneer: not only is the word broken up, but there is also a parenthetical comment which describes both the pronunciation and its effect on the hearer. In fact, "spöttisch ziehen" translates not "sneeringly" but the later description of James's drawl: "Sie wunderte sich, daß die witzige, die kluge, die gehorsame, die gott" "se" "lige Clärchen, (das letzte Beiwort konnte sie so spöttisch ziehen) sich in einen so liederlichen Bösewicht so sterblich verliebet" (I, 479). James's remark, though the pauses are still there, has all its nuances removed: "Mein Bruder stichelte mit diesen drei Worten: zum . . . Schein . . . kaltsinnig" (I, 59). "Sticheln," meaning literally or figuratively "to needle," is not quite "drolled." The ellipses are also meaningless, since silence *between* the words of an utterance could signify anything or nothing. The impression is that James is speaking slowly and archly, rather than sarcastically.

If Clarissa deliberately stretches spelling rules, she rejects characters who do not know them: "If I [am] to be compelled [to marry], let it be in favour of a man that can read and write" (151). Clarissa's family make much fun of her rejection, on the grounds of his poor linguistic performance, of the proposed suitor Solmes. The commentary in her letters and her attempts at reproducing his inarticulateness focus attention on Solmes as the representative of a class of rich illiterates with satiated bodies and empty souls. Clarissa takes care not only to give the contents of Solmes's letters, but also to copy them out in full, with every misspelling. We read Solmes's letter, see that he cannot spell, and depreciate him as much for his inability as Clarissa does.

Though Solmes's sexual unattractiveness, his "squat ugly weight," and his parsimony are equal counts against him, his poor writing ability is the only aspect of him that the reader of *Clarissa* can experience "directly," through reading samples of his letters. The reader is also allowed to infer James Harlowe's control of Solmes by contrasting the latter's first and second letters. The first is perfectly spelled; the second is comically misspelled. Since the first letter is accompanied by one from James and the second arrives alone, the logical

conclusion would be that James Harlowe helped Solmes to write the first letter, and that Solmes wrote the second letter on his own. The second letter can be said to uncover a defect which Solmes would rather have hidden. An excerpt from the letter demonstrates the frequency and type of error:

> I have something to communicate to you that concernes you much, if you be pleased to admitt me to youre speech. Youre honour is concerned in itt, and the honour of all youre familly. Itt relates to the designes of one whom you are sed to valew more than he deserves; and to some of his reprobat actions; which I am reddie to give you convincing proofes of the truth of. (250)

The spelling errors allow us to "hear" Solmes, allow writing to substitute for speech in what is called "eye dialect." We get the impression that Solmes's spoken English is substandard simply because he spells words as they are pronounced. It is a purely visual disgust which we and Clarissa feel at seeing words like "sed" and "valew." Richardson uses this disgust, made possible by the fact that spelling had been standardized a few decades earlier. As is usual in the use of eye dialect, one finds inconsistencies: the commas, a semicolon, the "g" in "design" all point to a higher level of literacy than should be assumed from the rest of the letter. But misspelling can become meaningful only through a simultaneous reading of correct and incorrect versions of the word. The misspelled letter thus partakes in dialogism between system and caprice, and between written and spoken competence.

The dialogism so important to Richardson's novel was especially meaningful because the period in which Richardson wrote was volatile in terms of standardization. N. F. Blake has described the period in his book *Non-Standard Language in English Literature*:

> The clamour for an academy to regulate the language was stilled only by the publication of Johnson's *Dictionary* in 1755, which to many made an academy superfluous. . . . Everywhere people were looking for models to imitate and rules for guidance in their search for correctness. . . . The language of the lower classes and of the regions was automatically branded as base. . . . Correct spelling was also made much of by Lord Chesterfield [1694–1773] and deviation from the accepted norm was now a marker of non-standard language. (108)

Clarissa gives one of the first examples in English literature of non-standard spelling used for the purpose of inspiring disgust in the reader. Had the standardization process been completed long before—as in France—poor spelling would have been able to function only as social dialect. Prévost's treatment of this letter is unusual not because he makes changes, but because he is willing to allow a non-standard French. As in "murmerer," the dialect of translation wins a brief victory over standard literary French:

> Sependant j'ai quelque chose à vous communiquer qui vous conserne beaucoup, s'il vous plaît de m'admettre à l'onneur de votre antretien. Votre réputation y est intéressée, aussi bien que l'onneur de toute votre famille, c'est à l'oquasion d'un omme qu'on dit que vous estimez plus qu'il ne mérite, et par rapport a quelqu'unes de ses actions de reprouve, dont je suis prêt à vous donner des preuves convainquantes de la vérité. (II, 165–66)

A footnote assures the reader that this is the orthography of Solmes. As in the English, only errors of spelling are involved, principally the logically consistent substitution of "s" for "c" ("sependant," "conserne"), ignorance of the silent "h" ("l'onneur," "omme"), and a substitution of "qu" for the double "c" of "occasion." These failings are somehow combined with a perfect knowledge of diacritics and gender endings. Most extraordinary in this is that fair copies of Prévost's own personal letters show numerous errors in diacritics! Note the errors in the following:

> Si je croiois que vous eussiez quelque moment libre pour jetter les yeux sur quelques unes des Feuilles imprimées je me ferois un plaisir de vous les envoier. J'ai l'honeur d'*e*tre avec une parfaite estime . . . Votre tr*e*s humble Et tr*é*s obeist. serviteur D'Exiles. (Holland, *Manon Lescaut*, 4)

> (If I thought you would have any spare time to glance at some of the printed sheets, I would gladly send them to you. With the highest esteem I have the honor of being . . . your very humble and very obedient servant D'Exiles.)

The differences in errors between Solmes and Prévost show that there was some thought given to creating a system of error which would make Solmes's writing particularly deviant.

In trying to demonstrate Solmes's incompetence, Michaelis finds it necessary to give not only spelling errors, but also deviations in pro-

nunciation and grammar. The strange pronunciation, along with the usage of "gewest" as a past participle, marks Solmes's speech as a regional dialect:

> Wehrteste Frolin, Ich halte mich fur einen seer unglucklichen Mahn zu sein, da ich noch niemahls so glücklich gewest bin, ihnen meine Aufwartung eine halbe Stunde lange zu machen. Ich habe Ihnen etwas zu sagen, daran Ihnen viel gelegen ist, wenn Sie mich nur vor sich lassen wollen. Es betrifft die Absichten der Perschon, von der Sie mehr halten sollen, als sie werth ist, and es betrifft einige gottlose Streiche, die er gespielt hat, die ich zu erweisen bereid bin. (II, 134)

The passage goes far beyond the orthographic deviance of the English and French, to include grammatical and phonological deviance. "Bereid" is purely a spelling error since there is no phonological difference between a final "d" and a "t" in German; similarly, "seer" replaces the elongating "h" with a doubling of the vowel in a mistake Germans are still capable of making today. However, the spelling of "Fräulein" as "Frolin," of "Mann" as "Mahn" ("man" would be a simple spelling error), and of "Person" as "Perschon" must represent nonstandard pronunciation of those words. Most recognizable is the change in "Person," from a voiced [z] to a voiceless fricative common in some German dialects. Similarly, the incorrect past participle "gewest" would be read as a dialectical version of the proper "gewesen." Reading Solmes's letter in German, then, we are not sure whether we are dealing with a poor speller or a good reproducer of spoken dialect.

Thus if French orthography was stable enough to follow Richardson, German orthography was too unstable to reproduce the difference between standard and nonstandard spelling, and hence resorted to the very changes in pronunciation which Prévost had carefully avoided. Adolf Bach has documented the confused orthography of the period in his history of the German language:

> Die sichere Kenntnis einer streng geregelten Rechtschreibung ist erst im 19. Jh. Gemeinbesitz der Deutschen geworden. Noch im 18. Jh. zeigen etwa die Briefe einer Liselotte von der Pfalz, einer Frau Rat Goethe oder der Mutter des Freiherrn vom Stein die ganze Willkür, die damals auch bei Gebildeten in orthographischen Dingen bestand. (*Geschichte der deutschen Sprache*, 229)

(Exact knowledge of a regulated orthography first became the common possession of all Germans in the nineteenth century. As late as the eighteenth century, the letters of Liselotte von der Pfalz, of Goethe's mother, or of the mother of Freiherr von Stein show the complete arbitrariness of orthography which reigned at that time even among the educated.)

Another example of the lack of standardization for the German language is provided by the very man who was instrumental in having Richardson translated into German. Albrecht von Haller, who we remember stimulated Michaelis's translation of *Clarissa*, had become an extremely important figure in the development of German poetry despite the strong Swiss elements in his language. More telling than his original deviations, however, are the difficulties he had in changing his "incorrect" Swiss into a standard high German. Eric Blackall reports that Haller's corrections to later editions of his poems show "a general uncertainty about what is correct and what is not. Hence he vacillated between three forms of one suffix: *-nuß, -nüß* and *-niß*. He failed to distinguish between *wenn* and *wann*, and between *denn* and *dann*. He used some quite archaic "literary" forms like *ich sieh* and *du solt.* . . . It is clear that Haller often did not know what was correct" (*Emergence of German*, 263). For our purposes it is not as interesting that Haller did not know what was correct, as that there was no standard to which he could turn to find out what *was* correct.

Little wonder then that not just Solmes, but all of the characters in Michaelis's translation exhibit irregularities in their spelling and grammar vis-à-vis the modern rules. One of the most noticeable irregularities is the interchangeability of "vor" and "für," when the difference between the two prepositions had supposedly been standardized by Johann Bödiker in the last decade of the seventeenth century (Bach, *Geschichte*, 265). We get sentences such as this one: "Was kann sie vor eine Absicht dabey haben" (III, 96). Even more telling is Anna's choice of the preterite form of the verb "finden": "Wir funden die arme Frau in den letzten Zügen" (II, 215). The archaic form ("funden") of the simple past puts Anna on the same linguistic level as Solmes. Given such irregularities as these, it becomes very hard to show Solmes as a man at the gates of language. Michaelis was forced to intensify his errors by giving him a regional dialect.

In her study of the various editions of Johann Bödiker's important *Grund-Sätze der deutschen Sprache*, Eva Diedrichs notes that between

the first edition of 1690 and the last edition of 1746, the relation between "Hochdeutsch" (standard German) and dialect had radically altered, from that of equally valid dialects ("Mundarten") to that of a sun surrounded by planets:

> J. Bödikers Verständnis von Dialekt liegt die Auffassung zugrunde, daß jeder Dialekt aufgrund einer Norm funktioniert. Ebenso hat auch das Hochdeutsche eine Norm. J. Bödiker hat sich die Kodifizierung der Norm einer Mundart, nämlich des Hochdeutschen zum Ziel gemacht. Bei den späteren Bearbeitern ist diese Gleichstellung von Hochdeutsch und Mundarten nicht mehr zu beobachten. Das Hochdeutsche wird nicht mehr auf den geschriebenen Bereich beschränkt betrachtet, sondern auch auf den gesprochenen ausgedehnt. In der letzten Ausgabe werden die Mundarten als Hindernis für das Hochdeutsche angesehen. Dies ist nur möglich, wenn dem Hochdeutschen ein höherer Prestigewert eingeräumt wird als den Mundarten. (*Johann Bödikers Grund-Sätze*, 121)

> (J. Bödiker's understanding of dialect is based on the concept that each dialect functions by means of a norm. Thus High German also has a norm. J. Bödiker's goal was to codify the norm of one dialect, namely of High German. This equivalence between High German and dialect is absent from the work of later linguists. High German is no longer considered to be confined to written German, but rather is also to be applied to spoken German as well. In the last edition, the dialects are seen as an impediment to the mastery of High German. This is only possible because High German is seen as more prestigious than dialect.)

The German term "Mundart," literally "oral form," points to the original difference between dialect and Standard or High German as one between spoken and written languages. Thus when Solmes deviates from educated writing, he automatically falls into "Mundart." As Diedrichs notes in the attitudinal changes in the different editions of Bödiker's word, during the very years when Michaelis was making his translation the Germans were becoming increasingly self-conscious about the need for a standardized "Hochdeutsch," and beginning to be ashamed of speaking "Mundart."

As punishment for her rejection of Solmes, Clarissa is further isolated linguistically, allowed to talk only to her sister's servant Betty,

who continually taunts her. The reversal of hierarchies involved in making Betty Clarissa's warden represents an extreme humiliation for the latter. Clarissa is as careful to note Betty's language as she was to note those of her brother and sister and suitor. She describes, for example, what Betty responded when asked why Hannah, Clarissa's own servant, had been ordered to leave. Here the folksy "troop" is seen as intrusive, capable of being spoken to a superior only by a "confident creature": "Why, Miss, the short and the long is this: Your papa and mamma think Hannah has staid long enough in the house to do mischief; and so she is order'd to *troop* (that was the confident creature's word)" (119). Remarkable, again, is that Clarissa gives not merely the substance of Betty's response, but a verbatim quotation of it. The obligatory parenthetical remark alerts the reader to the unacceptable nature of part of the language. Such colloquial expressions as "short and long" and "troop" are recollected by Clarissa and used to characterize her warden. Betty's words grate on Clarissa's ear because they remind her of Betty's social standing and thus intensify the humiliation of this rôle reversal between servant and master. Just as Clarissa is glad when Lovelace speaks her "dialect," she is upset at being made to partake, even as a listener, of Betty's. Clarissa, a voiceless prisoner in her own home, takes revenge by drawing a linguistic caricature of Betty, just as it had been important to her to draw one of James and Arabella. Betty's language is as paradigmatic as her name, the generic name for female servants in England, which is lost in German where the full name Elizabeth is always given. Michaelis attempts to make Betty's language colloquial, but the passage is not as vivid as the English: "Wie? Fräulein! Kurz und gut; ihr Herr Vater meint, daß Hannichen lange genug im Hause gewesen ist, lose Händel anzufangen; darum hat er sie weggejagt, und ich soll ihnen künftig aufwarten" (I, 254). "Lose Händel" (literally "loose dealings") is certainly colloquial, but "poppa and mamma" are replaced by the more formal "ihr Herr Vater," and "weggejagt" is so neutral in comparison with "ordered to troop" that Michaelis has not bothered to include Clarissa's parenthetical statement about Betty's language. Prévost does a bit better with the term "troop," but nothing else is distinctive: "Sans vous laisser dans l'embarras, miss, voici l'histoire. Votre père & votre mère croient qu'Hannah a fait assez de mal dans la maison. Elle a reçu ordre de plier bagage (c'est le terme de cette audacieuse créature,) & je suis chargée de vous servir" (I, 250). "Plier bagage" (literally "to fold baggage"), like "troop," had its origins in the military, and was about as colloquial as the English—though it became even more colloquial when used as a euphemism for "to die." In neither translation does

the full conflict between dialects come to the reader's attention as it does in the English.

Betty's boyfriend, Joseph Leman, is Lovelace's mole among the Harlowe servants. Leman's letters to Lovelace afford the most extensive sample of nonstandard English in the novel. If Betty's main trait is her impertinence, Joseph's is his obsequiousness. In the letters to Lovelace he runs on for pages about his plans to marry Betty and become an innkeeper, about the possibiity of Lovelace's death (he wants to be remembered in the will), and about how much he admires Clarissa, whom he is about to betray. The two Leman letters are Richardson's most ambitious attempt at creating a written servants' dialect, as opposed to Solmes's phonetic spellings. Here, as in Michaelis's translation of Solmes, the spelling errors tend to mark a nonstandard pronunciation. From his spelling, Joseph's vowels would seem to be consistently open and placed farther back in the mouth than in standard English. For example, "serving" and "service" become "sarvinge" and "sarvise"; "impertinent" becomes "impartinent," and "might" becomes "mought." As for the consonants, sloppy elocution leads to spellings which leave out sounds or whole syllables. Thus "Exactness" is inexactly rendered as "exacknesse." There are also some peculiar vocabulary items. We have the adverbial "clene" taking the meaning of "completely" in phrases such as "clene contrary." "Howsomever" is a comic item. There are also expressions which help to characterize Joseph as obsequious. "If it like your Honner" and "and please your Honner" make little sense grammatically, but seem to be drawn from a standard repertoire of lower-class dialects, as popularized in English newspapers of the time. Indeed, Richardson is not trying here to reproduce the actual language of any one region or social group, but simply using "funny sarvent" writing to identify Joseph as an uneducated user of a nonstandard English.

Confronted with that language of the other, Prévost reverses his Solmes decision and declares that the French literary language cannot accommodate such a dialect. Like Clarissa at the beginning of this chapter, Prévost reports but does not reproduce a reprehensible dialect. He renders the letter in simple sentences with the following footnote at the bottom:

> L'auteur, s'attachant a garder les caractères, pousse ici la fidelité jusqu'à donner cette lettre avec les fautes de langage et d'orthographe, qui sont ordinaires dans la condition de Léman. Mais le goût de notre nation n'admet pas de si grossières

peintures. Il suffira de conserver ici un style et des traits de simplicité qui puissent faire connaître un valet. (II, 10)

(Insisting on preserving his characters, the author here pushes verisimilitude to the point of giving this letter with the mistakes and misspellings normal to Leman's station. But the taste of our nation does not allow such crude portrayals. It will suffice if we preserve a simple style and the stupidities which serve to identify a valet.)

If we keep in mind that the bourgeois Solmes was allowed his "fautes d'orthographe," then it seems clear that it is above all Leman's "condition" which enables Prévost to erase his language. Yet the word "condition" has as wide a possibility of meaning in French as in English. It can refer either to a temporary condition, or to "l'estat où on est né." (Furetière; "the status into which one is born"). Does Prévost refer to Leman's social or his economic status? Does Prévost's defense of French taste in this instance mean that people of other "conditions" were not allowed to speak in French literature? Prévost's reliance on decorum, if we may consider it characteristic, poses problems for the generality of Bakhtin's theory of dialogism as the originating force behind the novel.

Certainly the degree of standardization of the French language, and the purity of its literary language in the eighteenth century, far exceeded that of English or German. Yet it is surprising that the insistence upon pure language could also hold for the novel, an officially despised genre outside the normal bounds of literary decorum. Prévost's invocation of "goût" conveniently disguises a much more complicated decision. Vivienne Mylne has noted that there were two types of novel when it came to dialogism:

> Des mots mal orthographiés pour suggérer un parler vulgaire n'étaient pas bannis de tous les romans français: dans les années 1730 et 1740, par exemple, il est paru un certain nombre d'oeuvres en style "poissard," par des auteurs comme le comte de Caylus et Vadé, qui exploitaient délibérément un orthographe soi-disant phonétique, et qui eurent un certain succès. Mais ces ouvrages appartenaient au genre burlesque ou comique, dans lequel de tels procédés étaient acceptés. La question du genre est décisif. ("Prévost," 53)

(Poorly spelled words suggestive of common speech were not banned from all French novels: in the 1730s and 1740s, for

example, a few works in the "poissard" style appeared, by authors such as Count Caylus and by Vadé. These works, which deliberately used a so-called "phonetic" spelling, were somewhat popular. But such works belonged to the comic or burlesque genre in which such procedures were acceptable. The question of genre is decisive.)

Clarissa has often been called the first tragic novel in the English language. For Richardson, as we have already noted, it was not a novel at all. Prévost's censorship of Leman's language thus provides a strange sort of fidelity precisely to the "genre" of the original. He swerves away from language that would plunge the text into the bathos of the burlesque and comic genres. But Richardson's notion of tragedy came above all from Shakespeare, and hence included burlesque and other genres in dialogic proximity, the mixing and mutual illumination of various speech genres.

In Prévost's phrase "un style et des traits de simplicité" we confront an ambiguity. Does "de simplicité" modify "un style" as well as "traits"? In describing style, "simplicité" is cognate with the English. In describing personality, it would merely mean "stupidity," either as an act or a state of mind. And what is the "style" of a servant? Leman's sentences are not shorter than those of many other characters, nor is he inclined to parataxis, more simple grammatically than hypotaxis. His lack of a coherent rhetorical strategy is obvious, but this only makes his letter more "intricket" than it needs to be. Prévost's declaration in the footnote is much more important than the letter itself. It shows dialogism where the letter does not. Prévost does not translate the dialect of Leman; he merely substitutes a dialect of simplicity, which he believes corresponds to the social category of valet. Let us look at a small representative sample from Leman's letter in each of our three languages:

> *Honnered Sir,*
> I Must confesse I am infinnitely oblidged to your honner's bounty. But this last command!—It seems so intricket!—Lord be merciful to me, how have I been led from littel stepps to grate stepps!—And if I should be found out! (385)

> Monsieur, Je suis fort obligé à votre bonté. Mais votre dernier commandement me parait bien fort. Dieu me pardonne et vous aussi, monsieur! vous m'avez engagé dans une grande affaire; & si la mèche était découverte. . . . (III, 10)

Huchgeehrtester Herr, Daß mus ich gestehen, ich bin ihrer
Knaden sehr verbunden vor ihre grosse Generosigkeit. Aber,
aber, die letzte Urdre! Wie intrikat ist die! das Gutt erbarme,
wie bin ich von kleinem zum grossen versieret worden. Wenn
ich entdect würde, das wäre ja nichts als mein Urin. (III, 42)

The French uses one exclamation point in comparison to four in the
English, and partly as a result the sentences are better formed, the
information flows in a straighter line. Through the repeated use of
the adverb "fort" Prévost has tried to establish a colloquial dialect
and preserve some of Leman's "oral" style. Lost is the surprised,
bemused, wholly unplanned twisting and turning of Leman's writ-
ing. The French Leman shows a much cooler, more matter-of-fact,
indeed simpler reaction. Prévost invents rather than conserves a
Lemanian stylistic simplicity.

In contrast, Michaelis heightens the comic impact of Leman's
character in much the same way as with Solmes's letter. As in the
English, Leman attempts to use words which he does not really have
under his control. Whereas Richardson chose Latinate terms, Mi-
chaelis has drawn fashionable phrases from the French: "Ordre" in-
stead of "Befehl"; "Ruin" for "Zugrundegehen"; and "Gener-
osigkeit" for "Grosszügigkeit." Leman's attempt at a highfalutin style
backfires comically as he writes "Urin" for "Ruin." Michaelis also at-
tempts to show a different pronunciation, as in several words short
"o" is substituted by "u." Michaelis is here parodying the widespread
preference of French to German terms during this period of Ger-
man cultural history, appropriately called the "Alamodezeit." The
intensified bathos of Leman's linguistic errors was also necessary to
establish his actual linguistic incompetence, as opposed to mere dia-
lectal usage, as one might have suspected in Solmes.

Poor spelling, then, sets certain characters below others. What
other traits do those poor spellers share? Not all of them are bad.
We read letters from Mrs. Hodges, housekeeper to Clarissa's Uncle
Antony, and from Hannah, whom Clarissa praises highly as a faith-
ful servant. All of these letters are either excised or cleaned up by
Prévost, reproduced with intensified effects by Michaelis. Nor are
the rakes consistent. Though Mowbray has a few misspelled pas-
sages, Lovelace and Belford are good spellers. Thus the inability to
master standard written English divides people neither into social
classes (Leman is lower-class, Solmes bourgeois, Mowbray an aristo-
crat), nor into categories of good and evil. What does seem to unite
all the characters considered here is their subordination to another's

will. Solmes and Betty are the tools of James and Arabella; Hannah and Hodges are servants; Leman, Will Summers, and Mowbray are controlled by Lovelace. All of these figures can be characterized as servants. The redaction of Solmes's first letter by James is not just a linguistic act, but a sign for the submission of the former to the will of James. The lesson is that he or she who is not able to control language, and especially writing, must submit to those who do control it.

This division of society into lettered and unlettered reflects the real power of literacy in Richardson's England. It is estimated that 60 percent of the men and 40 percent of the women could read in England in 1750, as opposed to 47 percent of the men and 27 percent of the women in France (Cressy, *Literacy*, 176). Literacy in England had become increasingly indispensable for participation in business and politics, the two activities which conferred the most power on the successful:

> During the century which followed the civil war the diversification of the economy and the growth of towns and trade brought an increased proportion of the population into occupations or social settings where literacy was important. Reading and writing became increasingly useful to an expanding sector of the community. . . . With the expansion of printing in London and the provinces there was certainly more to read, and with a budding taste for news and increased political participation and partisanship there was perhaps a greater demand for literacy than ever before. (Cressy, *Literacy*, 177)

It was only natural that the printer Richardson would be one of the first to portray this growing antagonism between lettered and unlettered through a dialogic work of literature. It was just as natural that Prévost would suppress the theme, and that Michaelis would transform it into a war of regional or social dialects.

Passionate Pronouns

In the last chapter we pointed out how Lovelace's language tended to undermine the binary oppositions which structure the novel. Similarly, Lovelace is also the character who departs from the principle of "one person, one style" and himself exhibits the characteristics of

dialogism. Dialogism must be termed a Lovelacean device, for in its portrayal of incommensurate languages in conflict it denies that there can ever be one language of truth. Lovelace's forgeries become model cases for the larger phenomenon of his appropriation of every available speech genre. The languages that Lovelace assumes, or that assume him, are continually in a state of contradiction with each other. Lovelace himself is aware of this, as he writes to Belford "Do not despise me, Jack, for my inconsistency—In no two letters perhaps agreeing with myself" (694). The most dramatic representation of the struggle between languages comes when Lovelace is visited by his conscience (a female, naturally) and is forced to kill her. Here language literally takes on a life of its own. Lovelace represents the struggle with his conscience as palpable: "She had stolen my pen . . ." (848). In this example the fourth line is the voice of conscience:

> Welter on, once more I bid thee!—Gasp on!
> *That* thy last gasp, surely!—How hard diest thou!—
> ADIEU!
> 'Tis kind in thee, however, to bid me *Adieu!*—
> Adieu, Adieu, Adieu, to thee, O thou inflexible, and till
> now, unconquerable bosom intruder—Adieu to thee
> for ever! (848)

If these two sides of Lovelace, his conscience and his will, his right and left hands, address each other in the familiar "thou" form, it is appropriate that the letters between Lovelace and his other conscience, Belford, should also be written in "thou" form, and that they should be written both in code and in a "Roman style," in a highly artificial literary language whose spoken equivalent had long since died out. The adoption of the "thou" form in *Clarissa* always marks a linguistic zone exempt from the proprieties of standard English. Within this privileged space, the editor tells us, everything is allowed: "*These gentlemen affected Roman style, as they called it, in their letters: And it was an agreed rule with them, to take in good part whatever freedoms they treated each other with, if the passages were written in that style*" (142). In his original footnote, the "editor" chose not to list the markers of the "Roman style." The third edition gives more information: "To wit, the Thee and the Thou" (*Clarissa* 1930, I:210). In fact, by using the opposition between "thou" and "you" to signal their "Roman style," Lovelace and Belford make use of an opposition which did not exist for the Romans, who used only the "tu" form. On the other hand, though the opposition existed in French and German, it was so highly codified and standard that it could not

be used, as it is in the English, to reverse normal linguistic expecta-
tions. "Thou," after the Norman invasion and the resulting contact
with the French language, went from universality to usage primarily
in two nearly opposite situations: "Superior persons or strangers
were addressed as *you*; *thou* thus becoming the mark either of the
inferiority of the person spoken to, or of familiarity or even intimacy
or affection between the two interlocutors" (Jesperson, *Growth and
Structure*, 250). "Thou" could thus express either affection or abuse.
That double possibility is used to break down the barriers between
the two concepts, to turn the world upside down.

Thus the term "Roman" has another connotation: that of carnival
and its release from social convention. The change of pronoun
marks off a profane space within which any social dialectis tolerated.
This is precisely a linguistic freedom noted at the eighteenth-century
English version of carnival, the masquerade, where, a contemporary
visitor remarked in terms similar to those used to describe Lovelace's
"Roman style," "there is an absolute Freedom of Speech, without the
least Offence given thereby; which all appear better bred than to
offer at any Thing prophane, rude, or immodest; but Wit inces-
santly flashes about in Repartee, Honour, and good Humour, and
all kinds of Pleasantry" (*Gentleman's Magazine*, 15 February 1718;
cited in Castle, *Masquerade and Civilization*, 25). Belford and Love-
lace, in their use of "thou," create a carnival space. And indeed, one
reads back from their linguistic freedom to their infringement of
social rules, for during carnival "there is a temporary suspension of
all hierarchic distinctions and barriers among men and of certain
norms and prohibitions of usual life. . . . An ideal and at the same
time real type of communication, impossible in ordinary life, is es-
tablished. . . . When two persons establish friendly relations, the
form of their verbal intercourse also changes abruptly; they address
each other informally, abusive words are used affectionately, and
mutual mockery is permitted" (Bakhtin, *Rabelais*, 15–16).

In languages such as French and German, where the distinction
between the two pronoun forms was a matter of daily language use
and of relative status between the speakers, the peculiar nature of
the Lovelace-Belford correspondence, its particular connection to a
carnivalized world, is lost. Prévost, left with no clue as to what the
Roman style consisted of, did not bother to consider the pronouns:

> L'auteur remarque que ces messieurs affectaient souvent de
> s'écrire en style romain, comme ils le nommaient entr'eux, et
> qu'ils etaient convenus de prendre en bonne part toutes sortes
> de libertés mutuelles, lorsqu'elles étaient dans ce style. Il se

trouve souvent dans leurs lettres des citations de leurs meilleurs poètes, qu'on s'est contenté de traduire en prose, et qui ne demandent pas de l'être autrement. (I, 320)

(The author comments that these gentlemen had the quirk of often writing to each other in Roman style, as they called it, and that they were bound to take in good part all sorts of mutual liberties, whenever they were done in that style. Citations of their best poets are often found in their letters, which we have contented ourselves with rendering in prose, and which deserve no other treatment.)

The "liberty" of the Roman style has become infectious, as Prévost uses the last part of the footnote to take a potshot at English poetry. Prévost's mingling of his translator's footnote with Richardson's suggests that the quotation of poetry is one of those liberties which Lovelace and Belford make use of, and hence is a marker of their "Roman style."

Yet Prévost's transposition of "you" and "thou" into "vous" and "tu" does mark off a different sort of linguistic space, one almost verging on the colloquial, for the "tu" form had no place in the literature of the day. Significantly, the "tu" form is used in *Manon Lescaut* only by the elder des Grieux when addressing his son. And that parental usage of the informal has influenced both translators: the angry letter from Clarissa's father ("I write, perverse girl . . ." 125–26), which uses "you," is given in both French and German in the familiar form, whereas the angry James writes to Clarissa formally, as "vous" or "Ihr." Even the most impassioned discourse of the lovers in *Manon* is rendered in the "vous" form, as are the dialogues between des Grieux and his best friend Tiberge.[6] Prévost's decision to keep the familiar forms in a discourse of friendship represents again the creation of a new dialect for French literature out of the dialogic relation between original and translation. That new dialect is opposed to current French practice; it is also in one sense opposed to that of the original, since Lovelace and Belford use an essentially

6. Thus Vivienne Mylne's remark on the difficulty of translating Richardson's pronouns only begins to tell the story: "['Thee' and 'Thou'] étaient désuètes dans le langage de tous les jours, tandis que le *tutoiement* n'entraînait pas de connotations archaïques semblables." ("Prévost's," 56; "['Thee' and 'Thou'] were obsolete in cotidian speech, whereas the use of 'tu' in French did not carry with it equivalent connotations of archaism"). Certainly everyday English conversation was very different in this regard, but Mylne is silent about the contradiction between Prévost's translation, where "tu" and "vous" freely interchange, and the virtual absence of *tutoiement* in his own novels.

literary form absent from most daily speech, whereas in French the "tu" form represents the invasion of the literary by the colloquial.

Michaelis had a richer arsenal of pronouns to choose from in order to reproduce the various social classes and moods of intimacy between the characters. Since the Middle Ages, forms of address in German had been divided into two camps: familiar ("Du"), and formal ("Ihr"). During the seventeenth century, singular third-person forms had been introduced ("Er" and "Sie"), and during the last part of the century the plural third-person "Sie" had replaced "Ihr" as the highest form of respect (aside from using a title). As in French, the "du" form was extremely uncommon in literature. In Christian Gellert's *Leben der schwedischen Gräfin von G**** of 1750, a sentimental novel influenced by Richardson, "Sie" is used in most conversations, and in letters, including those from wife to husband. Husband to wife, on the other hand, and brother to sister is rendered with "Ihr," just as James's letters to Clarissa use the "Ihr" form, while the Anna-Clarissa correspondence uses "Sie" and the Belford-Lovelace correspondence "Du." In his theoretical works, Gellert, the arbiter of German epistolary style in his day, had confronted the problem of translating from the real "Roman style" of Pliny the Younger and Cicero. A footnote explaining his choice of formal "Sie" to translate the Latin "tu" sheds an interesting light on the use of German pronouns in the period:

> Ich habe so wohl in diesem, als in dem bald folgenden Briefe des Cicero, das lateinische Du durch unser Sie ausgedrückt. . . . Das Sie schien mir nöthig zu sein, um die Ähnlichkeit der alten und unserer Briefe fühlbar zu machen, und den Leser geschwinder zu überzeugen, daß die Regeln eines guten Briefs allezeit eben dieselben gewesen sind. (*Die epistolographischen Schriften*, 38)

> (Both in this and the following letter of Cicero's, I have expressed the Latin "tu" with our "Sie." . . . The "Sie" seemed indispensable in order to make tangible the resemblance between the ancient letters and our own, and to convince the reader that the rules of a good letter have remained constant.)

Gellert decides for equivalence rather than transposition. The "Sie" form is the norm in German, just as the "tu" form was in Latin. Gellert's implication that the use of "Du" in a letter would appear strange, and would emphasize the cultural distance between German

and Roman letter-writing, shows us that by reproducing the "thou" forms of the original Michaelis was also creating a new dialect for German literature.

If Lovelace and Belford use "thou" to create a separate linguistic space, Clarissa's own use of "thou" when speaking to Lovelace is more problematic. It is very different from Belford and Lovelace's use, in that it always appears spontaneously (rather than as an indication of an affected literary style), and is not an indicator of gallantry. Her alternations between "you" and "thou" betray emotional intensity, just as used by Shakespeare in, for example, the famous interview between Gertrude and Hamlet. Theatrical works of the eighteenth century continued the convention of using "thou" in special moments of affection or hatred. Clarissa's use of "thou" takes up the abuse side of the dichotomy, which however, as Bakhtin points out, is always dialectically linked with affection. Her usage is rather similar to that between parent and child, indicating her moral elevation above her interlocutor. Clarissa begins to use the "thou" form after the fire scene when Lovelace attempts her virtue, and continues to use it in moments of intense emotion up to the very end of her discourse with Lovelace, including the penknife scene when she threatens to kill herself. Interestingly, though both characters use "thou," they never do so in a direct exchange. Lovelace is careful to note every time that Clarissa changes the pronoun.

For example, in transcribing a dialogue at Hampstead Heath, where he has tracked Clarissa down after her first escape, Lovelace notes an interesting transition by Clarissa from "you" to "thou" and matches it with his own, more secretive code-switching. Lovelace is trying to keep Clarissa from saying too much to her newfound lady friends about their past relationship. What follows is literally logomachia, as Lovelace is forced to shout Clarissa down. Clarissa begins:

> Let me judge for myself, upon what I shall *see*, not upon what I shall *hear*—Do you think I shall ever—I dreaded her going on—I *must* be heard, Madam, raising my voice still higher. You must let me read one paragraph or two of This Letter to you, if you will not read it yourself—
>
> Begone from me, Man!—Begone from me with thy Letters! What pretence hast thou for tormenting me thus—
>
> Dearest creature, what questions you ask! Questions that you can as well answer yourself—
>
> I *can*, I *will*—and *thus* I answer them—

> Still louder raised I my voice. She was overborne. Sweet
> Soul! It would be hard, thought I [and yet I was very angry
> with her], if such a spirit as thine cannot be brought to yield
> to such a one as mine! (777)

Clarissa uses the "thou" when her patience is exasperated, when she
feels that only abuse will suffice, when she most looks down upon
Lovelace. But is it anger which causes Lovelace to use the "thou"
form, or affection? The double purpose of the form expresses per-
fectly the mixture of love and revenge which motivates his character.
The abrupt changes in this passage between the two forms reflect
the mercurial nature of the relationship between the speakers. Both
the German and the French translations reproduce these changes,
and in doing so they introduce a new idiom into literature and let-
ters. In fact, German letter-writing of the Sturm und Drang period,
which began two decades after *Clarissa*'s appearance in German,
shows precisely these sorts of changes. Even a man of refined liter-
ary taste such as Christoph Martin Wieland could write letters in
which the difference between "Du" and "Sie" was emphasized
through its very obliteration, as in this one of 4 March 1776 to Lava-
ter: "Engel Gottes! Lieber, bester Lavater! Mein Herz nennt Deinen
Namen! Glaube nicht, Bester, daß ich zu gut von Dir denke. . . .
Verzeihen Sie mir diese Vertraulichkeit!" (Zeitler, *Deutsche Freun-
desbriefe*, 68, emphasis added; "Angel, My Dear, my best Lavater! My
heart calls your name! Don't think, my best one, that I think too
highly of thee. Forgive me this intimacy!"). The "Du" is proffered in
a crime of passion; the next moment, aware of his transgression,
Wieland erases it with a return to the "Sie." And the rest of the letter
continues in "Sie" form.

The Sturm and Drang movement wanted to eliminate the rigid
social system—"die bürgerlichen Verhältnisse," as Goethe's Werther
expressed it—that found perfect expression in the complicated Ger-
man pronoun system. Sturm und Drang drew on this aspect of Rich-
ardson, as well as on the religious dialect of Pietism and other
sources, in forging a new language of feeling. Similarly, in France,
Rousseau's epistolary novel *Lettres de deux amans*, better known as the
Nouvelle Héloïse (1761), also profoundly influenced by Richardson,
showed from its first few pages a new ability to record lambent feel-
ing by means of pronoun changes. Near the beginning of the novel,
Julie writes to Saint-Preux that he should stay, and betrays her feel-
ings in a slippage of pronouns: "Si mes jours *te* sont chers, crains
d'attenter aux *tiens*. Je suis obsédée, et ne puis ni *vous* parler ni vous
écrire jusqu'à demain. Attendez" (14, emphasis added; "If my days

are precious to *thee*, worry about shortening *thine* own. I am obsessed, and cannot speak or write to *you* until tomorrow. Wait"). Like Wieland in his letter, Julie draws back in hers from the brink of intimacy by retreating into the "vous" form. Thereafter, the "tu" form is used by the lovers. These emotional changes in German and French are anticipated and perhaps influenced by the entirely analogous alternations in the language of Belford, Lovelace, and Clarissa.

Grammar is often untranslatable. Yet within grammar lies meaning of every kind. The completely different usages of pronouns in these three languages mean a different set of social relations and a different set of friendships. Yet only the Dutch translator Stinstra openly contemplated the impossibility of reproducing Richardson's pronoun differences. His refusal to follow Richardson, his preference in his translation for equivalence over transposition, signals the importance of the opposite decision taken by Prévost and Michaelis. In the preface to the first and second volumes of his translation of *Clarissa*, Stinstra notes the sheer impossibility of using the "du" form in Dutch to reproduce the "thou" of the English. The "du" form is used only by the Frisians:

> If I had intended this work for Frisians alone, I would have preserved another of the fine turns of the original in my translation, which I must now eliminate entirely, in order not to appear ridiculous to most readers: to wit, that which Lovelace and Belford call in their correspondence "the Roman style," consisting of addressing each other in what is comparable to the old informal Frisian "du" and "dij" instead of the more formal "gij" and "u", as is the custom today between all educated Dutchmen, except that the older forms are still used by the Frisians. Although it is a matter of indifference how people speak as long as they understand one another, I cannot restrain myself from being somewhat disturbed about this gothic taste of addressing several people in one person, because I am deprived of the opportunity of expressing the witty quality of the original. (Slattery, *Richardson-Stinstra*, 123)

Today the "du" form is very much alive in Dutch. It had been only temporarily stifled by a period of extreme formality and distance. Oddly it is Stinstra, the translator most concerned with renewing his audience's moral language, who declines to renew Dutch grammar through translation. Yet his point that in the opposition between "du" and "gij," nonstandard grammar would be read as regional dia-

lect, is well taken, and corresponds to Michaelis's decision to reproduce nonstandard spelling as dialect.

Stinstra's decision contradicts his statement that grammar is a matter of indifference; his intuition that the purely grammatical matter of the "thou" form is *not* a matter of indifference, that its loss deprives the original of its "wit," is surely more correct than his logical theory of linguistic equivalence. Literature, especially dialogic literature, is precisely a form of discourse in which "how" something is said matters as much as "what" is said.

Legal Dialects

The importance of legal discourse for *Clarissa* has been noted by many of its readers. David Demarest sides with the Harlowes, believing that Richardson had a rigorist conception of law, and that legal language, in particular that of Clarissa's will, ultimately succeeds in its struggle against other forms of discourse. On the other hand, Charles Knight argues that the failure of the law is more noticeable, and that this failure reflects the fact that "the institutions of society cannot deal with the moral needs of individuals" ("The Function of Wills," 1190). Similarly, John P. Zomchick notes that the law is less an instrument of justice than one of exploitation: "The law that is meant to constitute society and protect it informs the behavior of the Harlowes and the Lovelaces of the world, suggesting tactics and establishing a protective armor of self-interest as they ready themselves to enter the arena where the battles for possession rage" ("Tame Spirits," 116). However, according to Knight, Clarissa's legal language in her will does serve the purpose of redefining relationships between characters—reflected particularly in the formation of the previously unthinkable triumvirate of Belford, Morden, and Anna Howe, which Clarissa appoints to interpret dubious points in her will ("The Function of Wills," 1188). Terry Castle moves the discussion to another arena, claiming that Clarissa's will is just another of her ciphers, open to any and all interpretations. The very triumvirate of interpreters Knight finds so remarkable shows only that "interpretations are creative, arbitrary—imposed from without on the imperfect object" (*Clarissa's Ciphers*, 132–33).

As with every other aspect of *Clarissa*, the extremities of these positions are anticipated within the novel itself. As Jocelyn Harris

writes, they are embodied in the different legal theories of Clarissa and Lovelace:

> Like Portia in *The Merchant of Venice* Clarissa turns to law, her ultimate guarantee of fixed meanings and protective contract. She implicitly subscribes to Locke's belief that the law preserves and enlarges that *"Liberty* [which] is to be free from restraint and violence from others," just as Lovelace maintains a definition that Locke calls its opposite, a *"Liberty for every Man to do what he lists. . . ." (Samuel Richardson,* 92–93)

In other words, law functions for Clarissa as transcendental signifier, as truth, whereas for Lovelace it is but one other form of language used to obtain power. Most important for our purposes is Richardson's presentation of the law not as an objective institution, but as a social dialect in competition and dialogue with other language systems.

Clarissa's parents share her view of the law. When Clarissa expresses her concern for the danger which Lovelace might pose to other members of her family—he has already wounded James in a duel—her mother responds confidently: "The Law will protect us, child!—Offended magistracy will assert itself" (98). Mrs. Harlowe offers an organic image of the law. She portrays an independent, self-assertive organism that will strike back on its own accord when provoked. Clarissa assents to the metaphor's validity, though she corrects its confused chronology: "But madam, may not some dreadful mischief first happen?—The law asserts not itself till it is offended" (98). The dreadful mischief does indeed happen; and offended magistracy asserts itself neither before nor after the deed. Clearly the greatest challenge to this organic concept of the law is the chief crime of the novel, the rape of Clarissa.

Legal punishment of Lovelace for the rape he has committed depends entirely upon Clarissa's willingness and ability to produce testimony, i.e., to manipulate or be manipulated by legal discourse. The two greatest legal scholars of the eighteenth century, Sir Robert Chambers and Sir William Blackstone, agreed in their assessment that rape was one of the most difficult crimes to prove. As there were usually no witnesses, only the woman's testimony could prove the rape. That testimony had to be explicit, had to use words which contradicted the dialect of femininity. Anna Howe, for example, was shocked when Morden almost had "indelicacy enough to have gone into the nature of the proof of the [rape]" (1314) in her presence.

Yet Clarissa would be compelled to exhibit the same indelicacy in front of complete strangers. Thus rape trials inevitably involved the confrontation of two discourse systems: that of legal epistemology, and that of feminine decorum. Here is one such confrontation, the moment of "truth" for a Ms. Batten. She hesitates when asked to describe her violation:

> Batten. And must I speak plain English then?—and before all these Gentlemen.—I vow I am ashamed.—I don't know how to say such a word.—But if I must, I must. They two held me while the Prisoner————. (*Select Trials*, II:319)

Trials have always been theater for the Anglo-American reading public. The book *Select Trials*, which contains this transcript, always printed trials in the dialogue format of cross-examination. It was not a genteel publication, and so the dashes indicate that Batten used the most graphic language imaginable. But the dashes are also more "literary," more powerful and significant than any complete transcription could have been. In the passage as a whole, we see the plaintiff examining her role, questioning its language, taking cognizance of her audience. We see the plaintiff fully aware of the dialogism between her own female language and that of the law. The dashes between her sentences recall Richardson's favorite device for translating emotion. The rhetorical figure of hesitation heightens the effect of her final sentence, whose expurgated verb in turn heightens the reader's perception that this woman has crossed the boundary of decency, has been made to speak another, untranslatable dialect. The popular appeal of books such as the *Select Trials* (which went through several editions) demonstrates that the English reading public, no less than Plato's Greeks, took one of their greatest sensual delights in discourse. And as in the *Protagoras*, the interest of the dialogue lies in seeing how one can be made to respond to questions as the interlocutor would have it done.

No wonder Clarissa feels that her appearance in court and, more importantly, the testimony which she would be required to produce there, would kill her. In addition, Clarissa's chances of winning her case are slim. She was drugged during the rape and so cannot produce the necessary testimony. Also, long delays between event and prosecution tended to produce skepticism in the minds of jurors. Finally, we shall see below that Lovelace arranged on various occasions for Clarissa to suffer without protest being addressed as "Mrs. Lovelace," prima facie evidence that she willingly cohabited with

him. The events of the novel ironize Mrs. Harlowe's declaration, for
Lovelace is punished not by the law, but rather by another illegal
action, his duel with Morden.

Lovelace's is the mercurial imperial will, unbound by statute. "The
law was not made for such a man as me" (569), he boasts. And Love-
lace's fantasy of his trial following his imagined rape of the Howes
provides a complete reversal of the courtroom drama pictured
above. If Batten shows trepidation because of her male *audience*, a
fear of men as hearers, Lovelace revels in the apprehension that at
his trial "Women will be five-sixths of the spectators" (*Clarissa* 1930,
IV:274). This is but one instance of the way Lovelace, as Zomchick
puts it, "directs the spectators and the *dramatis personae* of the juridi-
cal theater to his own advantage" ("Tame Spirits," 109). Lovelace's
defense is based entirely on the appearance he will make in court,
his handsomeness causing the women in the audience to intercede
for his acquittal. He transforms his trial into a theatrical perfor-
mance, in which not the truth but the ability to move the audience
counts. The theatrical parallel is completed with his inserted stage
direction indicating the "scene":

> How bravely shall we enter a court, I at the head of you. . . .
> What brave fellows!—What fine gentlemen!—There goes a
> charming handsome man!—meaning me, to be sure!—Who
> could find in their hearts to hang such a gentleman as that?
> whispers one lady, sitting perhaps on the right hand of the
> recorder: [I suppose the scene to be in London:]. (*Clarissa*
> 1930, IV:273)

Lovelace then silences Anna Howe by bowing to her and kissing his
own hand. Lovelace's drama resembles the fatal mime show in *Ham-
let* with the stage silent and the spectators all aflutter. Indeed, the
comments from the women *translate* the gestures of the actors. The
passage shows three sorts of dialogism: the conflict between gesture
and language; the rewriting of legal by amorous dialect—brilliantly
symbolized by placing one woman at the ear of the recorder; and the
overwhelming of a truth-seeking discourse by an aesthetic one. As in
the passage from the Batten case, these are struggles between widely
divergent dialects. Whereas Batten was forced to speak a dialect
which negated her social status as woman, here the plaintiff Anna
Howe could triumph only through spoken language, but is silenced
by gesture. Not an abstract relation to truth or propositional state-
ment, but the aesthetic relations between actors and audience deter-

mine the outcome of this trial. When Clarissa decides not to pros-
ecute Lovelace for rape, the reader must necessarily remember this
scene and understand why.

This passage demonstrates that if legal discourse (much to Pré-
vost's disapproval) invades the literary body of *Clarissa*, literary lan-
guage in turn impinges upon, interprets, and translates legal dialect.
Law here is not so much a language open to conflicting interpreta-
tions as a dialect conversing and conflicting with other speech
genres. Once aestheticized, legal dialect loses its pretensions to pu-
rity or truth. Prévost's disapproval of legal dialect within the novel
thus cuts both ways: dialogism impedes the pleasure of the text, but
it also makes legal discourse something less than it should be. Thus
Prévost cuts most of the legal or quasi-legal documents from his
translation. But where he does translate, it is with a great care for
the proper terms. Michaelis is more willing to follow Richardson in
his dialogism, but is content with a few markers of conventional
"Amtsdeutsch" to indicate it.

This difference is best shown in one of the few passages which
both translators handle. Again we are faced not with a genuine legal
document, but with Lovelace's vision of a day in court defending
himself against a charge of rape. His defense hinges upon the fact
that numerous people have seen Lovelace and Clarissa together at
Sinclair's and heard him address her as his wife. Once again a piv-
otal role is played by the woman's acceptance of male discourse. In
persuading Clarissa to allow him to address her as if he were her
husband, Lovelace has obtained a legal advantage over her. He envi-
sions how "the jet of the business," the testimony at his trial, might
unfold. In answering his own question, Lovelace slips easily from the
colloquial into the legal:

> How many persons are there who, after Monday night, will be
> able to swear, that she has gone by my name, answered to my
> name? . . . No less than four worthy gentlemen, of fortune
> and family, who were all in company such a night particularly,
> at a collation to which they were invited by Robert Lovelace,
> of Sandoun-Hall, in the County of Lancaster, Esquire, in com-
> pany with Magdalen Sinclair widow, and Priscilla Partington
> spinster, and the Lady complainant; when the said Robert
> Lovelace addressed himself to the said lady, on a multitude of
> occasions, as *his* lady; as they and others did, as Mrs. Lovelace;
> every one complimenting and congratulating her upon her
> nuptials; and that she received such their compliments and
> congratulations with no other visible displeasure or repug-

nance, than such as a young bride, full of blushes and pretty confusion, might be supposed to express upon such contemplative revolvings as those compliments would naturally inspire. (539)

Lovelace, Sinclair, and Clarissa herself are transfigured by this language into carefully defined objects, as though, for example, the naming of Lovelace's residence identifies him any more precisely than does his name. "The said . . ." and "the aforesaid . . ." are phrases that add no new information to the names that accompany them, and that provide no insurance against possible misinterpretation—can the reader of the letter be thinking of some "unsaid" with the same name as Lovelace? Perhaps the strongest irony here is the mention of Sinclair, since "Sinclair" is an assumed name which accompanies her assumed widowhood. By naming the procuress Sinclair "Magdalen Sinclair widow," the whore Partington "spinster," and Belford and the other rakes as "worthy gentlemen," Lovelace achieves not only irony, which will not help his case, but more importantly a certain alienation effect (Brecht's "Verfremdungseffekt" or the Russian "ostranenie"). Familiar people and familiar events now appear strange and unrecognizable—indeed they must, if their testimony is to have any weight. Here Lovelace's legal language is also literary, exploiting the gap between illusion and reality. The embedding of this testimony within Lovelace's other dialects causes its legal language to fall apart. The preciosity of "pretty confusion," the salaciousness of the "contemplative revolvings" alienate these phrases from the "real" legal language which Lovelace attempts to imitate.

Prévost is careful to capture the legal flavor of this passage by using some of the French equivalents for the English legal phrases. The verb "déposer" ("to testify in court") is used, making it even more clear in French than in English that we are reading (imagined) testimony. At the same time, however, the introduction of a main verb absent from the original also makes the legal language more independent from Lovelace's other musings. The redundance of "de personne & d'origine," the orthography of "Ledit" and "ladite," and such phrases as "fille nubile" and "dame complaignante" round out the legal terminology. The passage in full:

> Quatre dignes officiers, nobles de personne & d'origine, invités tel jour à une collation par Robert Lovelace de Sandon-hall, écuyer; en compagnie de Madelaine de Sinclair, veuve; de Priscilla Partington, fille nubile, & de la dame complai-

gnante, déposent, que ledit Robert L. s'est addressé plusieurs
fois à ladite dame comme à sa femme; qu'ils se sont addressés
à elle, eux & d'autres, en qualité de Madame Lovelace, chacun
lui faisant des complimens & des félicitations sur son mariage,
que ces complimens & ces félicitations, elle les a reçus sans
autres marques de déplaisir & de répugnance, que celles qui
sont ordinaires aux jeunes mariées, c'est-à-dire avec un peu
de rougeur & d'agréable confusion, qu'on pouvait attribuer à
l'embarras naturel dans ces circonstances. (III, 463–64)

A heightening of legal language accompanies Prévost's refusal to ex-
pose the embedding of legal dialect within others. The final sen-
tences continue poker-faced, with the amelioration of "pretty confu-
sion" into the slightly less pretty "agréable confusion," and the
analogous euphemism of "embarras" for "contemplative revolvings."
Also important is the phrase "c'est-à-dire," which posits the remain-
ing words as a recapitulation of the objective phrase "jeune mariée."
This idea of recapitulation, or rewording or explaining, does not
occur in the English. There Lovelace's sentence itself revolves, infat-
uated with its own artistry and power over women. Prévost has
shown himself able to reproduce legal dialect, but only as a separate
language, not as dialogism.

Like Prévost, Michaelis noted that the single long sentence of this
passage lacks a main verb, and gave it one indicating that both a trial
and a dramatic scene is imagined: "Vier angesehene Cavalliers, von
guten Mitteln und von alter Familie, treten auf" (III, 486). "Als
Zeuge auftreten" means to appear as a witness in court. But "Auf-
treten" is also the German verb indicating stage entrances. Even
though the theatrics of Lovelace's other legal fantasy were unavail-
able to Michaelis (they were included for the first time in the third
edition), he was nevertheless able to grasp the connection between
theater and courtroom so important to Lovelace. Just as the single
word "auftreten" unites legal and theatrical language, so the Ger-
man passage as a whole shows an extraordinary slippage between
the two:

> Vier angesehene Cavalliers, von guten Mitteln und von alter
> Familie, treten auf. Sie sind an einem gewissen Abend in
> einer Gesellschaft gewesen, zu der sie Robert Lovelace von
> Sandown-Hall in Lancaster gebeten hatte. Es war sonst noch
> gegenwärtig Magdalen verwittwete Sinclairin, und Jungfrau
> Priscilla Partington. Der besagte Robert Lovelace redete bey
> unzähligen Gelegenheiten obenbenannte Fräulein als seine

eheliche Liebste an; und die übrige Gesellschaft nannte sie nie anders als Frau Lovelace: sie empfing von einem jedweden die Glückwünsche zu ihrer Verehelichung, ohne darüber einiges Mißvergnügen zu bezeigen, als nur dieses, daß sie nach Art aller Bräute etwas schamhaft that. (III, 486)

The passage is peppered with stock phrases from "Amtsdeutsch," such as "besagt" and "obenbenannt." Yet where Lovelace merely has "wife," the German gives "eheliche Liebste." "Ehe" is from the realm of law, "Liebste" from that of passion, and their mixture is dialogic. The odd mixture is perhaps a variant of "Eheliebste," a common expression in the eighteenth century for "wife," more polite than "Frau" but less grand than "Gemahlinn." Thus the term gives not so much a legal flavor to the passage as a middle-class setting. Michaelis also goes a bit farther than Prévost in referring in his last sentence to the sexual, though he refers to the blushing bride rather than to her thoughts. The entire passage reads as a carefully written colloquial report rather than legal testimony. Yet the use of legal terms in certain key places—not found in the English—enables Michaelis to preserve at least some of the dialogism of this passage.

Both of the courtroom scenes cited so far remain at the level of Lovelace's imagination. Lovelace does not rape the Howes, nor is he called upon to offer evidence that Clarissa had agreed to cohabit with him, since he is never brought to trial. Yet there is one legal document in the novel that does have its desired effect: Clarissa's will. Indicative of the importance which Richardson attributed to this last testament of Clarissa is the fact that he at one point thought of naming his novel *The Lady's Legacy*. The will is presented in full; every person who has ever helped Clarissa appears in the will and receives some part of her estate—only James and Arabella are not mentioned in the will's ten printed pages. As Charles Knight points out, the will functions to enumerate and solidify the change in relations between characters. Thus its legal force is its literary force, and rather than make any attempt at eliminating ambiguity through the use of legal dialect, Clarissa uses her own dialect, and links the will's efficacy to its interpretation by three very different interpreters: Belford, Morden, and Anna Howe. Clarissa characteristically exerts her will by withdrawing from it. She makes no attempt to master legal language, nor even to limit her will to points of law and property. But it is this very ability to keep her own language in her will, rather than to mimic the patriarchal dialect of law, which allows these ten pages to represent the novel in miniature as woman's discourse triumphant. The will is thus Clarissa's alternative to prosecuting Love-

lace for rape, the potential disastrous consequences of which we have examined.

Surprisingly, Clarissa's will shows the same relation between theater and courtroom as we have seen in Lovelace. Her description of the disposition of her body, which takes up an inordinate amount of the will, is not a legal arrangement, but stage directions for a spectacle. Clarissa seems to respond directly to Lovelace's legal fantasies, for she intends to exclude him and his impromptu performances from her theater:

> And I could wish, if it might be avoided without making ill-will between Mr. Lovelace and my Executor, that the former might not be permitted to see my corpse. But if, as he is a man very uncontroulable, and as I am Nobody's, he insist upon viewing *her dead*, whom he ONCE before saw in a manner dead, let his gay curiosity be gratified. Let him behold, and triumph over the wretched Remains of one who had been made a victim to his barbarous perfidy: But let some good person, as by my desire, give him a paper, whilst he is viewing the ghastly spectacle, containing these few words only————— "Gay, cruel heart! behold here the Remains of the once ruined, yet now happy, Clarissa Harlowe!————See what thou thyself must quickly be;————and REPENT!————
>
> Yet, to show that I die in perfect charity with *all the world*, I do most sincerely forgive Mr. Lovelace the wrongs he has done me. (1413)

The modal "could" signals that we are now in the realm of the subjunctive, and Clarissa piles hypothesis on hypothesis, thus passing from the instructions of a will to a theater of the mind. Only the emphatic present of the last sentence brings us back to reality. But the sentence is also ambiguous, not so much in its semantics as in its status as a speech act and in the dialect it belongs to. Clarissa could be: making a statement ("this is how I feel"); performing an illocutionary act of legal forgiveness ("I enjoin the courts to legally forgive Lovelace for the wrongs he has done me"); or performing a perlocutionary act of forgiveness ("I am now forgiving a man who has wronged me").[7] The last option seems precluded by the fact that

7. These categories of performative utterance derive from J. L. Austin's *How To Do Things With Words*. Unlike statements which can be judged true or false, illocutionary speech-acts succeed or do not succeed according to the conditions surrounding them and the competence of the speaker to make them. Perlocutionary speech-acts are always successful, for the action they complete already lies within the utterance itself. Thus "I forgive you" is normally perlocutionary.

Clarissa sends Lovelace a separate letter of forgiveness. The first op-
tion would make this last sentence a continuation of Clarissa's thea-
ter, whose objective is to move the audience rather than to achieve a
desired legal end. The first clause shows that Clarissa is as interested
in showing her state of mind as in forgiving Lovelace. In its gener-
ality the sentence contrasts with the previous scene, where every de-
tail is prepared, including a prompter to hold up a cue card in front
of Lovelace's eyes. If Lovelace insists upon performing in Clarissa's
spectacle, he must play the role she assigns him. Such a scene is
supralegal, the translation of an ideology of divine punishment
(which operates in the world of the novel) into the human legal
world. It is an attempt to go beyond the law and control the very
mind and will of Lovelace as part of a struggle that has been carried
on over the course of the novel. The contrast between the rhetorical
violence of Clarissa's legal theater and the superfluous cheerfulness
of her forgiveness is almost comic.

Prévost, perhaps disturbed by the intrusion of legalism and useless
detail, or perhaps by the thought of woman speaking law, chose not
to translate Clarissa's will. But Jean-Baptiste Suard, who restored the
lost passages to later editions of Prévost's translation, has translated
Clarissa's coda as a legal forgiveness: "Cependant, pour montrer que
je meurs dans une parfaite charité envers tout le monde, je déclare
que je pardonne absolument & sans réserve à M. Lovelace les torts
qu'il m'a faits" (VI, 649). The legal redundancy ("absolument & sans
réserve"), not present in the English, makes this an illocutionary
speech act. Suard has chosen to make Clarissa's words into an illocu-
tionary act, despite the fact that there is no such thing as legal for-
giveness (except for debts). It was natural for Suard to make the
statement sound legal, for otherwise it has no business being in a
will—in fact it demonstrates once again that in *Clarissa* legal dialect is
formed through dialogism with literary or religious dialect.

Monologism versus Dialogism

We may in closing speculate about why dialogism was central to
Richardson's project to a degree that his translators could not attain.
It is a literary-historical commonplace that French literary language
and taste had been codified much earlier and in a much more rigid
fashion than had the languages of any of her neighbors: France, as
the first nation-state in Europe, was the first state to subjugate the
rivals to its main dialect, that of Paris. It was within this world of

Paris, of the *cité bourgeoise*, that Literature was produced, and within this narrow sphere literary language easily became ingrown and subject to careful codification. The restrictions on the use of "low" or "inappropriate" language are based not so much upon clear principles of what is "right," as upon an inability to recognize an otherness which had been wrong for so long. Lionel Gossman's formulation does much to explain the absence of dialogism in France in either original work or translation: "The irremediably other in the eighteenth century was simply not recognized: it could be neither understood nor talked about. The *cité bourgeoise* was still impregnable. Even Diderot's Tahitian was schooled in French rhetoric" (*French Society and Culture*, 121). Diderot, perhaps the most enthusiastic admirer of Richardson on the Continent, created in his Tahitian the equivalent of Prévost's Léman: an outsider who still spoke literature. The Tahitian appears in Diderot's *Supplément au voyage de Bougainville*, a work written partly in dialogue, but which, as Gossman points out, does not partake in dialogism in the Bakhtinian sense.

In this regard one cannot neglect the effect that publishing laws had in separating French letters into the two camps of legitimacy and illegitimacy. No one has done more to illuminate the Byzantine politics of French publishing in this period than Robert Darnton, who informs us that "in 1666 Colbert had settled a trade war between the Parisian and provincial publishers by, in effect, ruining provincial printing and placing the industry under the control of the Communauté des imprimeurs et libraires de Paris. By ruling this guild, a few families of master printer-booksellers dominated legal French publishing throughout the eighteenth century" ("Reading, Writing, and Publishing," 228). Darnton goes on to document how everything, pornographic "libelle" or text of Jean-Jacques Rousseau, not approved as publishable and submitted to those few privileged publishers, became contraband and illegal. The strictness of the opposition between correct and incorrect French was upheld not only in the literary salons, but also in the halls of government. Official censors were known to reject works for purely stylistic reasons, as well as for content (Shaw, "Censorship and Subterfuge," 295). It is difficult to reconcile this restricted picture with Bakhtin's vision of the novel as a kind of vacuum cleaner sucking up every available genre and social dialect.

Everything which found its way into literature was by necessity correct, as Prévost's comments in his translation prove. Thus in the many battles between English and French literary language which took place on the field of translation, it was inevitably the French language which carried the day, which contradicted the English. In

such a context, it is more important to look at the many instances where Richardson's language triumphs over Prévost's: in the first Solmes letter, in the verb "murmerer," in the use of "tu." Prévost, who has for so long been seen as a mangler of Richardsonian discourse, produced a translation which in certain passages must have seemed uncanny to his French readers. In this context we should note that the *Lettres angloises* were published in London and not Paris.

In the sixteenth and seventeenth centuries, France had undergone a political centralization which had served to elevate and then establish the supremacy of the single dialect of its capital. The Académie Française had been established in 1635, and had published their dictionary in 1694. Vaugelas, in his *Remarques sur la langue françois* of 1647, had established the language of the court as the model for the rest of France. The question in Germany would be, which court? Germany had preserved its federalist system, under which the power of the local princes was barely held in check by the Holy Roman Emperor. In this condition of political fragmentation (particularly severe during and following the Thirty Years War 1618–48), it is little wonder that no single Germanic dialect could achieve hegemony over the others.

As noted previously, in the German eighteenth century the Meissner dialect was preferred in literature for several reasons; however, as long as Leipzig was not a political capital for the whole of Germany, this superiority could not be maintained. Thus Goethe would later write of the attempt to make Meissner into *the* German language: "Wir haben viele Jahre unter diesem pedantischen Regimente gelitten, und nur durch vielfachen Widerstreit haben sich die sämtlichen Provinzen in ihre alte Rechte wieder eingesetzt" (*Dichtung und Wahrheit*, 36; "We suffered for many years under this pedantic tyranny, and only after repeated opposition have all the provinces regained their former rights"). There was a balanced tension, then, between Meissner and other German dialects, which allowed Michaelis to recognize *Clarissa*'s dialogism. He seized upon this difference between standard and regional as the closest equivalent to Richardson's use of varying social dialects. In Richardson or Fielding, if a servant misspells words or uses incorrect English, the servant is classified as a subordinate, an "other." In German, however, deviations can appear as new possibilities brought from other dialects rather than deficiencies in the standard one. Michaelis attempts to compensate for this by making the errors more outlandish than in the original, such as when Joseph gives "Urin" for "Ruin."

We may see from this comparison that it was a unique historical

situation that allowed Richardson to use dialogism and make it significant for the larger themes of his novel. *Clarissa* is a beautiful example of Bakhtin's dialogic definition of the novel:

> This latecomer [the novel] reflects, in its stylistic structure, the struggle between two tendencies in the languages of European peoples: one a centralizing (unifying) tendency, the other a decentralizing tendency (that is, one that stratifies languages). The novel senses itself on the border between the completed, dominant literary language and the extraliterary languages that know [dialogism]. (*The Dialogic Imagination*, 67)

We have seen that the struggle which Bakhtin describes was carried on by *Clarissa*'s translators, who constantly found themselves on the border between literary and extraliterary languages.

Bakhtin's dialogic definition of novelistic discourse attempts to function both synchronically, allowing one to differentiate the novel from other genres by means of its language(s), and also historically. The idea expressed in the above quotation of two different types of novel, one taking advantage of and promoting the disparities between competing dialects that offer themselves to literature, the other simultaneously resting upon and helping construct a single dominant literary language, has received some confirmation in our examination of these three texts so important to the "rise of the novel." The examination revealed that three different literatures handle dialogism in three very different ways. But what about history? How did changes in literary and language systems affect later translations of *Clarissa*?

5

Clarissa's Blooming;
or, Translation and
Textual Life

Ist doch die Übersetzung später als das Original, und bezeichnet sie doch bei den bedeutenden Werken, die da ihre erwählten Übersetzer niemals im Zeitalter ihrer Entstehung finden, das Stadium ihres Fortlebens.

(Coming after the original, translation marks for significant works, which never find their proper translator in the era of their creation, the stage of their continuing life.)
　　—Walter Benjamin, "Die Aufgabe des Übersetzers" (78–79)

L'intraduisible est social et historique non métaphysique (l'incommunicable, l'ineffable, le mystère, le génie).

(The untranslatable is social and historical, not metaphysical [the incommunicable, the ineffable, enigma, genius]).
　　—Henri Meschonnic, "Propositions pour une poétique de la traduction" (309)

Sooner or later every student of translation discovers that the movement from the translation of "information"—newspapers, medical and scientific articles, instructions—to the translation of literature is a quantum leap. Computers go on strike, dictionaries' pages spring leaks, algorithms self-destruct. Perhaps the best way to characterize the difference between translation and literary translation is to say that in translating literature we are concerned above all in preserving the "life" of the text, for literary texts have life in a way that other texts do not. The epigraphs to my epi(dia)logue point towards

a history of translation not as an abstract totalization, but as the curriculum vitae of the continuing and changing "life" of a literary work, as Benjamin puts it. Benjamin's untranslatable German "Fortleben," like reading itself, is directional, referring us to a continuing life, to living on. To describe the readings and re-readings to which a literary work is subjected in its "life," readings which in fact constitute its life, is to draw on Benjamin's metaphor in an attempt to "graph" a process which is inherently invisible and impalpable. Clearly translation study justifies itself as such a graph, for if Henri Meschonnic's proposition is correct, the possibilities of translation are always related to history and culture, rather than to metaphysics. Indeed, our discussion of *Clarissa*'s translations has continually confirmed the correctness of Meschonnic's proposition; behind each grammatical point lies a complex web of social relations.

We must also recognize the dialectic inherent in both Benjamin and Meschonnic: history may make untranslatable works translatable, translatable works may become untranslatable. And great works, when translatable at all, require constant retranslation. Each new translation will then realign the previous ones around the central, absent core of the original, like the collection of letters arranged around the central, absent core of Clarissa's rape and of all the other "actions" which refuse to take place in Richardson's novel.

This point can be carried even further, until history itself becomes the most formidable translator of literary works. With airy fingers history "carries" works from one literary system to another (e.g., from classicism to realism), where they are transformed by the very instability of those systems. This is the point made by John Frow, who in a recent work on literary history uses the term "translation" in an expanded sense to apply both to interlingual transfer and historical transmutation: "Both 'writer' and 'reader' are the categories of a particular literary system and of particular regimes within it. . . . But these categories are therefore unstable, and they shift in value as texts are translated from one literary system to another" (*Marxism and Literary History*, 186). Whether between languages or between historical periods, the preservation of a text's original value is precluded not by its own ephemeral nature, but by the reader's. In these last pages, then, I shall sketch the movement of *Clarissa* through history, providing a diachronic supplement to my previous synchronic treatment, as a way of discovering *Clarissa*'s history, that is, as a way of discovering *Clarissa*.

Modernizing *Clarissa*

As was pointed out in the first pages of this work, readers of *Clarissa* have tended to fall into one of two camps: they become supporters of Lovelace, master manipulator of texts; or supporters of Clarissa, the passive signifier exchanged between the males of the novel. I have allegorized Lovelace and Clarissa as two different models of translation: one way, that of strong mistranslation, seeks to master the text by reshaping it in the translator's own image, creating new meaning rather than preserving old; the other way, the academic, seeks to preserve every iota of the text, as if the loss of a single seme were to end creation. One method adjusts the original by immersing it in the host system, the other contorts the host system through the introduction of an alien body. No single translation totally follows one or the other of these models, just as Lovelace is not totally manipulative, nor Clarissa totally passive.

We introduced Prévost at the beginning of our investigation as a man alone, in need of money, but with the self-assurance and aggressiveness that come from belonging to the literary aristocracy, and from adapting a work of an underdeveloped literary culture into a great one. Prévost's translation strategy was overdetermined. That is, not one but several factors drove him not to accept the moral instruction or the aesthetics of prolixity which the original presented: Prévost's personal history, which lay at the far end of the spectrum of excitement and controversy from that of Richardson; French literary taste, which encouraged the domestication of foreign literary texts in translation; censorship in France, which inhibited the expression of certain ideas and inspired a tendency to see all unapproved writing, whether pornography or philosophy, as non-literature.

Again and again we have seen how Prévost tends to turn Richardson's polyphonic, dialogic, decentered text into a monologic third-person narrative in standard literary French. Prévost is especially willing to eliminate the letters of the minor characters and thus to focus the story on the love intrigue between Lovelace and Clarissa. Such a procedure accords with a classical notion of balance and a classical distaste for extraneous material, but it also serves to highlight the conflict between between the two main characters, to tell in straightforward fashion a "love story" which may be absent from the original but which nevertheless forms its center.

In chapter 2 I remarked that this love story could have been a point of attraction between Richardson's work and Prévost's. *Clarissa*

and *Manon Lescaut* are "Zerrbilder" of each other, sharing elements of plot and characterization but opposing each other in their structure and in their treatment of morality and love. Prévost attempted not only to mold Richardson's work to French literary taste, but also to bring it closer to his own literary practice. A remodeling of Clarissa into a Manon must be a silencing, for Manon is one of the most unfathomable of literary heroines and Clarissa one of the most straightforward. This may explain why the most obtrusive of Prévost's cuts come after the rape scene, when (in the original) Clarissa's point of view begins to control the narrative again.

F. H. Wilcox suggests that Prévost removed anything "too highly colored for French taste" (*Prévost's Translations*, 377). The deaths of Sinclair and Belton certainly fit in this category. But why are so many of Clarissa's writings removed as well, along with writings about her? Her mad papers, her own account of the rape, her imprisonment, most of the description of her death, and the whole account of her interment are eliminated. Manon's attraction lies in the unsaid, and it seems that Prévost tried to transfer this economy of discourse to Richardson's heroine. In doing so, he made Clarissa the object of his discourse just as Manon is the object of des Grieux's. Such a reading of Prévost's intentions may seem excessively speculative, but the next few pages will show a later translator of *Clarissa*, Jules Janin, going even farther than Prévost in transforming a narrating woman into a narrated object, and in confessing what he is doing in a way that leaves little room for doubt about his intentions.

While some of Prévost's invocations of "goût" may refer to French literary taste, at other times he uses the word to camouflage his own creative desires with the text. After all, Prévost had consistently and explicitly defended English "goût" in his journal *Le Pour et Contre* (1735–40). In that journal, says Henri Roddier:

> [Prévost] ne cesse de parler . . . de la question des goûts nationaux. Il songe même à en faire l'histoire et à transformer son journal en une *École du Goût*, car si la querelle des Anciens et des Modernes se prolonge, comme il nous l'affirme, dans la rivalité entre le goût français et le goût anglais, il penche décidément, quoique avec une certaine modération, *vers le goût anglais* ("L'Abbé Prévost," 179, emphasis added)

> (In the *Pour et Contre*, Prévost speaks constantly of the question of national tastes. He even dreams of writing a history of

taste and of transforming his journal into a *School for Taste*, because if, as he maintains, the quarrel of Ancients versus Moderns continues in the rivalry between French and English taste, he leans decidedly *towards English taste*.)

In translating *Clarissa*, Prévost changed course and abandoned his attempts to reeducate the French public. The attempt to translate this particular text, written in the genre which had made him most famous, but in a style totally alien to his own, caused Prévost to change his public position on taste.

In opposition to Prévost, Michaelis can be seen as the member of a committee for the importation of foreign literary wealth. Secure in his academic post but insecure in his approach to a superior literary tradition and his own decadent language, Michaelis respectfully translated *Clarissa* as a scholar rather than as an artist. Michaelis's interpretive strategy was also overdetermined. His primary interest in the translation of ancient texts and in Biblical commentary, his positive perception of women's issues, his acceptance of Richardson's didactic purposes, and the absence of any creative prose works of his own and of any important contemporary novels in the German language—all these factors combined to make his translation complete and painstaking, more transposition than equivalence. Above all, Michaelis's translation is a search for a style. In opposition to Prévost, whose own theory of the novel brands his translation, Michaelis moves from strategy to strategy, from dynamic to literal equivalence, in a vain attempt to capture Richardson's vernacular. Michaelis writes in his preface that he has attempted to preserve Richardson's dialogism, for example the loose descriptions ("lose Beschreibungen") of Anna Howe versus the forced humor of "Jacob" Harlowe. Yet the vivacity and variety of the English styles do not appear in the German.

Michaelis's failure in this regard was apparent both to his biographers and to later German translators. Like Henri Meschonnic, both of Michaelis's biographers insist on the historical contingencies of style, on the historicity of translation. Eichhorn reports that "the period in which [Michaelis] was educated, was ill adapted to communicate to his German style, any degree of conciseness, flexibility and skill" (*An Account*, 36). Hassencamp finds not only Michaelis's writing, but also his critical ability hampered by the period in which he lived, since "die erste Ausbildung seines poetischen Gefühls, und seiner deutschen Schreibart fiel in Zeiten, wo noch wenige deutsche Gelehrte das Edle und Unedle, das Kraftvolle und Wässerichte zu

unterscheiden wußten" (*J. D. Michaelis' Lebensbeschreibung*, xxii; "His poetic sensibility and his German style were developed at a time when still only a few German scholars knew how to differentiate the noble from the base, the dynamic from the flabby").

That Michaelis's biographers blame his style on the lack of great literature in the era in which he lived, indicates the Germans' awareness of the literary transformation which their country had undergone in a relatively short period of time. Even as Michaelis was translating *Clarissa*, the German literary scene was being transformed from a wasteland into the tribunal of some of the greatest literary minds in Europe. In a dialectical process between existing language norms and individual creativity, authors like Christoph Martin Wieland, Gotthold Ephraim Lessing, and above all J. W. Goethe were to raise German literary language from a stiff and convoluted academic prose ("Kanzleistil") to a supple and expressive vehicle. With this transformation, and with the pan-European success of Goethe's novel *Die Leiden des jungen Werther* (1774) came the strength to domesticate in translation. Thus, after the Sturm und Drang literary revolution of the seventies, re-creation or equivalence ("Nachbildung") began to shape the translation process.

Re-creation can be seen in Friedrich Schulz's 1788 version of *Clarissa*, which received the title *Albertine: Richardsons Clarissen nachgebildet und zu einem lehrreichen Lesebuche für deutsche Mädchen bestimmt*. In his preface, Schulz directly addressed the need for a new translation, specifically pointing out the inadequacy of Michaelis's:

> Richardsons *Clarissa* (dies Magazin von praktischen Lebensregeln für das weibliche Geschlecht, meinen wir) erschien im deutschen Gewande zu einer Zeit, wo unsre Sprache noch sehr in ihrer Kindheit war: wo unsre Dichter und Philosophen und alle übrigen Schriftsteller, in welchem Fache der Litteratur sie auch arbeiteten, in ihren Bemühungen, sie zu bilden, nur vor kurzem erst den Anfang gemacht hatten; wo Klopstock, Lessing, Bode, und viele andere unsrer vorzüglichen Dichter und Prosaisten theils erst auftraten, theils sich noch im Stillen zu den Männern bildeten, die unsre Litteratur nach der Zeit an ihnen erhielt; und wo endlich noch großer Mangel an sogenannten Modeschriftstellern war, die ganz Deutschland einmütig dafür erkannt hätte, und deren Schriften in den Studierzimmern ernsthafter Gelehrten, wie in denen der Kaufleute, auf den Putztischen unsrer Mütter und Töchter, und in den Werkstätten der Künstler und Handwerker überall gefunden worden wären. (I:i–ii)

(Richardson's *Clarissa* [in our opinion a treasury of practical life rules for the female sex] appeared in German dress at a time when our language was still too much in its infancy: at a time when our poets and philosophers and all other writers, in whatever literary field they might have been, had only just begun their efforts to shape the language; at a time when Klopstock, Lessing, Bode, and many of our other outstanding poets and fiction writers were either just appearing, or were still secretly forming themselves into the men who would eventually take over our literature: and finally at a time, when a great dearth of so-called popular writers was being felt, which all Germany would gladly have recognized, and whose works would have been found not only in the studies of serious scholars, but also on the vanity tables of our mothers and daughters, and in the workshops of our artists and craftsmen.)

The untranslatable word "bilden," of the most extraordinary importance in the German culture of the period, occurs twice in this passage. In his last sentence, the translator links the success of the new literature specifically to the formation and broadening of new classes of educated readers, a process which occurred at about the same time as Michaelis was working on his translation. The first stanzas of Klopstock's epic *Messias* had appeared in the year 1748, the date of *Clarissa*'s publication in English. Lessing's drama *Miss Sarah Sampson*, which used both Richardson and English plays as models in creating German middle-class drama, was first performed in 1755. Remarkably, these two authors, whose works helped to revolutionize German poetry and drama, are referred to in the same breath as Johann Bode, whose fame rests on his translations of the novels of Laurence Sterne, Henry Fielding, and Oliver Goldsmith. In particular, Bode's translation of Sterne's *Sentimental Journey* (1768) into *Yorick's empfindsame Reise* (1776) had given a name to the literary impulse, now to be known as *Empfindsamkeit*, which had begun three decades earlier and was to culminate in the sensational international success of Goethe's *Werther*. Schulz fails to mention another great translator who had also appeared on the scene. Johann Heinrich Voss's translations of Homer, published between 1781 and 1793, exerted an immense influence on German poetic language. Voss's explicit goal had been to broaden the range of German poetic expression through translation.[1] In this revolutionary atmosphere, where "Emp-

1. On the influence of Voss's Homer on German writing see Günther Häntzschel, *Johann Heinrich Voss*, 150–223.

findsamkeit" had replaced "Aufklärung," where the *Göttinger Mu-senalmanach* had replaced the *Gelehrte Anzeigen*, and where literature had left the aristocracy and the professoriate and found a home among craftsmen, in short, where Meschonnic's all-important histor-ical and social conditions had changed utterly, translation could not remain the same.[2]

In consonance with these changes in the reading public, the last two decades of the eighteenth century increasingly saw publication ventures specifically addressed to the education of young women. The examination of Michaelis's preface in chapter 1 showed that he thought of *Clarissa* not as *Bildung*, but as a warning. In his dedicatory poem to Richardson, Michaelis had specifically envisioned his reader as male, as "des Lasters Freund." In 1748 *Clarissa* was discussed by Haller in the anatomy class at all-male Göttingen University, whereas in 1788 it is to be found on women's vanity tables. Forty years later, both the title and the preface of *Albertine* specifically address them-selves to young women, presumably of the middle *Stände*, who could afford vanity tables and, more importantly, the separate bedroom in which to put them. Schulz sees the novel not as "Beispiel und Ab-schreckung," but as a storehouse of wisdom, as a necessary part of a young woman's social education.

As discussed briefly in chapter 3 (see above 45), one of the salient features of *Albertine* is its replacement of the original English names with German ones, a symptom of the method of equivalence, and in this case a sign of the reshaping of a foreign text into a national one. "Clarissa" has become "Albertine," Lovelace is now "Graf Winter-feldt." Where before Michaelis had felt compelled to bend the Ger-man language in order to accommodate Richardson's influence, now importation is felt to be possible only as "strong" translation, as equivalence, as re-creation and abridgement. The translator feels not only that national differences will interfere with the understand-ing of his readers, but also that the length of the book will prove distasteful. A new confidence in his own literary tradition, however, has allowed him to transfer the action and characters of the novel to Germany:

> Dadurch, daß wir den Schauplatz der Geschichte aus England nach Deutschland überpflanzten, verkürzte sich das Original

2. Modern studies of the German reading public tend to confirm Schulz's picture of its growth and of the increase in "Modeliteratur," under which term we must under-stand, at least in part, the novel. On page 168 of his book on literary developments in the period, Albert Ward gives a graph which shows a 500 percent increase in the number of novels published in Germany between 1750 and 1789. On the subject of changes in the reading public, see also Rolf Engelsing's *Der Bürger als Leser*.

um viele Bögen von selbst, und unsere Bearbeitung gewann, wie wir glauben, zugleich an Interesse und Zweckmässigkeit dadurch. So bedarf es keiner Anstrengung für Leserinnen, sich nach England zu versetzen, und das ins Gedächtniß zurück zu rufen, was sie von London und den englischen Sitten überhaupt gelesen oder gehört haben, und die dürfen nicht fürchten, daß ihnen, selbst bei einer ziemlich vollständigen Kenntniß der politischen und sittlichen Lokale von England, doch wohl manche Stellen und Scenen der Clarisse ganz unverständlich oder unnatürlich bleiben möchten. Auch glauben wir, daß die Geschichte einer Deutschen für deutsche Leserinnen anziehender und nützlicher sein müsse, als einer Engländerin. (I:xii)

(Just in transplanting the scene of the story from England to Germany, the original reduced itself by many pages, and we believe our version gained interest and purposiveness. In this way women readers won't need to expend their energy imagining themselves in England and recalling what they have heard or read about London or English customs, nor will they need fear that any passages and scenes of *Clarissa* would remain incomprehensible or unnatural for them despite their thorough knowledge of the politics and customs of England. We also feel that the story of a German woman is necessarily more compelling and more useful for German women readers than the story of an English woman.)

We remember Clarissa's fear of being "engrafted" into a strange family. Schulz's verb "überpflanzen" provides a vegetative metaphor for the act of translation. The reasons behind Schulz's changes thus have the same basis as did Prévost's frequent suppressions of letters: the original would be interesting only for those who already have a thorough knowledge of the source culture. The last sentence shows a new sense of German nationalism. Germans should read about Germans. The preconditions for this sort of adaptation into German are similar to those for Prévost's adaptation into French forty years earlier. However, one does not encounter the concept of pleasure anywhere in the preface, as one does in Prévost. Here the principles of "Zweckmäßigkeit" ("purposiveness") and "Nützlichkeit" ("utility"), not those of aesthetic pleasure, guide the production of a strong translation which will remold the text in the image of the target culture.

The translation of *Clarissa* by Gotthard (Theobul) Ludwig Kosegarten, which appeared in the year 1790, may also be counted

as an adaptation and abridgement with didactic ends. In many ways
Kosegarten resembled Albrecht von Haller. Both were academics
with poetic and theological talents. Kosegarten was later to become
professor of theology and history at the University of Greifswald. As
a poet, and as the coeditor of Schiller's famous literary almanach *Die
Horen*, Kosegarten was very much a part of the new literary move-
ment in Germany. Interestingly, two different editions of his transla-
tion appeared: the Mannheim edition bears the name of the educa-
tor Ludwig Kosegarten, whereas the Leipzig edition uses his nom de
plume Theodore Hiobul. In the years 1788 to 1790—during which
two-year period approximately five times as many novels were writ-
ten in German as between 1748 and 1750, when Michaelis under-
took his first translation of Richardson—a need for new, strong
translations of Richardson's work was being felt. One sought to re-
place the deficiencies of Michaelis's novelistic discourse with the
more vital language developed during the periods of Sturm und
Drang and Classicism. The historical movement of the translations
of *Clarissa* in Germany, then, has been from a literal rendering of
the English text to abridgement and adaptation for national consid-
erations. A constant remains, however: the emphasis on the didactic
elements of the text.

The conception of *Clarissa*'s audience also changed, from largely
male to largely female. *Clarissa* began in France with much of its
heroine's discourse suppressed. By the end of the century much of it
had been restored. The historical movement of incorporation was in
the opposite direction (*sens*) from that in Germany. Though by and
large the public approved of Prévost's emendations of both *Clarissa*
and *Grandison*, Richardson's death in 1761 inspired a series of edi-
tors and translators to restore the shattered text, piece by piece. "La
mort de Richardson et *l'Éloge* de Diderot lança une nouvelle série de
tirages, surtout à Paris et à Genève. De 1770 jusqu'à la Révolution, il
y eut au moins onze tirages et traductions nouvelles [de *Clarissa*]"
(Rosselot, 85; "Richardson's death and Diderot's "Éloge" launched a
new series of printings, mostly in Paris and Geneva. From 1770 to
the Revolution, there were at least 11 reprintings and new transla-
tions [of *Clarissa*]").[3]

3. The revival of interest in Richardson would seem to have been part of—or to
have caused—a wave of interest in the epistolary novel in France just before the
revolution. The masterpiece of this genre in the French language, *Les liasons danger-
euses* by Choderlos de Laclos, published in 1782, was just one of many titles to appear
in the '80s. The number of new epistolary titles increased each year, reaching an all-
time high in the years 1788, with thirty-one titles published, and 1789, with twenty-
three. (Figures taken from Giraud, *Bibliographie du roman épistolaire en France des ori-
gines à 1842*.)

One example of the changed French attitude towards Richardson upon his death can be found in a letter to Voltaire by Charles de Brosses, dated 27 May 1761. The "auteur qui ne laisse pas dormir son monde" is actually the translator Prévost:

> Quand on me prêta *Clarisse*, je maudis mille fois le chien d'auteur qui ne laisse pas dormir son monde, et j'écrivis promptement à Londres pour avoir l'original de ce livre si original, si chaud et comparable seulement à l'Iliade. (Besterman, *Corneille*, 51)

> (When someone lent me *Clarisse*, I cursed a thousand times that dog of an author who won't let his world sleep, and I wrote promptly to London to get the original of this book which is so unique, so passionate, and comparable only to the *Iliad*.)

De Brosse's metaphor "qui ne laisse pas dormir son monde" is both intriguing and ambiguous. In this context it probably refers to Prévost's tendency to inject his own fictional world, plus commentary, into Richardson's. *Clarissa*'s new translator, Tourneur, will say the same thing less metaphorically.

The first supplement to Prévost came from the pen of Jean Baptiste Antoine Suard, who is chiefly remembered as the editor of a number of journals, including the *Journal de Paris* and the *Journal étranger*. Diderot's famous "Éloge de Richardson" first appeared in the latter, in January of 1762.[4] It was followed in March by the "Enterrement de Clarisse," a translation of Morden's description of Clarissa's burial (1394–1409). Though library catalogs attribute the translation to Suard and none of Diderot's biographers mentions the translation, Suard's own biographer gives the credit to Diderot (Hunter, *J. B. A. Suard*, 59). Most interesting from our point of view, however, is the fact that all later editions of Prévost's translation incorporate these supplements, as though they had been done by Prévost himself. His *Ouevres complètes* of 1784 contains both the Suard supplement and Diderot's "Éloge."

Further repairs were to follow. Pierre Prime Félicien de Tourneur had already translated into French such typically English works as Edward Young's "Night Thoughts," the supposed primitive Scots poet Ossian (a literary forgery), and some of Shakespeare's dramas.

4. Diderot's essay has often been studied. See Rita Goldberg's *Sex and Enlightenment*, 137–45, and June Siegel's "Diderot and Richardson." Again, the date of the "Éloge" indicates that it was inspired by Richardson's death, rather than by the first appearance of *Clarissa*.

One can see from the foregoing list a greater sympathy for the dark, Gothic side of English literature than Prévost was able to muster, and in 1785 Tourneur brought out a version of *Clarissa* which was billed as the first complete translation of the novel into French. The change in title, from the deliberate exoticism of Prévost's *Lettres angloises* to the more literal *Clarisse Harlowe*, already indicates a different approach to translation. In the preface Le Tourneur, in mentioning the part of the text already restored by Suard, takes care to oppose his own rôle as translator to the rôle of author which Prévost had assumed. In doing so he refers to Suard's restitution, and accuses Prévost not of incompetence, but rather of strong mistranslation, of the substitution of a will to creation for the will to translation:

> On nous avoit déjà restitué une portion intéressante que l'abbé Prévost avoit comme dérobée à la gloire de Richardson, et à nos plaisirs, sans autre motif apparent que son empressement de sortir de l'humble rôle de traducteur, pour créer lui-même, et puiser, comme il a si heureusement fait, dans son propre fonds (ix)

> (An important part has already been restored, which the abbé Prévost had as it were stolen from Richardson's glory and from our own pleasure, with no other motive than his haste to leave behind the humble role of translator in order to create, and to draw on his own creative resources, as he so happily did).

The use of the word "heureusement" in the final sentence is ambiguous: it can indicate Tourneur's positive assessment of Prévost's success as a novelist, or simply refer to the emotion which Prévost undoubtedly experienced while creating. In either case, the word shows a grudging admiration of the man whom Tourneur is supposedly trying to correct. Tourneur betrays here the ambiguous feelings of all those who come *after*, of those who must circumnavigate a literary monument. He anticipates by two centuries my own analysis of Prévost's seduction of his readers. And though he lambastes Prévost for strong mistranslation, he does not analyze the direction which Prévost's changes took.

If the burden of Richardson's authorship lay heavily on Prévost, then the burden of Prévost's translation also presented an obstacle for Tourneur to overcome. While Prévost's translation purposely

emphasizes the gaps between his text and that of Richardson, Tourneur's version inevitably recalls the gaps between his own method and that of Prévost. For example, he inserts brackets around those parts of the work which were missing from Prévost's translation. In the preface he gives a complete account of the pages that had been lost from each volume through Prévost's omissions. Yet Tourneur's unending critiques of Prévost show an absolute familiarity with the latter's translation, and it is no accident that many passages in the two translations read exactly the same, a sure sign that Prévost was as much a source for Tourneur as Richardson was. Similarly, at many places Tourneur makes choices similar to those of Prévost. Thus there are still parts of Richardson's novel which could not be captured in French, such as the badly spelled letters of Joseph Leman and Will Somers. Tourneur's comments here are scarcely distinguishable from those of his predecessor: "L'orthographe est grossièrement défectueuse et l'imitation seroit choquante et illisible en françois." Like Prévost, and undoubtedly from the same motive of not provoking the censors, Tourneur also fails to translate one of the last sentences of the novel, which states that Lovelace had "refused ghostly attendance, and the Sacraments in the Catholic way" (1488). Tourneur renders more of *Clarissa* into French than Prévost, but he does not render all. His translation, which supposedly was to oust Prévost's, confirms and pays tribute to its supposed nemesis.

And in the end, the French reading public seemed to prefer strong translation. Though *Clarissa* was read in France throughout the eighteenth century, Tourneur's biographer states that it was Prévost's expurgated version, rather than Tourneur's "complete" one, which gained the favor of the reading public.[5] E. S. Dallas, editor of an English-language abridgement of *Clarissa*, is even more enthusiastic about Prévost's work. In a rapturous celebration of strong mistranslation—and of his own project of edition—Dallas links Richardson's success in France to the necessity of abridging his work, so that Prévost becomes the virtual author of an enormous literary success:

5. Mary Cushing, *Pierre le Tourneur*, 133. In any translation, *Clarissa* seemed to be less popular than *Pamela*, Richardson's first and less serious novel. Although Rosselot documents twenty editions of each work by 1790 (*Samuel Richardson*, 83), the numbers printed are also important. *Clarissa* appeared, for example, in 1778–89 at Rouen in an edition of only 750 copies, whereas *Pamela* had a run of 1200. Both novels lost out to Prévost's own *Cléveland* with 2500 copies (Brancolini, "La vie provenciale," 17). That was the same number of copies as reserved for the German translation of *Grandison*, which was published by Weidmann (Fabian, "English Books," 131). *Clarissa* appears to have been Richardson's least popular novel even in England.

> The version of *Clarissa* by the Abbé Prévost, which made the
> reputation of Richardson in France, and sent the French into
> the wildest raptures at the mention of his name, was, in fact,
> an abridgement. We read . . . how Diderot glorified the work
> in the Café Procope, how for a whole month its author was
> exalted above Voltaire, how the Encyclopaedia was neglected
> for it, how Crébillon paled before it, how Dorat wept in
> despair, and how the reigning mistress trembled for her em-
> pire because she had seen it on the king's table. It was the
> abridged translation of Prevost [sic] that stirred all this and
> much more enthusiasm. (*Clarissa* 1868, I:x)

Dallas is responding not just to Prévost, but also to a second, rela-
tively undocumented wave of French interest in *Clarissa* during the
mid-nineteenth century. A drama, a musical, a new edition of Pré-
vost's translation, and two new translations bearing the name of *Cla-
risse* appeared between 1845 and 1851. It was this revival of interest
among the French which caused Dallas to bring out the first English-
language abridgement of *Clarissa* in 1868. Inspired by Prévost, but
also by the success of Jules Janin's translation, Dallas wished to re-
duce Richardson as well.

Janin's literary output could perhaps best be described as a de-
based Romanticism. His fascination for gratuitous erotic violence is
best indicated by the title of his first novel, *L'Ane mort et la femme
guillotinée* (1829). The short story was probably his most successful
genre (*Contes fantastiques* appeared in 1832). But by the time he came
to his translation of *Clarissa*, Janin had long devoted himself more to
salon life and theater criticism than to creative writing. Perhaps the
real literary monument of this caustic critic, as formidable in Pari-
sian literary life as he was to be innocuous in literary history, were
the 735 letters which he wrote to his wife, in nearly every one of
which he addressed her as his "enfant," though once he switched to
"ma bien aimée Clarisse" ("My beloved Clarisse"). The etymology of
"enfant," from the Latin for "unable to speak," recalls the silencing
of women addressed in chapter 4 (see above, 125–42). Prévost's strat-
egy in his translation mirrored that of Clarissa's family. He reduced
Clarissa's opportunities to express herself in order to increase his
own. Janin spoke for his wife, his "Clarissa," and we shall see that he
spoke for Richardson's Clarissa as well.

Madame Janin had the privilege of writing down the dictations of
her husband. Apparently they were partners in the *Clarissa* transla-
tion, though her rôle was confined to that of passive secretary. In a
letter dated 15 May 1845, Janin speciously comforts her that, after

all, this was no different from the role that Mrs. Richardson had played:

> C'était un bon homme ce Richardson et sa jeune femme a écrit sous la dictée de son mari tout le roman de *Clarisse!* C'est très bien fait pour Mrs. Richardson, mais je suis bien sûr, qu'elle n'avait pas, tant s'en faut, l'intelligence, la grâce, le dévouement, le coup d'oeil, la main leste et prompte de ma petite secrétaire de la *Clarisse*. Toutefois, c'est là une chose curieuse qu'à une si grande distance, la femme du romancier, et la femme du traducteur aient eu leur part de ce travail de leur mari! (*735 Lettres*, II:103–4)

> (Richardson was a good man, and his young wife wrote the whole novel of *Clarissa* at his dictation! That was well done on the part of Mrs. Richardson, but I am certain that she never had the intelligence, the grace, the devotion, the vision, the swift and steady hand of my little secretary of *Clarisse*. All the same, it is a curious fact that both the novelist's wife and the translator's wife, at such a great distance from each other, both had a part in the work of their husband.)

Janin is able to identify himself with Richardson, but only by first linking the two wives together, indicated grammatically by the use of the singular "mari." The male inspirational affinity is available only through the identification of Janin's wife with Richardson's (second) wife, as though the male literary community were held together through the circulation of its women. However, the information on Mrs. Richardson as her husband's amanuensis was either a misunderstanding, a confusion of Mrs. Richardson with Victor Hugo's Juliette Drouet, or a fabrication to flatter his wife. Janin emphasized repeatedly their mutual literary project as though it were the very foundation of marital bliss. We can see the use of translation as seduction in Janin's later invitation to his wife to visit him in Germany: "Nous vivrons très calmes, très tranquilles, tout à nous, nous finirons *Clarisse!*" (*735 Lettres*, 127; "We will live very calmly, very tranquilly, all by ourselves, we will finish *Clarisse!*"). Writing can seduce (as can translation) through its illusion of finality, of its containing an object; but here translation itself is the object of desire, a metaphor for the sexual act for which the utmost privacy and affection are required.

In 1846 the lovers had finished *Clarisse* and presented her—with only the name of Mr. Janin on the title page—to the public. The translation was quite successful. A musical drama was based on it,

and E. S. Dallas took the work as a model for his own English abridgement of the novel. The success of the translation depended on two by now familiar factors: its brevity, and its substitution of a single narrator's voice for the epistolary structure of the original. Yet Janin, as though intimidated by the power of the original, waits as long as he can before inserting this voice.

In the preface to his translation, Janin invokes the authority of Jean-Jacques Rousseau, whose own planned abridgement of *Clarissa* never materialized, to justify his transformation of the text. Janin's idea, remarkably similar to that which the author of *Albertine* had expressed a half-century earlier, is that a great historical change has taken place. Here, however, the change has necessitated less the gallicization of *Clarissa* than its shortening. Modern civilization, rather than French culture, now provides the target system so different from Richardson's:

> Pendant qu'une civilisation avancée et qui n'a pas de temps à perdre, abrège même les travaux et les plaisirs de l'esprit, et lorsqu'on fait tant de résumés des histoires même les plus serieuses, il serait utile de réduire ces longs romans à des proportions plus modernes; quand la vérité a tant de peine à trouver audience, la fiction n'a pas le droit de se faire écouter si longtemps! (3)

> (While an advanced civilization with no time to spare is abridging even intellectual works and diversions, and since even the most important stories are often condensed, it would be useful to reduce the long novels to more modern proportions; when truth has so much trouble finding an audience, fiction has no right to such a long hearing!)

The shibboleth "utile" appears here as though lifted from Prévost. Janin anxiously negates the seductive power of fiction; only truth "has the right" to a modern audience's attention. Near the very end of his preface, Janin is able to reduce this long and lofty cogitation to a single sentence: "la vie de chaque siècle est un procès dont tous les détails intéressent les contemporains, mais qu'il faut abréger pour l'avenir" (5; "The life of each epoch is a process whose every detail interests those living within it, but which it is necessary to abridge for the future"). Janin is abridging not *Clarissa* as such, but rather the eighteenth century which lives on within the book. Like Prévost, Janin denies that the purpose of translation can be to introduce the

new and alien into the target system. One wonders why the contrary to Janin's argument should not be more true: that writers of one era take social realities for granted which disappear in the course of history, a phenomenon which allows an older work of literature to produce an alienation effect which interests later readers. Janin replaces the gulf of culture with the gulf of time as a justification for strong translation. The distance in time will serve as an excuse for Janin to creatively mistranslate Richardson.

Janin has cut more freely than *Clarissa*'s other translators, reducing the eight-volume work to a single tome of less than 300 pages. His strategy for doing so is clear. Where Richardson had woven a web of conjectures, contradictions, and rhetoric around an unspeakable central event, Janin will clear away the farrago of words in order to arrive at, to create, to write the event. To this end it will behoove him to destroy the epistolary form of the work, thus placing narrative authority in his own hands as translator/narrator; the surprise is only that he does not do so from the beginning. The first part of the novel remains a collection of letters, but one from which all but the barest essentials of plot have been stripped. The illusion created by Richardson that there really had been an epistolary exchange among the characters of the novel is not important here; openings and closings of letters, and the chit-chat which alternates with serious news has been eliminated. The letters of Clarissa, Lovelace, Belford, and Anna Howe are deprived of their conversational quality and molded into the minimal units of plot. This same procedure will be followed by all abridgers of *Clarissa*. But this new use of letters merely to recount the story becomes tedious, and Janin finally abandons it. After Clarissa is returned to Lovelace from Hampstead, that is, in the short space of time before Clarissa's rape, a narrator, unknown in the English original, an imposter like Lovelace's creatures, suddenly slips into the text:

> Racontons à présent, à la façon d'un historien qui ne recherche que la vérité et l'exactitude du récit, les suites lamentables de cette histoire. Jusqu'à ce moment, notre terrible héros a jeté à pleines mains l'ironie, l'esprit, l'insolence, la négation des meilleurs et des plus honnêtes sentiments de l'homme. . . . Nous irons donc, de notre mieux, jusqu'au dénouement de ce drame, et nous passerons par toutes ses péripéties abominables jusqu'à ce que le courage nous manque. (161)

(Let us narrate now, in the manner of an historian who seeks nothing but truth and accuracy in his narrative, the sad events of this story. Up to this point our terrible hero has thoroughly sown irony, wit, insolence, the negation of the best and most decent human feelings. . . . Therefore, we will proceed as best we can to the dénouement of this drama, and we will pass through all its peripeties until our courage fail us.)

This passage shows a bizarre mixture of vocabulary, half of it from the realm of narrative ("racontons," "récit," "histoire") and half from the realm of drama ("héros," "drame," "dénouement," "péripéties"). Indeed, the epistolary novel is precisely that form of narrative which most resembles the drama—not because an exchange of letters could be mistaken for dialogue, but because the force of drama lies in the agon, the battle between opposing concepts embodied in opposing characters and dialects. On the other hand, the force of narrative resides, as Janin puts it, in its truth and exactness. Yet here Janin clearly means to neutralize the dangerous dramatic potential of Richardson's text by subordinating the dramatic to the historical, for it is only by entering the text as narrator that Janin is able to describe the text as drama. In turn, the dramatic effect of epistolarity is eliminated by the same gesture which draws attention to it.

Curiously, the paradox of narrated drama which Janin seemingly creates here is in fact one of the central elements of Richardson's art. (It will reappear in the titles of Mark Kinkead-Weekes's *Samuel Richardson: Dramatic Novelist*, and Ira Konigsberg's *Samuel Richardson and the Dramatic Novel*.) Near the end of his penetrating analysis of the resemblances between epistolary form and the drama, Kinkead-Weekes states that "Richardson's basic form is an attempt to push his fictions as far toward the spoken, the inward, and the dramatic as he could. Hence the interplay between the epistolary and the dramatic seems to expose a paradox" (461). That paradox irrupts in Kinkead-Weekes's own statement, where "spoken" and "inward" appear in the same series as though synonymous. Nor is Janin's designation of Lovelace as hero very far off base. Margaret Doody in *A Natural Passion* (99–127), and Ira Konigsberg in his study, have both demonstrated that Lovelace's character is drawn from stage figures such as Nicholas Rowe's Lothario.

Janin's impatience with the ahistorical aspects of Richardson's text shows through in this quotation. He repeats here his concern with truth and exactness—in the world of fiction. His narration will itself be a heroic act, supplementing the negative heroism of Lovelace.

Janin the Good (good because truthful), the new hero of the text, will go as far as his courage allows him, which is farther than either Lovelace or Clarissa goes in describing her rape:

> Plongée dans ce rêve, dans ce délire, il lui semblait qu'une fille, cachée dans sa chambre et à demi-nue, ouvrait les portes, tirait le verrou, et que cette fille, prenant la voix et l'habit de sa maîtresse, introduisait Lovelace dans le lit même de Miss Harlowe. Ici s'arrêtait le songe, mais pour reparaître l'instant d'après, mêlé à une épouvantable confusion. Plus de Clarisse, plus de vierge sainte et sacrée! Elle se levait, le transport au cerveau; elle marchait au hasard dans cette maison maudite, elle voyait s'enfuir Lovelace, éperdu de son crime, et puis, fascinée elle-même de sa propre douleur, ivre de poison et d'épouvante, elle se traînait jusqu'à cette porte où elle entendait des voix humaines, pour demander pitié et vengeance. (166)

> (Deep in this dream, in this delirium, it seemed to her that a girl, hidden in her bedroom and half-naked, was opening the doors, was drawing back the bolt, and that this girl, assuming the voice and costume of her mistress, was introducing Lovelace into the very bed of Miss Clarissa. Here the dream ended, but only to reappear an instant later, mixed with a terrifying confusion. No more Clarissa, no more holy and sacred virgin! She got up, frenzy in her brain; she wandered randomly through this cursed house, she saw Lovelace fleeing, crazed with his crime, and then, fascinated by her own grief, drunk with poison and terror, she went up to the door where she heard human voices, to demand pity and revenge.)

In the previous passage, Janin's ambiguous designation of Lovelace as "hero," along with the paradoxical mixture of irony, intellect, and insolence said to characterize him, hinted at a Romantic fascination for aberration. Here that fascination with evil and violence becomes more obvious. The report that Clarissa was in a state of "transport" after her rape can indicate both delirium and ecstasy. The use of "éperdu" to describe Lovelace is of a similar ambiguity. "Éperdu" is used to indicate the loss of mental capacity due to a strong emotion, either pleasurable or unpleasurable. One can be, for example, "éperdu d'amour." Is "crime" merely a substitute for "amour" in Janin's description of Lovelace? Nor does the exclamation "plus de vierge" escape the tone of a snicker. It is rhetorically equivalent to

Lovelace's own famous "Clarissa lives!" to describe his deed. Janin's detailed description of the rape is largely invented. Since Clarissa was drugged, there was no need for the girl-hidden-in-the-closet trick, although Lovelace does mention the device earlier in the novel as a possible scheme. Adding that the helper was half-naked provides a clear, erotic, Boucher-like etching for the reader of the scene.

Janin's whole handling of Clarissa's rape reverses the play of presence and absence in the original. The absence of the rape scene is bound to Clarissa's own ability to maintain her integrity—expressed here as "virginity"—in the face of physical violation. Clarissa refuses to make a legal claim against Lovelace because she realizes that the court would force her to describe in graphic language, in even greater detail than Janin gives, what has happened to her, leaving her outside the bounds of feminine decorum and integrity. Instead, the closest Clarissa comes to describing the rape is the following passage, which may be compared to Janin's description above:

> I grew worse and worse in my head; now stupid, now raving, now senseless. . . . I remember, I pleaded for mercy—I remember that I said *I would be his—Indeed I would be his*—to obtain his mercy—But no mercy found I!—My strength, my intellects, failed me!—And then such scenes followed—O my dear, such dreadful scenes!—Fits upon fits (faintly indeed, and imperfectly remembered) procuring me no compassion. (1011)

Janin's narrator has supplemented (both aided and replaced) Clarissa's poor memory.

When Janin emphatically writes that Clarissa is no longer a virgin ("plus de vierge"), he contradicts what several characters say later in the novel, that she remains a virgin despite her violation. His declaration of her loss of virginity is the direct product of his description of it. In writing the rape, Janin has committed it; he has inserted himself into *Clarissa* and raped Clarissa, for it is he and no other who has destroyed her virginity. This process is the same one as we have seen earlier, in Janin's letter to his wife comparing her with Mrs. Richardson: the female is used as the pathway to Janin's brotherhood with Richardson. It is through the female that Janin, obsessed with his role of "auteur," with his wish to be the maker and controller of all action within his text, wishes to touch Richardson's great-

ness by changing *Clarissa*'s complicated, dramatic textuality into heroic narrative.

Another of Janin's letters to his wife confesses both this urge to mastery, and his failure to obtain that mastery through the act of translation. Even when he knows the success of his translation, with copies being ordered from as far away as Russia,[6] Janin is tormented by the thought that for some reason Richardson will still be thought the author of the work. He writes on 9 October 1846, half a year after the first printing of his translation, and complains—needlessly—that it will be read as a *mere* translation:

> C'est un livre accepté; mais on peut dire: ça n'est pas son oeuvre! Il a imité, il a copié! Le livre que je veux faire, que je fis, m'appartiendra en entier, la forme, le fond, l'idée, le détail, la vérité, le paradoxe, tout sera pour moi (*735 Lettres*, 188)

> It is a well-received book; but they can say: it's not his work! He imitated, he copied! The book which I wish to make, which I have made, will belong entirely to me, the form, the essence, the idea, the detail, the truth, the paradox, all will be for me alone).

The use of the preterite "fis" underlines Janin's realization that his major creative work lay two decades in the past. And that word "vérité," which Janin had previously only tried to discover in Richardson's text, here appears within a series comprised of the objects of the translator's voracious creative desire. To be an author is to create and thus possess Truth, an achievement far superior to the mere search for another's Truth that is undertaken by the translator. And paradox must also be there, for of course Janin's attitude towards translation is paradoxical from the start. Janin has not merely found Truth in his translation, but has created it through strong mistranslation. Like Prévost, he has done his best to leave his mark on Richardson's text. As have its English abridgers.

6. In eighteenth- and nineteenth-century Russia, French translations of literature were more highly valued than Russian ones. Janin's translation competed against Prévost's for an upper-class reading public which had already made "Clarissa" and "Lovelace" common nouns in its vocabulary. According to Vladimir Nabokov, Alexander Pushkin read Prévost's version of *Clarissa*, remarking that he "cannot endure her—such a tedious goose" (*Eugene Onegin*, II:346).

Strong Editing

In the concluding chapter of *After Babel*, George Steiner argues for the absorption of various terms, such as "translation," "adaptation," and "re-creation," into the single metaphor "topologies of culture," a term which would cover any reappearance of a complete text in a different context. Though few would countenance abolishing the distinctions between terms such as "translation" and "adaptation," equally few would succeed in drawing precise borderlines between them. As a coda to this study of the translations of a masterpiece, I would like to risk adding another term to the synonyms listed above: edition. If we have seen that translators could also act as editors and abridgers, it is perhaps worth examining the two most popular editions of *Clarissa*—The Riverside Edition by George Sherburn, and the Modern Library version by John Angus Burrell—to see the extent to which editors can act as translators. Janin, we remember, made less of the linguistic or national differences between Richardson and himself than he did of the historical shifts which had rendered the book unreadable. Like Janin, the abridgers see themselves as bringing *Clarissa* across a great gulf of cultural difference created by history.

Both of these editions are abridgements, and it is important to remember that *Clarissa* is the only great novel in the English language which is consistently taught in abridged form. A new complete one-volume *Clarissa*, based on Richardson's first edition, has become available through Viking Press, and may replace abridgements as the canonical university text. However, the fact that editor Angus Ross used the first edition rather than the fourth as his source once again denies the validity of bibliographic rules in the same way that translation practice challenges the validity of translation theory. Ross states baldly that he used the first edition because it is—to him—the best text. Is not Prévost's reasoning precisely always that he should give his readers the best possible text, rather than the one Richardson would have given them?

To return to Benjamin's metaphor, abridgement is what has kept *Clarissa* alive, from Prévost to Sherburn. Indeed, Burrell uses precisely that metaphor of textual life in his introduction: "That *Clarissa* is too long, everyone who has not read it will admit. Only one who has just removed fifteen hundred of its two thousand pages is in a position to say that most abridgements of the book are too short. It may be, however, that this kind of surgery is necessary if the patient is to live" (*Clarissa* 1950, xiii). Burrell knows what he is talking about.

Whereas Michaelis's careful, plodding translation with full appendix
died aborning, Prévost's translation, as we have seen, lived on well
into the nineteenth century, in Russia as well as in France. Abridgers
of Richardson like Burrell and Sherburn are in the "re-creative"
camp of readers, for it is always their express purpose to reshape
Richardson according to their own modern aesthetic, just as Prévost,
Schulz, and Janin have done. In fact, their methods of abridgement
parallel these translators' strategies in many ways.

In matter of form, both Sherburn and Burrell express a desire to
correct the defects of epistolary narrative. Indeed, Sherburn's re-
marks introducing his abridgement resemble nothing so much as a
Prévostian interpolation. Sherburn writes that "we are at last forced
to conclude that the [epistolary] method, while apt in producing a
good moral book (we all get good moral counsel in letters!), is likely
to be repetitious and slow in telling a story" (*Clarissa* 1962, xi). This
observation could be an English translation of Prévost's juxtaposition
of *Clarissa*'s "inutiles détails" with its "plus sages leçons." Thus both
abridgers eliminate the parts of the letters which had the discursive
purposes outlined in the preceding chapters. Burrell's strategy, so
familiar from Prévost and Janin—and, as pointed out in chapter 2,
almost indistinguishable from the editor's strategy in the original—is
made clear in the following interpolation, in which he eliminates
Lovelace's letter to Joseph Leman, (and then goes Prévost one better
by also eliminating Joseph Leman's letter entirely): "Omitted here is
a long letter, Lovelace to Joseph Leman, giving specific directions
for tricking Clarissa in the garden scene, which Clarissa's letter re-
cords" (208). Since Clarissa's letter records them, repeating them
would be "inutile." For Burrell as for Janin this novel consists of
Truth, of facts which must be stated only once. The perspectivism
which repetition provides, not to mention the social relationship em-
bodied in the exchange between Lovelace and the unlettered Le-
man, are sacrificed to forwarding the plot.

Sherburn shows similar impatience. In a letter from Lovelace re-
cording an escape attempt by Clarissa, the voice of the editor Sher-
burn intervenes to speed things up. Despite the brackets, his voice
seems to blend with Lovelace's:

> I went out early this morning, and returned not till just
> now; when I was informed that my beloved, in my absence,
> had taken it into her head to attempt to get away.
> [Mrs. Sinclair stopped her.]
> I will endeavour to see her. (311)

Both Burrell and Sherburn benefit greatly, as did Prévost, from Richardson's own editor. An unsuspecting reader might not notice the brackets which mark the difference between editor and abridger. That original editorial voice, with its own stodgy and truthful tone, in fact gives the abridgers their own authority for deletion and censure. (It is doubtful that the tedious parts of Henry James's omniscient third-person narratives could ever be replaced with such brackets.) Margaret Doody and Florian Stuber note the confluence of editorial markings in Sherburn:

> An innocent reader, coming to *Clarissa* for the first time in Sherburn's version, will naturally assume when faced within a letter by a row of dots that here something has been omitted. Sometimes this is Sherburn's mark of omission—sometimes it is Richardson's own convention to indicate a passage of time. Sherburn never makes clear when he has retained Richardson's time symbol . . . and when he is marking omission. (*"Clarissa* Censored," 75).

Like Janin, the Romantic Burrell at times transforms the intertextual density of Richardson's novel into a single moment of acute sensibility. Burrell's ability to translate Richardsonian *écriture* into a single poignant event can be demonstrated in his editing of one of Clarissa's early letters. The focus of the original passage is on the incessant hammering of voices upon Clarissa, which succeed in publicizing her most private moments. The abridgement eliminates the noise, thus restoring a peaceful stillness to Clarissa's private agony. Burrell's Clarissa ends her letter thus: "I was in the Ivy Summerhouse, and came out shivering with cold, as if aguishly affected" (*Clarissa* 1950, 182). In the following fuller quotation, we can see the part of the letter that, like an iceberg beneath the surface of the water, does not appear in the abridgement, even though it represents the true purport of Clarissa's comments:

> I was in the Ivy Summer-house, and came out shivering with cold, as if aguishly affected. Betty observed this, and reported it.—"O, no matter!— Let her shiver on!—Cold cannot hurt her. Obstinacy will defend her from harm. Perverseness is a Bracer to a love-sick girl, and more effectual than the Cold Bath to make hardy, altho' the constitution be ever so tender."
> This said by a cruel Brother, and heard said by the dearer friends of one, for whom, but a few weeks ago, every-body

was apprehensive at the least blast of wind to which she exposed herself!

Betty, it must be owned, has an admirable memory on these occasions. Nothing of this nature is lost by her repetition: Even the very air with which she repeats what she hears said, renders it unnecessary to ask, who spoke This or that severe thing. (*Clarissa* 1930, II:290–91)

The reader of the abridgement receives the impression that Clarissa's health is really the issue in this passage, or that her shivering is an objective correlative to the agony she is undergoing, or that her death is being foreshadowed, or all these things at once. We witness a private moment shared in a letter. In the unabridged version, the focus is upon Clarissa's lack of privacy, as her every word and movement are observed, dissected, and interpreted by her family. The very moment which could invoke a reader's empathy, as it no doubt does in Burrell's version, is immediately negated by its ironic linguistic echo. Clarissa's refraining from first naming her brother as the source of the jeering makes it the gossip of eternity: communal, anonymous, ubiquitous. The use of Betty as an intermediary in both directions—as observer of Clarissa and as tape recorder for James's caustic statements—further complicates and socially debases the linguistic web in which Clarissa is trapped, and from which Burrell in his mercy has freed her.

Sherburn is more interested in liberating Lovelace. After describing in his introduction how Clarissa's decorum consistently "blocks the road to happiness" (*Clarissa* 1962, ix), Sherburn lets the reader know that he too, like Prévost and Janin, is devoted enough to this novel to improve it:

Although Clarissa's plight must arouse and move readers overwhelmingly, the sympathy may be somewhat lessened by the dazzlingly mixed character of Lovelace, who, whether kindly regarded or viewed with horror, steals the show. The Rosebud episode at first tips the scale for some in his favor. Later his unfeeling and brutal sexual plots, not merely against Clarissa but also against the ladies of Hampstead, and against Anna Howe and her mother, should make him either despicable or absurd. His plot against the Howes, inserted first in 1751, is here omitted as an improbable fantasy designed crudely to make Lovelace blacken himself—to show that to him rape is just good fun. (x)

Lovelace's later plots "*should* make him despicable." The "should" is ambiguous here, either denoting a moral imperative or revealing Richardsonian intentions that fail to correspond with the Truth. The next sentence makes it clear that Sherburn means the latter. In omitting Lovelace's bizarre rape fantasy, Sherburn takes advantage of his position as abridger to reverse one of the most fundamental rules of textual criticism: that the last edition to appear during the author's lifetime best represents his "final intentions"—a reasoning all the more cogent in Richardson's case, since he was his own printer! Clearly, for Sherburn the third edition of 1751 is hopelessly corrupt, ruined by Richardson's misreading of the very character he had created. Sherburn accuses Richardson of designing something "to make Lovelace blacken himself," of putting words in Lovelace's mouth. Burrell also obliquely mentions the rape fantasy—apparently one of the most controversial passages in the book: "[Lovelace] writes one letter to Belford in which he betrays himself clearly as a sadistic person. This letter is usually omitted in abridgements, as are several other details which, taken together, and with even a modicum of Freudian interpretation, make Lovelace a much less enigmatic figure that he has heretofore appeared" (xiii). Having identified the rape scene as a key to plucking out the heart of Lovelace's mystery, Burrell proceeds to follow tradition and delete it from his abridgement! Again, we may note in this strategy a certain Romantic tendency to preserve and heighten rather than reveal enigma. The comments of Burrell and Sherburn reveal their belief in a character named Lovelace who exists apart from and outside of language, and who is entitled to his privacy. These touching defenses of Lovelace indicate not only where these male editors' loyalties lie, but also what kind of control they will wish to exert over the text.

Sherburn's defense of Lovelace's privacy may lie at the bottom of an editorial procedure that at first puzzles. The first edition of *Clarissa* presented more or less balanced epistolary axes, with Lovelace writing 160 letters to Belford and Clarissa 132 to Anna Howe. We recall that Prévost preserved that balance, reducing the number of letters written by other characters, and also omitting some of Clarissa's more important texts, such as her mad papers and her will. Sherburn's abridgement, on the other hand, drastically reduces Lovelace's writing: he writes only eighty-one letters compared to Clarissa's 108. The comments of both abridgers on the rape letter show that the less we read of Lovelace's writing the better we think of him. After her rape and subsequent escape, Clarissa asks Belford for copies of Lovelace's letters to him precisely in order to form a better

idea of his machinations; and the fictional justification for the publication of the letters of Clarissa and Lovelace is to establish the former's innocence and the latter's guilt. Sherburn's strategy, as he himself tells us, is to diminish that guilt.

Not only the substance, but also the manner of editing shows a sympathy to Lovelace. Whereas Burrell tends to cut without comment, Sherburn makes use of the editor's voice planted by Richardson in the text. At nearly every point, his decisions and his commentary parallel those of Prévost. Thus, like Prévost, Sherburn feels no compunction about removing Belford's "long and gruesome" description of Mrs. Sinclair's agony (*Clarissa* 1962, 486). Just as Prévost repeatedly emphasized the differences between French and English literary taste, so Sherburn's interpolations emphasize the differences between Richardson's choices and modern expectations. Modern readers cannot be assumed to have the same bizarre interests as the eighteenth-century set: "Gentlefolk of the eighteenth century found wills especially fascinating. Thus Richardson naturally printed entire Clarissa's will, which ran to fourteen pages of print and which is here omitted" (*Clarissa* 1962, 494). But I have shown in chapter 4 that the reasons for printing Clarissa's will go far beyond a mere desire to satisfy English enthusiasm for legalese. The will provides closure, both in terms of its content and in terms of its structure. Furthermore, there are aspects of the will, such as Clarissa's provisions for Lovelace, which will-readers of the period would hardly have found conventional. Here Sherburn uses the standards of post-Kantian criticism, for which aesthetic discourse remains protected from invasion by extra-literary dialects such as legalese. Similarly, whereas Burrell ends his abridgement with De la Tour's letter reporting Lovelace's death, attempting to close the novel on that note of romantic desolation which we have seen earlier, Sherburn summarizes what is reported in the "Conclusion." Thus the last words which a reader of Sherburn's *Clarissa* comes upon are by Sherburn himself, and seem to place a chilling judgement on the book: "[Richardson's] conclusion is followed by a shorter Postscript that deals with poetical justice, the doctrine of rewards and punishments, and the theory of tragedy. The ideas are conventional of their time" (517). Like Prévost's, Sherburn's comments continually place *Clarissa* in a glass jar, emphasizing as they do the strangeness and untranslatability of the text.

And like Prévost, Sherburn does not hesitate to tell his readers of the value of scenes which he is for some reason unable to give them: "In his next letter . . . Belford tries, in a moving scene, to persuade

Clarissa to accept from him as banker £100—which she refuses"
(387). Like Prévost, Sherburn avoids the unpleasantness and ped-
antry of Belton's death scene, while praising its moral qualities:

> For at least a week (August 19–25) Belford has been at Ep-
> som, performing "the last friendly offices for poor Mr.
> Belton." At this time it helps to have Belford "off-stage"; and
> besides for Richardson there is a powerful moral lesson—por-
> trayed at length—in the fate of this hapless rake, Belton. The
> whole episode is here omitted. (434)

We see, then, the close parallels between Sherburn's editing and
Prévost's translating. Both the passages deleted and the reasons
given for deletion are remarkably similar, as though Sherburn had
consulted Prévost to see where he should make his cuts. Both au-
thors cite cultural and aesthetic differences to justify their taking
control of the text. The remarkable parallels between the translation
and editing of literature should make us recognize that the two activ-
ities do indeed belong together as topological reformations of a text.
 Doody and Stuber's "*Clarissa* Censored" has lambasted Sherburn's
edition in fine eighteenth-century style. Many of the points they
raise—censorship, intentional misreading, sexism, confusion of
abridger with fictional "editor"—have surfaced in my analysis of *Cla-
rissa*'s translations. While agreeing with the article's conclusion that
"Sherburn's abridgement is a hostile trivialization of a great work of
western literature" (86), I wish to locate that hostility within a larger
context. Sherburn's "reading" is but one more example of *Clarissa*'s
"power to recreate its antagonisms and sexual polarization in the
reader" (Gwilliam, "'Like Tiresias,'" 102). I have demonstrated in
this study that *Clarissa* has *always* been subject to hostile recupera-
tion, by readers from an astonishing variety of nationalities, histori-
cal periods, and aesthetic philosophies. *Clarissa* has always provoked
reactions rather than consensus, and thus has never achieved the
"Empire of Meaning" that W. B. Warner ascribes to it. Reader "hos-
tility," however—which is often based in admiration, and which
should be renamed strong misreading, strong mistranslation, or to-
pological reformation—is rarely aimed at the book as a whole, but
rather at a particular aspect which the reader attempts to improve
upon. Readers, critics, translators, and abridgers direct their attacks
not at *Clarissa*, but at Clarissa—or at Lovelace, or at legal dialect, or
at prolixity, or at morbidity, or at moral instruction. Perhaps *Clarissa*
suffers from these misreadings, but the fascination of an article like
"*Clarissa* Censored" lies in how much the comparison of *Clarissa* with

its corruption can tell us about the work's essence. It would seem that each corrupt text, when read in conjunction with a more perfect one, contributes to our understanding of the work's "reine Sprache," of its pure essence that no single version can capture by itself. That "reine Sprache" is perhaps a synonym for what Yves Bonnefoy has called a text's "sacred structure." Bonnefoy points out that it is the great works of literature, and the deepest understandings of those works, which have inspired the boldest translations: "The translator, to the extent that he has intelligence of this sacred structure, will be entitled to translate the original work with boldness; his deed adds only one new variation to all those which have been aroused by the original theme" ("Transpose," 125).

The figures of Janus and of Vishnu tell us that creation and destruction form a dialectic whole. "Destruction" in literature takes the form of what Harold Bloom has called "strong misreading." And it is only through such destructions, such "amputations," that *Clarissa* has been able to "live on." The present day, so concerned with problems of reading and interpretation, may allow *Clarissa* to develop new life, new intertexts, new topologies, both in English and in other languages. The recent single-volume *Clarissa*, in making the whole work available for the first time in a relatively inexpensive edition, would seem to confirm this "Lebenswandel." What emerges from such re-presentations of the text will be new textual life and new destruction. Again, to rephrase Meschonnic's words which stand at the beginning of this chapter, texts (as opposed to "works") are historical and social, not metaphysical beings. A text is not the product but the act of its creation in the reader, just as a translation is neither the original nor its imitation, but the questioning of one text by another. The truth of *Clarissa* lies in its living, not in its life; its truest form would be a variorum, including all its translations and editions.

Each of our translators, even at the wildest moments of misreading, has plumbed the depths of *Clarissa* and given us insight into it. The paradox of translation, thus presented, should demonstrate that neither deconstruction nor historicism, neither providence nor religion, neither faithfulness nor apostasy will provide us with an adequate reading of *Clarissa*, because no one reading strategy can account for the germ of the Other found within this novel. For all their wild variance, every one of the forms of Richardson's masterpiece considered here "is," for a certain lifetime and a certain audience, *Clarissa*.

Bibliography

I. Editions and Translations of Clarissa

1. The Five Editions Published by Richardson (in London):

1747–48 *Clarissa. Or, the History of a Young Lady: Comprehending The most Important Concerns of Private Life, and particularly shewing, The Distresses that may attend the Misconduct Both of Parents and Children, In Relation to Marriage. In Seven Volumes.* 12°.

1749 *Clarissa. Or, the History of a Young Lady: Comprehending The most Important Concerns of Private Life, and particularly shewing, The Distresses that may attend the Misconduct Both of Parents and Children, In Relation to Marriage. In Seven Volumes.* 12°. [The first four volumes are reprinted from the first edition.]

1751 *Clarissa. Or, the History of a Young Lady: Comprehending the most Important Concerns of Private Life. In Eight Volumes, To Each of which is added A Table of Contents. The Third Edition, in which Many Passages and some Letters are restored from the Original Manuscripts. And to which is added, An ample Collection of such of the Moral and Instructive Sentiments Interspersed throughout the Work, as may be presumed to be of general Use and Service.* 12°.

1751 *Letters and Passages Restored From the Original Manuscripts of the History of Clarissa.* 12°. [Made changes for the third edition available to owners of first and second editions. Translated by Michaelis, but not by Prévost]

1751 *Clarissa. Or, the History of a Young Lady: Comprehending the most Important Concerns of Private Life. In Seven Volumes, To Each of which is added A Table of Contents. The Fourth Edition, in which Many Passages and some Letters are restored from the Original Manuscripts. And to which is added, An ample Collection of such of the Moral and Instructive Sentiments Interspersed throughout the Work, as may be presumed to be of general Use and Service.* 8°. [Identical to the third edition except for format.]

1759 *Clarissa. Or, the History of a Young Lady: Comprehending the most Important Concerns of Private Life. In Eight Volumes. The Fourth Edition.* 12° [Printed page for page from the third edition.]

2. Selected Later Editions and Abridgments

1756 *The Paths of Virtue Delineated; or, The History in Miniature of the Celebrated Pamela, Clarissa Harlowe, and Sir Charles Grandison, familiarised and adapted to the Capacities of Youth.* London: R. Baldwin.

1783 *Clarissa, or the History of a Young Lady.* Vols. 14 and 15 of *The Novelist's Magazine.* London: Harrison.

1795 *Clarissa, or the History of a Young Lady. Abridged from the works of Samuel Richardson.* Boston: Samuel Hall.

1868 *Clarissa: A Novel.* 3 vols. Ed. Eneas Sweetland Dallas. London: Tinsley Brothers.

1870 *Clarissa Harlowe. A Novel.* London: Milner and Sowerby.

1874 *Clarissa; or, the History of a Young Lady.* Ed. C. H. Jones. New York: H. Holt & Company.

1880? *Clarissa Harlowe, a New and Abridged Edition.* Ed. Mrs. Ward. London: Routledge and Sons.

1930 *Clarissa. Or, the History of a Young Lady.* 8 vols. Stratford upon Avon: Basil Blackwell.

1950 *Clarissa or the History of a Young Lady.* Ed. John Angus Burrell. New York: Modern Library.

1962 *Clarissa or the History of a Young Lady.* Ed. George Sherburn. Boston: Houghton Mifflin.

1971 *Clarissa or the History of a Young Lady.* Ed. Phillip Stevick. New York: Rinehart.

1985 *Clarissa. Or, the History of a Young Lady.* Ed. Angus Ross. New York: Viking.

3. Selected Translations

1749–53 *Die Geschichte der Clarissa, eines vornehmen Frauenzimmers.* 8 vols. Trans. Johann David Michaelis. Göttingen: Vandenhoeck.

1751 *Lettres angloises, ou Histoire de Miss Clarissa Harlove.* 12 vols. Trans. L'abbé François-Antoine de Prévost. London: Nours.

1752–55 *Clarissa; of, De historie van eene jonge juffer.* 8 vols. Trans. Johannes Stinstra. Harlingen: F. van der Plaats.

1762 "L'Enterrement de Clarisse." [Trans. Jean-Baptiste Suard?]. *Journal Étranger* 8 (1762): 126–38. [Restores Morden's five letters describing Clarissa's burial.]

1762 *Lettres angloises, ou Histoire de Miss Clarisse Harlove. Tome septième.* [Trans. Denis Diderot?]. Lyon: Périsse. [A different version of Clarissa's burial, plus her will and posthumous letters.]

1766 *Lettres angloises, ou Histoire de Miss Clarisse Harlove, augmentée de l'Éloge de RICHARDSON, des lettres posthumes & du Testament de*

CLARISSE. 13 vols. Trans. Prévost [and Jean-Baptiste-Antoine Suard?]. Paris: Libraires associés. [Further editions with this publisher appeared in 1770, 1774, and 1777.]

1767–69 *Die Geschichte der Clarissa, eines vornehmen Frauenzimmers.* 7 vols. Ed. Johann David Michaelis. Göttingen: Vandenhoeck. [New edition of the 1749–53 translation.]

1784 *Lettres angloises, ou Histoire de Miss Clarisse Harlove, augmentée de l'Éloge de RICHARDSON, des lettres posthumes & du Testament de CLARISSE.* Vols. 19–24 of the *Oeuvres choisies de l'abbé Prévost.* Trans. Prévost [and Jean-Baptiste-Antoine Suard?]. Amsterdam and Paris: n.p.

1788 *Albertine: Richardson's Clarissen nachgebildet und zu einem lehrreichen Lesebuche für deutsche Mädchen bestimmt.* 5 vols. Trans. Friedrich Schulz. Berlin: Arnold Wever.

1788 *Clarisse Harlowe. Traduction nouvelle et seule complète.* 12 vols. Trans. Pierre P. F. de Tourneur. Geneva: P. Barde.

1790–91 *Klarissa oder Geschichte eines jungen Frauenzimmers, aus dem Englischen des Richardson.* 16 vols. Trans. Ludwig Theobald Kosegarten. Mannheim: Schwan und Götz.

1790–91 *Clarissa, Neu verdeutscht, und Ihro Majestät der Königin von Grossbrittanien zugeeignet.* 8 vols. Trans. Theodore Hiobul. Leipzig: Gräffische Buchhandlung.

1829 *Clara Harlowe.* Trans. José Marcos Gutierrez. Paris: Libreria Americana.

1846 *Clarisse Harlowe.* Trans. Jules Janin. Paris: Amyot.

1846 *Clarisse Harlove, par Richardson, traduit sur l'édition originale par l'abbé Prévost, précédé de l'Éloge de Richardson, par Diderot.* 2 vols. Trans. Prévost. Paris: Boulé, 1846.

1851 *Clarisse Harlove.* Vol 9 of the *Veillées littéraires illustrés.* Trans. André de Goy. Paris, n. p.

II. Other Sources

Adelung, Johann Christoph. *Grammatisch-kritisches Wörterbuch der hochdeutschen Mundart, mit beständiger Vergleichung der übrigen Mundarten.* 4 vols. 2nd ed. Vienna: A. Pichler, 1808.

Altman, Janet. *Epistolarity: Approaches to a Form.* Lafayette: Indiana University Press, 1981.

Austin, J. L. *How to Do Things With Words.* Cambridge, MA: Harvard University Press, 1975.

Bach, Adolf. *Geschichte der deutschen Sprache.* Heidelberg: Quelle and Meyer, 1956.

Bakhtin, Mikhail. *The Dialogic Imagination.* Trans. Caryl Emerson and Michael Holquist. Austin: University of Texas Press, 1981.

———. *Rabelais and his World.* Trans. Hélène Iswolsky. Cambridge, MA: M.I.T. Press, 1968.

Ball, Donald L. *Samuel Richardson's Theory of Fiction*. The Hague: Mouton, 1971.

Barbauld, Anna Laetitia, ed. *The Correspondence of Samuel Richardson*. 6 vols. London: Lewis and Roden, 1804.

Barrère, Jean-Bertrand. *L'idée de goût*. Paris: Klincksieck, 1972.

Barthes, Roland. *S/Z*. Trans. Richard Miller. New York: Hill and Wang, 1971.

Beaulieux, Charles. *Histoire de l'orthographe française*. 2 vols. Paris: Honoré Champion, 1927.

Beebee, Thomas. "Deciphering the Word 'Cypher' in Samuel Richardson's *Clarissa*," *American Notes and Queries* 1, 2 (April 1988): 50–53.

———. "Doing Clarissa's Will: Samuel Richardson's Legal Genres." *International Journal of Law and Semiotics* 2, 5 (1989): 159–82.

Benjamin, Walter. "Die Aufgabe des Übersetzers/The Task of the Translator." Trans. James Hynd and E. M. Valk. *Delos* 2 (1968): 76–99.

Besterman, Theodore, ed. *Corneille*. Vol. 46 of *Voltaire's Correspondence*. Geneva: Institut et Musée Voltaire, 1959.

———. *Lord of the Manor*. Volume 41 of *Voltaire's Correspondence*. Geneva: Institut et Musée Voltaire, 1958.

Bickerton, Derek. *Roots of Language*. Ann Arbor, MI: Karoma, 1981.

Billy, André. *Un singulier Bénédictin: L'abbé Prévost, auteur de* Manon Lescaut. Paris: Flammarion, 1969.

Blackall, Eric A. *The Emergence of German as a Literary Language, 1700–1775*. 2d ed. Ithaca, NY: Cornell University Press, 1978.

Blake, N. F. *Non-Standard Language in English Literature*. London: André Deutsch, 1981.

Bloom, Harold. *The Anxiety of Influence: A Theory of Poetry*. New York: Oxford University Press, 1973.

———. *A Map of Misreading*. New York: Oxford University Press, 1975.

Bödiker, Johann. *Grund-Sätze der teutschen Sprache*. Berlin: C. G. Nicolai, 1723.

Bonnefoy, Yves. "Transpose or Translate?" *Yale French Studies* 33 (1964): 120–26.

Brancolini, Julien, and Marie-Thérèse Bouyssy. "La vie provinciale du livre à la fin de l'ancien régime." In *Livre et Société dans la France du XVIIIe siècle*, vol. 2, ed. François Furet, et al., 3–37. Civilisation et Sociétés, no. 16. Paris and The Hague: Mouton, 1970.

Braudy, Leo. "Penetration and Impenetrability in *Clarissa*." In *New Approaches to Eighteenth-Century Literature*, ed. Philip Harth, 177–206. New York: Columbia University Press, 1974.

Brewer, John, and John Styles, eds. *An Ungovernable People: The English and their Law in the Seventeenth and Eighteenth Centuries*. London: Hutchinson, 1980.

Brissenden, R. F. *Virtue in Distress: Studies in the Novel of Sentiment from Richardson to Sade*. London: Macmillan, 1974.

Brockes, Bartold Hinrich. *Irdisches Vergnügen in Gott, bestehend in physicalisch und moralischen Gedichten*. 9 vols. 4th ed. Hamburg: Kissner, 1728–48.

Browne, Sir Thomas. *Religio Medici.* New York: Appleton-Century-Crofts, 1966.

Brownstein, Rachel Mayer. "An Exemplar to Her Sex: Richardson's Clarissa." *Yale Review* 67 (1977): 30–47.

Bruford, W. H. *Germany in the Eighteenth Century: The Social Background of the Literary Revival.* Cambridge: Cambridge University Press, 1965.

Bullen, John Samuel. *Time and Space in the Novels of Samuel Richardson.* Monograph Series 12, no. 2. Logan: Utah State University Press, 1965.

Carne-Ross, D. S. "Translation and Transposition." In *The Craft and Context of Translation. A Literary Symposium,* ed. William Arrowsmith and Roger Shattuck, 3–21. Austin: University of Texas Press, 1964.

Carroll, John J., ed. *Samuel Richardson: A Collection of Critical Essays.* Englewood Cliffs, NJ: Prentice-Hall, 1969.

———, ed. *Selected Letters of Samuel Richardson.* Oxford: Clarendon Press, 1964.

Castle, Terry. *Clarissa's Ciphers: Meaning and Disruption in Richardson's "Clarissa."* Ithaca, NY: Cornell University Press, 1982.

———. *Masquerade and Civilization: The Carnivalesque in Eighteenth-Century English Culture and Fiction.* Stanford: Stanford University Press, 1986.

Chambers, Ross. *Story and Situation: Narrative Seduction and the Power of Fiction.* Minneapolis: University of Minnesota Press, 1984.

Coates, Paul. "*Clarissa*, Dialectic and Unreadability." In his *The Realist Fantasy: Fiction and Reality Since "Clarissa,"* 23–49. London: Methuen, 1983.

Cotgrave, Randle. *A Dictionarie of the French and English tongues.* London: A. Islip, 1611.

Crane, Ronald S. "A Note on Richardson's Relation to French Fiction." *Modern Philology* 16 (1918–19): 495–99.

Cressy, David. *Literacy and the Social Order.* New York: Cambridge University Press, 1980.

Culler, Jonathan. "Presupposition and Intertextuality." In his *The Pursuit of Signs: Semiotics, Literature, Deconstruction,* 100–118. Ithaca, NY: Cornell University Press, 1981.

Cummings, Katherine M. "Clarissa's 'Life With Father.'" *Literature and Philosophy* 32, 4 (1986): 30–36.

Cushing, Mary Gertrude. *Pierre Le Tourneur.* New York: Columbia University Press, 1908.

Damrosch, Leopold, Jr. "*Clarissa* and the Waning of Puritanism." In his *God's Plot and Man's Stories: Studies in the Fictional Imagination from Milton to Fielding,* 213–62. Chicago: University of Chicago Press, 1985.

Daphinoff, Dimiter. *Samuel Richardsons Clarissa: Text, Rezeption und Interpretation.* Swiss Studies in English, no. 108. Bern: Francke, 1986.

Darnton, Robert S. "Reading, Writing, and Publishing in Eighteenth-Century France: A Case Study in the Sociology of Literature." *Daedalus* 100 (1971): 214–57.

Defoe, Daniel. *Colonel Jack.* London: Oxford University Press, 1975.

De Man, Paul. *Allegories of Reading.* New Haven: Yale University Press, 1979.

Demarest, David Porter. "Legal Language in the Eighteenth-Century Novel: Readings in Defoe, Richardson, Fielding, and Austen." Ph.D. diss., University of Wisconsin, 1963.

Denton, Ramona. "Anna Howe and Richardson's Ambivalent Artistry in *Clarissa.*" *Philological Quarterly* 58 (1979): 53–60.

Derrida, Jacques. *Of Grammatology.* Trans. Gayatri Spivak. Baltimore: Johns Hopkins University Press, 1976.

Diedrichs, Eva Pauline. *Johann Bödikers Grund-Sätze der deutschen Sprache.* Heidelberg: Carl Winter, 1983.

Doederlin, Sue Warrick. "Clarissa in the Hands of the Critics." *Eighteenth-Century Studies* 16 (Summer 1983): 401–14.

Doody, Margaret Anne. *A Natural Passion: A Study of the Novels of Samuel Richardson.* Oxford: Clarendon Press, 1974.

Doody, Margaret Anne, and Florian Stuber. "*Clarissa* Censored." *Modern Language Studies* 18, 1 (Winter 1988): 74–88.

Dussinger, John A. *The Discourse of the Mind in Eighteenth-Century Fiction.* The Hague: Mouton, 1974.

———. "Love and Consaguinity in Richardson's Novels." *Studies in English Literature, 1500–1900* 24 (1984): 520–21.

Eagleton, Terry. *The Rape of Clarissa.* London: Methuen, 1982.

Eaves, T. C. Duncan, and Ben D. Kimpel. *Samuel Richardson: A Biography.* Oxford: Clarendon Press, 1971.

Eichhorn, J. G. *An Account of the Life and Writings of John David Michaelis.* Trans. R. B. Patton. In vol. 2 of *The Students' Cabinet Library of Useful Tracts,* 3–46. Edinburgh: Thomas Clark, 1836.

Emerson, Caryl. "The Outer Word and Inner Speech: Bakhtin, Vygotsky, and the Internalization of Language." In *Bakhtin: Essays and Dialogues on His Work,* ed. Gary Saul Morson, 21–40. Chicago: University of Chicago Press, 1986.

Engel, Gisela. *Individuum, Familie und Gesellschaft in den Romanen Richardsons.* Frankfurt: Akademischer Verlag, 1974.

Engelsing, Rolf. *Der Bürger als Leser.* Stuttgart: Metzler, 1974.

Fabian, Bernhard. "English Books and Their German Readers." In *The Widening Circle: Essays on the Circulation of Literature in Eighteenth-Century Europe,* ed. Paul J. Korshin, 117–96. Philadelphia: University of Pennsylvania Press, 1976.

Facteau, Bernard A. *Les romans de Richardson sur la scène française.* Paris: Presses Universitaires de la France, 1927.

Farrell, William J. "The Style and Action in *Clarissa.*" *Studies in English Literature, 1500–1900* 3 (1963): 365–75.

Fitch, Brian T. "L'intra-textualité interlinguistique de Beckett: La problematique de la traduction de soi." *Texte,* 2 (1983): 85–100.

Flynn, Carol H. *Samuel Richardson, A Man of Letters.* Princeton: Princeton University Press, 1982.

Fordyce, William. *Sermons to Young Women.* 3d ed. London: Millar and Cadell, 1766; rpt. Philadelphia: M. Carey, 1809.

Foster, James R. "The Abbé Prévost and the English Novel." *PMLA* 42 (1927): 443–64.

Frame, Donald M., trans. *Manon Lescaut*, by the Abbé Antoine François de Prévost. New York: Signet, 1961.

Frow, John. *Marxism and Literary History*. Cambridge, MA: Harvard University Press, 1986.

Furetière, Antoine. *Dictionaire universel, contenant généralement tous les mots françois*. 3 vols. The Hague and Rotterdam: Leers, 1690.

Gadamer, Hans-Georg. *Truth and Method*. New York: Crossroad, 1985.

Gellert, Christian Fürchtegott. *Die epistolographischen Schriften*. Leipzig: Bernhard Christian Breitkopf, 1742; rpt. Stuttgart: Metzler, 1971.

_____. *Leben der schwedischen Gräfin von G****. Stuttgart: Reclam, 1975.

Gillis, Christina Marsden. *The Paradox of Privacy: Epistolary Form in "Clarissa."* University of Florida Monographs in the Humanities, no. 54. Gainesville: University Presses of Florida, 1984.

Giraud, Yves. *Bibliographie du roman epistolaire en France des origines à 1842*. Fribourg: Editions Universitaires, 1977.

Goethe, Johann Wolfgang von. *Aus meinem Leben. Dichtung und Wahrheit*. Leipzig: Reclam, n.d.

Goldberg, Rita. *Sex and Enlightenment: Women in Richardson and Diderot*. Cambridge: Cambridge University Press, 1984.

Golden, Morris. "Public Context and Imagining Self in *Clarissa*." *Studies in English Literature, 1500–1900* 25 (1985): 575–98.

_____. *Richardson's Characters*. Ann Arbor: University of Michigan Press, 1963.

Goncourt, Edmond and Jules de. *The Woman of the Eighteenth Century*. Trans. J. Le Clerc and Ralph Roeder. New York: Minton, Balch, 1927.

Gopnik, Irwin. *A Theory of Style and Richardson's "Clarissa."* The Hague: Mouton, 1970.

Gossman, Lionel. *French Society and Culture: Background for Eighteenth Century Literature*. Englewood Cliffs, NJ: Prentice Hall, 1972.

Gouge, William. *Of Domesticall Duties*. London: I. Havilland, 1622.

Greenberg, Janelle. "The Legal Status of the English Woman in Early Eighteenth-Century Common Law and Equity." In *Studies in Eighteenth-Century Culture, vol 4*, ed. Harold Pagliaro, 171–82. Madison: University of Wisconsin Press, 1975.

Greimas, A. J. and François Rastier. "The Interaction of Semiotic Constraints." *Yale French Studies* 41 (1968): 86–105.

_____. *Sémantique structurale*. Paris: Larousse, 1966.

_____ and Joseph Courtés. *Sémiotique: Dictionnaire raisonné de la théorie du langage*. Paris: Hachette, 1979.

Gwilliam, Tassie. "'Like Tiresias': Metamorphosis and Gender in *Clarissa*." *Novel* 19, 2 (Winter 1986): 101–17.

Gundolf, Friedrich. *Shakespeare und der deutsche Geist*. 8th ed. Berlin: Bondi, 1927.

Habbakuk, H. J. "Marriage Settlements in the Eighteenth Century." *Transactions of the Royal Historical Society*, 1950, 7–33.

Habermas, Jürgen. *Strukturwandel der Öffentlichkeit*. Berlin: Luchterhand, 1965.

Hagstrum, Jean H. *Sex and Sensibility: Ideal and Erotic Love from Milton to Mozart*. Chicago: University of Chicago Press, 1980.

Hakemeyer, Ida. *Bemühungen um Frauenbildung in Göttingen 1747*. Göttingen: Dieterische Universitätsbuchdruckerei, 1949.

———. *Three Early Internationalists of Göttingen University Town*. Göttingen: Dieterische Universitätsbuchdruckerei, 1956.

Haller, Albrecht von. "Clarissa: ou l'Histoire d'une Demoiselle de Qualité." *Gentleman's Magazine*, August 1749, 345–49.

———. "A Critical Account of *Clarissa* in 7 Volumes." *Gentleman's Magazine*, June 1749, 245–46.

———. *Gedichte*. 2 vols. Vienna: F. A. Schrämbl, 1793.

———. *Versuch Schweizerischer Gedichte*. 5th ed. Göttingen: Vandenhoeck, 1749.

Häntzschel, Günther. *Johann Heinrich Voss. Seine Homer-Übersetzungen als sprachschöpferische Leistung*. Zetemata, Heft 68. Munich: C. H. Beck, 1977.

Harrington, James. "A System of Politics." In *The Political Works of James Harrington*, ed. J. G. A. Pocock, 833–55. Cambridge: Cambridge University Press, 1977.

Harris, Jocelyn. *Samuel Richardson*. Cambridge: Cambridge University Press, 1987.

Harrisse, Henry. *L'abbé Prévost: Histoire de sa vie et de ses oeuvres, d'après des documents nouveaux*. Paris: Levy, 1896; rpt. New York: Lenox Hill, 1972.

Hassencamp, Johannes Matteus, ed. *J. D. Michaelis' Lebensbeschreibung von ihm Selbst abgefaßt, mit Anmerkungen von Hassencamp. Nebst Bemerkungen über dessen literarischen Charakter von Eichhorn, Schulz, und dem Elogium von Heyne*. Rinteln: n.p., 1792.

Havens, George R. *The Abbé Prévost and English Literature*. Princeton: Princeton University Press, 1921; rpt. New York: Kraus Reprint Corporation, 1965.

Hay, Douglas. "Property, Authority and the Criminal Law." In *Albion's Fatal Tree: Crime and Society in Eighteenth-Century England*, ed. Douglas Hay, et al., 17–64. New York: Pantheon, 1975.

Haywood, Eliza. *The Perplex'd Dutchess: Or, Treachery Rewarded*. London: J. Roberts, 1728; rpt. in *Four Novels of Eliza Haywood*, ed. Mary Anne Schofield, n.p. Delmar, NY: Scholars' Facsimiles and Reprints, 1983.

Hazard, Paul. *The European Mind [1680–1715]*. Cleveland: Meridian, 1964.

Hecht, S. H. *T. Percy, R. Wood and J. D. Michaelis. Ein Beitrag zur Literaturgeschichte der Genieperiode*. Göttinger Forschungen, 3. Stuttgart: Mitscherlich, 1933.

Hepworth, Brian. *Robert Lowth*. Boston: Twayne, 1978.

Herden, Innes, and Gustave Herden, trans. *The World of Hogarth: Lichtenberg's Commentaries on Hogarth's Engravings*, by Georg Christoph Lichtenberg. Boston: Houghton Mifflin, 1966.

Hermans, Theo, ed. *The Manipulation of Literature: Studies in Literary Transla-tion.* New York: St. Martin's Press, 1985.

Hill, Christopher. "Clarissa Harlowe and her Times." *Essays in Criticism* 5 (1955): 315–40.

Holland, Alan. *Manon Lescaut 1731–1759.* Geneva: Slatkine, 1984.

Hunter, Alfred C. J. B. A. *Suard, un introducteur de la littérature anglaise en France. Bibliothèque de la Revue de Littérature Comparée,* no. 22. Paris: Champion, 1925.

Jacobs, Eva, et al., eds. *Woman and Society in Eighteenth-Century France.* Lon-don: Athlone, 1979.

Jakobson, Roman. "Linguistics and Poetics." In *The Structuralists From Marx to Lévi-Strauss,* ed. Richard and Fernande DeGeorge, 85–122. Garden City, NY: Doubleday-Anchor, 1972.

———. "On Linguistic Aspects of Translation." In *On Translation,* ed. Ruben Brower, 232–39. Cambridge, MA: Harvard University Press, 1959.

Jameson, Fredric. *The Political Unconscious.* Ithaca, NY: Cornell University Press, 1981.

Janin, Jules. *L'Ane mort et la femme guillotinée.* Paris: Baudoin, 1829.

———. *Contes fantastiques et contes littéraires.* Paris: A. Levavasseur and A. Mesnier, 1832.

———. *735 Lettres à sa femme.* 3 vols. Ed. Mergier-Bourdeix. Paris: Klicksieck, 1973.

Jenkins, Annibel. *Nicholas Rowe.* Boston: Twayne, 1977.

Jenny, Laurent. "The Strategy of Form." In *French Literary Theory Today,* ed. Tzvetan Todorov, 34–63. Cambridge: Cambridge University Press, 1982.

Jesperson, Otto. *Growth and Structure of the English Language.* Garden City, NY: Doubleday-Anchor, 1955.

Johnson, Glen M. "Richardson's 'Editor' in *Clarissa.*" *Journal of Narrative Technique* 10 (1980): 99–114.

Johnson, Samuel. *A Dictionary of the English Language.* 2 vols. London: W. Strahan, 1755.

Josephson, Mirjam. *Die Romane des Abbé Prévost als Spiegel des 18. Jahrhun-derts.* Winterthur: P. Keller, 1966.

Jost, Francois. "Prévost traducteur de Richardson." In *Expression, Communi-cation and Experience in Literature and Language,* ed. Ronald G. Popper-well, 297–300. Leeds: Maney & Son, 1973.

Kauffman, Linda S. "Passion as Suffering: The Composition of Clarissa Harlowe." In her *Discourses of Desire: Gender, Genre, and Epistolary Fic-tions,* 118–57. Ithaca, NY: Cornell University Press, 1986.

Kinkead-Weekes, Mark. *Samuel Richardson: Dramatic Novelist.* London: Me-thuen, 1973.

Knabe, Peter-Eckhard. *Die Rezeption der französischen Aufklärung in den "Göt-tingschen Gelehrten Anzeigen" (1739–1779).* Analecta Romana 42. Frankfurt am Main: Klostermann, 1978.

Knight, Charles A. "The Function of Wills in Richardson's *Clarissa.*" *Texas Studies in Language and Literature* 11 (1969): 1183–90.

Konigsberg, Ira. *Samuel Richardson and the Dramatic Novel.* Lexington: University of Kentucky Press, 1968.

Kristeva, Julia. *La révolution du langage poétique.* Paris: Editions du Seuil, 1974.

Lee, Vera. *The Reign of Women in Eighteenth-Century France.* Cambridge, MA: Schenkman, 1975.

Lichtenberg, Georg Christoph. *Gesammelte Werke.* Ed. Wilhelm Grenzmann. 2 vols. Frankfurt: Holle, 1949.

Lovejoy, A. O., and George Boas. "Nature as Aesthetic Norm." In their *Essays in the History of Ideas,* 69–78. Baltimore: Johns Hopkins University Press, 1948.

Luther, Martin, trans. *Biblia, Das ist: Die ganze Heilige Schrift.* Halle: Waysenhause, 1748.

Lynch, Lawrence W. "Richardson's Influence on the Concept of the Novel in Eighteenth-Century France." *Comparative Literature Studies* 14 (1977): 233–43.

McIntosh, Carey. *Common and Courtly Language: The Stylistics of Social Class in Eighteenth-Century English Literature.* Philadelphia: University of Pennsylvania Press, 1986.

McKillop, A. D. *Samuel Richardson: Printer and Novelist.* Chapel Hill: University of North Carolina Press, 1936.

MacPherson, C. B. *The Political Theory of Possessive Individualism, Hobbes to Locke.* Oxford: Clarendon Press, 1962.

———. "The Social Bearings of Locke's Political Theory." *The Western Political Quarterly* 7 (1954): 1–22.

Mattern, Eleanor Rust. "Samuel Richardson and Feminism: A Study of the Secondary Relationships in *Clarissa.*" Ph.D diss., Michigan State University, 1979.

May, Georges. *Le Dilemme du roman au XVIIIe siècle: étude sur les rapports du roman et de la critique (1715–1761).* New Haven: Yale University Press; Paris: Presses Universitaires de France, 1954.

———. "The Influence of the English Novel on the French Mid-Eighteenth-Century Novel." In *Aspects of the Eighteenth Century,* ed. Earl Wasserman, 265–80. Baltimore: Johns Hopkins University Press, 1965.

Meschonnic, Henri. "Propositions pour une poétique de la traduction." in *Pour la poétique II,* 305–23. Paris: Gallimard, 1973.

[Michaelis, Johann David]. *Allerunterthänigste Bittschrift an Seine Königliche Majestät in Preussen, um Anlegung einer Universität für das schöne Geschlecht.* [Göttingen] 1747.

Michaelis, Johann David. *Beantwortung der Frage von dem Einfluß der Sprache eines Volcks in seine Meinungen und seiner Meinungen in die Sprache.* Berlin, 1760.

———. *De l'influence des opinions sur le langage et du langage sur les opinions.* Bremen: Förster, 1762; rpt. Stuttgart: Frommann, 1974.

———. *A Dissertation on the Influence of Opinions on Language, and of Language on Opinions.* London: W. Owen, 1769.

———. *Einleitung in die göttlichen Schriften des neuen Bundes.* 1st ed. Göttingen: Vandenhoeck, 1750.

————. *Introduction to the New Testament*. 4 Vols. Trans. Herbert Marsh. Cambridge: J. Archdeacon, 1793–1801.

————. *Literarischer Briefwechsel von Johann David Michaelis*. Ed. Johann Gottlieb Buhle. 3 vols. Leipzig: Weidmann, 1794–96.

————. *Raisonnement über die protestantischen Universitäten in Deutschland*. 4 vols. Frankfurt: n.p., 1768–76.

Mylne, Vivienne. "Prévost et la traduction du dialogue dans *Clarissa*." *Cahiers Prévost d'Exiles*, 1986, 43–58.

————. *Prévost: Manon Lescaut*. London: Edward Arnold, 1972.

Nabokov, Vladimir, trans. *Eugene Onegin, A Novel in Verse*, by Alexander Pushkin. 2 Vols. Bollingen Series, 72. Princeton: Princeton University Press, 1975.

O'Flaherty, James C. "J. D. Michaelis: Rational Biblicist." *Journal of English and Germanic Philology* 49 (1950): 172–81.

Perry, Ruth. *Women, Letters, and the Novel*. AMS Studies in the Eighteenth Century, no. 4. New York: AMS Press, 1980.

Poggioli, Renato. "The Added Artificer." In *On Translation*, ed. Ruben Brower, 137–47. Cambridge, MA: Harvard University Press, 1959.

Pomorska, Krystina. "Mikhail Bakhtin and His Verbal Universe." *PTL* 3, 2 (April 1978): 379–86.

Poulet, Georges. "L'abbé Prévost." In his *Studies in Human Time*, trans. Elliott Coleman, 149–57. New York: Harper and Brothers, 1956.

Pound, Ezra. *Cathay*. London: Elkin Mathews, 1915.

Preston, John. *The Created Self: The Reader's Role in Eighteenth-Century Fiction*. New York: Barnes and Noble, 1970.

Prévost, L'abbé Antoine François de. "Avis de l'auteur des *Mémoires d'un Homme de Qualité*." In his *Manon Lescaut*. Paris: Gallimard, 1959.

————. *Histoire du Chevalier des Grieux et de Manon Lescaut*. In *Oeuvres de Prévost*, vol. 1, 363–440. Grenoble: Presses Universitaires de Grenoble, 1978.

————. *Le Philosophe anglais ou Histoire de Monsieur Cleveland*. 7 vols. Utrecht: Etienne Neaulme, 1731–39.

————. *Le Pour et contre: Ouvrage périodique d'un goût nouveau*. 20 vols. Paris: Didot, 1735–1740.

Price, Lawrence M. "On the Reception of Richardson in Germany." *Journal of English and Germanic Philology* 25 (1926): 7–33.

Rabb, Melinda Alliker. "Underplotting, Overplotting, and Correspondence in *Clarissa*." *Modern Language Studies* 11, 3 (Fall 1981): 61–71.

Richardson, Samuel. *The History of Sir Charles Grandison*. 7 vols. Hitch and Hawes, Rivington, Millar, and Dodsley, 1753–54.

————. *Meditations Collected from the Sacred Books; and adapted to the Different Stages of a Deep Distress; Gloriously surmounted by Patience, Piety, and Resignation*. London: Osborn, Miller, and Rivington, 1750.

————. *Pamela: Or, Virtue Rewarded*. 2 vols. London: Rivington and Osborn, 1741.

————. "Six Original Letters upon Duelling." *Candid Review and Literary Repository* 1 (March 1765): 227–31.

"Richardson's Novels." *Cornhill Magazine* 17 (1868): 48–69.

Riffaterre, Michael. "Syllepsis." *Critical Inquiry* 6, 4 (Summer 1980): 625–38.

———. *Text Production.* Trans. Terese Lyons. New York: Columbia University Press, 1983.

———. "La trace de l'intertexte." *Pensée*, 215 (1980): 4–18.

Roddier, Henri. "L'Abbé Prévost et le problème de la traduction au XVIIIe siècle." *Cahiers de l'Association Internationale des Études Françaises* 8 (1956): 173–81.

Rogers, Katherine M. *Feminism in Eighteenth-Century England.* Chicago: University of Illinois Press, 1982.

———. "Richardson's Empathy with Women." In *The Authority of Experience: Essays in Feminist Criticism*, 118–36. Amherst: University of Massachusetts Press, 1977.

Rosselot, E. Lavelle. "Samuel Richardson et son influence en France avant la révolution." Ph.D. diss., Université Laval, 1955.

Roudiez, Leon S., trans. *Desire in Language: A Semiotic Approach to Literature and Art*, by Julia Kristeva. New York: Columbia University Press, 1980.

Rousseau, Jean-Jacques. *Julie ou la nouvelle Héloïse. Lettres de deux amans, Habitans d'une petite Ville au pied des Alpes.* Paris: Garnier-Flammarion, 1967.

Rowe, Nicholas. *Ulysses. A Tragedy.* In vol. 1 of his *Works*, 1–68. London: Lowndes, 1792.

Ruprecht, Hans-George. "Intertextualité." *Texte. Revue de critique et de théorie littéraire* 2 (1983): 13–22.

Sale, William M. *Samuel Richardson: A Bibliographical Record of his Literary Career with Historical Notes.* New Haven: Yale University Press, 1936.

———. *Samuel Richardson, Master Printer.* Ithaca, NY: Cornell University Press, 1950.

Saussure, Ferdinand de. *Cours de linguistique générale.* Payot: Paris, 1967.

Schmidt, Erich. *Richardson, Rousseau, Goethe.* Jena: E. Fromann, 1875.

Schmitz, Robert M. "Death and Colonel Morden in *Clarissa*." *South Atlantic Quarterly* 69, 3 (Summer 1970): 346–53.

Segal, Naomi. *The Unintended Reader: Feminism and "Manon Lescaut."* Cambridge: Cambridge University Press, 1986.

Seguin, Jean-Pierre. *La langue français au XVIIIe siècle.* Paris: Bordas, 1972.

Select Trials for Murder, Robbery, Burglary, Rapes, Sodomy, Coining, Forgery, Pyracy, and Other Offences and Misdemeanours, at the Sessions-house in the Old Bailey, to Which are Added Genuine Accounts of the Lives, Exploits, Behaviour, Confessions, and Dying-Speeches, of the Most Notorious Convicts, from the Year 1720 to this time. 4 vols. London: G. Strahan, 1742.

Selle, Götz von. *Die Georg-August-Universität zu Göttingen 1737–1937.* Göttingen: Vandenhoeck and Ruprecht, 1937.

Sévigné, Madame de. *Sevigniana; ou, Recueil de pensées ingénieuses, D'Anecdotes Litteraires, Historiques & Morales, Tirées des Lettres de Madame La Marquise de Sévigné.* N.p.: A. Grignan, 1756.

Sgard, Jean. "Antoine Prévost d'Exiles." *Cahiers Prévost d'Exiles* 1 (1984): 5–14.

———. *Prévost Romancier*. Paris: Libraire José Corti, 1968.

Shaw, Edward P. "Censorship and Subterfuge in Eighteenth-Century France." In *Literature and History in the Age of Ideas*, ed. Charles G. S. Williams, 287–309. Columbus: Ohio State University Press, 1975.

Sherburn, George. "Samuel Richardson's Novels and the Theatre: A Theory Sketched." *Philological Quarterly* 41 (1962): 325–29.

Siegel, June Sigler. "Diderot and Richardson: Manuscripts, Missives, and Mysteries." *Diderot Studies* 18 (1975): 145–67.

Slattery, William C., ed. *The Richardson-Stinstra Correspondence and Stinstra's Prefaces to "Clarissa."* Carbondale: Southern Illinois University Press, 1969.

Smend, R. *Johann David Michaelis*. Göttingen: Dieterichsche Universitäts-Buchdrückerei, 1898.

Smernoff, Richard A. *L'Abbé Prévost*. Boston: Twayne, 1985.

Sophia, A Woman of Quality (pseudo.). *Woman Not Inferior to Man; Or A short and Modest Vindication of the Natural Right of the Fair-Sex to a Perfect Equality of Power, Dignity, and Esteem, with the Men*. London: John Hawkins, 1739.

———. *Woman's Superior Excellence Over Man: Or, A reply to the author of a late treatise, entitled, Man superior to Woman. In which, the excessive weakness of that gentleman's answer to Woman not inferior to Man is exposed*. London: John Hawkins, 1740.

Spearman, Diane. *The Novel and Society*. New York: Barnes and Noble, 1966.

Steffens, Johann Heinrich. *Clarissa, ein bürgerliches Trauerspiel*. Zelle: G. C. Gsellius, 1765.

Steiner, George. *After Babel*. New York: Oxford University Press, 1975.

———. "The Distribution of Discourse." In his *On Difficulty and other Essays*, 61–94. New York: Oxford University Press, 1978.

Streeter, Harold Wade. *The Eighteenth-Century English Novel in French Translation*. New York: Benjamin Blom, 1970.

Tancock, Leonard, trans. *Letters on England*, by Voltaire. New York: Penguin, 1980.

Taylor, Anne Robinson. "An Odd and Grotesque Figure: Samuel Richardson and Clarissa." In her *Male Novelists and Their Female Voices: Literary Masquerades*, 57–90. Troy, NY: Whitston, 1981.

"Über die verschiedenen Verdeutschungen von Richardsons *Clarissa*." *Journal von und für Deutschland* 9 (1792): 16–25.

Voltaire. *Lettres Philosophiques*. 2 vols. Ed. Gustave Lanson. Paris: M. Didier, 1964.

Ward, Albert. *Book Production, Fiction, and the German Reading Public 1740–1800*. Oxford: Clarendon Press, 1974.

Warner, William Beatty. *Reading "Clarissa": The Struggles of Interpretation*. New Haven: Yale University Press, 1979.

———. "Redeeming Interpretation." *The Eighteenth Century: Theory and Interpretation* 26 (1985): 73–94.

Watt, Ian. *The Rise of the Novel: Studies in Defoe, Richardson and Fielding.* Berkeley: University of California Press, 1964.

Wells, C. J. *German: A Linguistic History to 1945.* Oxford: Clarendon, 1985.

Wilcox, Frank Herbert. *Prévost's Translations of Richardson's Novels.* University of California Publications in Modern Philology, vol. 12, no. 5:341–411.

Wilt, Judith. "'He Could Go No Farther': A Modest Proposal about Lovelace and Clarissa." *PMLA* 92 (1977): 19–31.

Wolff, Cynthia Griffin. *Samuel Richardson and the Eighteenth-Century Puritan Character.* Hamden, CT: Archon, 1972.

Yip, Wai-lim. *Ezra Pound's "Cathay."* Princeton: Princeton University Press, 1969.

Zeitler, Julius, ed. *Deutsche Freundesbriefe aus sechs Jahrhunderten.* Leipzig: J. Zeitler, 1909.

Zomchick, John P. "Tame Spirits, Brave Fellows, and the Web of Law: Robert Lovelace's Legalistic Conscience." *ELH* 53, 1 (Spring 1986): 99–120.

Index

Indexed are primarily: (1) important concepts such as "translation" and "translator"; (2) names of seventeenth-, eighteenth-, and nineteenth-century literary persons, which have been provided with dates and, in the case of the more obscure names, with a designation of the activity for which they were noted; and (3) characters from *Clarissa*.